Contents

Foreword

> The past should be altered by the present, as much as the present is directed
> by the past.
>
> <div align="right">T. S. ELIOT</div>

The distinctive character of the Tate Gallery derives from the unusual range of its Collections. Most major museums across the world are devoted to either 'classic' or 'modern' art or to a 'national' or an 'international' view. The Tate manages to combine all these forms in one small building and in so doing spreads confusion, but also the seeds of great potential. Where else can we see Blake and Bacon, Turner and Kiefer, Constable, Nash and Long under the same roof?

In the sixties the Tate, in common with the thinking of the time, made a separation between two collections, 'Historic British' and 'Modern', absorbing twentieth century British art into the story of the development of international modern art. This was exciting and reflected the aspirations of many of the most accomplished British artists, but with hindsight we can see that it caused us to overlook the contribution of British artists whose interests took them in other directions; visionaries like Spencer, Nash and Collins, academics like Augustus John and Munnings, expressive realists like later Bomberg, Auerbach and Freud were difficult to place in the display of the collections.

Now, at a time when many different strands of contemporary British art are highly regarded abroad, and during a period in which living artists of all nationalities find increasing relevance and inspiration for their art in the painting and sculpture of the eighteenth and nineteenth centuries, it is perhaps right to break the rigid divisions between British and Foreign, Historic and Modern.

The new display, which this book accompanies, therefore establishes three new principles for the presentation of our Collections. Firstly, a simple chronological sequence provides a skeleton which can be followed backwards or forwards in time from the Tudors to the present, tracing the evolution of British art until Impressionism and then the interrelationship of British and Foreign art through the schools of Paris, New York and now continental Europe. Secondly, within that general sequence we have taken advantage of the richness of the Collections to present some artists or themes in depth. Limitations of space at the Tate are now such that we are obliged to show such artists or themes in rotation, but we believe that such a policy is preferable to an even handed representation of everything at all times. Our aim is to enhance enjoyment and deepen understanding, rather than to encourage visitors to look only at those works with which they are most familiar. Finally we wish to diversify the conventional patterns and readings by a series of *Cross-Current* displays which will trace the persistence of the certain themes or ideas through many generations of art.

Such displays will become a regular part of our programme, as will *Focus* displays which will bring together the complete holdings of an artist.

A museum is conventionally regarded as an assembly of objects recording the achievements of the past but as Eliot has pointed out it also exists as 'the present moment of the past', throwing a light both backwards and forwards from history into history from our own time. A museum which continues to add works by living artists to its collection is in a specially privileged position. Our perception of both Blake and of Bacon is changed by the knowledge that Bacon painted a study after the life mask of Blake, that of Turner and Rothko by knowledge of the regard in which Rothko held the British artist and by the fact that they may be seen close together in this Gallery. In few institutions can it be more true that we should be able to perceive for ourselves that 'time present and time past are both perhaps present in time future, and time future contained in time past.'

Nicholas Serota *Director*

Acknowledgments

This *Illustrated Companion* serves both as a souvenir and as a complement to a visit to the Tate Gallery. It has been published to coincide with the complete redisplay of the collections from January 1990, under the title 'Past, Present, Future'. Both the book and the new displays have been made possible by the most generous support of BP. As a company they are well-known for their sponsorship of the arts, but their support for the Tate Gallery at this moment in its development has been exemplary, not simply from the point of view of finance, but also from the moral encouragement which they have given to a new venture. We are also pleased to acknowledge the support which this book has received from Westminster City Council. They have an enlightened programme of support for the arts and we are glad to see that the Tate Gallery can play a part in this. The book, itself, has been written by Simon Wilson, Head of Education at the Tate Gallery. He is the first to acknowledge the support and assistance which he has received from his own colleagues, but the task of illuminating the development of art over five hundred years is not an easy one and we are all in his debt for the refreshing insights which he conveys.

Author's Note

Like many great museums the Tate Gallery cannot exhibit all at once even the cream of its holdings, and in the new display certain designated galleries will change at planned intervals to show in depth fresh areas of the collections. The present volume is intended to accompany the collections as displayed in January 1990, together with changes to be made in the autumn of 1990 and spring of 1991. A further edition is in preparation to include those parts of the collections which will not come on view until later.

The structure of the book follows the planned displays as closely as possible, but for reasons of balance and space, historically related sections have sometimes been put together under one chapter heading. Each chapter consists of a brief historical summary, followed by a selection of major works from that part of the collection, each accompanied by a short commentary. As far as possible these commentaries are based on what is known or understood of the artist's intentions in creating the work. In general I have tried to avoid art historical or critical jargon and to tell a simple story.

A publication such as this does not have a sole author. Its primary source is the accumulated knowledge of the collections compiled by generations of curators and contained in the Gallery's catalogues of acquisitions. The present curators of the Tate Gallery played a major role in the creation of this book in respect both of the standards of cataloguing that they are now setting and the pains they took in reading the manuscript in draft, making many valuable suggestions. I must particularly acknowledge the contributions of David Blayney Brown and Jeremy Lewison who wrote the chapters on works on paper.

Simon Wilson January 1990

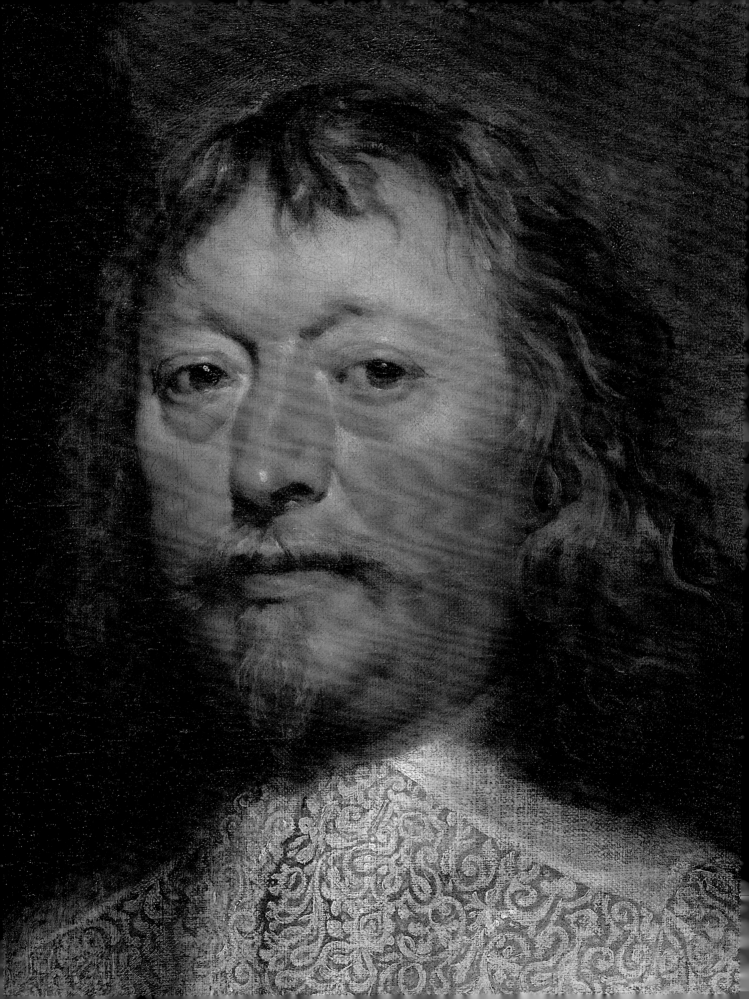

British Painting in the Sixteenth and Seventeenth Centuries

John Bettes **A Man in a Black Cap**
1545

Hans Eworth **Portrait of a Lady, Probably of the Wentworth Family**
*c.*1565–8

◁ William Dobson **Endymion Porter**
*c.*1643–5 (detail)

The story of British art begins at the Tate Gallery with John Bettes's portrait of an unknown man in a black cap, painted in 1545, two years before the death of Henry VIII. Bettes was an English follower of Henry's great court painter Hans Holbein, who had brought the Renaissance style to England from his native Basle. 'Man in a Black Cap' is painted with the clear realism characteristic of the style of Holbein and is inscribed on the back 'faict par Jehan Bettes Anglois' – 'made by John Bettes Englishman'. This is interesting, since from Holbein right up to the time of Hogarth two centuries later, art in Britain tended to be dominated by successful foreigners.

The style of Holbein was continued by Hans Eworth who came from Antwerp in about 1549 and became the most important painter in England from then until the rise of Nicholas Hilliard in about 1570. Eworth's brilliant 'Portrait of a Lady, Probably of the Wentworth Family', painted about 1565–8, ten years into the reign of Elizabeth I, is notable for its emphasis on richness of jewellery and costume and on using these to create highly decorative, flatly patterned effects. One of the splendid jewels is also symbolic or emblematic; this is the carved chalcedony set in gold and diamonds dangling from the lady's hand on a black ribbon. It represents Prudence and may refer to the lady's character, or possibly her name or family motto.

This elaborate decorative style with frequent use of emblematic elements became characteristic of the Elizabethan age and was vigorously encouraged by the Queen herself, not least in her own portraits, which she used as propaganda to promote her image as an almost divine monarch, head of both state and church. The basic type of portrait of Elizabeth I was created for her by Nicholas Hilliard, the first great native born genius of English art, who became the Queen's court painter in about 1570. His portrait of her is reproduced and discussed on p.15.

George Gower was appointed Sergeant Painter to Elizabeth in 1581 and three years later went into partnership with Hilliard in an attempt to gain a monopoly of royal portrait painting. His portraits of Sir Thomas and Lady Kytson show well how the decorative Elizabethan style could be combined with a sharp depiction of the character of the sitter. Lady Kytson in particular comes across as a vivid personality.

The last ten years of Elizabeth's reign saw the rise of Marcus Gheeraedts the Younger, a Flemish born painter, whose Protestant family came to London in 1568 to escape religious persecution. In 1592 he painted the celebrated portrait of Elizabeth now in the National Portrait Gallery, and his fame was assured. His great full length portrait of Captain Thomas Lee is reproduced and discussed on

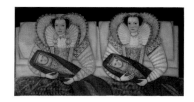

British School **The Cholmondeley Sisters** *c*.1600–10

British School **William Style of Langley** 1636

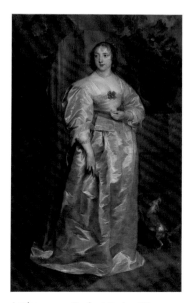

Anthony van Dyck **A Lady of the Spencer Family** *c*.1633–8

p.16. Also worth a look are his portrait of 'Lady Harrington', his tender portrait of an unknown pregnant young 'Woman in Red', dated 1620, and his head and shoulder portrait of the Fourth Earl of Pembroke, which is a splendid characterisation of a favourite of King James I who was notorious at court for being bad tempered and foul mouthed, but was loved by the King for his knowledge of horses and hunting.

One of the most striking and memorable examples in the Tate Gallery of the highly stylised and decorative Elizabethan portrait is 'The Cholmondeley Sisters'. The inscription in the lower left corner tells the story of these ladies: 'Two ladies of the Cholmondeley Family/Who were born on the same day/Married the same day/And brought to bed the same day.' The painter of 'The Cholmondeley Sisters' is not known, but this is often the case with British portraits of this period when painters rarely signed their work.

Gheeraedts lived until 1636 but was eclipsed as a fashionable painter by the arrival in London at about the same time, around 1618, of two Dutchmen, Paul Van Somer and Daniel Mytens (sometimes pronounced 'mittens'). Van Somer's portrait of the Countess of Kent shows the richer, more solid style that brought him success, but he was overshadowed by Mytens whose full length portrait of the First Duke of Hamilton as a young man has a quite new elegance and sophistication.

Mytens in turn was overshadowed by the Flemish painter Anthony Van Dyck who settled in London in 1632 as court painter to the greatest of English royal art collectors Charles I. Van Dyck's portrait of 'A Lady of the Spencer Family' (the same family as the present Princess of Wales) shows the radically new style that he introduced into England: the figure is fully three-dimensional, existing in a real space and articulated so as to convey movement. Van Dyck has exploited the reflection of light on the folds of her dress to create the kind of shimmering beauty of colour for which he was celebrated. These effects of light, the suggestion that the lady is walking forward, and the active pose of the dog chasing a lizard, all help to give the picture a feeling of life and a relaxed quality that combines with its elegance and grandeur in a formula that made Van Dyck the most sought-after court portraitist of his time.

Among lesser artists, the stiff and decoratively patterned Elizabethan style often lingered on into the age of Charles I and could produce fascinating results. One masterpiece of this type is 'The Saltonstall Family' which is reproduced and discussed on p.17. Another is the portrait of 'William Style of Langley', dated 1636, by an unknown artist. It seems to have been painted to record the entry of this gentleman into a new understanding of religious life. This is signified by the way he turns his back on his worldly pleasures and possessions symbolised by the 'kit' or dancing master's violin on the table. The strange object he is pointing at is a burning heart containing a globe, which signifies that the human heart cannot just be satisfied with the things of the world, but also needs God.

Peter Lely **Frans Mercurius van Helmont** 1670–1

Van Dyck died in 1641 just as the Civil War was breaking out in England. Charles I set up a court in exile at Oxford. Here for a few years, until his own death in 1646, the English painter William Dobson took over as court painter to Charles I and produced a group of outstanding paintings. Dobson's masterpiece of this period, his portrait of Endymion Porter, is reproduced and discussed on p.18.

After Dobson's death the gap in British painting was again filled by a foreigner, Peter Lely, who came to England from Holland in about 1643. He quickly made his mark and in 1647 was commissioned to paint Charles I and his son while they were under arrest at Hampton Court Palace after the end of the Civil War. Lely's adaptability enabled him to flourish during the years of Parliamentary rule before the restoration of the monarchy in 1660. Of particular interest are the biblical or mythological subjects with which he seems to have had considerable success at this time, since this type of subject, known as 'history', is rare in British art right up until the late eighteenth century. It is also interesting that during a period of puritan rule many of Lely's pictures of this type, like 'Susanna and the Elders', appear to have been of erotic subjects. In fact, Lely's evident leaning towards sensuality came into its own during the reign of Charles II: 'Two Ladies of the Lake Family' is a fine example of his ability to interpret the sleepy, pop-eyed voluptuousness fashionable at court. Lely became enormously successful, was appointed Principal Painter to Charles II and was knighted. However, Lely's artistic personality did have another side and his portrait of the celebrated alchemist Frans van Helmont is impressive in its austere realism. An inscription on this picture records that Van Helmont used his alchemical skills to embalm the body of Lady Conway when she died in 1679, so that it could be preserved for her husband's return from abroad. The portrait was presumably commissioned by Lord Conway whose close friend Helmont had been for nine years.

Lely died in 1680, and it was not until the confusion of the reign of James II and the revolution of 1688 was sorted out that a new Principal Painter was appointed. This was Godfrey Kneller, who remained the major artistic figure in England through the reigns of William and Mary, Queen Anne and George I until his death in 1723. Kneller studied in Holland and Italy, returning to his native Hamburg by 1676. In that year he also moved to London, probably at the urging of John Banckes, a merchant and banker based in London and Hamburg. Kneller lived in Banckes's London house for about a year while Banckes assiduously sought patronage for him. Kneller's 'Portrait of John Banckes' of 1676 is a sympathetic portrayal of the man who launched the painter on his remarkably long and successful career. It is also one of Kneller's most attractive works, luminously painted in warm colours. The papers on the table appear to refer to Banckes's business interests in Amsterdam. Kneller's style later became more austere and pompous as perhaps befitted the much grander sitters he

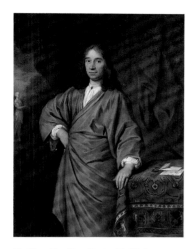

Godfrey Kneller **Portrait of John Banckes** 1676

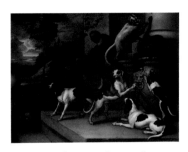

Francis Barlow **Monkeys and Spaniels Playing** 1661

acquired with court patronage and increasing success through the 1680s. His portrait of 'John Smith, Speaker of the House of Commons' of about 1707–8 is a particularly fine example of official portraiture in the time of Queen Anne and shows Kneller's work in the 'grand style' at its most dignified. Smith is shown in the full dignity of the Speaker's robes with the Speaker's chair and mace behind him. The chair is thought to have been designed by Sir Christopher Wren in 1706. The portrait was probably to commemorate Smith's success in the negotiations for the union of England and Scotland which was enshrined in the Union Act of 1707. The scroll he is holding is inscribed "The Union Act".

Not all seventeenth-century British art was portraiture. In the second half of the century a good deal of decorative subject painting was done on walls and ceilings in palaces and country houses. It was, again, mostly executed by fashionable foreigners such as Verrio but one major native exponent was Sir James Thornhill. Only preparatory sketches by these artists can be seen in the Tate Gallery; but Thornhill's most famous work is to be seen in the Painted Hall at the Royal Naval College, Greenwich. He also decorated the dome of St Paul's Cathedral.

The latter part of the seventeenth century also saw the beginnings of two kinds of painting which were to become very important in Britain in the next century, landscape and 'sporting' painting – the painting of animals and hunting scenes. There were two chief figures in these developments: Francis Barlow, whose 'Monkeys and Spaniels Playing' shows the great charm and warmth of his style, and Jan Siberechts whose 'Landscape with Rainbow, Henley on Thames' is reproduced and discussed on p.19.

NICHOLAS HILLIARD 1547–1619
Queen Elizabeth I *c.*1575
Oil on panel 787 × 610 (31 × 24)

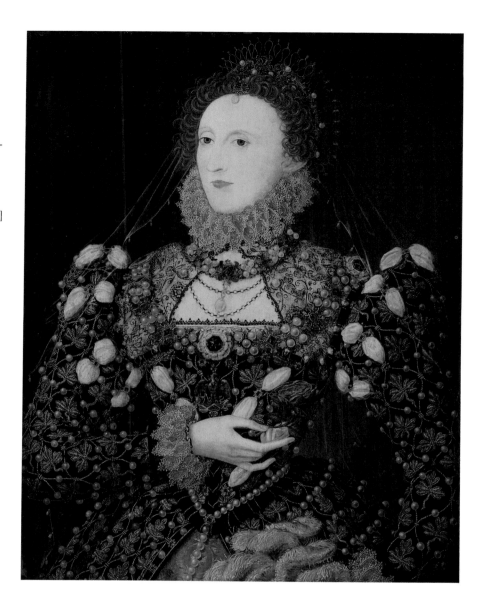

Nicholas Hilliard was a miniaturist and this is one of only two normal size, or 'in large', portraits that can reasonably be attributed to him. Hilliard was the most important artistic personality of the Elizabethan age. He was born in Exeter and brought up in Geneva, where he may well have first seen work by Holbein, whom he later described as 'the most excellent painter and limner [miniaturist] . . . Holbein's manner of limning I have ever imitated and hold it for the best.' This was written in Hilliard's *Treatise on the Art of Limning*, an account of the technical and aesthetic principles of his art which adds a significant intellectual dimension to his artistic personality. Hilliard returned to London at the age of fifteen, was apprenticed to the Queen's goldsmith and by 1672, when he made his first known miniature of her, was himself high in the Queen's favour. Before Hilliard appeared, Elizabeth had been unable to find a satisfactory court painter to create the awesome goddess-like image of herself that she required. This portrait of her, from just a few years after that first miniature, shows the standard that he set for all other painters of the Queen. In style it is extremely artificial, flat, linear and shadowless. These were all qualities encouraged by the Queen because it gave her portraits the same visual character as religious icons. Her face is a white, almost inhuman mask and her dress is incredibly rich – encrusted with gold embroidery, hundreds of pearls and other jewels. Only one hand is visible but it is very prominent and holds a rose. Above the hand is a magnificent jewelled pendant representing the mythical bird, the Phoenix. The Phoenix was supposed to reproduce by burning itself and arising renewed from the flames and is thus a symbol of virginity and chastity as well as of immortality. The rose is not only an emblem of the Tudor dynasty, the red rose of Lancaster, but is also associated with the Virgin Mary, who in Christian literature has long been referred to in terms such as 'the rose of heaven', 'the mystic rose' and 'the rose without thorns', meaning without sin. The rose is also a symbol of perfection. Elizabeth I carefully cultivated the idea of her own virginity and the association with the Virgin Mary as well as with more ancient deities such as the virgin goddess, Astraea, who was supposed to bring eternal spring time. Portraits like this were not only intended to impress her own subjects but were also sent abroad as diplomatic gifts to foreign rulers.

MARCUS GHEERAEDTS THE YOUNGER c.1561–1635
Captain Thomas Lee 1594
Oil on canvas 2305 × 1510 (90¾ × 59 1/16)

Thomas Lee served under the Earl of Essex as a troop commander in Elizabeth's army of conquest in Northern Ireland. He was an extraordinary, swashbuckling character often praised by his military superiors for brave deeds, but often in trouble for acts of banditry and alleged treason. He was eventually executed at Tyburn for plotting against the Queen in support of his patron the Earl of Essex, after the latter's abortive rebellion in 1601. Lee considered himself misunderstood and felt that his work in Ireland was not appreciated by the Queen. He also complained of lack of money and men. This portrait was painted when Lee was in England in 1594 to try to put his case to the Queen and was clearly intended as a personal statement.

Lee is dressed in a beautifully embroidered shirt and carries a fine pistol and helmet, but his legs are bare so that he has the appearance of a common Irish foot soldier, who had to travel barelegged through the bogs. This seems designed to draw attention to his complaint of poverty. He stands in an Irish landscape with open bogland on the left. In the woods behind him is a stretch of water with a group of armed men just visible by it. This may be a reference to Lee's valour, the previous year, in a battle against superior enemy forces for a ford near Belleek. Lee stands under an oak tree which is a symbol of reliability and constancy, and may also represent the solid protection given him by his influential cousin, Sir Henry Lee. The fact that he is standing in its lee or shelter may be a deliberate pun. In the tree is inscribed the Latin motto 'Facere et pati Fortia' which translates as 'To act and suffer bravely' – a reference to Lee's brave deeds, and also the suffering he felt he had undergone in the Queen's service. There is more to it than this, since the quotation comes from the historian Livy's account of a Roman commander, Caius Mucius Scaevola, who penetrated in disguise the camp of rebel Etruscan forces besieging Rome, in an attempt to assassinate their leader, Porsena. He was captured but behaved so bravely at his trial that the Etruscans, impressed, concluded a peace treaty and Mucius was

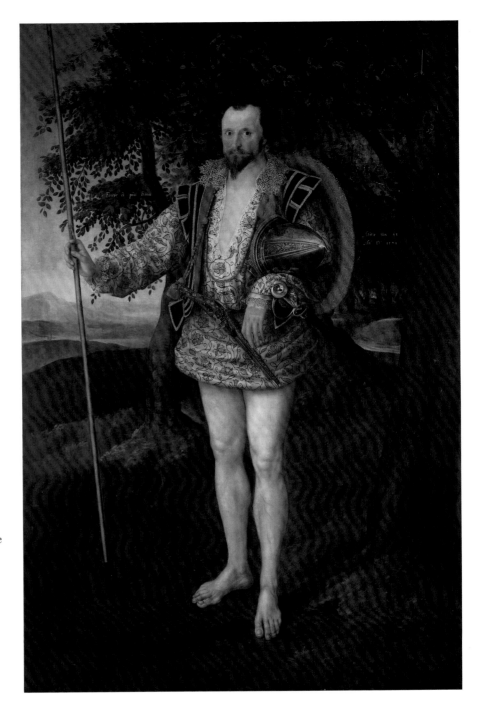

rewarded by the Roman Senate with a grant of land. This story has parallels with Lee's attempts to negotiate with the rebel Irish leader, the Earl of Tyrone. Lee was convinced he could bring about a settlement and for his reward hoped for a grant of land in Ireland. His use of the quotation, whose words are those of Mucius at his trial, is an attempt to associate himself with the Roman hero.

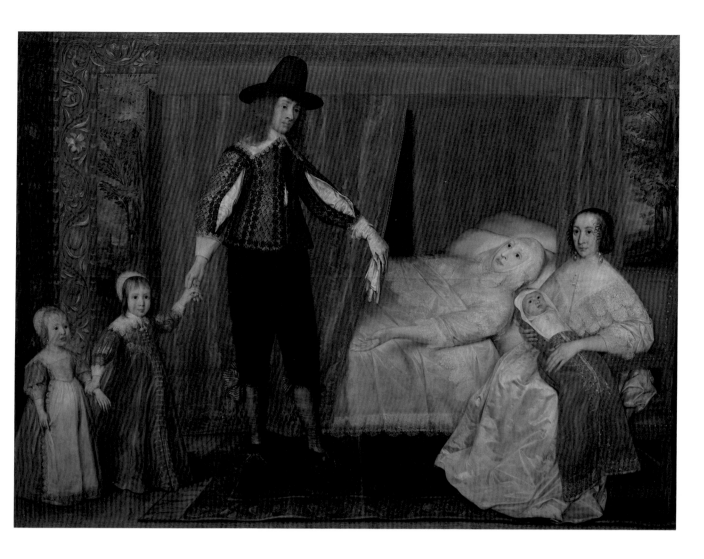

DAVID DES GRANGES 1611 or 13–1675

The Saltonstall Family c.1636–7
Oil on canvas 2142 × 2755 (84½ × 108⅜)

The painting shows Sir Richard Saltonstall of Chipping Warden, near Banbury, with his family. It appears to represent the father bringing the elder children to his wife's bedside to congratulate her on the arrival of a new member of the family. The fact that she has just given birth would account for her very pale and ill looking appearance. However, the lady holding the baby is far too grandly dressed and prominent in the picture for her to be just a nurse or relative. The probable answer to this puzzle is that she is Sir Richard's second wife Mary, holding their son Philip who was born in 1636. The lady in bed is probably Sir Richard's first wife Elizabeth who died in 1630, which would account even better

for her death-like pallor and for the way in which the artist has put her in a white head-dress and gown, in a white bed, to create a positively ghostly appearance. The two children on the left are her son Richard and daughter Ann who were seven and three respectively when she died, so she and her children seem to have been depicted just as they were at that time, some seven years or so before the picture was painted. In those days, incidentally, boys were dressed in girls' clothing until the age of about nine when they were 'breeched'. The idea of including Sir Richard's first wife in the picture would have seemed quite normal at the time: many Elizabethan and Jacobean tombs in particular, depict together dead and living members of a family.

A number of psychological touches reinforce this warm picture of family life and family history. The first wife gestures towards her children; Sir Richard looks

with tenderness at his present wife and new baby and draws back the curtain of the bed to reveal its occupant. The downward pointing glove makes a visual link that completes a chain of hands uniting the first Lady Saltonstall with her husband and children.

The richness of subject matter of this painting is reinforced by the strikingly decorative and bold colour scheme of red and pearly white, set off by the sombre elegance of Sir Richard's black and gold suit and tall black hat, in what was the latest fashion.

WILLIAM DOBSON 1611–1646
Endymion Porter *c.*1643–5
Oil on canvas 1499 × 1270 (59 × 50)

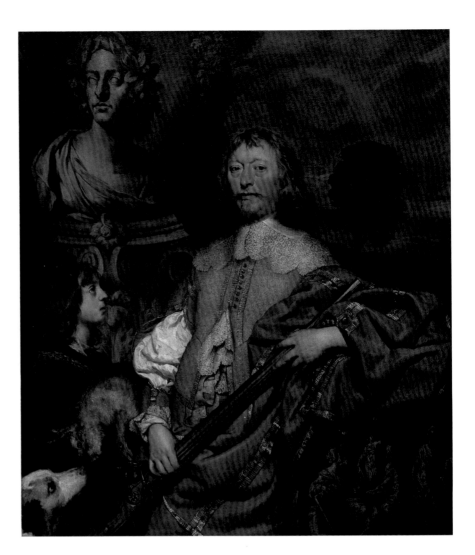

The historian Aubrey, who knew him, called Dobson 'the most excellent painter that England hath yet bred', and leaving aside Hilliard, who as a miniature painter is a special case, this remains the modern view. Nothing is known of Dobson until the last years of his short life, when he appears in 1642 as court painter to Charles I in exile in Oxford during the Civil War. Only about sixty paintings by Dobson are known and this one is often considered to be the best of them all. In it Dobson's style appears as completely accomplished in the new manner introduced by Van Dyck, but Dobson had evidently studied on his own account, and with profit, the great Renaissance paintings in the Royal Collection: the rich and beautiful colour scheme of brown and gold in this picture is reminiscent of Titian, and the pose is in fact taken from a Titian then in the Royal Collection, an imaginary portrait of the Roman emperor, Vespasian. This, like almost everything else about this picture, is significant: the reference links both painter and sitter to one of the most admired Italian Renaissance painters and to the world of classical culture. This latter is referred to much more explicitly by the bust of Apollo, Greek god of the arts, in the top left corner of the painting, and the classical sculptural frieze that Porter is leaning on. It depicts three figures representing, from left to right, the arts of painting, sculpture and poetry. All this is meant to tell us that Porter was a man of great intellectual accomplishment, particularly in the arts, which, in fact, he was. A leading courtier of Charles I, he knew and assisted many of the best writers of his day and played an important part in locating and acquiring works of art for the King. The sculpture being made by the central figure in the frieze is a statue of Pallas Athene, the Greek goddess of the arts and sciences, but also of war: she carries a shield and spear. This is almost certainly a reference to the war that Porter was assisting his King to fight at that time.

Although the picture emphasises Porter's intellectual accomplishment, it also presents him as an outdoor man and if not a warrior, at least a huntsman. He is in hunting costume and carries a fine wheel-lock hunting gun which takes a prominent place in the picture.

Although owing much to Van Dyck, Dobson's style is personal, with a down-to-earth quality which is characteristically British. This is particularly apparent in the painting of the face, where the puffy eyes hint at the strains of war. It is possible that the dead hare is also a reference to what was an ever present threat at that time, but the young page boy and faithful dog bring a gentler touch of pathos to the otherwise rather austere gloom of the work.

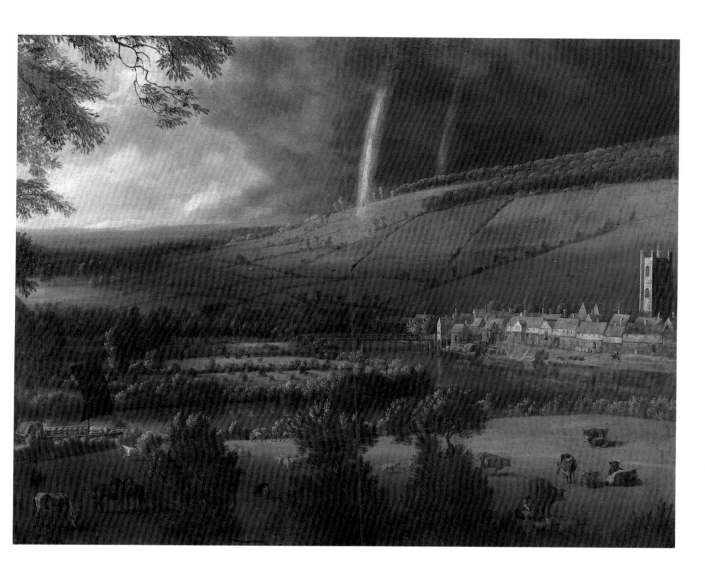

JAN SIBERECHTS 1627–c.1700
**Landscape with Rainbow,
Henley on Thames** c.1690
Oil on canvas 819 × 1029 (32¼ × 40½)

This is the most important early landscape painting in the Tate Gallery collections. It marks the beginning of a kind of art that became increasingly widespread in Britain through the eighteenth century, and reached its fullest flowering in the first half of the nineteenth in the work of Turner and Constable. In it can be seen both the love of the domestic, agricultural English rural scene later so celebrated by Constable, and the fascination with the wilder aspects of nature, such as storms and their accompanying dramatic effects of light, including rainbows, that were of more particular interest to Turner. In British landscape art at this early date, Siberechts's painting is

also remarkable for the fact that it shows a recognisable and specific English scene treated with such thoughtfulness. Particularly notable is the attention Siberechts has paid to the complex effects of light and atmosphere and the skilful naturalism with which he has rendered these – notice the way in which the areas of light and shadow on the landscape relate to the light and dark areas of the sky.

The whole idea of this kind of landscape painting grew up in Holland and Flanders in the seventeenth century and reflects the changes which took place in human attitudes to the landscape as the modern world evolved. Jan Siberechts came to England from Antwerp, in Flanders, in 1674, at the age of about forty-seven and stayed for the rest of his life. He mainly earned a living by painting views of country houses and their

surroundings for their owners – a kind of picture whose primary purpose was to display pride in ownership. This picture may also have been ordered by a landowner but it speaks to us too of a purely meditative love of nature.

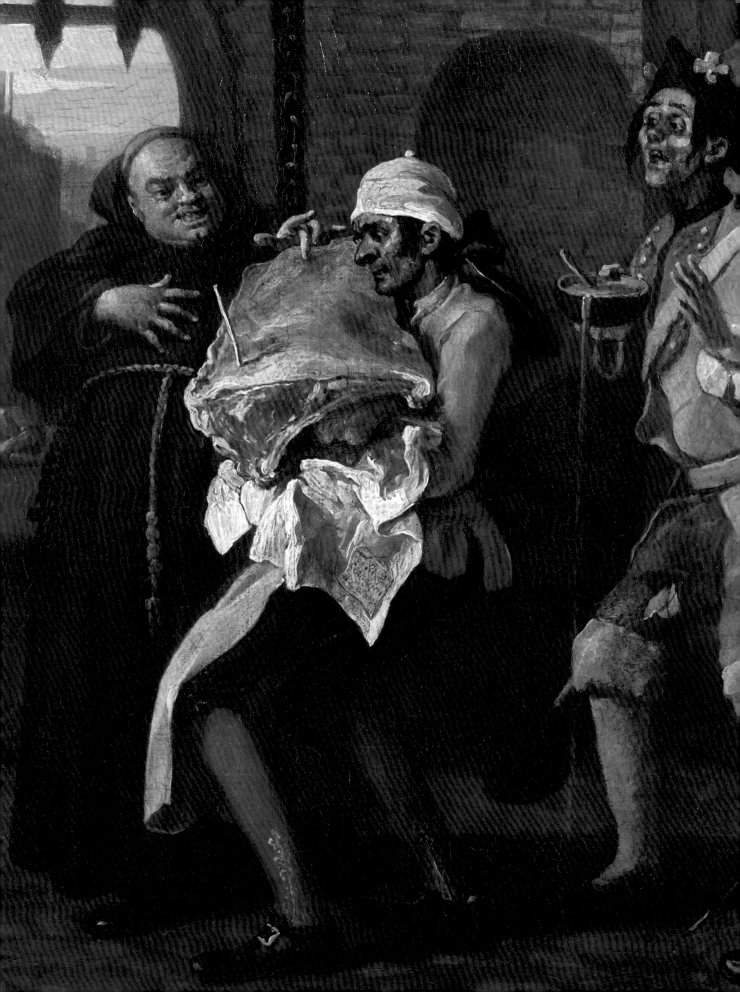

The Age of Hogarth

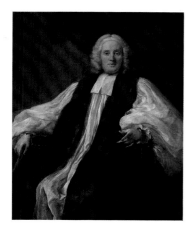

William Hogarth **Thomas Herring,
Archbishop of Canterbury** 1744–7

William Hogarth now appears as the dominant figure in British art from about 1730 to his death in 1764, and his career marks the beginning of a great flowering of painting in Britain. Hogarth was a distinguished portraitist, but he also extended portraiture to create in his 'modern moral subjects' and satires, an art which reflected and commented on the world around him. He made great efforts to establish what was called 'high art' or 'history' painting as a normal practice for British artists, and his aesthetic treatise, *The Analysis of Beauty*, published in 1753, although not well received in Britain, was within a month translated into German. Hogarth's character and the range of his artistic and intellectual interests are vividly evoked in his celebrated self-portrait of 1745, which is reproduced and discussed on p.23.

'Thomas Herring' shows Hogarth doing a grand formal portrait of one of the most important men in England, but the famous portrait of six of Hogarth's servants exhibits the brilliant naturalism and empathy with his fellow human beings that Hogarth was capable of when painting a less demanding subject. This remarkable picture may have hung in Hogarth's studio to demonstrate his ability to paint all age groups and it is possible that the heads were meant to represent the seven ages of man – there is room for a seventh head in the lower left corner. They may also demonstrate Hogarth's theory of the changes in the face that take place with age, set out by him in *The Analysis of Beauty*. 'The Strode Family' is a small informal group portrait, known as a 'conversation piece', of a kind which Hogarth did much to popularise. It is reproduced and discussed on p.26.

In 'The Beggar's Opera' of 1731 Hogarth has extended the idea of the conversation piece to create a subject picture dealing with the life of his times. It is the forerunner of his 'modern moral subjects' and satires. 'The Beggar's Opera', of which there are several versions, brought Hogarth to public attention for the first time and launched him on his career, and is discussed on p.24.

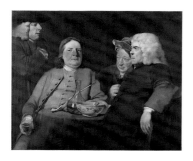

Joseph Highmore **Mr Oldham and
his Guests** *c.*1750

The Tate Gallery does not own one of Hogarth's series of 'modern moral subjects'; for a complete set one has to go to the National Gallery or the Soane Museum. But 'O The Roast Beef of Old England ("The Gate of Calais")' is a splendid satire and one of Hogarth's most accomplished paintings. It is reproduced and discussed on p.25.

Hogarth's attempts to paint 'history' had one particularly interesting result in the small unfinished painting of 'Satan, Sin and Death', an illustration to 'Paradise Lost', the seventeenth-century poet John Milton's epic version of the Biblical story of Satan and Adam and Eve. Both Blake and Fuseli, as well as other Romantic painters, later made versions of this subject clearly inspired by Hogarth's design.

◁ William Hogarth **O The Roast Beef of
Old England ('The Gate of Calais')**
1748 (detail)

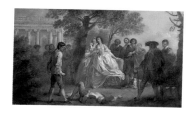

Francis Hayman **The Wrestling Scene from 'As You Like It'** *c.*1744

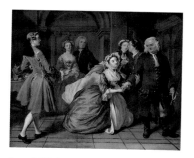

Joseph Highmore **Pamela Asks for Sir Jacob Swinford's Blessing** 1743–4

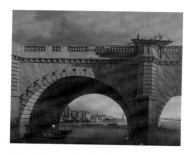

Samuel Scott **An Arch of Westminster Bridge** *c.*1750

The other two leading painters of Hogarth's time were Francis Hayman and Joseph Highmore both of whom, like Hogarth, expanded the range of their painting from grand 'history' to popular illustration. Both, however, could produce notable portraits, as Hayman's 'Thomas Nuthall and his Friend Hambleton Custance' and Highmore's elegant 'Gentleman in a Brown Velvet Coat' demonstrate. The Tate Gallery also owns Highmore's wonderfully observed portrait of 'Mr Oldham and his Guests'. This picture was commissioned by Nathaniel Oldham after he had invited three friends to dine with him, but had then stayed out hunting so long that when he finally arrived home they had finished eating and were drinking punch. The artist himself was one of the guests and is the central of the three seated round the table. Hayman is particularly remembered for the fifty or so paintings he made to decorate the supper boxes at the Vauxhall Pleasure Gardens in London, whose owner had been persuaded by Hogarth to decorate them with paintings and sculptures by native English painters. Few of these paintings now survive but one of them is 'The See-Saw' whose mildly erotic subject is in keeping with the general atmosphere of the gardens. A youth takes advantage of a young woman's disarray after a hard landing, while her lover, or perhaps brother, rushes forward to defend her. More brilliantly executed is Hayman's 'Wrestling Scene from "As You Like It"' which has the distinction of being one of the earliest painted scenes from Shakespeare – a source which was to become increasingly important for English artists.

Outstanding among Highmore's surviving subject pictures are his twelve scenes illustrating Samuel Richardson's enormously popular novel *Pamela* published in 1740. *Pamela* tells the story of the attempted seduction of a virtuous lady's maid by 'Mr. B.', the son of her late employer. In 'Mr B finds Pamela Writing' Mr. B. finds Pamela alone and is about to exploit the situation. It all ends happily in marriage and even Mr. B.'s snobbish uncle Sir Jacob Swinford is finally won over in another of the episodes illustrated by Highmore.

Landscape painting continued to develop in the 'Age of Hogarth', its leading practitioner being George Lambert who, as it happens, was one of Hogarth's friends. His 'View of Box Hill, Surrey' is reproduced and discussed on p.27.

Samuel Scott was another of the most gifted artists of this time painting sea-pieces, river views and some views of London. His beautifully observed, classically calm picture of 'An Arch of Westminster Bridge' is the most important of a number of such views he painted from studies while the Bridge was under construction. It was, typical of such pictures at this time, designed to be seen from below, since it would have been placed above a high Georgian mantle-piece. For this reason it is hung high today.

WILLIAM HOGARTH 1697–1764
Portrait of the Painter and his Pug 1745
Oil on canvas 900 × 699 ($35\frac{7}{16}$ × $27\frac{1}{2}$)

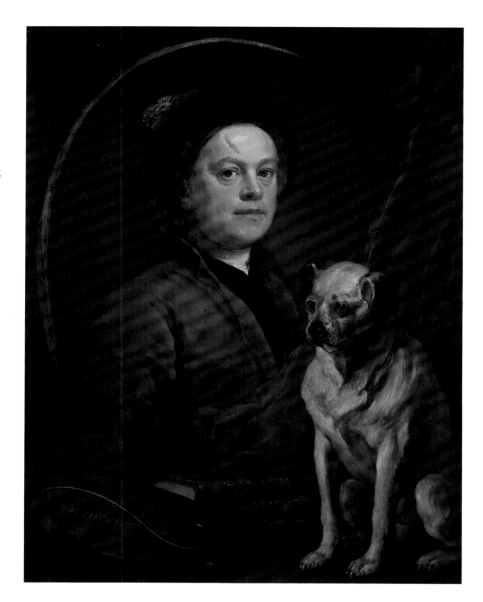

This painting is a statement of Hogarth's artistic beliefs. The self-portrait is in fact a picture within a picture, an oval canvas resting on the pile of three books. Close examination reveals that these are labelled Shakespeare, Swift and Milton on the spines. Hogarth seems to be saying that his own art is based on the tradition of English literature, so much stronger than the tradition of painting, represented by these three great writers, from the sixteenth century, the seventeenth century and Hogarth's own time respectively. He also seems to be suggesting that he is their equal, and by placing his palette beside the books, that painting is now the equal of literature. Hogarth's choice of these writers undoubtedly reflects as well his own interests: Shakespeare for the theatre and high tragedy and comedy, Milton for imagination and epic poetry, and Swift for acute social and political comment and wit. The palette is a symbol of the artist's profession, but it has on it a curved three-dimensional line and the words 'The LINE of BEAUTY and GRACE'. The words 'and GRACE' have been painted out, but are now clearly visible as the oil paint has become transparent with age. (Changes of mind such as this, which later become visible with age, are known as pentimenti. They are common in oil painting and can be useful in establishing whether a painting is an original or a copy). The line and the words refer to Hogarth's theory, later set out in his book *The Analysis of Beauty*, published in 1753, that this curved serpentine line is the basis of artistic harmony and beauty. In 1749 Hogarth published an engraving of his self-portrait and was delighted by the response to the line: '. . . no Egyptian hieroglyph ever amused more than it did for a time. Painters and sculptors came to me to know the meaning of it. . .'.

Opposite the palette is Hogarth's pet pug dog, Trump, one of a succession of pugs that he owned through his life. Hogarth was apparently fond of remarking on the resemblance of himself and the dog and probably saw the dog as a reflec-

tion of his own pugnacious nature in defending the rights of himself and fellow British artists. Hogarth's own image in the picture is interesting in this connection. X-rays have revealed that underneath the present surface Hogarth originally painted himself in a full wig and a coat with large gold buttons – the dress of a gentleman. At some stage he must have decided to have confidence in his status as an artist and to present himself in casual working artist's attire.

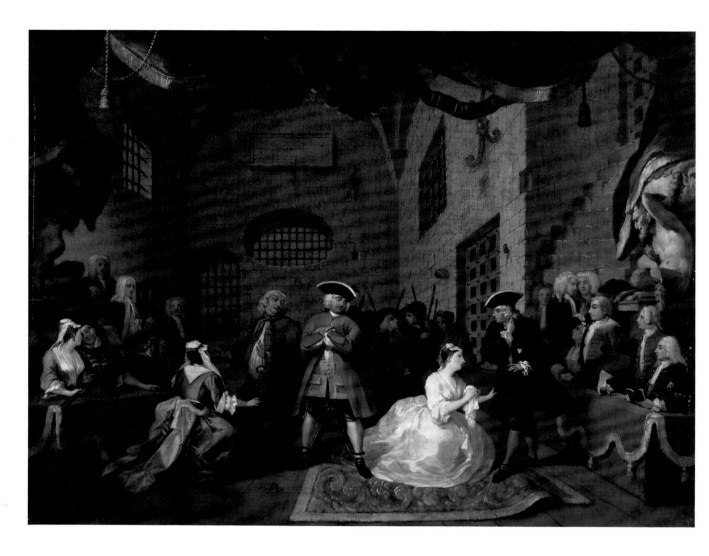

WILLIAM HOGARTH 1697–1764
The Beggar's Opera VI 1731
Oil on canvas 575 × 762 (22⅝ × 30)

The Beggar's Opera, by John Gay, was a
new kind of musical entertainment first
put on by John Rich at the Lincoln's Inn
Fields Theatre, London, in January 1728,
where it became a huge success. In form
it was a satire on Italian grand opera,
using popular tunes and ballads and sub-
stituting topical, recognisable, low-life
characters, for classical gods and god-
desses. This would have obvious appeal
to Hogarth with his belief in the superior-
ity of British to foreign art, but he would
also have been strongly attracted by the
opera's depiction of low-life and its thinly
disguised satire on the government of the
day. Hogarth's picture shows the climac-
tic scene of *The Beggar's Opera* in which
the highwayman hero, MacHeath, is
under sentence of death. The two kneel-

ing women, Lucy Lockit and Polly Pea-
chum, both believe themselves to be mar-
ried to him and are pleading for his life.
The picture is one of the earliest known
records of an actual stage performance.
Hogarth produced six versions of it
during the unprecedently long run of *The
Beggar's Opera*, the last two of which are
the most elaborate and complete. In par-
ticular, they include the figure of the
Duke of Bolton, seated with other high-
ranking members of the audience
actually on the stage. This was normal
practice at the time, but much disliked by
the actors and was finally abolished in
1763 by the great actor-manager, David
Garrick. The Duke is the seated figure in a
blue coat on the extreme right of the
stage. He is wearing the sash and star of
the Order of the Garter, one of the highest
British honours. However, Hogarth has
included him here because during the
run of *The Beggar's Opera* Bolton fell in

love with the leading actress, Lavinia
Fenton. She is the figure in white, centre
stage, and the Duke is clearly following
her performance with rapt attention. By
the time Hogarth painted this version the
affair had become well known. The Duke
was twenty-three years older than Lavi-
nia Fenton and married, and it is possible
that Hogarth has used the opportunity to
compare the criminal MacHeath's big-
amous behaviour in the opera with the
Duke's very similar behaviour in the
audience, and to point out that aristo-
crats are not necessarily morally any
better than those who are supposed to be
their inferiors. Hogarth adds emphasis to
his point by placing the Duke beneath the
statue of a satyr, a symbol of lust, which
furthermore appears to be pointing an
accusing finger at him. The two ladies
opposite, balancing the Duke, are
obviously gossiping about the scandal.

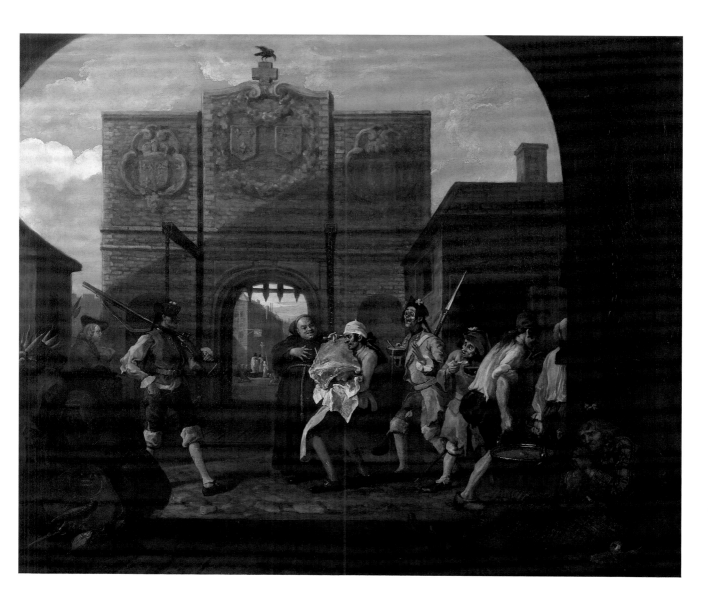

WILLIAM HOGARTH 1697–1764
O The Roast Beef of Old England ('The Gate of Calais') 1748
Oil on canvas 788 × 945 (31 × 37¼)

This picture was painted after Hogarth's second visit to France in 1748, when he was arrested in Calais as a suspected English spy. He was evidently extremely annoyed by the episode and the picture is a pungent anti-French satire. The cloth in which the beef is being carried bears a label inscribed 'For Madm. Grandsire at Calais'. Grandsire was the name of the landlord of the Lion d'Argent, the inn at Calais favoured by English travellers and where Hogarth was held in custody after his arrest.

In the background, on the left, Hogarth himself appears holding the sketchbook which was presumably the cause of his arrest. The tip of the arresting soldier's pike can be seen, as well as the hand on Hogarth's shoulder. Hogarth indeed paints a telling contrast of the starving French, who have only thin gruel to eat, with the huge side of beef, symbol of the well-fed Englishman. Only one of the Frenchmen, the fat monk, clearly is not starving and he is ogling the beef as it passes, perhaps in anticipation of eating it later at the inn. Here Hogarth is indulging anti-Catholic feeling and perhaps commenting on the pre-revolutionary system in France under which the nobility and the Church paid very little tax. Hogarth's anti-Catholic and anti-French sentiments also account for the miserable figure of the Scottish Highlander, a remnant of Bonnie Prince Charlie's defeated army, with only bread and a raw onion to eat. Hogarth's contempt for what he probably regarded as the over-demonstrative and superstitious religious behaviour of the French, is shown by the scene, visible through the gate, of people kneeling in the middle of the street as a religious procession passes. In the left hand corner are three fishwives who appear to be praying to a large fish of the ray family which they are holding up towards the spectator. A close look reveals that Hogarth has painted its mouth and gill opening so as to produce a very human looking face, with a striking resemblance to those of the fishwives.

WILLIAM HOGARTH 1697–1764
The Strode Family c.1738
Oil on canvas 870 × 915 (34¼ × 36)

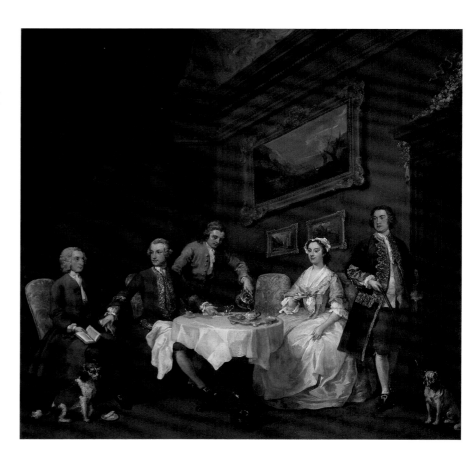

This is a fine example of the 'conversation portraits' or 'conversation pieces', as they are also known, that were the basis of Hogarth's practice in the early part of his career. Hogarth started out as an engraver, but his growing ambition, as he later recounted, made him 'turn his head to painting portrait figures from 10 to 15 inches high, often in subjects of conversation. It had some novelty. . . . it gave more scope to fancy [imagination] than the common portrait.' The 'scope to fancy' given by the conversation piece enabled Hogarth to develop it into the record of contemporary life combined with social comment or satire, that first appears in 'The Beggar's Opera', and later in paintings such as 'The Gate of Calais' and the multi-picture series of 'modern moral subjects'. However, an ordinary conversation piece can also provide a vivid evocation of the life of its time, as does 'The Strode Family'. The picture is said to be a breakfast scene although no food is in evidence. Tea is being taken and the butler is filling the tea-pot with hot water. The man on the left holding a book is a clergyman, Dr Arthur Smyth, who later became Arch-bishop of Dublin. Next to him is William Strode whose wealthy family were traders in the East. Opposite, is his wife Anne and the standing man is Colonel Strode, another member of the family. William Strode and Dr Smyth had done at least part of the Grand Tour together a few years earlier: they are known to have been in Venice at the same time. The pictures on the wall are the sort of thing that a wealthy young Englishman would bring back from Italy: the small one on the left is in fact a Venetian scene, perhaps by Francesco Guardi and the large one above is a landscape in the manner of Salvator Rosa. The pug dog belonged to the Colonel which is presumably why the Colonel is pointing at him with his gold topped cane. The other dog is William Strode's. On the floor in the foreground is the lockable tea caddy essential for what was then a very expensive commodity.

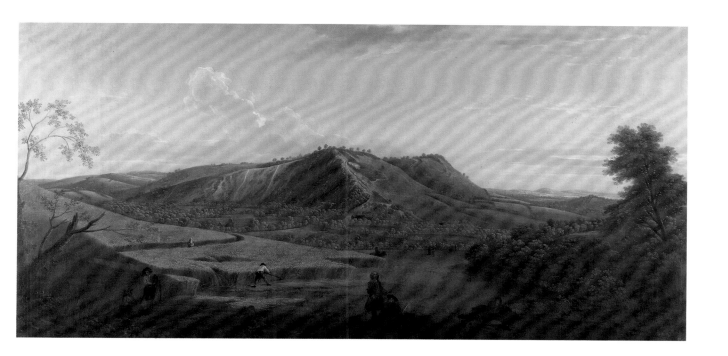

GEORGE LAMBERT 1700–1765
A View of Box Hill, Surrey 1733
Oil on canvas 908 × 1842 (33¾ × 72½)

George Lambert was a friend of Hogarth and is the first substantial figure in the history of English landscape painting. By the early eighteenth century two distinct kinds of landscape painting had developed: 'classical' landscape based on the example of Claude Lorraine, who transformed the Italian landscape of his day into imagined scenes of classical antiquity, and 'topographical' landscape which was concerned with rendering the natural beauty of a particular scene. Classical landscape was by far the most popular with collectors, and commentators such as Horace Walpole in his *Anecdotes of Painting in England* (published 1765) complained at both the lack of good landscape painters and the lack of interest in English scenery: 'In a country so profusely beautiful with the amenities of nature, it is extraordinary that we have produced so few good painters of landscape. . . . Our ever-verdant lawns, rich vales, fields of haycocks and hop grounds, are neglected as homely and familiar objects.' These comments occur immediately before a few lines devoted to Lambert in Walpole's book. In fact, Lambert himself mostly painted the classical type of landscape and his 'View of Box Hill' is all the more remarkable for the freshness and accuracy of its vision of an English landscape on an English summer's day: particularly notable is the gradation across the sky of the light from the setting sun and its play on the clouds. Hogarth himself, in his book *The Analysis of Beauty*, said that the ability to render this kind of effect 'was Claud de Lorain's peculiar excellence and is now Mr. Lambert's'. In the foreground are three gentlemen who have evidently been picnicking – the one on the ground is looking at an overturned wine bottle. Opposite him is a country-woman sitting down with a leather ale bottle by her side. One of the gentlemen is sketching, an interesting inclusion by Lambert of a reference to his own business of landscape art.

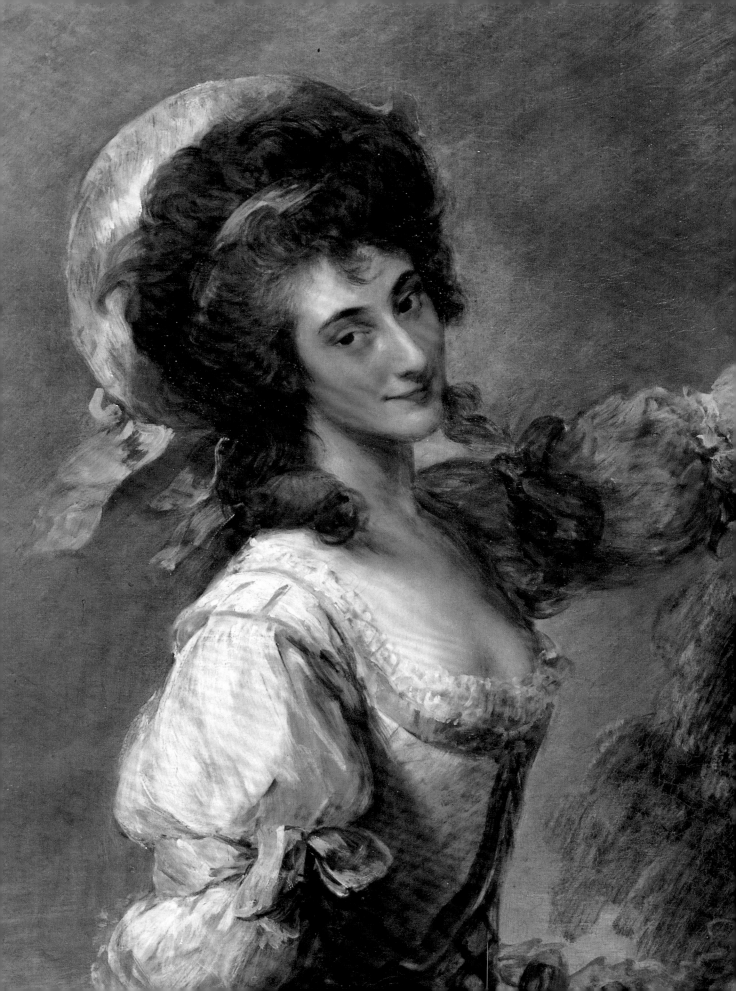

Eighteenth Century Painting: The Grand Style

Joshua Reynolds
Self-Portrait c.1773

'The Grand Style', or 'Grand Manner', is a term which came into use in the eighteenth century to describe in a general way the style of the great Italian Renaissance masters, as exemplified by Michelangelo and Raphael in their great cycles of narrative or 'history' painting in the Vatican and elsewhere. 'History' is a technical term meaning the painting of scenes from the Bible, classical history or classical mythology. Later artists such as Van Dyck, Claude and Poussin adapted the Grand Style to portraiture and landscape painting but in academic theory 'history' always remained superior to these and was known as 'high art'.

The Grand Style became a particular issue in British art after the foundation of the Royal Academy in 1768 with Joshua Reynolds (knighted the following year) as its first President. Reynolds began his career as a portrait painter in his native Devon, but in 1749 at the age of twenty-six he set sail for Italy, where he spent over two years in Rome steeping himself in Renaissance and Classical art. On his return, he set up practice in London and became phenomenally successful. Interestingly, Reynolds very rarely himself painted 'history', although he encouraged his students at the Royal Academy Schools to do so. Reynolds realised that British patrons, as Hogarth had earlier discovered, were not very interested in history pictures by British artists but were interested in portraits. He therefore adapted elements of history painting to portraiture and created a personal version of the Grand Style portrait. It was the prestige of these portraits, elevated from second to first rank in the hierarchy of genres, and the outrageous way in which Reynolds often flattered his sitters by depicting them as classical gods or goddesses, that brought him his success. One of the most famous examples, from the height of Reynolds's career is 'Three Ladies Adorning a Term of Hymen (The Montgomery Sisters)' which is reproduced and discussed on p.33. Also from this time of Reynolds's life is the 'Self-Portrait' painted in the manner of Rembrandt and exuding self-confidence.

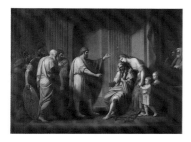

Benjamin West **Cleombrotus Ordered into Banishment by Leonides II, King of Sparta** 1768

Reynolds's great rival, Thomas Gainsborough, also created grand art and glamorous portraits, as can be seen from his 'Benjamin Truman' and 'Giovanna Baccelli', but his work is nevertheless very different from that of Reynolds: Gainsborough rarely used the sort of classical trappings that can be seen in Reynolds's 'Three Ladies', and whereas Reynolds often put his sitters into poses derived from famous old master paintings or classical sculpture, Gainsborough's poses, while classical, are much less obviously so. Reynolds's plagiarisms were actually satirised by his fellow Royal Academician Nathaniel Hone in his 'The Conjuror', which in effect accused Reynolds of 'conjuring up' his pictures from engravings of old masters. One of the engravings shows quite distinctly figures in the same poses as those in Reynolds's 'Three Ladies'. But

◁ Thomas Gainsborough **Giovanna Baccelli** 1782 (detail)

Nathaniel Hone **Sketch for 'The Conjuror'** 1775

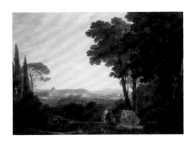

Thomas Gainsborough **The Revd John Chafy Playing the Violoncello in a Landscape** c.1750–2

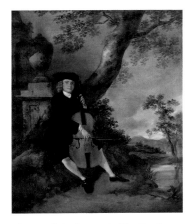

Richard Wilson **Rome: St. Peter's and the Vatican from the Janiculum** c.1753

above all there is a difference in visual quality between Gainsborough and Reynolds: Gainsborough was a master of colour, light, and the beautiful handling of paint, in a way that Reynolds simply was not. Gainsborough's 'Giovanna Baccelli' is reproduced and discussed on p.32.

The beginnings of Gainsborough's charming and informal version of the Grand Style can be seen in the small early portrait of 'The Revd John Chafy Playing the Violoncello' which does in fact have significant classical elements. However, these are very much subordinated to the landscape setting which was a major feature of his early portraits and reminds us that he was an important painter of landscape in its own right. John Chafy was a wealthy clergyman and amateur musician; the statue in the niche behind him carries a lyre and in Greek mythology might therefore represent Apollo, god of the arts, Terpsichore the muse of dancing and song, or Erato, the muse of poetry, all of which might be appropriate to the talents of the sitter.

Apart from Gainsborough the great landscape painter of this time was Richard Wilson, who, like Reynolds, went to Italy, staying there for about seven years and steeping himself in the Grand Style. His 'View of Rome' is a fine example of the landscapes he painted in Italy, in which close observation of light and atmosphere is combined with the classical subject of Rome itself and the compositional structures are derived from the 'classical' landscape art of Claude. Wilson's 'Meleager and Atlanta' is an example of a Grand Style Landscape at its most austere and also most complete, since it includes a subject drawn from classical literature.

Reynolds's successor as President of the Royal Academy was the American-born artist, Benjamin West, who settled in London in 1763 and became a founder member of the Royal Academy. His 'Cleombrotus Ordered into Banishment by Leonidas, King of Sparta', a subject taken from the ancient Greek historian Plutarch, is a perfect example of a history picture done according to the academic rules. However, West later introduced with great success the idea of painting contemporary events in the Grand Style. A famous example of this 'modern history' painting in the Tate Gallery is 'The Death of Major Peirson' by another American who settled in London, John Singleton Copley. This is reproduced and discussed on p.35.

Two of the most original and innovative artists of the second half of the eighteenth century were George Stubbs and Joseph Wright of Derby, both of whom visited Italy. Stubbs adapted the Grand Style to sporting and animal painting while Wright, among much else, applied it to genre painting, and also produced one of the most fascinating and extraordinary eighteenth-century portraits, 'Sir Brooke Boothby', which is reproduced and discussed on p.31. Stubbs's 'A Lion Devouring a Horse' is reproduced and discussed on p.34.

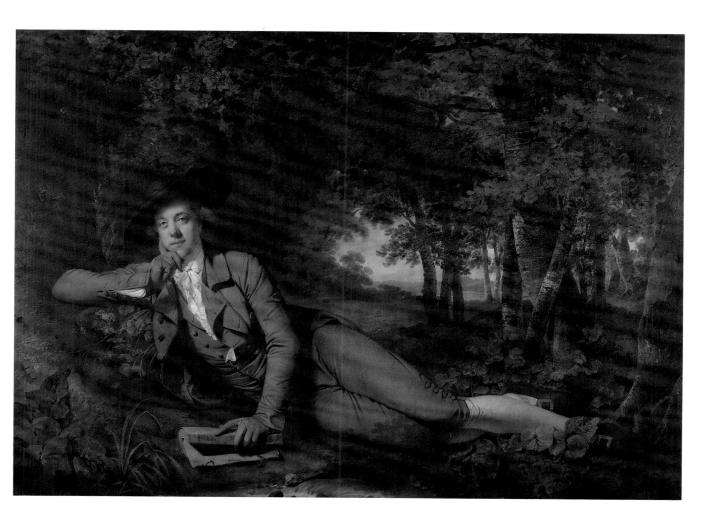

JOSEPH WRIGHT OF DERBY
1734–1797
Sir Brooke Boothby 1781
Oil on canvas 1486 × 2076 (58¼ × 81¼)

The idea of an aristocratic gentleman lying down in a wood, on the damp and possibly muddy bank of a stream, to do his thinking, would have seemed odd to most people at the time this picture was painted. Why is he not indoors in his well-stocked library in a comfortable armchair? The clue to Sir Brooke Boothby's strange action lies in the book he is holding under his left hand. Boothby's finger is pointing to the name of the author on the spine of the book, and looking closely it can be read: 'Rousseau'. This is Jean-Jacques Rousseau (1712–88), the French philosopher whose ideas have had a profound effect on politics, social behaviour, education and art. In the context of this painting it is probably Rousseau's idea that civilisation could be improved by adopting more

'natural' ways of doing things, which is particularly relevant, since Boothby seems deliberately to have adopted a pose that shows him in a harmonious relationship with nature.

Sir Brooke Boothby was an amateur poet and philosopher who took an active interest in the new scientific and technical ideas which were bringing about the industrial revolution in the English Midlands at that time. He had formed a friendship with Rousseau of which he was very proud. In 1776 Boothby visited Rousseau in Paris and Rousseau, fearing prosecution by the authorities, gave him for safekeeping the manuscript of *Rousseau Juge de Jean-Jacques* ('Rousseau judge of himself'), an important defence of himself and his ideas.

Rousseau died two years later, in 1778, and two years after that, in 1776, Boothby had the manuscript published in England. This is the book in the picture and Boothby was clearly so pleased with himself for publishing it that he com-

missioned the painting: it may be seen as a tribute from an English liberal thinker to the great French revolutionary philosopher.

Boothby's clothes are also interesting. It was poets and artists from about this time who seem to have established the idea that artists and 'intellectuals' should dress in an unconventional and informal way. At first glance, Boothby looks very elegant and tidy but a closer look reveals that by the standards of the time he was carelessly dressed – both his waistcoat and coat sleeves are unbuttoned and this was understood as symbolic of an intellectual and poetic personality who is above everyday trivialities such as 'correct' dress. The wide-brimmed black hat would also have indicated that Boothby had turned away from the civilised world to think deep thoughts alone in nature.

THOMAS GAINSBOROUGH
1727–1788
Giovanna Baccelli 1782
Oil on canvas 2267 × 1486 (89¼ × 58½)

Giovanna Zanerini, whose stage name
was Baccelli, was for many years one of
the principal ballerinas at the King's
Theatre in the Haymarket in London. Her
career as a dancer reached a peak in the
season of 1780–81 when she appeared in
a series of ballets staged by the innova-
tory French ballet-master J.G. Noverre
that took London by storm. The costume
she is wearing in this picture seems to be
adapted from one of these, 'Les Amans
Surpris'. From about 1779 Giovanna
Baccelli was the mistress of George Sack-
ville, 3rd Duke of Dorset, with whom she
lived in lavish style both at his country
seat at Knole, Sevenoaks, and in Paris
during his term as British Ambassador
there from 1783 to 1789. She was
painted by Reynolds as well as Gainsbor-
ough and there is a life-size nude sculp-
ture by Locatelli at Knole.

This painting is generally agreed to
represent one of the peaks of Gainsbor-
ough's mature portrait style, displaying
particularly his brilliant fluency of brush-
work and his ability to create compo-
sitions expressive of life and movement. It
also exhibits his famed ability to catch a
likeness, for which it was praised when
shown at the Royal Academy in 1782,
although one critic also wittily noted that
'. . . the face of this admirable dancer is
paint painted', by which he meant to point
out that she is wearing stage make-up
(known as paint).

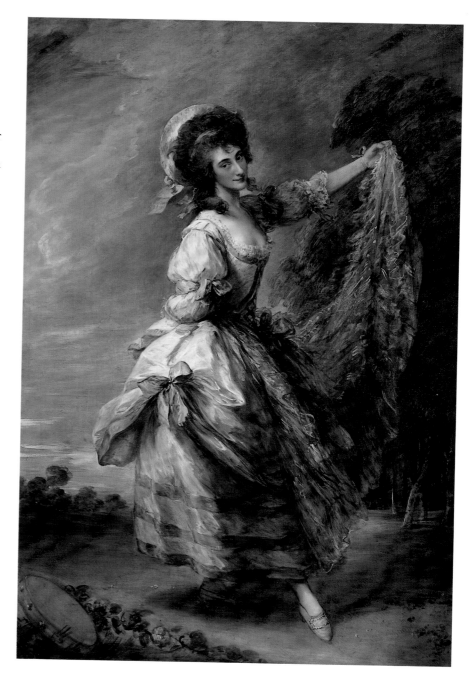

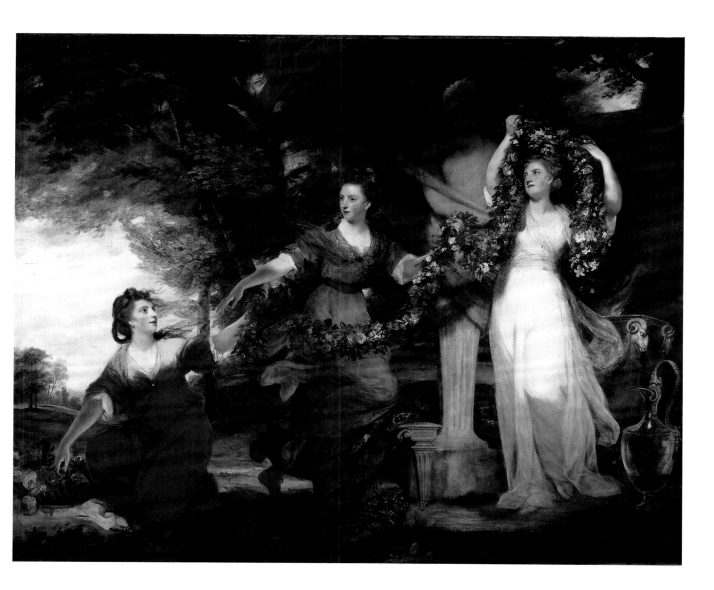

JOSHUA REYNOLDS
1723–1792

**Three Ladies Adorning a Term of Hymen
(The Montgomery Sisters)** 1773
Oil on canvas 2335 × 2950 (92 × 114½)

This is a perfect example of a Reynolds
Grand Style portrait. It was com-
missioned by Luke Gardiner of Dublin
who was at that time engaged to Eliza-
beth Montgomery, the central figure of
the three. The Montgomery sisters were
brought up in Ireland and became
known as 'The Irish Graces' because of
their beauty. Marrying one of such a trio
Luke Gardiner no doubt decided to
include the other two in the painting.
The picture has often been known as
'The Three Graces', but Reynolds has not
in fact depicted the sisters as the three

Greek goddesses. However, they are in
the vaguely classical costume that Rey-
nolds considered appropriate for this kind
of picture, as well as in a classical setting,
and some flattering implication remains.
In his letter of commission to Reynolds,
Luke Gardiner asked for the sisters to be
painted 'representing some emblematical
or historical subject' the choice of which
he left to the artist's 'genius and poetic
invention'. Reynolds was noted for his
ability to find an appropriate subject for a
Grand Style portrait and in this case he
has shown the three sisters paying
homage to the Greek god of marriage,
Hymen. The sister on the right, in white,
is Anne who was married just before the
picture was commissioned. It is possible
that for that reason Reynolds placed her
to the right of the god – 'past the post', as
it were. Barbara, the youngest sister, on

the left, was married the following year.
Reynolds wrote to Gardiner saying that
the subject 'affords sufficient employment
to the figures and gives an opportunity of
introducing a variety of graceful histori-
cal attitudes'. In accordance with Rey-
nolds's methods of raising the status of
portraiture to the level of the Grand Style
these 'historical attitudes' are derived
from a number of distinguished old
masters, including Poussin and Rubens.
The old master engraving that Reynolds
must have used can be seen in 'The Con-
juror', (p.30) a painting by Nathaniel
Hone satirising this practice of Reynolds,
although it was and is perfectly accep-
table; Hone was probably indulging a fit
of jealousy at Reynolds's success.

GEORGE STUBBS 1724–1806
A Lion Devouring a Horse 1767
Enamel on copper 243 × 282 ($9\frac{9}{16}$ × $11\frac{1}{8}$)

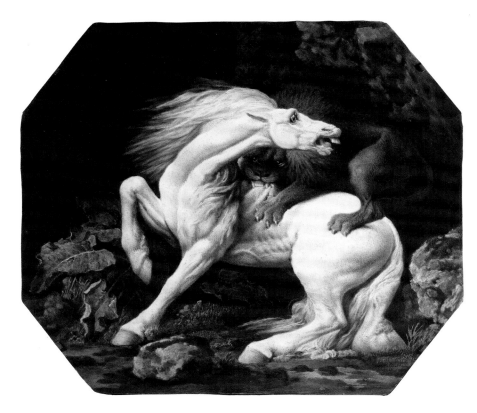

George Stubbs visited Italy in 1754 and there gained a knowledge of Renaissance and antique art that enabled him to raise his own painting of animals and the English sporting scene to the level of the Grand Style. Indeed, pictures such as this, showing a dramatic episode from the life of animals were called 'animal history' by the Stubbs scholar, Basil Taylor. As Taylor has also shown, the basis of Stubbs's composition here is almost certainly a well known classical sculpture of a horse attacked by a lion, which in Stubbs's day was on public view in the courtyard of the Palazzo dei Conservatori in Rome. Stubbs was so fascinated by the story of the horse and lion that he produced no less than seventeen works inspired by it, in various media, including engraving, a relief model in Wedgwood clay and this version in enamel on copper. Stubbs experimented with enamel as a means of picture making because he rightly considered it to be a more permanent medium than oil paint on canvas. But it also involves considerable technical difficulties and expense and Stubbs's output of enamels remained small. Those that survive, however, have great freshness and brilliance. This one is the earliest of Stubbs's known enamels and was exhibited at the Society of Artists in 1770 and sold to Lord Melbourne for 100 guineas.

Ozias Humphry, Stubbs's first biographer, describes how Stubbs made studies for another of the horse and lion series from a live lion kept by Lord Shelburne at his house on Hounslow Heath: 'Whilst he was executing these drawings many opportunities occurred of observing the disposition of this animal; of the manner in particular in which they watch and spring upon their prey. . .'. He goes on to describe how the lion stiffened and then sprang at a man who approached its cage while Stubbs was drawing. As well as drawing live animals from close personal observation, Stubbs carried out extensive anatomical studies, making scientifically precise drawings of dissections of many types of animals. It was this knowledge of his subjects combined with his knowledge of Renaissance and Classical art, which put him so far above the other sporting and animal painters of his time. The Tate Gallery owns one other work from the horse and lion series and has another on long-term loan. These show different episodes in the encounter of the two beasts.

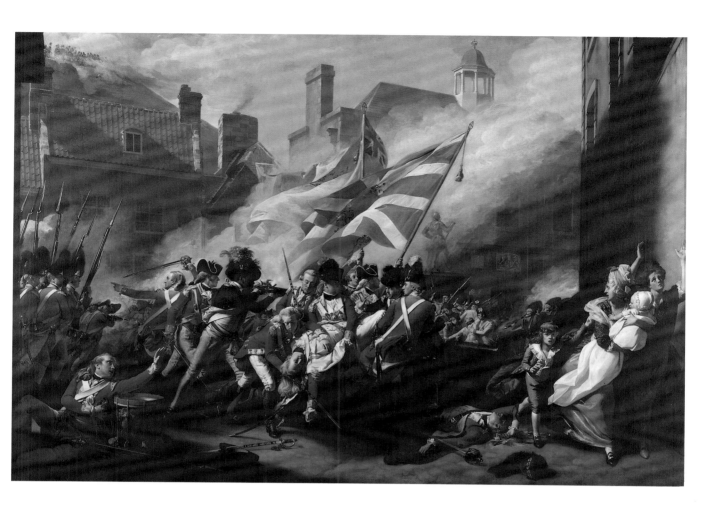

JOHN SINGLETON COPLEY
1738–1815
**The Death of Major Peirson 6 January
1781 1783**
Oil on canvas 2515 × 3658 (99 × 144)

On the night of the 5–6 January 1781 a
small French army landed on the island
of Jersey in what was to prove the last of
the many attempts made to return the
island to France since it had become an
English possession in 1066. In the early
hours of the morning the French
marched straight to the capital, St Helier,
captured the Governor, Moses Corbet,
and forced him to sign a document of
surrender. However, the British garrison
and the Jersey Militia, quartered outside
St Helier, refused to accept the surrender
and organised a counter-attack, led by a
young Major, the twenty-three year old
Francis Peirson. Positioning his men for
the final attack on the town centre, Peir-
son was shot dead by a French sniper
who was in turn shot by Peirson's black
servant, Pompey. After some confusion

Peirson's troops were rallied by one of the
local militiamen, Lieutenant Philippe
Dumaresq and a brisk battle ensued in
Royal Square resulting in the defeat of
the French. News of the splendid victory
reached London with great speed, a full
report appearing in the *London Gazette*
only ten days later on 16 January 1781,
and was particularly welcome at a time
when defeat in the American colonies
was imminent. One of the City of London
Aldermen, the successful engraver and
printseller John Boydell, immediately
commissioned this painting from Copley,
who had already made a name as a
painter of modern history with his
picture of the death of the Earl of
Chatham. 'The Death of Major Peirson'
was completed and put on show in May
1784 and one critic later wrote that '. . .
the chorus of praise reached all the way
to Buckingham Palace.' The setting of
Copley's painting is notably accurate: we
are looking towards Royal Square along
what is now Peirson Place, where Peir-
son was shot. The houses on both sides

are still as they are shown by Copley,
complete with bullet holes in the wall of
the one on the left, now a pub. The build-
ings on the far side of the square are no
longer the same but the statue of King
George II, in whose honour Royal Square
was named, is also still in place.

Copley has, however, considerably
increased the dramatic potential of the
event by moving Peirson's death from
just before the battle to what is evidently
the very moment of victory for the British
as they pour fire into the Square. The
French troops grouped around the statue
of George II are clearly in disarray and
Copley has contrived that one of their
number should be the sniper who killed
Peirson, now himself dying from the
instant retaliatory shot of Peirson's black
servant. In fact, the whole battle scene is
a brilliantly staged drama, not least in the
way Copley has heightened the effect by
introducing the group of terrified women
and children running straight out of the
picture on the right.

Eighteenth Century Landscape, Genre and Sporting Painting

Henry Robert Morland **A Laundry Maid Ironing** c.1765–82

Although the Grand Style tended to dominate painting in Britain in the second half of the eighteenth century, from the time of Hogarth onwards there was also a proliferation of more informal kinds of art: English, rather than Italian landscapes or scenes, sometimes treated in the naturalistic Dutch, rather than the classical, manner; *genre* painting, meaning scenes from everyday life; and sporting painting, which celebrated the country life-style of the aristocracy and gentry. Sometimes, leading practitioners of these kinds of art were among the great artists of the day, such as Gainsborough, Wilson and Stubbs, whose work was on the level of, or to a greater or lesser extent within the conventions of, the Grand Style.

Gainsborough is usually thought of as being first and foremost a portrait painter, but from the very beginning of his career he painted landscape and there is evidence that he himself attached more importance to this than to his portrait practice. Gainsborough was born and brought up in the town of Sudbury in Suffolk. After training in London he returned to Suffolk in 1748, at the age of twenty one, staying there until 1759 when he moved to the smart spa resort of Bath, where his career as a fashionable portrait painter was launched in earnest. Gainsborough's early landscapes are naturalistic views of the Suffolk scene such as the 'Wooded Landscape with Peasant Resting' of about 1747, which is reproduced and discussed on p.40. After his move to Bath, Gainsborough's landscape style changed, becoming less naturalistic, more poetic and richer in colour and paint handling, with compositional elements from the Grand Style. This was probably in response to the taste of the smart clientele he found in Bath as well as his own increasing interest in the art of Claude and other 'classical' landscape painters.

Among Richard Wilson's earliest works are London views such as 'The Hall of the Inner Temple after the Fire of 4 January 1736/7' of 1737 and 'Westminster Bridge under Construction' of 1744, a subject which also inspired Samuel Scott (see 'The Grand Style'). The Temple was the centre of England's law profession and its partial destruction by fire in January 1736–7 (until 1752 the English calendar year began on what is now 25 March) attracted considerable attention. Wilson has produced a finely detailed record of the aftermath of the fire, including the figure of Frederick, Prince of Wales, in the central group with the star of the order of the garter on his coat, paying a royal visit of sympathy. It is possible that by showing the Prince in a concerned public role Wilson may have been making a bid for royal patronage, but if so it did not succeed.

Richard Wilson **Westminster Bridge under Construction** 1744

Wilson's 'Westminster Bridge under Construction' offers another vivid image of London and its life at that time, prominently featuring the London boatmen

◁ George Stubbs **Reapers** 1785 (detail)

Richard Wilson **On Hounslow Heath**? exh.1770

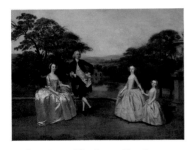

Arthur Devis **The James Family** 1751

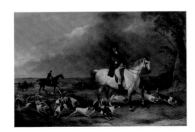

John Ferneley, Snr **John Burgess of Clipstone, Nottinghamshire with his Harriers** 1838

who were then the main means of crossing the river. Their livelihood was, of course, threatened by the new bridge, which they attempted to sabotage, although this is not evident in Wilson's painting which shows one of them welcoming a well-dressed couple on board.

Most of Wilson's later landscape painting belongs to the Grand Style but, particularly towards the end of his career, he occasionally painted in a less formal way. His 'On Hounslow Heath' of about 1765 is a peaceful and luminous evocation of a very ordinary scene. It was painted for a London bookseller, Tom Davies, rather than for a landowning patron and may represent a more unpretentious, middle-class taste.

Sporting painting is the painting of hunting and other rural sporting scenes, of horse racing, and of the horses, hounds and wild animals associated with these. Like landscape, it grew in popularity from the late seventeenth century and reached its peak of achievement in the art of George Stubbs. Among Stubbs's eighteenth-century precursors were Peter Tillemans, John Wootton and James Seymour. Tillemans was a landscape painter who came to England from Antwerp in 1708 and seems to have found it profitable to add sporting scenes to his landscapes. His 'Foxhunting in Wooded Country' of about 1720–30 is an early scene of the sport which increasingly replaced staghunting from the late seventeenth century onwards to become an integral part of English country life. Of the famous fox hunts the Quorn was founded in 1698, the Belvoir (pronounced 'Beever') in 1740 and the Pytchley in 1750. It was foxhunting which led to the development of horse racing and increasing interest in horses and horse breeding, and it was in this way that these became additional subjects for sporting painters.

John Wootton was an English contemporary of Tillemans and a much more important artist, who made a considerable contribution to landscape painting. His abilities as a landscape painter are well displayed in his large picture of the 3rd Earl of Litchfield out shooting. James Seymour, on the other hand, was exclusively devoted to painting the sporting scene itself. His 'A Kill at Ashdown Park' is reproduced and discussed on p.39.

George Stubbs, with his knowledge of Italian Renaissance and classical art, with his scientific approach to anatomy and with his brilliant natural gifts as a draughtsman, was able to raise sporting art to the level of the Grand Style. Three of his paintings are reproduced and discussed on pp.34, 41, 42. After Stubbs, sporting painting continued to be a popular and lively element in British art, and John Ferneley's picture of the gentleman farmer, John Burgess, out with his own pack of harriers, is an example by one of the most prominent later practitioners of the genre.

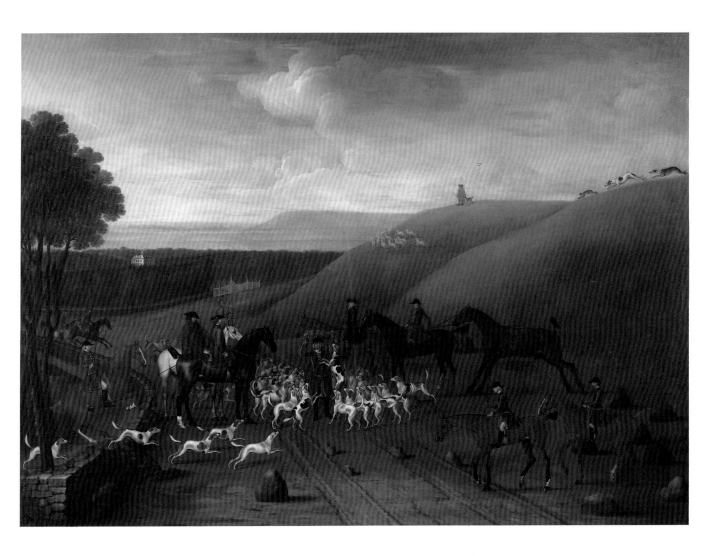

JAMES SEYMOUR ?1702–1752
A Kill at Ashdown Park 1743
Oil on canvas 1805 × 2390 (71 × 94)

James Seymour was the son of a wealthy banker and jewel merchant who was also an amateur draughtsman. The son inherited his father's talent for drawing, but not for making money, as the contemporary diarist George Vertue recorded: 'Jimmy Seymour . . . from his infancy has a genius to the drawing of Horses – this he pursued with great Spirit, set out with all sorts & of modish extravagances . . . the darling of his Father run thro some thousands – livd gay high and loosely – horse racing gameing women &c . . .' Seymour eventually appears to have ruined both himself and his father, who was declared bankrupt in 1736. He then turned to painting full time to earn a living and it is a nice irony that having lost a fortune to

horses they then became his means of subsistence. Seymour's style was not very sophisticated: his paintings have a slightly 'primitive' or 'naive' quality, apparent in the flat perspective and stiffness of the figures, that is the result of a lack of formal art training. On the other hand, he had a strong sense of design and his pictures such as this one have great charm and vitality. The stylised hounds, jumping the wall and running up to the huntsman holding the dead fox, make a dynamic and decorative pattern of movement across the canvas; Seymour similarly makes use of a stylised repetition of hounds to create another vivid pattern round the huntsman, which inescapably focuses attention on the central incident in the picture. On the right, Seymour shows one of the horses frankly 'staling' (urinating), a nice touch which adds pungency to his evocation of the flavour of eighteenth-century rural life. The set-

ting is the Berkshire estate of the 4th Baron Craven, who is the figure on the left on the dark grey hunter. In the background is Ashdown House, one of his country seats. In the foreground, Seymour has painted some of the sandstone boulders known as 'Sarsens' that still characterise this part of the country. On the hill on the right, two greyhounds course a hare, again painted in a stylised way to form a distinctive pattern on the horizon.

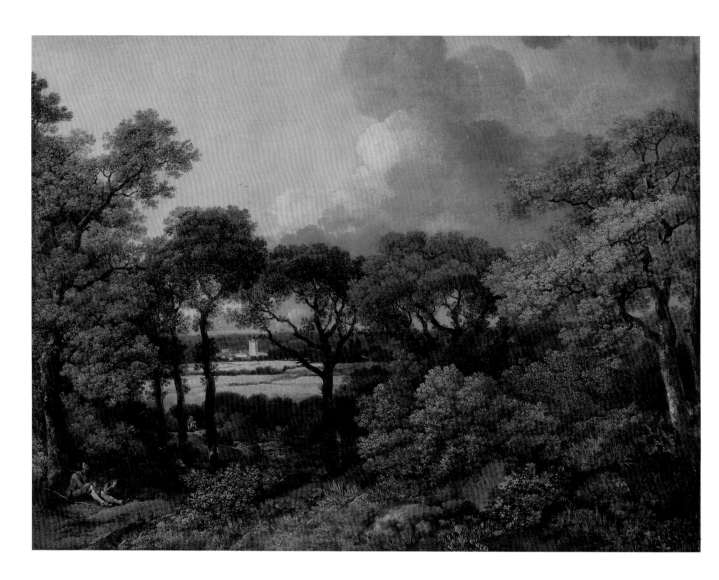

THOMAS GAINSBOROUGH
1727–1788
**Wooded Landscape with Peasant
Resting** *c.*1747
Oil on canvas 625 × 781 (24⅝ × 30¾)

In his early years in London in the 1740s
Gainsborough seems to have been
known only as a landscape painter and
by 1748 his talent was already suffi-
ciently noted for Hogarth to commission
a small landscape from him. On his
return to Suffolk, after his marriage in
1746, Gainsborough became primarily a
portrait painter, but he continued to
paint landscapes even though he often
could not find a buyer for them. After he
became a great fashionable success as a
portrait painter in Bath from 1759, land-
scape painting, together with music,
became even more important to him as a
relaxation from the pressures of his por-

trait practice: 'I'm sick of Portraits and
wish very much to take my Viol da
Gamba [cello] and walk off to some sweet
village where I can paint Landskips and
enjoy the fag end of life in quietness and
ease. But these fine Ladies and their Tea
drinkings, Dancings, *Husband huntings*
and such will fob me out of the last ten
years . . .' This is in a letter to his friend,
William Jackson, who gave him music
lessons in return for lessons in drawing.
 'Wooded Landscape' is one of Gains-
borough's early Suffolk landscapes, when
he was still painting in a naturalistic vein
developed from the combination of his
love of Suffolk and his admiration for
Dutch seventeenth-century landscape. It
looks extremely natural, but in fact the
composition is highly ordered, with a
central path between two balanced
masses of trees leading the eye to the
sunlit landscape beyond. In the last year

of his life Gainsborough remarked in a
letter on the subject of his early land-
scapes: 'the touch and closeness to
nature in the study of the parts and *minu-
tiae* are equal to any of my latter produc-
tions'. Of particular note in 'Wooded
Landscape' is the variety of different
greens that Gainsborough has observed
and taken the trouble accurately to
represent, and the equally careful obser-
vation of the pattern of light and shade in
the landscape and how this corresponds
to the pattern of light and cloud in the
sky. Half a century later the landscape of
Suffolk was to be the inspiration of John
Constable, who famously remarked 'Tis a
most delightfull country for a landscape
painter. I fancy I see Gainsborough in
every hedge and hollow tree.'

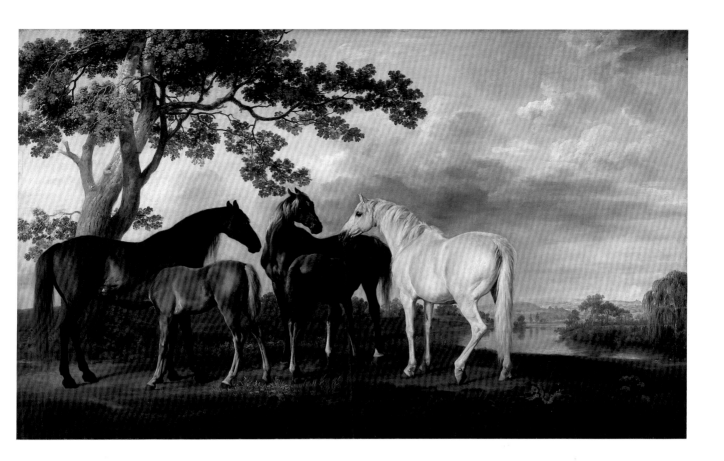

GEORGE STUBBS 1724–1806
Mares and Foals in a River Landscape
*c.*1763–8
Oil on canvas 1020 × 1620 (40 × 63¾)

A large part of Stubbs's achievement can be understood by considering the series of nine paintings of mares and their foals done in the 1760s for various aristocratic patrons, among them Earl Grosvenor, the Duke of Grafton and the Marquis of Rockingham. This series marks one of the high points in English painting in the eighteenth century. The horses are accurate portraits of specific mares (although in this case we do not know their exact identity) famous either for their racing success or as the dams (mothers) of successful racehorses. The extraordinary precision with which the mares and foals are painted, with every vein and muscle visible under the skin, and the naturalness of their poses, are perhaps the most immediately striking things in the picture. This naturalism was based on Stubbs's careful and loving observation of living animals, but also on long and arduous anatomical studies of horses and other animals, including

humans. His study of horses was carried out early in his career when he spent about a year, from 1758 to 1759, in a remote farm house in Lincolnshire, dissecting horse carcases, carefully and beautifully drawing the dissections. The results were eventually published in 1766 as *The Anatomy of the Horse*, with the plates engraved by Stubbs himself because he could find no professional engraver he would trust with the job.

But a closer look at this group of mares and foals reveals that beneath the scientific anatomy and the seeming naturalness of both the individual poses and the whole arrangement of the group, lies a complex compositional structure in which Stubbs's knowledge of classical principles gained on his trip to Italy in 1754, as well as his highly personal sense of pattern and rhythm are in evidence. The three mares and their foals are placed so as to form very roughly a cone, with their rumps marking the perimeter and their heads the apex. This is a 'classical' composition, which gives an overall symmetry and balance to the group. Within this structure, which also gives unity to the group, holding it

together, Stubbs beautifully judges the spacing of the mares' heads so that they are just far enough apart to make distinctively individual outlines against the sky but not so far apart that the unity of the composition is lost. He also exploits the beauty of the curves of their necks and backs by silhouetting them against the sky. The spectator's eye is drawn over the whole group in a slow revolving rhythm, across the four rumps, up to the heads and down and round again. The fact that both the foals are feeding looks entirely natural, but it is also, of course, essential to Stubbs's composition.

GEORGE STUBBS 1724–1806
Reapers 1785
Oil on panel 900 × 1370 (35½ × 53⅞)

This is one of a pair of pictures in which
the landscape background is carefully
composed on 'classical' principles so that
the two will hang perfectly together, the
clump of trees on the right of 'Reapers'
balancing the clump on the left of its pair,
'Haymakers', and with a recession to a
distant horizon in the centre. But within
each painting the arrangement of figures
is completely self-contained and it is these
people who are Stubbs's real subjects
here. Made at a time when peasants or
farm workers were introduced into paint-
ing mainly as decorative elements
Stubbs's 'Reapers' and 'Haymakers' have
always been noted for the sympathy and
objectivity with which he has depicted
these workers as individuals. Equally
notable is the way he has devoted his
powers of observation to a realistic por-
trayal of their skills at cutting corn, stac-
king sheaves or raking or loading hay,
making these activities an important part
of the subject of the picture. By including

the landowner, or possibly his agent or
manager, on his horse, idly looking on,
Stubbs also reminds us, in a completely
unforced way, of the social inequalities
inherent in this apparently idyllic scene.
The composition of 'Reapers' is formed of
two roughly pyramidal groups, the man
and woman flanking the stack of sheaves
on the left, and the horseman, with the
bending reaper below the horse's head,
on the right. These groups are linked by
the strong pattern of the three bending
men dramatically broken by the standing
figure of the young woman in the centre.
She is the real focus of the composition
and with the dignity and presence Stubbs
has given her, might be the true subject
of the picture.

There is evidence that 'Reapers' and
'Haymakers' were based on careful draw-
ings from life: in the sale of Stubbs's stu-
dio after his death were 'Six Studies of the
Reaper and two finished drawings of
ditto', 'A capital Drawing, the original
design for the Corn Field with Reapers'
and 'Ditto, ditto, the original design for
the Painting of the Hay Field and Men
loading a Hay Cart'.

GEORGE STUBBS 1724–1806
**Portrait of a Young Gentleman Out
Shooting** 1781
Enamel on Wedgwood biscuit earthenware 457 × 622 (18 × 24½)

In the eighteenth century, enamel was normally used for miniatures, snuffboxes and other decorative purposes. However, from about 1769 Stubbs developed it as a medium for making normal size pictures, and eventually produced a substantial group of enamels of which this is one. He seems to have been attracted by the quality of colour of enamel, and particularly by its permanence. Unlike oil paintings, enamels do not decay and Stubbs's enamels are probably unique among eighteenth-century paintings in looking now exactly as they did when they were made.

Initially Stubbs had a number of difficulties to overcome: a suitable range of colours did not exist and Stubbs also found that for technical reasons it was not possible to make enamels on the usual support, copper, larger than about 380 × 450 mm (about 15 × 18 inches) which is why his enamel on copper of the 'Horse Attacked by a Lion' (p.34) is so relatively small. It is entirely characteristic of Stubbs's questing and scientific mind that he solved the first problem by doing his own experiments with colour and the second by setting up a collaboration with Josiah Wedgwood, the first great industrial potter, to develop a ceramic base on which larger enamel pictures could be made. After lengthy and extremely expensive experiments, Wedgwood was eventually able to produce enamel paintings on ceramic plaques up to a maximum of 1070 mm (42 inches) across. 'Portrait of a Young Gentleman Out Shooting' exhibits all the freshness and clarity associated with Stubbs's ena-

mels and shows off those characteristics of the medium particularly well since it is an outdoor subject. It is an example of Stubbs's beautifully ordered and balanced compositions, the young man's raised hand being at the apex of a triangle formed by the slope of the gun and the answering slope of the back and muzzle of the pointing dog. The dog is painted with such care and given such character, that it rather steals the show from the ostensible sitter, probably one William Huth, of whom nothing at present is known.

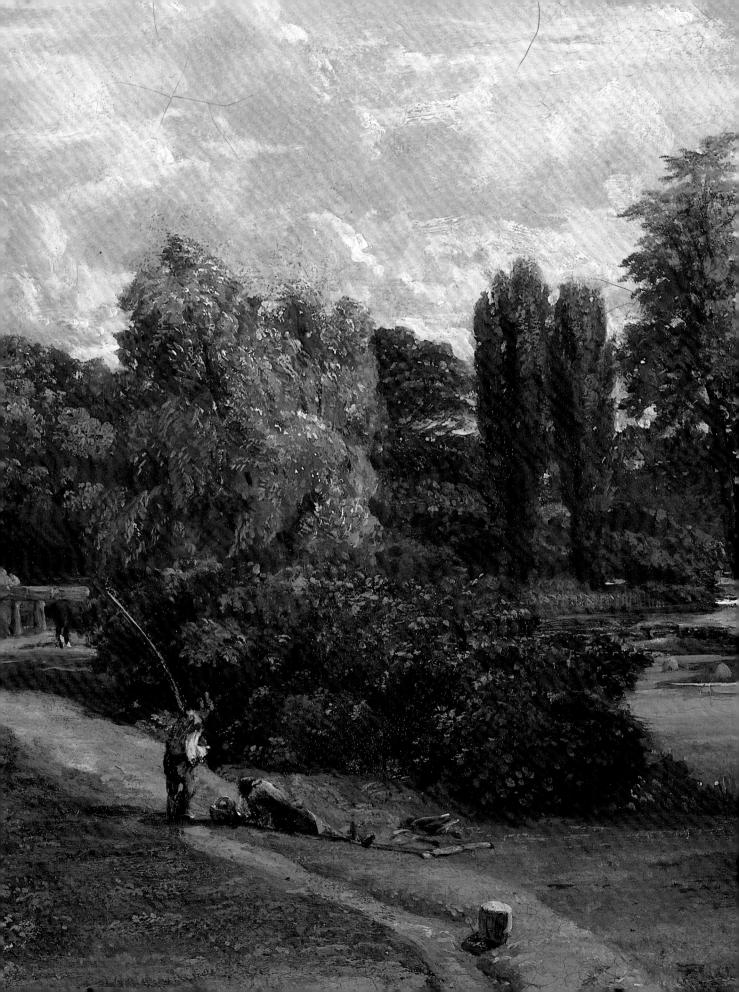

Constable and Early Nineteenth-Century Landscape Painting

The art of John Constable is often said to be 'revolutionary'. It was, in the sense that he invented, and practised for a lifetime, a kind of landscape painting based on the direct study of nature rather than on the existing models of the Classical or Dutch styles, although he fully understood and assimilated these. Constable also developed his art entirely free of the demands of patrons and of academic ideas of what constituted 'high' or 'low' art. Naturally, he was not appreciated, as he himself was bitterly aware: 'my art flatters nobody by imitation, it courts nobody by smoothness, it tickles nobody by petiteness, it is without either fal de lal or fiddle de dee, how then can I hope to be popular?'

Constable's art was founded on a deep love of nature that was both matter-of-fact and mystical: he loved the physical detail of landscape and also saw it as a manifestation of God. In a letter to his wife Maria he wrote 'Every tree seems full of blossom of some kind & the surface of the ground seem[s] quite living – every step I take & on whatever object I turn my Eye that sublime expression in the Scripture "I am the resurrection & the life" seems verified about me' And in the draft of the last of the ten lectures on landscape painting that he gave in London and Worcester between 1833 and 1836, he says 'In conclusion I must again repeat the necessity of keeping one's mind alive to that external nature with which we are surrounded, for few there are who seem to be aware of the beauty of the Paradise in which we are placed. We exist but in a landscape and we are the creatures of a Landscape . . .' Constable's insistence on the significance of the relationship of humans to the natural world speaks very directly to us in the late twentieth century, aware as we are of the destruction already wrought on the world by man.

Constable's feelings about landscape and his view of it as 'God's own work' (letter of 1831) led him inevitably to the belief that landscape painting should be as completely naturalistic as possible. It also led him to the belief that this pure landscape painting could be the equal, in terms of the ideas and feelings it expressed, of any 'history' or 'high art' picture. Indeed, since his painting was free of the eroticism or violence (or both) so often a part of 'history' subjects, it was therefore superior and Constable spoke of 'the moral feeling of landscape'.

The specific landscape that inspired Constable's feelings and formed the basis of his art was that of his native Suffolk around the village of East Bergholt on the Essex border, where Constable was born, the son of a prosperous merchant. Constable wrote lyrically of 'the beauty of the surrounding scenery, the gentle declivities, the luxuriant meadow flats sprinkled with flocks and herds, and well cultivated uplands, the woods and rivers, the numerous scattered villages and churches, with farms and picturesque cottages . . .'

John Constable **Hampstead Heath, with the House Called 'The Salt Box'** *c.*1820

Thomas Jones **Naples: Buildings on a Cliff Top** 1782

1 John Constable **Flatford Mill (Scene on a Navigable River)** 1817 (detail)

John Linnell **Kensington Gravel Pits**
1811–12

George Robert Lewis **Hereford, Dynedor and the Malvern Hills, from the Haywood Lodge, Harvest Scene, Afternoon** ?1815

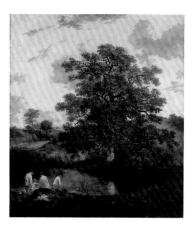

John Crome **The Poringland Oak** c.1818–20

Constable's approach to creating a kind of painting that would do justice to his feelings was almost scientific: in one of his lectures he said, 'Painting is a science, and should be pursued as an enquiry into the laws of nature'. For Constable the main means of this 'enquiry' was the practice of sketching in oils direct from nature, which he began to do systematically from 1802 onwards. By about 1809 he had developed his sketching technique into an accomplished method of capturing the essential features of a scene in a form which later, in the studio, could be used in the creation of a larger, 'finished' picture for exhibition or sale. 'Dedham from Langham' of 1813 is an example of this kind of sketch and is reproduced and discussed on p.47.

Constable met with little success and by 1816–17, when he painted 'Flatford Mill ("Scene on a Navigable River")' he seems to have felt the need to enlarge the size of the pictures he sent to the annual Royal Academy exhibitions, the better to compete with the generally large scale of the most ambitious work there. 'Flatford Mill', as it is usually known, is the herald of the famous series of 'six-foot' canvases that Constable sent to the Royal Academy from 1819 onwards and on which he pinned his reputation. It is reproduced and discussed on p.48.

Working on this new, large scale, posed problems, and to cope with these Constable initiated the extraordinary practice of making a full size sketch. The one for his painting 'Hadleigh Castle' of 1829 is reproduced and discussed on p.51.

Constable was not exclusively devoted to Suffolk. From 1799 when he went as a student to the Royal Academy Schools in London, he divided his time between London and Suffolk and after his marriage in 1816 he settled permanently in London. From 1819 he began regularly renting a house for the summer in Hampstead, then still very rural, and produced a group of Hampstead subjects. Other major non-Suffolk paintings in the Tate Gallery collection are 'Chain Pier Brighton', the full-size sketch for 'Hadleigh Castle' already mentioned, and 'The Opening of Waterloo Bridge'. These are reproduced and discussed on pp.49–50.

Constable was not quite alone. In fact there was a considerable ferment going on in English landscape painting in the first two decades of the nineteenth century, which is still being explored by scholars. The practice of sketching in oils direct from nature seems to have been of increasing interest to artists at that time and a separate display shows that such sketching can be found as early as 1782, in the work of Thomas Jones. With Constable are displayed finished works by other naturalistic painters of the period. John Linnell's 'Kensington Gravel Pits' of 1811–12 is remarkable in its directness, and not surprisingly did not find a buyer when first exhibited. In Norwich, in 1803, John Crome founded the Norwich Society of Artists. He was joined in 1807 by John Sell Cotman and they became the leaders of what is now known as the Norwich School. Crome's 'The Poringland Oak' is a famous example of Norwich School work.

JOHN CONSTABLE 1776–1837
Dedham from Langham ?1813
Oil on canvas 137 × 190 (5⅜ × 7½)

One of a number of drawings and oil
sketches Constable made in the years
1812–13 of a view looking eastwards
down the valley of the Stour from the
hills near the village of Langham. The
tower of Dedham church can be seen in
the distance. The white, yellow and black
blob in the foreground is a seated cow.
Constable was evidently very interested
in this view and this is precisely the type
of oil sketch he made as part of his infor-
mation gathering for a large
composition.

The sketch is dated August 24,
although the exact year it was made is
not certain. It is generally agreed that in
works such as this, Constable's technique
of sketching directly in oils from nature
reached its full development. Compared
with his earlier sketches there is now
much less detail, he records only the es-

sentials of the scene: the quality of light,
the structure of the sky and the landscape
below, the shape of a clump of trees.
Perhaps the most extraordinary thing
about these sketches is the paint han-
dling: the elements he records are cap-
tured in vital dabs and whorls and scoops
of paint, which visibly convey the tension
of the artist directly confronting and
grappling with, the raw material of his
art.

Although there is no finished oil
version of this subject Constable included
it in the set of mezzotint prints of his
work, accompanied by his own commen-
tary, that he published towards the end of
his life. The whole thing was titled 'Vari-
ous Subjects of Landscape, Characteristic
of English Scenery, from pictures painted
by John Constable, R.A.' but it is gener-
ally referred to as 'English Landscape'.
The version of 'Dedham from Langham'
that appears in 'English Landscape' is
titled 'Summer Morning'. In a draft of the
text to accompany this print Constable

wrote 'Nature is never seen, in this cli-
mate at least, to greater perfection than
at about 9 o'clock in the morning of July
and August when the sun has gained
sufficient strength to give splendour to
the landscape "still gemmed with the
morning dew"'. And in the same draft:
'This view of the beautiful valley of the
Stour – the river that divides the counties
of Suffolk and Essex – is taken from Lang-
ham . . . where the elegance of the tower
of Dedham Church is seen to much
advantage . . .'.

JOHN CONSTABLE 1776–1837
Flatford Mill ('Scene on a Navigable River') 1817
Oil on canvas 1017 × 1270 (40 × 50)

After his marriage and move to London in 1816, Constable became an infrequent visitor to his native Suffolk. But the emotion he felt for the scenes of his childhood became an even stronger driving force in his art. 'Flatford Mill', is the first of the large paintings of scenes on the River Stour in Suffolk, including 'The Haywain', which lie at the core of Constable's achievement and for which he is best remembered.

In 1821 in a letter to his friend and patron the Reverend John Fisher, Constable wrote 'I associate my "careless boyhood" to all that lies on the banks of the *Stour*. They made me a painter (& I am gratefull)'. In the light of this it may be more than a coincidence that the focus of the composition of 'Flatford Mill' is a boy on a barge horse. Certainly, the strange signature in the foreground, painted as if scored into the earth by the artist, emphasises Constable's close identification with this particular scene of his 'boyhood', the stretch of the river from the footbridge, part of whose woodwork can be seen in the left corner of the picture, to his father's mill.

There is no doubt that this painting has an extraordinarily convincing naturalness. One of the ways in which Constable achieved this was by careful use of a wide range of greens to reflect the range he found in nature. The extent to which he did this was noted as innovatory at the time by the great French Romantic painter Eugene Delacroix, who visited Constable in 1825 and afterwards recorded in his journal, 'Constable says that the superiority of the green in his meadows comes from it being composed of a multitude of different greens. The lack of intensity and life in the foliage of most landscape painters arises because they usually paint them in a uniform tone.' The 'intensity and life' of Constable's paintings comes also from his way of putting on the paint in separate dabs. This gives the whole surface its own life and texture, directly expressing the life and texture of the scene, and Constable enhanced this effect with the flecks and dabs of pure white which can be seen for example on the clump of trees on the left in the middle distance.

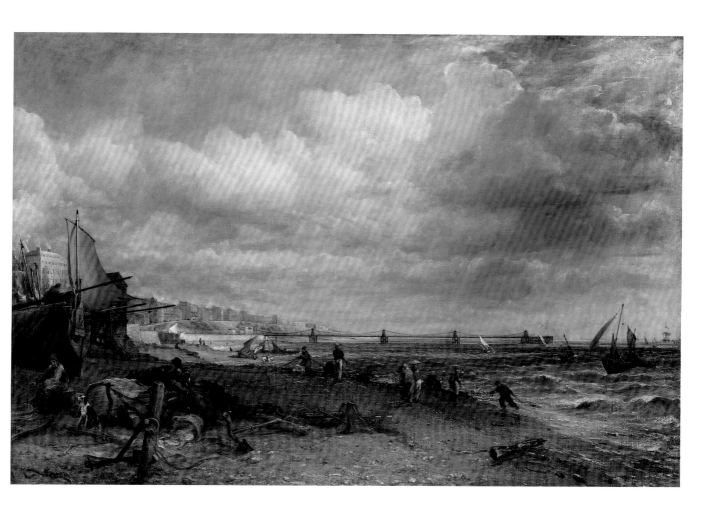

JOHN CONSTABLE 1776–1837
Chain Pier, Brighton 1826–7
Oil on canvas 1270 × 1829 (50 × 72)

Although Constable made many draw-
ings and oil studies in the Brighton area
this is his only major painting of a Brigh-
ton subject. It shows the Chain Pier,
which was opened in November 1823
and destroyed by a storm in 1896. On the
left Marine Parade stretches into the dis-
tance. The large building on the extreme
left is the Royal Albion Hotel, opened in
August 1826. This painting has the kind
of freshness, the brilliant evocation of
wind and weather, that caused Henry
Fuseli, the Swiss-born history painter, to
remark 'I *like de landscape of Constable* . . .
but he makes me call for my great coat
and umbrella'. It already seems to have
too that degree of turbulence, a sense of
the darker side of nature, that became
even more marked in Constable's work
after his wife's death in 1828. The sky in
particular is magnificent, and by this
stage of his career Constable had become

probably the greatest painter of skies in
the whole history of landscape painting.
This was the result of his belief in the
crucial importance in landscape painting
of the sky, which he described as the 'key
note', the 'standard of scale' and the chief
'organ of sentiment'. He also emphasised
that 'the sky is the source of light in
nature and governs everything . . .'
When he wrote this, in a letter to his
patron the Reverend Fisher, he was in
fact engaged in making a systematic
study of skies. In 1822 he reported to
Fisher that he had made about 50 careful
sketches of skies, 'tolerably large'. One of
the survivors of this group must be the
'tolerably large' oil sketch in the Tate
Gallery collection. Like many of his sky
studies it was inscribed with almost
scientific precision '27 aug.t 11 o clock
Noon looking Eastward large silvery
Clouds [probably, the word is not clear]
wind Gentle at S. West.'
 Constable appears to have disliked
Brighton, at least at first, and in a letter to
Fisher of 1824 he amusingly gives vent

to his feeling, emphasising the contrast
between the magnificence of nature and
the mass of people who flocked to what
was already a popular resort: 'Brighton is
the receptacle of the fashion and off-
scouring of London. The magnificence of
the sea, and its (to use your own beauti-
full expression) everlasting voice, is
drowned in the din and lost in the tumult
of stage coaches . . . and the beach is only
Picadilly by the seaside. Ladies dressed
and *undressed* – gentlemen in morning
gowns and slippers on, or without them
altogether about *knee deep* in the breakers
– footmen – children – nursery maids,
dogs, boys, fishermen – preventitive
service men (with hangers and pistols),
rotten fish and those hideous amphibious
animals the old bathing women, whose
language both in oaths and voice
resembles men – are all mixed up
together in endless and indecent
confusion.'

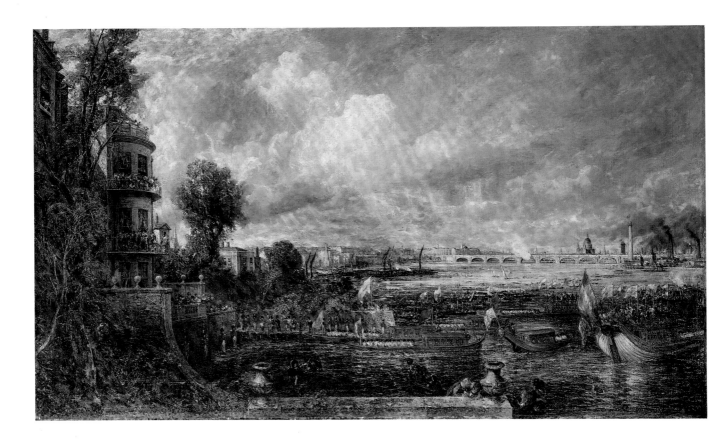

JOHN CONSTABLE 1776–1837
The Opening of Waterloo Bridge
('Whitehall Stairs, June 18th, 1817')
exh. 1832
Oil on canvas 1346 × 2197 (53 × 86½)

This is one of the great set-piece paintings from the later part of Constable's career, glittering and flickering with extraordinary effects of light and colour. So much so indeed, that Turner, the great colourist, was taken aback when he found it hanging next to his own sea-piece 'Helvoetsluys' just before the 1832 Royal Academy exhibition opened to the public and was forced to add an element of red to his picture, in the form of a buoy, to redress the balance.

Waterloo Bridge (demolished in the 1930s and replaced by the present one) was opened by the Prince Regent on 18 June 1817, the second anniversary of the Battle of Waterloo. The occasion was one of great festivity, with crowds thronging the river and neighbouring streets. Constable's painting shows the Prince embarking at Whitehall Stairs for the short river journey to the new bridge. The splendid Lord Mayor's barge is prominent on the right. Beyond the left-

hand end of the bridge can be seen Somerset House, then the home of the Royal Academy, and in the centre, St Paul's. Constable was in London on that day and presumably witnessed the ceremonies, but does not appear to have thought of making a picture of them until two years later. However, he then seems to have become almost obsessed with the subject and produced a whole group of versions of it over the years up to the appearance of this one at the 1832 Royal Academy exhibition. Oddly, one of these versions is even larger than the final exhibited picture. Constable's recorded comments on the subject are extremely non-committal and the true significance of it to him remains a mystery.

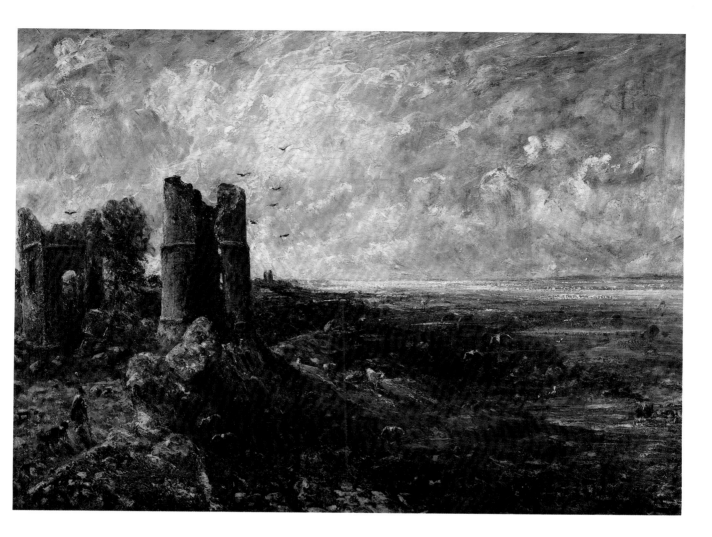

JOHN CONSTABLE 1776–1837
Sketch for 'Hadleigh Castle' c.1828–9
Oil on canvas 1225 × 1675 (48¼ × 66)

This is the full-scale sketch for
Constable's 'Hadleigh Castle. The Mouth
of the Thames – morning, after a stormy
night', exhibited at the Royal Academy in
1829.

There is no precedent in the history of
art for the full-size sketches that
Constable made for some of his large
landscapes. Since they were time con-
suming, and expensive in paint and
canvas they must have fulfilled a real
need. They seem to indicate the difficulty
of organising into large and elaborate
exhibition pictures, the diverse material
derived from direct observation that he
accumulated for any particular subject.
The large sketch enabled him to try out
different ideas and move elements of the
composition around, although some-
times he got it right first time and the

sketch is very close to the finished
picture.

The 'Sketch for "Hadleigh Castle"'
may originally have shown less of the
scene along the left-hand and bottom
edge than appears in the final picture, in
which the forms are also more sharply
defined and the paint handling less free,
more 'finished'. But the main difference
between them is in the tonality: the
sketch is coldly coloured in blues and
whites and has few of the warmer tones
of the final painting, which is much more
expressive of the sub-title 'morning after
a stormy night' whereas in the sketch it is
the storm itself which is still strongly
suggested.

The restless character of the 'Sketch for
"Hadleigh Castle"' has often been seen as
a reflection of Constable's unhappy state
of mind after the death in November
1828 of his wife Maria, whose portrait,
painted by Constable in 1816 just before
they married, speaks powerfully of his

feelings for her. In a letter to his brother
in December 1828 Constable wrote
'Hourly do I feel the loss of my departed
Angel . . . I shall never feel again as I
have felt – the face of the World is totally
changed to me'.

J.M.W. Turner

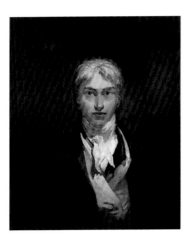

J. M. W. Turner **Self-Portrait** *c.*1798

Joseph Mallord William Turner has a good claim to be the greatest artist that Britain has ever produced, and appears as a leading figure in the European Romantic movement. As a young man he took the tradition of landscape painting in watercolour, that had emerged in the eighteenth century, and developed it to unparalleled levels of accomplishment. He went on in his full maturity to do things with watercolours which can only be described as magical. His extraordinary understanding of the media of art applied equally to oil painting, where in the early part of his career he created an entirely new means of rendering the shifting phenomena of nature – weather and water – and later went on to paint light in a way not truly matched before or since. The range of Turner's art, in subject, style and content, is equally astonishing: from straightforward views to elaborate historical or mythological subjects, from enormously confident reworkings of the old masters to the completely original and personal statements of his mature years, and from a lyric evocation of the tranquil, luminous and poetic aspect of nature to a tragic vision of the vanity of human existence in the face of its awesome grandeur and unlimited destructive power.

In his will, Turner bequeathed to the nation about 100 of his own 'finished' oil paintings, and asked for a special gallery to preserve and display them. His relatives challenged the will and eventually the nation received about 300 oil paintings and 19,000 watercolours and drawings. This collection, known as the Turner Bequest, together with some later additions, and minus a small group of works kept at the National Gallery, is now housed in the Clore Gallery, a purpose-built extension to the Tate Gallery opened in 1987.

From 1790, when he was fifteen, Turner successfully exhibited watercolours at the Royal Academy and showed his first oil painting, 'Fishermen at Sea', at the Royal Academy in 1796. 'Fishermen at Sea' is interesting both because it shows Turner's mastery of the new medium and because it announces two of the main themes of his art: light, and the relationship of humanity to the natural world. It also reveals his already remarkable ability to paint moving water. Over the next ten years or so Turner followed this up, with a series of large and dramatic sea pieces in the manner of the Dutch seventeenth-century masters, and a sequence of equally large and dramatic biblical, mythological and historical subjects in the severe manner of the seventeenth-century French 'classical' landscapist Poussin, and in the 'Sublime' and turbulent style of the Italian Salvator Rosa. These works, basically traditional, made a huge impact at the annual Academy exhibitions and earned Turner his early election as a full member. Among the sea pieces is 'Shipwreck' of 1805, in which Turner's early and innovatory naturalism is well displayed, particularly in the way in which

J. M. W. Turner **Shipwreck** exh.1805

J. M. W. Turner **Norham Castle, Sunrise** *c.*1845–50 (detail)

J. M. W. Turner **The Bay of Baiae, with Apollo and the Sibyl** exh.1823

J. M. W. Turner **St Benedetto, Looking Towards Fusina** exh.1843

J. M. W. Turner **Sunset: ?Tours** *c.*1833

he recreates, in paint texture and through movement of the brush, the moving, foaming water. The threat to the overcrowded lifeboat is emphasised by the organisation of the storm water into a circulating system around it, a device Turner was to develop and use again, notably in 'Snowstorm, Steamboat off a Harbour's Mouth' of 1842.

Of Turner's early history subjects 'Snowstorm: Hannibal and his Army Crossing the Alps' of 1812 is probably the most famous and is reproduced and discussed on p.55. At the same time he was painting tranquil studies of English scenes and weather, such as the marvellously atmospheric 'London from Greenwich' of 1809, one of the few paintings that Turner signed. From about 1810 his interest in Claude became particularly marked and resulted in much grander and more poetic English scenes, treated in the 'classical' manner, such as 'Crossing the Brook' of 1815 or 'England: Richmond Hill, on the Prince Regent's Birthday' of 1819, as well as in wholly imagined classical subjects such as 'The Decline of the Carthaginian Empire' of 1817. 'Crossing the Brook' is reproduced and discussed on p.56.

Claude had drawn his inspiration from the ruins of Rome and from the landscape around it, and in 1819 Turner made his first visit to Italy, returning in 1828 and again in 1833 and 1840. By this time Turner had already travelled extensively in England and Wales in search of subjects, making his first sketching tour in 1791. He visited France and Switzerland for the first time in 1802 and after the Napoleonic Wars was a frequent visitor to France, Germany and Switzerland as well as to Italy. There is no doubt that the experience of Italian light increased the emphasis on light and colour in Turner's work. This can first be seen in the group of only three oil paintings that he made after his 1819 visit, of which the most famous is 'The Bay of Baiae' shown at the Academy in 1823. Among later Italian subjects 'Childe Harold's Pilgrimage', 'Caligula's Palace' and 'Ancient Rome' are magical fantasies, while the real Italian landscape, albeit again magically transformed by Turner's imagination, appears in 'View of Orvieto' and 'Palestrina'. 'Childe Harold's Pilgrimage' is reproduced and discussed on p.57. It is often said that in Turner's later paintings the physical objects and features of landscape seem to be dissolved in light. This phenomenon can be experienced with most impact in the group of Venetian scenes which Turner painted from 1833, in the set of sketches of Petworth Park and neighbouring scenes of about 1828, and in certain late oil sketches, never publicly exhibited in his time, such as 'Norham Castle'. The extreme tranquillity of a work like 'Norham Castle' does not mean that Turner ceased to paint storms; 'Snowstorm: Steamboat off a Harbour's Mouth', exhibited in 1842, is one of the last and most extraordinary of these. These two paintings are reproduced and discussed on p.58 and 59.

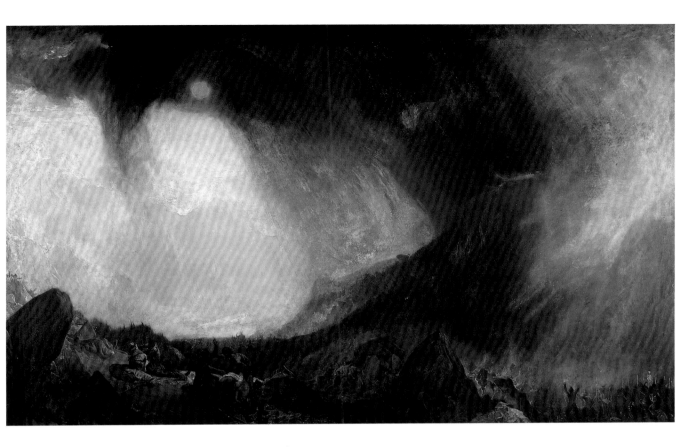

J.M.W. TURNER 1775–1851
**Snow Storm: Hannibal and his Army
Crossing the Alps** exh.1812
Oil on canvas 1460 × 2375 (57 × 93)

In this painting Turner has combined his
fascination with storms with his deep
interest in the history of the ancient
North African city state of Carthage.
From 264–146 BC, Carthage fought a ser-
ies of wars with Rome, known as the
Punic Wars, and Turner may have seen a
parallel between the conflict of these two
empires, and the long rivalry between
England and France which culminated in
the Napoleonic War which was at its
height at the time of this painting.

The Carthaginian general Hannibal
started the Second Punic War in 218 BC
by sacking the Roman city of Saguntum
in Eastern Spain. He then marched across
Southern France, and in one of the most
famous exploits in military history,
crossed the Maritime Alps into Italy,
crushed the Romans at a battle by the
River Ticino and went on to win three
more victories before lack of reinforce-
ments, and a Roman threat to Carthage,
forced him to return to Africa. Turner's
picture evokes the difficulties and

dangers encountered in the Alpine passes
by Hannibal's army, complete with ele-
phants, one of which can be seen against
the horizon. Chief of these dangers is the
great storm cloud, curving across the
sky, about to descend on the hapless
troops in the valley below. But in the
foreground local Salassian tribesmen are
also busy, murdering stragglers. Turner's
carefully composed title for this painting
indicates that the storm is as important
an element in the work as Hannibal, and
a story connected with it gives an import-
ant insight into Turner's sources of inspi-
ration and working methods. In 1810 he
was staying at Farnley Hall in Yorkshire
with his patron Walter Fawkes, whose
son recorded how one day Turner called
him out to admire a thunderstorm.
Turner was making notes of its form and
colour on the back of a letter: 'I proposed
some better drawing block but he said it
did very well. He was absorbed – he was
entranced. There was the storm rolling
and sweeping and shafting out its light-
ning over the Yorkshire hills. Presently
the storm passed and he finished.
"There," he said, "Hawkey, in two years
you will see this again, and call it Hanni-
bal crossing the Alps".' The use of the

back of a letter for recording the storm is
typical. Throughout his life the infor-
mation Turner took direct from nature
was almost always of the sketchiest kind:
his watercolours and oils were worked up
from these sketches, from his prodigious
visual memory and from his imagination.
He recreated in intensified pictorial form
those aspects of nature which most
deeply moved him.

In the catalogue of the Royal Academy
exhibition of 1812 Turner printed some
lines of his own poetry to accompany
'Hannibal'. He described these lines as
coming from his 'M.S.P.' (probably stand-
ing for Manuscript Poem) *Fallacies of
Hope*. This was an epic poem which
Turner composed intermittently through
his life but which was never completed.
The title of the poem indicates a pes-
simism which Turner seems to have
found echoed in the story of Hannibal's
triumph followed by retreat. The lines
quoted dwell on Hannibal's difficulties
rather than his victories and in the last
line contain a warning that Hannibal
and his troops might be seduced and
enfeebled by the well known luxury of
the city of Capua.

J.M.W. TURNER 1775–1851
Crossing the Brook exh.1815
Oil on canvas 1930 × 1650 (76 × 65)

From the beginning of his career Turner
painted calm pastoral pictures of English
landscape and from about 1810 he
painted several large pictures in which he
developed his interest in the art of
Claude, the great French seventeenth-
century master of classical landscape,
much admired and collected by English
connoisseurs. Claude's art was based on
the landscape of Italy combined with ele-
ments of classical architecture, myth-
ology and history. Turner painted many
historical and mythological subjects in
the manner of Claude but here he is tak-
ing Claude's basic approach and making
a highly personal adaptation of it to an
English scene – the Tamar valley in
Devon.

Claude invented a pictorial format for
landscape which was so satisfactory that
it dominated landscape painting right
down to the time of Turner and
Constable, both of whom embraced and
then went beyond it. Basically it involved
balancing groups of trees (or buildings) in
the foreground on the left and right of the
picture; these act as 'repoussoirs' to stop
you looking into the picture at the edges
and guide your gaze to the centre, which
then contains a carefully organised
recession to a distant horizon. Turner's
principal interest in 'Crossing the Brook'
seems to be to recreate in a very grand
and poetic way the delicate pale light and
atmosphere of an English summer's day.
This seems to be confirmed by his
comment to a friend visiting his studio
who noticed that a piece of paint had
flaked off the picture: What does it
matter', said Turner 'the only use of the
thing is to recall the impression'.

The two girls are said to be Turner's
daughters Evelina and Georgiana.

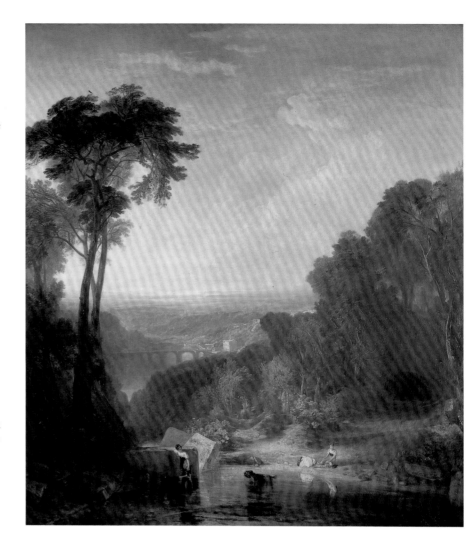

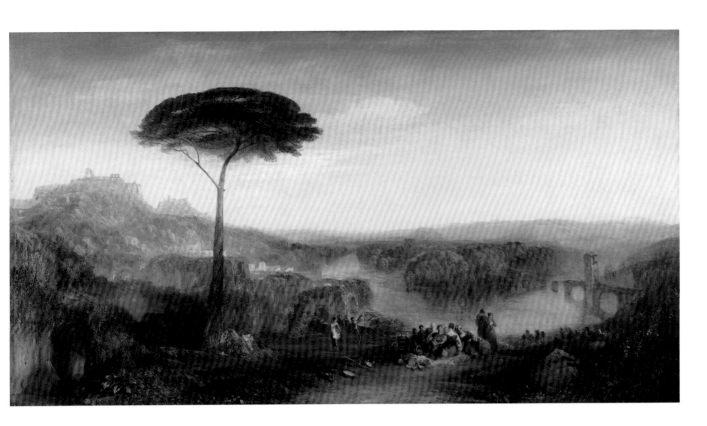

J.M.W. TURNER 1775–1851
Childe Harold's Pilgrimage: Italy
exh.1832
Oil on canvas 1420 × 2480 (59 × 97¼)

'Childe Harold's Pilgrimage' is one of the grandest of the golden glowing Italian landscapes that Turner produced at regular intervals after his second visit to Italy. The picture does not represent any actual place; it is an intensely imagined vision of the physical beauties of Italy, a kind of fantasy, although based on Turner's by now profound knowledge of the reality of the Italian scene.

The title refers to Lord Byron's immense epic poem *Childe Harold's Pilgrimage* (Childe is an archaic title for the son of a nobleman). Childe Harold, after a youth spent in complete dissipation, repents his sins and leaves England on a long pilgrimage. He finally arrives in Italy where he is captivated by its combination of beauty and decay. For Byron, the remnants of Italy's great classical past made a profoundly poignant statement in a land which, at this point in its history, had lost both liberty and integrity, but was still exquisitely lovely. Turner clearly shared this feeling; when he exhibited the picture at the Royal Academy Summer

Exhibition in 1832, he attached to it, printed in the catalogue, lines from the section of the poem where Childe Harold broods on Italy: '. . . and now, fair Italy!/ Thou art the garden of the world . . ./Thy wreck a glory, and thy ruin graced/ With an immaculate charm which cannot be defaced'.

The figure in the foreground, in what looks like a monk's habit, is presumably Childe Harold.

J.M.W. TURNER 1775–1851
Norham Castle, Sunrise *c.*1845–50
Oil on canvas 910 × 1220 (35¾ × 48)

The subject is Norham Castle on the
River Tweed, on the borders of England
and Scotland. Turner first drew and
made watercolours of this scene in 1797
and exhibited a finished watercolour of it
at the Royal Academy in 1798. A
number of other versions of it date from
1802, 1820 and 1825 and Turner made
new sketches on the spot in 1831. This
remarkable canvas marks the culmina-
tion of what seems to have been a lifelong
fascination with this place and is one of
Turner's greatest paintings of light and
atmosphere. In it the solid forms of the
landscape and the castle are treated pur-
ely as translucent elements of light and
colour. The castle itself is rendered in a
thin glaze of blue, so fluid that it has run
and dripped down the canvas. But

although Turner has created some of his
most atmospheric effects here, the place
is nevertheless immediately recognisable.
Furthermore, the compositional struc-
ture is strongly classical, the banks of the
river providing balancing foreground
forms on each side, with carefully orches-
trated recessions into a blue haze beyond
the castle and into the pale yellow sun-
light in the sky above.

'Norham Castle' is exceptionally well
preserved for a Turner oil painting and
unlike many of his canvases probably
looks very much as it did when it left his
easel. Turner would never have exhibited
in public a work like this, since it would
have been considered too lacking in
detail and 'finish' to be acceptable at the
Royal Academy. It is possibly a sketch for
a more finished picture that Turner may
have had in mind, or it could be what is
known as a 'lay-in' – the beginnings of a
picture which Turner would have

worked on much more to make a finished
exhibition picture. However, it appears to
most people now as a complete and satis-
fying work in its own right, and it is not
impossible that Turner saw it that way
and that it is a painting done for his
private satisfaction.

J.M.W. TURNER 1775–1851
Snow storm – Steam Boat off a Harbour's Mouth making Signals in Shallow Water, and going by the Lead. The Author was in this Storm on the Night the Ariel left Harwich exh.1842
Oil on canvas 915 × 1219 (36 × 48)

In this painting Turner developed to its fullest and most complex extent the vortex-like swirling structure that he had given to earlier pictures of stormy seas such as 'The Shipwreck'. Here, all the forces of the storm are focused on the small and fragile looking steamship, pitching in the waves in the centre of the composition. In the title Turner takes the trouble to inform us that the painting is the result of a direct personal experience, and he is reported to have said of it 'I did not paint it to be understood but I wished to show what such a scene was like; I got the sailors to lash me to the mast to observe it; I was lashed for hours and did not expect to escape but I felt bound to record it if I did'. However, no ship named 'Ariel' has been found sailing out of Harwich. The truly unusual quality of 'Snowstorm . . .' caused consternation among the art critics when it was exhibited at the Royal Academy in 1842. One famous comment was that the picture was nothing but a mass of 'soapsuds and whitewash'. John Ruskin recorded Turner's response to this when Turner was at his house one day: '. . . after dinner, sitting in his armchair by the fire I heard him muttering to himself at intervals "soapsuds and whitewash! What would they have? I wonder what they think the seas's like? I wish they'd been in it"'.

British Drawings, Watercolours and Prints
c.1680–1900

Few British painters have not felt a powerful compulsion to draw, either for drawing's sake or to develop ideas; some have made distinguished prints; and the independent art of watercolour at its most expressive, as in Girtin's 'White House at Chelsea', reproduced and discussed on p.63, has rightly been recognised as a uniquely British achievement. 'Works on paper' are therefore a vital part of the British Collection at the Tate Gallery. Highly sensitive to light, they can only be displayed for short periods. The Study Room in the Clore Gallery provides comfortable conditions for viewing works not on display; its holdings of the Turner Bequest, and of Blake and the Pre-Raphaelites among others, must rank it, young as it is, among the great 'print rooms' of the world.

The urge to record landscapes and buildings was the overriding impulse behind the development of watercolour to the point at which Girtin and Turner could use it with such authority. Yet British artists' involvement with their landscape began on a far more cautious and literal note. From the end of the sixteenth century and through the Stuart period, visiting artists from the Low Countries inspired them to record topography in pen and wash. Netherlandish influence predominates in the earliest drawing in the collection, a view of the Roman Colosseum made in the early 1680s by Thomas Manby, one of the first native-born landscape painters and one of that small group of Stuart draughtsmen who travelled south of the Alps.

Manby's drawing is a rare early glimpse of the love of Italy and things classical that was to be such a feature of the following century; but British topography continued to engage the majority of draughtsmen. By the 1750s, artists had outgrown the functional media of ink and monochrome, and Paul Sandby's 'Cemetery Gate of St. Augustine's Monastery, Canterbury' displays a new refinement; architectural description is accompanied by spirited foreground incident, and bright washes capture the lights and shades of a summer's day. Gainsborough, whose drawings are deliberately artificial compositions, justly considered Sandby the 'only Man of Genius' who had devoted himself to 'real Views from Nature in this country'.

Travel has been the truly liberating force in the history of British watercolour, and Turner is the greatest of many artists whose continental interpretations are in the collection. In the 1770s and 1780s, Italian light or Alpine gloom inspired that melancholy genius John Robert Cozens, and his near contemporaries William Pars and Thomas Jones, to new heights of atmospheric evocation. It was on these achievements that the great Romantics built, and the spare and brilliantly toned watercolours of the much-travelled Victorian, Edward Lear – well represented at the Tate – would be inconceivable without their example.

Paul Sandby **The Cemetery Gate of St Augustine's Monastery, Canterbury** 1782

Thomas Girtin **The White House at Chelsea** 1800 (detail)

John Ruskin **View of Bologna** 1845 or 1846

Dante Gabriel Rossetti **The Wedding of St George and Princess Sabra** 1857

Alexander Runciman **Agrippina with the Ashes of Germanicus** c.1775

Ruskin, whose 'View of Bologna' was made on one of his first visits to Italy in 1845 or 1846, was to proclaim a more minute study of nature and architecture, but always with a sense, learned above all from Turner, of the total design.

Ruskin's nature studies connect with the near-obsessional realism avowed by the Pre-Raphaelites, but often, as in Rossetti's jewel-like medieval fantasy, 'The Wedding of St. George and Princess Sabra', subordinated to nostalgic imagination. The Tate is rich in drawings of all phases of Pre-Raphaelitism, a movement that provoked an upsurge of figure and narrative drawing exceptional in British art. Two outstanding earlier figure painters, Hogarth and Reynolds, had been curiously uneasy draughtsmen, although the latter's 'Self Portrait as a Figure of Horror' matches in chalks the expressive intensity of his self portraits in oil. On the other hand Fuseli's fecund imagination gave birth to many drawings like 'The Debutante', and Thomas Rowlandson's witty characterisations were achieved with deceptive ease in ink and watercolour. Among nineteenth-century figure draughtsmen outside Pre-Raphaelitism, Sir David Wilkie is exceptional, his large drawings in chalks or ink, more rarely combined with watercolours, attaining an old-masterly grandeur. More frivolous, but just as skilful in their way, are the drawings of Charles Keene, in which Victorian flavours and mores, and sometimes an infinity of social innuendo, are caught in a few strokes of the pen.

As an illustrator, Keene worked frequently for reproduction. Besides their long history of service to the engraver, British artists have made distinguished contributions in original print-making, and these too can be studied in the collections. 'Agrippina with the Ashes of Germanicus' is one of a group of etchings by the Scottish painter Alexander Runciman, who had learned his neo-classical style in Rome; George Stubbs and Gainsborough produced beautiful prints in mixed method or soft-ground etching; and Palmer's late etchings have repercussions in our century in the early work of Graham Sutherland.

Artists often turned to print-making, or to professional engravers – and it was as an engraver that Blake, most truly original of all British graphic artists, began his career – to make characteristic or synoptic statements about their work. Turner's *Liber Studiorum* and Constable's *English Landscape Scenery* are the most impressive of such schemes from the Romantic period. Both artists used other engravers, but, J.R. Cozens's father Alexander had himself aquatinted the sixteen plates for his manual of landscape composition, the *New Method*, about 1785. James Barry made etchings from his paintings in the Royal Society of Arts in the 1790s, and between 1814 and 1825 William Daniell engraved the 306 copper plates after his own drawings for *A Voyage round Great Britain*. All these important publications are in the collection. As a means of popular communication, printmaking was integral to Pre-Raphaelitism, whether pursued by the Brothers themselves as in Holman Hunt's etched frontispiece to the movement's manifesto, *The Germ*, or by engravers, like the brothers Dalziel.

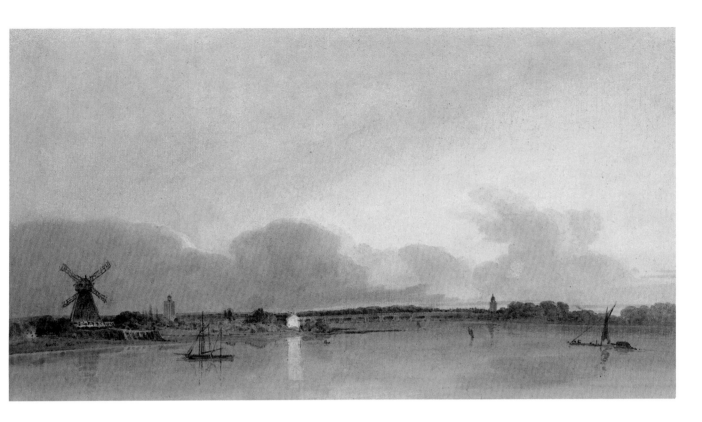

THOMAS GIRTIN 1775–1802
The White House at Chelsea 1800
Watercolour 298 × 514 (11¾ × 20¼)

This view of the Thames from Chelsea
Reach towards Battersea has long been
regarded as a supreme achievement of
English watercolour, and a famous story
relates that Turner himself, when a
dealer told him he had a drawing finer
than any of his, eventually replied, 'You
have got Tom Girtin's "White House at
Chelsea"'.

No less frequently quoted is Turner's
remark, 'Had Tom Girtin lived, I should
have starved'. It is hard to think of the
two artists apart. Besides being exact
contemporaries, both were Londoners;
they shared a similar background in
topographical drawing; and together
they transformed watercolour for ever
from a descriptive to an atmospheric and
truly independent medium. Girtin's tra-
gic death from asthma or tuberculosis in
1802 cut their association short, but it is
difficult to see how he could have
advanced upon the mastery he displays
here. His washes are floated with con-
summate skill, their tones and gradations
beautifully modulated; and the white
house is rendered by leaving the paper
bare save for some touches of pale yellow

to indicate its masonry. In fact the paper
is not white but biscuit, but opposed to
the surrounding blues and greys, the
house stands out as one of the boldest
exclamation marks in British art.

In 1788 Girtin had been apprenticed to
one of the most adept practitioners of
topographical drawing, Edward Dayes,
but he left prematurely to evolve a
personal style based on other examples.
Up to about 1794, the year of his first
exhibit at the Royal Academy, Girtin exe-
cuted a number of topographical com-
missions. By 1795 he was working
alongside Turner in the Adelphi house of
Dr Thomas Monro, copying drawings by
J.R. Cozens that suggested new possibi-
lites of atmospheric evocation and econ-
omy of handling; here too he may have
seen etchings by Rembrandt with their
simplified construction of landscape
along horizontal planes dotted with clus-
ters of detail, and broken by strong pat-
terns of light and shade; and in the same
period he learned to admire the dramatic
sweep of Rubens's landscapes and the
clarity of Canaletto's views of river and
city. His own artistic personality emerged
in the second half of the decade, in pictur-
esque or mountainous subjects found
mainly on tours to the north of England,
and treated broadly and monumentally –

though rarely on the large scale Turner
was then adopting – and in a sombre,
restricted palette that suggests something
of the melancholy introspection of
Cozens. The powerful conceptual quali-
ties of Girtin's watercolours were recog-
nised by connoisseurs and artists like
John Hoppner who observed that wher-
eas Turner 'finishes too much', Girtin dis-
played 'more genius'.

'The White House' belongs to the final
phase of Girtin's brief career when he
was working on panoramic prospects of
London and Paris. Though these sprang
from the topographical tradition, the sim-
ple grandeur, luminosity and sentiment
of the associated watercolours show Gir-
tin's complete liberation from it. If there
is a brooding atmosphere in the barren
spaces of some of his northern subjects,
the emptiness of 'The White House' sug-
gests rather an overwhelming serenity.
The river glides by at sunset, its glassy
surface broken only by small craft and
the reflection of the house. The low hori-
zon, subtly articulated by the silhouettes
of the mill, two towers and clumps of
trees, is Girtin's homage to Rembrandt.

D.B.B.

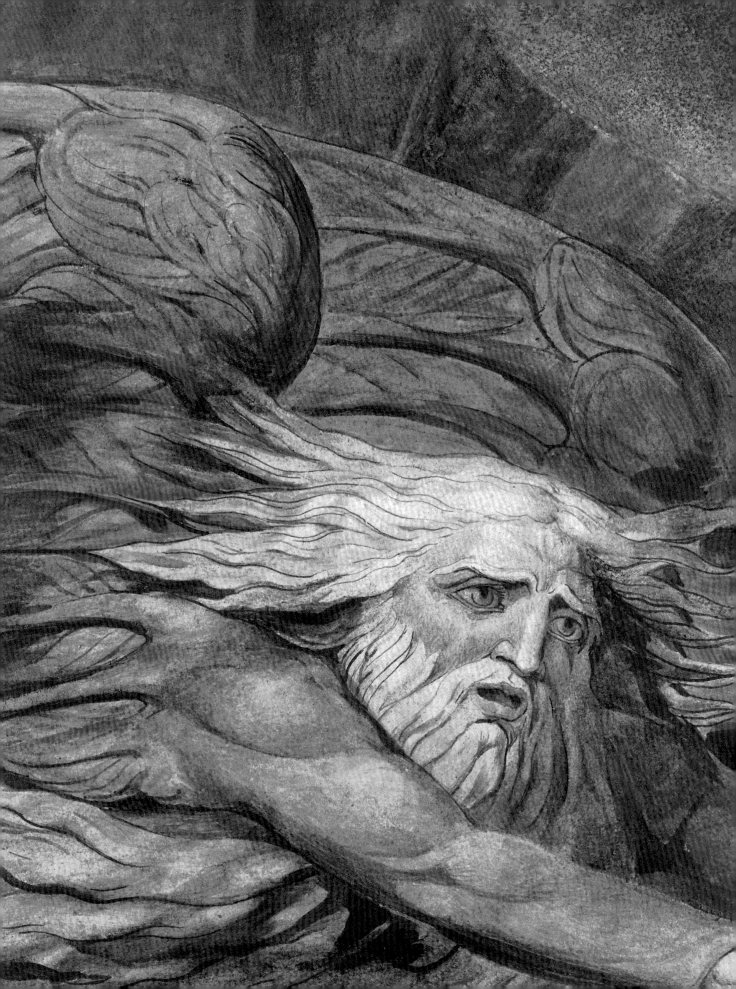

William Blake and his Followers

William Blake appears to us now as one of the great original geniuses of British art. Yet in his own time he was considered to be a minor and eccentric figure; even his friend Henry Fuseli, who became Professor of Painting at the Royal Academy, remarked on one occasion that Blake 'has something of madness abt. him'.

Blake's lack of recognition by his contemporaries can seem odd, since his basic ambition was to be a Grand Style painter of History, or High art (see also p.29), which was of course officially approved and promoted by the Royal Academy. Blake became a student at the Royal Academy Schools in 1779, at the age of twenty two, having already served a seven-year apprenticeship as an engraver, a branch of art that would afford an immediate means of earning a living to a young artist from a relatively poor background. In 1780 he exhibited at the annual Academy exhibition one of a series of watercolours he did at this time of subjects from English history. Another of this series was 'The Penance of Jane Shore'. In style these watercolours would have appeared perfectly orthodox, but Blake's choice of subjects already reveals a significantly independent approach. Jane Shore was the mistress of Edward IV and was noted for her goodness and beauty. On Edward's death in 1483 she was imprisoned and accused of harlotry by the future king Richard III, just before he murdered Edward's two sons in the Tower of London and seized the throne. Jane was condemned to do public penance at St Paul's and according to the historian Rapin de Thoyras, Blake's probable source of information, 'she behaved with so much modesty and decency that such as respected her Beauty more than her fault never were in greater admiration of her than now'. For Blake the significance of this story was probably as an example of the triumph of innocence and virtue over tyranny and sexual hypocrisy.

The philosophy behind Blake's unconventional attitudes was a highly personal form of Christianity, partly influenced by the Swedenborgian Church, in which Christ himself is seen as the one and only true God. In 'The River of Life', Christ is seen leading two children up the stream of time towards the divine sun. An essential part of Blake's philosophy was a profound anti-materialism, a belief in a much more significant spiritual world, beyond the physical. From this Blake evolved a complex vision of human existence and of humanity's relationship to the realm of the spiritual. This vision was embodied in an enormously elaborate personal mythology which, from early in his career, Blake seems to have decided to express through a combination of art and poetry, in the form of illuminated books, written, illustrated and printed entirely by himself. With these he hoped both to communicate with a wide audience and to make his fortune.

William Blake **The Penance of Jane Shore in St Paul's Church** c.1793

William Blake **The River of Life** c.1805

William Blake **Elohim Creating Adam** 1795/c.1805 (detail)

William Blake **'Thenot with Colinet Waving his Arms in Sorrow'** 1821

William Blake **'With Songs the Jovial Hinds Return from Plow'** 1821

George Richmond **Christ and the Woman of Samaria** 1828

The outcome was a total of fifteen illuminated books, produced mainly between 1790 and 1795, during one of the most intensive creative periods of Blake's career, when he was living outside central London, at Lambeth. They were bought by very few people and are now known only by a handful of copies. It was Blake's decision to turn away from becoming a painter in oils, as much as his baffling subject matter and unconventional opinions, that prevented him from eventually becoming an established figure in the art world of his time.

As Blake produced his illuminated books through the first half of the 1790s they grew larger and the element of illustration became more important. He also began to use a form of colour printing to enrich them and in 1795 he broke away from the book format to produce a series of separate works dealing with the myth of Creation, which he described as '12 Large Prints, Size of Each about 2 feet by 1½. Historical and Poetical, Printed in Colours'. These are now referred to as the Large Colour Prints and as a group are considered one of the greatest manifestations of Blake's powers as an artist. The Tate Gallery owns examples of ten of the twelve designs. The first of them, 'Elohim Creating Adam', is reproduced and discussed on p.67.

Success continued to elude Blake and from 1800 until his death he relied on the support of two men, first Thomas Butts, a civil servant who seems to have paid him a more or less regular wage in return for the bulk of his output and, from 1818, the artist John Linnell. For Butts, Blake produced a large number of Bible subjects in watercolour and in a technique which he called 'fresco', but which is usually referred to as tempera, although it differs from the usual recipe for tempera in that Blake used a kind of glue as his medium instead of the correct egg yolk. In 1809, in a last attempt to appeal to the public, Blake held an exhibition of nine tempera paintings and other works in his brother's house, publishing an elaborate *Descriptive Catalogue* to go with it. The exhibition was a complete failure. One of the tempera paintings from it is reproduced and discussed on p.68.

In the last ten years of his life Blake was commissioned by John Linnell to illustrate Dante's 'Divine Comedy' and was still working on this great project at his death. One of the Dante illustrations is reproduced and discussed on p.69. Linnell also introduced to Blake the young artist Samuel Palmer, who fell deeply under Blake's spell. Palmer became the leader of a small group of disciples who called themselves the 'Ancients'. Beside Palmer the principal members of the group were Edward Calvert and George Richmond and for a few years between 1826 and 1834 they gathered at the idyllic Kent village of Shoreham where Palmer owned a house. They were particularly inspired by Blake's small woodcut illustrations to the pastoral poems of Virgil done in 1821. Works by Palmer and Calvert are reproduced and discussed on pp.70 and 71.

WILLIAM BLAKE 1757–1827
Elohim Creating Adam 1795/c.1805
Colour print finished in ink and water-
colour 431 × 536 (17 × 21⅛)

This is probably the starting design in
Blake's series known as the Large Colour
Prints. These twelve prints were first
made in 1795 although some examples,
like this one, appear to have been pro-
duced at a later date. Blake's technique
for these works was a very simple form of
printmaking, which we would now call
monotype. The printing plate was a piece
of smooth millboard, the forerunner of
today's hardboard or masonite. On this
Blake painted his design using thick col-
ours, working quickly so that no colour
would have time to dry. He then laid a
sheet of paper over the board and took an
impression, repeating the process to

obtain further impressions before the
paint dried up, although these would
have become progressively fainter. He
then worked on the prints in pen and ink,
and in watercolours, to finish them. This
technique gave a richness of texture and
colour greater than could be obtained
from watercolour alone and helps to
make these works among the most
impressive of all Blake's pictures. How-
ever, the subjects of the Large Colour
Prints are also of great significance, none
more so than 'Elohim Creating Adam'
which reveals Blake's view of the rela-
tionship between man and the God of the
Old Testament, the Christian God, for
whom Elohim is one of the old Hebrew
names.

On the face of it the picture is a quite
literal illustration of the Book of Genesis
Ch.2, v.7: 'And the Lord God formed man

of the dust of the ground'. Elohim can be
seen reaching for a final handful of 'dust',
although it looks more like a rather
unpleasant green mud. This may be part
of Blake's message, since Adam is
stretched out in an agonised posture,
almost as if crucified, and round his legs
is coiled a great worm (not a snake).
Blake's view of the creation of man by
God gives a fundamental insight into his
whole philosophy and vision: man, a free
spirit or god himself, was trapped and
enslaved by being given a material form
in a material world. For Blake the God of
the Old Testament was a false god and
the Fall of man, the loss of Paradise, took
place, not as in the orthdox Christian
story, in the Garden of Eden, but at the
time of creation, when man was dragged
from the spiritual realm and made
material.

WILLIAM BLAKE 1757–1827
**The Spiritual Form of Pitt Guiding
Behemoth** (?) 1805
Tempera heightened with gold on canvas
740 × 627 (29⅛ × 24¾)

This is one of the nine tempera paintings
that Blake included in his one man exhi-
bition held at his brother James's house
in Golden Square, London, from May
1809 until June the following year. This
exhibition was a major attempt by Blake
to explain himself to the public and the
exhibition was accompanied by a detailed
'Descriptive Catalogue of Pictures, Poeti-
cal and Historical Inventions, Painted by
William Blake, in Watercolours, Being
the Ancient Method of Fresco Painting
Restored: and Drawings, For Public
Inspection and for Sale by Private Con-
tract'. Fresco was Blake's term for the
technique he invented which is normally
now referred to as tempera. Both
terms were misunderstood by Blake
through lack of knowledge of Italian art.
His 'frescos' or 'temperas' are painted in a
form of watercolour bound together with
glue, whereas true tempera uses egg yolk
as the medium, and true fresco is water-
colour painted directly into wet plaster
on a wall. What matters is the signifi-
cance of this technique to Blake, who
believed that art, in revealing the spiri-
tual world, should do so with the utmost
clarity and sharpness. He believed that
this was best done with tempera because
he also, incorrectly, believed that oil
painting was not invented until the
seventeenth century and therefore asso-
ciated it with the looser more indistinct
handling of paint which developed with
the Baroque style of Rubens: 'In this exhi-
bition will be seen real Art as it was left to
us by Raphael and . . . Michelangelo . . .
stripped from the Ignorances of Rubens
and Rembrandt . . .' It should perhaps be
added that because Blake's tempera tech-
nique is vulnerable to atmospheric
changes, pictures such as this one are
now rather less distinct than originally.

'The Spiritual Form of Pitt Guiding
Behemoth' has a companion, 'The Spiri-
tual Form of Nelson Guiding Leviathan'.
Behemoth and Leviathan are Biblical
monsters, from land and sea respectively,
that Blake adopted as symbols of 'the

War by Sea enormous and the War by
Land astounding'. Admiral Nelson and
the British Prime Minister William Pitt,
were two of the leading protagonists of
England's war against France at this
time. Blake appears to have used them to
illustrate his vision of the angels which
were sent by God to destroy the world as
a prelude to the Last Judgement, as pro-
phesised in the Bible in the Book of Reve-
lation. Pitt is accompanied by a gigantic
reaper and ploughman, before whom
tiny human beings flee in terror: these
are specifically referred to in Revelation
(Ch.14, v.v.14–19) as the angels who
prepare 'the great winepress of the wrath
of God'.

WILLIAM BLAKE 1757–1827
**Beatrice Addressing Dante from the
Car** 1824–7
Pen and watercolour 372 × 527
($14\frac{5}{8} \times 20\frac{3}{4}$)

The artist John Linnell was Blake's
patron and supporter from 1818 until
Blake's death in 1827. Among the com-
missions Linnell gave Blake was one for a
set of illustrations to the *Divine Comedy*,
Dante Alighieri's epic vision, composed
from 1300–21, of the Christian myths of
Hell, Purgatory and Paradise. Blake's dis-
ciple Samuel Palmer recorded seeing him
at work on the project when he and Lin-
nell visited Blake on 9 October 1824: 'We
found him lame in bed, of a scalded foot
(or leg). There, not inactive, though
sixty-seven years old, but hard-working
on a bed covered with books sat he up
like one on the Antique patriarchs or a
dying Michelangelo. Thus and there was
he making in the leaves of a great book
(folio) the sublimest designs from his (not
superior) Dante'.

Blake's illustrations to Dante are
notorious for containing a half-hidden
critical commentary on what Blake saw
as Dante's too orthodox Christian views.
Blake felt that Dante did not have a true
vision of the spiritual and that his great
poem was based too closely on the
natural world: 'Everything in Dante's
Comedia shows that for Tyrannical
purposes he has made this World the
Foundation of All and the Goddess
Nature Memory is his Inspirer and not
the Imagination the Holy Ghost'. Believ-
ing as he did in the total forgiveness of
sins, Blake particularly objected to
Dante's vengeful vision of the sinners
being punished in Hell.

In the Purgatory section of the Divine
Comedy Dante finds himself looking
across the river Lethe towards the Gar-
den of Eden, the Earthly Paradise.
Through the garden he sees an amazing
procession led by a two wheeled chariot
drawn by a Gryphon and accompanied
by the angelic forms of the four authors
of the Gospels, Matthew, Mark, Luke and

John. When the procession nears him,
the figure of Beatrice, Dante's dead lover,
descends from above and Dante suddenly
finds 'The power of ancient love was
strong with me'. It is all marvellously
described by Dante, and Blake has
created from it a magical fantasy, beauti-
fully coloured in blue, red and yellow,
highly decorative, and fascinating to look
at even if its true meaning is not known.
Dante stands by the head of the Gryphon,
and the three women in the foreground
are Faith, (in white) Hope, (in green) and
Charity (in red). The heads of the four
Evangelists appear from amidst their pea-
cock feather wings on either side of Bea-
trice. For Dante, Beatrice symbolised the
Christian Church, but Blake has given
her a gold crown and made her represent
the evil goddess Vala in his own myth-
ology. Vala is goddess of nature, and in
showing Dante submitting to her Blake is
commenting on Dante's inability to
transcend the material world and reach
the true world of the spirit.

SAMUEL PALMER 1805–1881
A Hilly Scene *c.*1826–28
Tempera on paper 206 × 137 (8⅛ × 5⅜)

Samuel Palmer was nineteen, a preco-
ciously talented young artist with a
strongly mystical temperament, when he
was introduced to Blake by John Linnell.
Afterwards Palmer wrote 'And there,
first, with fearfulness did I show him
some of my first essays in design; and the
sweet encouragement he gave me (for
Christ blessed little children) . . . made
me work harder and better that after-
noon and night. And after visiting him,
the scene recurs to me afterwards in a
kind of vision: and in this most false, cor-
rupt and genteely stupid town [London]
my spirit sees his dwelling (the chariot of
the sun) as it were an island in the midst
of the sea . . .' Over the next few years,
inspired by Blake, Palmer developed a
vision of his own in which the English
landscape is transformed into a warm
and magical pastoral paradise. His point
of departure was the wood engraved
illustrations, made by Blake in 1821, to
the pastoral poems, known as 'Eclogues',
of the Latin poet Virgil. Palmer's account
of his first view of these is famous: 'they
are visions of little dells, and nooks, and
corners of Paradise; models of the
exquisitest pitch of intense poetry. I
thought of their light and shade, and
looking upon them I found no word to
describe it. Intense depth, solemnity and
vivid brilliance only coldly and partially
describe them. There is in all such a
mystic and dreamy glimmer as pene-
trates and kindles the inmost soul . . .'.
Palmer was also crucially inspired by a
particular piece of the English landscape,
the valley of the river Darenth at the
village of Shoreham in Kent. He first
visited Shoreham about 1824–5 and in
1826 he bought a house there and
moved in. 'A Hilly Scene' is characteristic
of the paintings he made at Shoreham,
following Blake's disapproval of oil paint
and working in tempera. The theme of
the work is fertility, the gate in the fore-
ground opening into a field of gigantic
wheat with huge ears bulging with ripe-
ness. Above is a harvest moon, another
symbol of fertility that appears often in

Palmer's work. In the background the
hills are rounded and swelling in shape.
The scene is framed by two trees forming
a gothic arch and these, with the promi-
nent church spire, add the spiritual
dimension to the picture.

EDWARD CALVERT 1799–1883
The Bride 1828
Engraving 76 × 127 (3 × 5)

The Chamber Idyll 1831
Engraving 41 × 76 (1⅝ × 3)

The Ploughman 1827
Engraving 83 × 130 (3¼ × 5⅛)

Edward Calvert was born and brought up in Devon and at the age of fifteen joined the Navy, serving for six years until he left in 1820 and decided to become an artist. He moved to London in 1824 and soon met Samuel Palmer and the Ancients, the group of young artists around the aged William Blake. From 1826–32 Calvert visited Shoreham regularly and was the closest of the Ancients to Palmer.

Like Palmer, Calvert was inspired by Blake's Virgil illustrations, and during those years produced a series of woodcuts, mostly very small. He also made some engravings on copper, one of which is 'The Bride'. It is inscribed 'O God! Thy bride seeketh thee. A stray lamb is led to thy folds.' But it already displays a lush and pagan eroticism that was eventually to overwhelm Calvert's Christian faith. Particularly telling in this evocation of a landscape flowing with natural abundance are the huge bunches of grapes on the vine growing up the tree in the centre. One of them, on the right of the tree-trunk, is so ripe that it is oozing great drops of juice.

Calvert's eroticism found its most intense expression in his tiny, extraordinary, wood engraving 'The Chamber Idyll,' while the theme of natural fertility also appears in another wood engraving, 'The Ploughman'.

The Romantic Imagination

Henry Fuseli **The Shepherd's Dream, from 'Paradise Lost'** 1793

The term 'Romantic' embraces a complex shift in artistic attitudes which took place from about 1780–1830, although the origins of Romanticism are often traced back earlier than that, and its effects are still with us. Constable, Turner and Blake are all central figures in Romantic art; Constable for his fresh vision of the natural world, Turner for his stress on the extremes of nature, storm or calm, Blake for his emphasis on the irrational and the imaginative. The development of Romanticism was bound up with the French Revolution, and led to a questioning of existing rules of art and taste as well as a new freedom for artists to express their personal feelings and vision.

Beside the three great geniuses, Constable, Turner and Blake, who took British art to its heights in the first part of the nineteenth century, a whole host of lesser figures appear. First of these was Blake's friend Henry Fuseli, a Swiss-born artist who settled in London in 1764 after fleeing political trouble in his native city of Zurich. Fuseli's disenchanted follower, the painter Benjamin Robert Haydon, once said of him 'the engines in Fuseli's mind are Blasphemy, Lechery and Blood'. These are typical preoccupations of one kind of romantic art, and looked at as a whole, Fuseli's output does divide into dreamlike erotic scenes, often of the pagan world of faerie, such as 'The Shepherd's Dream', and scenes of violence and murder such as 'Lady Macbeth Seizing the Daggers' which is reproduced and discussed on p.75.

After Fuseli, fairy subjects flourished. The most extraordinary were painted by Richard Dadd, one of the great eccentrics of British art, whose 'The Fairy Feller's Master-Stroke' is reproduced and discussed on p.77. Another interesting, although obscure, artist was John Anster Fitzgerald, whose tiny 'The Fairy's Lake' is a convincing evocation of a parallel world.

Philip James de Loutherbourg **An Avalanche in the Alps** 1803

Of great theoretical importance to the Romantic Movement was Edmund Burke's concept of the Sublime, put forward in his *A Philosophical Enquiry into the Origin of our Ideas of the Sublime and Beautiful* published in 1757. He defined the Sublime as an artistic effect productive of the strongest emotion the mind is capable of feeling and, he wrote, 'whatever is in any sort terrible or is conversant about terrible objects or operates in a manner analogous to terror is a source of the Sublime.' He took the view that the Sublime was an aesthetic emotion superior to the traditional feeling of beauty, and played a major part in establishing the Romantic, and modern idea, that art is primarily about emotion, and that artists can set their own aesthetic standards.

Most of Fuseli's work reflects the theory of the Sublime, and in landscape two outstanding examples of the Sublime are Philip de Loutherbourg's 'An Avalanche in the Alps' of 1803 and James Ward's colossal painting of 'Gordale Scar' completed in 1815.

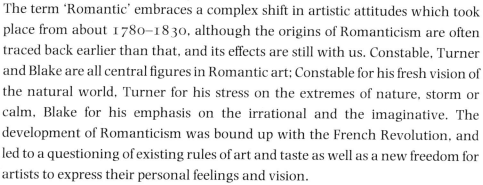

◁ Richard Dadd **The Fairy Feller's Master Stroke** 1855–64 (detail)

James Ward **Gordale Scar**
? 1812–14

Loutherbourg was an extraordinary character, born in Strasbourg and trained in Paris, who settled in London in 1771. He designed scenery for the Drury Lane Theatre, devised a quite new kind of visual entertainment called the Eidophusikon, a kind of indoor 'son et lumière', and produced a wide range of paintings. He was at his best with dramatic subjects, such as 'An Avalanche in the Alps' and his great pair of sea pieces 'The Battle of Camperdown' and 'The Battle of the Nile', commemorating victories by Nelson. He also painted Biblical fantasies such as 'The Vision of the White Horse'. 'An Avalanche in the Alps' was painted after Loutherbourg visited Switzerland in 1787, and although based on observation, is a drama in which he expresses the destructive and demonic aspects of the Alps. The picture is particularly notable for the way Loutherbourg depicts a frozen moment of time, the three figures motionless with horror as the avalanche crushes the bridge they were about to cross. 'An Avalanche in the Alps' belonged to Turner's early patron John Fleming Leicester, and it is recorded that Turner often went to look at it. His own, later, picture of an avalanche is in the Turner Collection.

James Ward was principally a painter of animals, and in 'Gordale Scar' the cattle play an important part, not least in establishing a sense of the terrifying scale of the great cliffs towering above them, topped by storm clouds. Gordale Scar is a well known landscape feature in Yorkshire; in reality it is not quite so awesome as Ward's picture makes out, as can be seen from some of his own sketches made on the spot. The finished work is a good example of an artist recasting reality to create a Romantic and Sublime effect.

Another Romantic animal painter, who went on to become one of the most famous of all Victorian painters, was Edwin Landseer. Early paintings such as his 'Hunted Stag' of 1833 show a remarkable empathy with animals, and raise questions about our pursuit of them in the hunt.

Edwin Landseer **The Hunted Stag**
exh.1833

The last major practitioner of the 'Romantic Sublime' was John Martin, whose Biblical fantasies seem to have caught the mood of the revivalist religious movements that were a feature of British society after the Napoleonic Wars. His work became immensely popular and circulated through engravings, often done by Martin himself, a skilled engraver. He specialised in scenes of divine retribution for which there seems to have been a particular demand; his 'The Last Judgement' is reproduced and discussed on p.76.

HENRY FUSELI 1741–1825
Lady Macbeth Seizing the Daggers
?exh.1812
Oil on canvas 1016 × 1270 (40 × 50)

Fuseli's interest in Shakespeare was instilled in him during his student days in Zurich by the Swiss scholar Jacob Bodmer, who also introduced him to Milton, Homer, Dante and the German medieval legends known as Niebelungenlied. All became important sources of inspiration for Fuseli, as did the aesthetic ideas of Bodmer who stressed the importance in art of the bizarre, the horrifying and the miraculous.

In 1766, Fuseli attended a production of *Macbeth* in London, with the celebrated actor David Garrick in the title role. Obviously struck by the moment in the play illustrated in this painting, he made a straightforward documentary drawing

of the scene on stage. In the later painting this is transformed into a tense and convincing drama. Driven by his ambitious wife, Macbeth has just reluctantly murdered his king, Duncan, in order to seize the throne of Scotland. He returns to Lady Macbeth still clutching the bloodstained daggers which, in his terror and remorse, he has forgotten to leave behind to incriminate the sleeping servants. Lady Macbeth orders him to return but he refuses, at which she says, 'Infirm of purpose! Give me the daggers' and takes them back herself. This is a turning point in the play, when Lady Macbeth's control of Macbeth becomes absolute and his fate sealed.

Fuseli was fascinated by dominant women and this picture touches on what was a recurring theme of his art. Fuseli had a remarkable ability, beyond any of his contemporaries, to reveal the

psychological realities underlying his literary sources. He also painted in a completely non-naturalistic style in which, as in this case, all non-essential detail is eliminated. He also once wrote, 'The most unexplored region of art is dreams'. All this can make him appear remarkably modern, looking forward to the ideas of the Surrealists and to painters like Francis Bacon. Not surprisingly, the only person in his own time really to understand him was William Blake who, in a letter to a magazine which had attacked Fuseli wrote, '. . . the truth is, he is a hundred years beyond the present generation'.

JOHN MARTIN 1789–1854
The Judgement Pictures:
The Great Day of His Wrath; The Last
Judgement; The Plains of Heaven
Triptych completed in 1853
Oil on canvas 1965 × 3032 (77⅜ × 119⅜);
1968 × 3258 (77½ × 128¼);
1988 × 3067 (78¼ × 120¾)

John Martin's 'Judgement Pictures' form
a triptych of which the central panel, 'The
Last Judgement', is illustrated here. They
were inspired by St John the Divine's fan-
tastic account of the Last Judgement
given in Revelation, the last book of the
New Testament.

The Last Judgement, as described by St
John the Divine, begins with the opening
of the Book of Judgement which is sealed
with seven seals. As each seal is broken
bizarre events occur, culminating at the
breaking of the sixth seal with 'the great
day of his wrath'. Martin's picture follows
the account of this quite closely: '. . . and,
lo, there was a great earthquake and the
sun became black as sackcloth of hair
and the moon became as blood. And the
heaven departed as a scroll when it is
rolled together and every mountain and
island were moved out of their places.'

The composition echoes the image of the
two ends of a scroll rolling up together
and the mass of rocks being hurled up
into the air on the right can, on close
examination, be seen to consist of an
entire city.

The painting of the Last Judgement
itself is based on Chapter XX of Revela-
tion. On the right the forces of evil com-
manded by Satan and led in the field by
the evil princes Gog and Magog, attack
the Holy City, Jerusalem, and are
defeated: '. . . and fire came down from
God out of Heaven and devoured them'.
Martin has shown the 'fire' as bolts of
lightning. Then: 'I saw a great white
throne and him that sat on it . . . And I
saw the dead small and great stand
before God . . . and they were judged
every man according to their works'.
Martin's composition separates the good
and evil by a great chasm, into which the
evil are falling. On the other side are the
good, who are already in 'the plains of
heaven' – the landscape in which they
are assembled continues into the com-
panion picture, just as the scene of des-
truction on the right carries over from
'The Great Day of His Wrath'. In the
background is the Holy City, Jerusalem,

one of the architectural fantasies for
which Martin was famous. It is interest-
ing to note that among the evil people in
the right foreground are a bishop and a
king and that among the good people
Martin has included a high proportion of
artists and poets! Many of these figures
were identified by Martin in a chart pub-
lished to go with the pictures.

'And I saw a new heaven and a new
earth. And I, John, saw the holy city, new
Jerusalem, coming down from god out of
heaven . . . Having the glory of God: and
her light was like unto a stone most pre-
cious'. This luminous city can just be
seen in the sky above the dream-like
landscape that is Martin's vision of
heaven.

These paintings became famous in
the years after Martin's death and were
exhibited all over England billed as 'The
most sublime and extraordinary pictures
in the world valued at 8000 guineas'.
However, by 1935 Martin had been
almost forgotten and the triptych was
sold for seven pounds and dispersed. It
was eventually reunited in the Tate Gal-
lery in 1974.

RICHARD DADD 1817–1886
The Fairy Feller's Master Stroke
1855–64
Oil on canvas 540 × 394 (21¼ × 15½)

Richard Dadd trained at the Royal Academy Schools in London from 1837–42. His early works reveal the influence of Fuseli, and in this painting there are echoes of Blake as well, in the figure of the white bearded patriarch in the centre for instance. Dadd painted a wide range of subjects but he is best known for his two fairy fantasies inspired by Shakespeare's *Midsummer Night's Dream*. This is the second of them and although Shakespeare's Oberon and Titania appear in the centre towards the top, the rest is Dadd's pure invention. Dadd's work was always imaginative, but the hallucinatory power that this painting possesses seems to have appeared after he became insane and murdered his father in 1843. He was incarcerated for the rest of his life, first in the criminal lunatic department of Bethlem Hospital in London (now the Imperial War Museum) and then, from 1864, in the newly opened Broadmoor Prison. Sympathetic staff enabled him to continue painting in both places and by the end of his life he had produced a large body of work, mostly in watercolour. This picture was painted for an official at Bethlem Hospital, G.H. Haydon, and Dadd left it behind, slightly unfinished in the foreground, when he was moved to Broadmoor. The following year he wrote a long rambling poem which describes, although it does not really explain, the picture. Dadd recounts that he imagined 'A Fairy band . . ./Fays, gnomes, and elves and suchlike fled/To fix some dubious point to fairies only/Known to exist . . .' However, they are now all watching the fairy woodman to see if he will split the hazlenut with one stroke. The Patriarch in the centre wears a triple crown, which appears to be a reference to the Pope. Dadd visited Rome in 1843 and later confessed to his doctors that while attending one of the Pope's public appearances he had been overcome by an urge to attack him, only refraining, because he was so well protected. Dadd explains that the gesture of the patriarch's right hand is to command the Fairy Feller not to strike the nut until the order is given. Dadd introduces occasional satirical elements: directly below the Patriarch, in a pink cloak, is a 'Politician

. . . with a senatorial pipe . . ./To hear him talk, Lord! how 't'would make you laugh.' To the left of the Patriarch are two maidservants, one holding a mirror and the other a brush. They are painted in an almost fetishistic way, with bulging calves and breasts and introduce a sexual note relatively rare in Dadd's art. He adds emphasis in this case by including a voyeur, a satyr, just visible by the rear foot of the maid to the right, peering up her skirt. Dadd devotes sixteen lines of his poem to this incident, in what may be a meditation on his enforced celibacy in prison.

At the top of the painting appears a group of figures representing the child-

hood fortune-telling game 'soldier, sailor, tinker, tailor, ploughboy, apothecary, thief'. Dadd's father was an apothecary and the one here looks very like him, judging from a portrait drawing done by Dadd in 1838. It has also been suggested that the Fairy Feller is a portrait of Dadd himself.

The Nineteenth-Century Academy and the Pre-Raphaelites

William Etty **Youth on the Prow, and Pleasure at the Helm** exh.1832

In the nineteenth century the Royal Academy reached its height as the dominant institution in English art, becoming increasingly a showcase for what was popular or officially approved. In 1822 Constable complained in a letter that 'The art of painting will die out, there will be no genuine painting in England in 30 years'. His gloom seems to have been related to the general level of painting shown at the Academy and more particularly to the success of painters like William Etty, whose work, while theoretically conforming to the principles of 'high art' was in practice debased in content, style, execution or all three. A case in point is Etty's 'Youth on the Prow, and Pleasure at the Helm' exhibited at the Academy in 1832. Constable sarcastically referred to this painting as 'Etty's bum-boat' (a good pun on the anatomical meaning of 'bum' and the maritime, a bum-boat being an open boat used to ferry provisions to ships at anchor.) Although Constable saw the picture as low erotic titillation, Etty did intend a serious moral message: the threatening storm cloud with its dimly seen figure of doom implies the vanity of human pleasure.

At the same time, genre, the painting of scenes of everyday life, saw a tremendous boom in popularity. The founder of this development in the nineteenth century was David Wilkie, whose works such as 'The Village Holiday', full of carefully observed detail, brought him immense success.

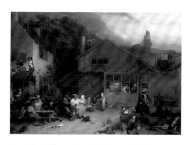

David Wilkie **The Villiage Holiday** 1809–11

Among the multitude of genre painters who followed Wilkie, outstanding were William Collins, William Maw Egley, William Powell Frith, the painter of 'Derby Day', Arthur Boyd Houghton, Charles Robert Leslie, the friend and biographer of Constable, William Mulready and, not least, Edwin Landseer whose anthropomorphic animal pictures are perhaps the quintessence of Victorian genre.

In 1846 two talented young students at the Royal Academy Schools met and became friends. They were John Everett Millais and William Holman Hunt. In the summer of 1848 they made friends with another student, Dante Gabriel Rossetti and began to meet at Millais' house, where they carried on intensive discussions about art. They were highly critical of the existing state of art in England and Hunt later recalled saying '. . . our talk is deepest treason against our betters', by which he probably meant the Academy. Their critique was three-pronged: they objected to the style of late Raphael and his followers, which was held up as a model by the Academy and exemplified by painters like Etty; they objected to the triviality of subject matter of the genre painters, and they disliked the dark colouring and free handling of paint common to both, which they referred to as 'slosh'. To combat this they formed a secret society of artists and called it the 'Pre-Raphaelite Brotherhood', or P.R.B. for short. Their

John Everett Millais **Ophelia** 1851–2 (detail)

Ford Madox Brown
The Hayfield 1855–6

Herbert Draper **The Lament for Icarus** exh.1898

William Dyce **Pegwell Bay, Kent – a Recollection of October 5th 1858**
? 1858–60

principles were to paint only serious subjects and to do so in a style of clear, sharply focused realism based on painting everything in the picture entirely from life.

The first 'P.R.B.' paintings, among them Rossetti's 'Girlhood of Mary Virgin', were shown in public in 1849 and were on the whole well received. The following year Rossetti exhibited 'Ecce Ancilla Domine' (Behold the Handmaiden of the Lord), a companion to his first picture, and Millais showed 'Christ in the House of His Parents'. This time the critical response was a howl of outrage. Rossetti's picture was denounced as 'an example of the perversion of talent which has recently been making so much headway . . .' and Millais' was called 'monstrously perverse', 'a nameless atrocity' and 'plainly revolting'. This outrage was partly the result of the existence of the secret brotherhood becoming publicly known; the art establishment reacted badly to a group of young men barely out of their teens setting out to reform it. But their realism and religiosity also caused offence, especially in relation to 'Christ in the House of His Parents', which is reproduced and discussed on p.82.

To its credit the Academy refused to give in to demands to ban the Pre-Raphaelites from its exhibition, and the group also found influential defenders in the critic John Ruskin and Queen Victoria's art loving husband Prince Albert. In 1852 the tide turned and Millais won a huge success at the Academy with his painting 'A Huguenot'. He also showed a Shakespeare subject, 'Ophelia', which attracted less attention, but is now seen as one of the greatest Pre-Raphaelite paintings. It is reproduced and discussed in detail on p.83.

As well as religious and romantic subjects, the Pre-Raphaelites produced a group of works dealing with contemporary social problems. One of the most famous of these, Hunt's 'The Awakening Conscience', is reproduced and discussed on p.84.

After 1852, the influence of the Pre-Raphaelites spread rapidly and many artists, both older and younger, responded to their work. One of the older artists was Ford Madox Brown, who had painted in a 'pre-Raphael' style from about 1845, when he had made the first version of his 'Chaucer at the Court of Edward III.' Rossetti became his pupil for a while in 1848. Brown made a considerable contribution to the development of Pre-Raphaelite landscape painting with pictures like 'Carrying Corn' and 'The Hayfield', painted direct from nature, often with immense effort. 'The Hayfield', a twilight scene, was painted on a succession of evenings from late August 1855. Brown was a pioneer in the observation of colour contrasts in nature, in this case being struck by the way in which the strong green of the grass made the brown hay appear almost pink by contrast, in the evening light.

Another older artist whose work was confirmed in its existing direction by the success of the Pre-Raphaelites was William Dyce, whose 'Pegwell Bay' is one of the most memorable of Pre-Raphaelite landscapes.

Augustus Leopold Egg **Past and Present, No.1** 1858

Among the artists who took up the social comment vein of Pre-Raphaelitism were Augustus Egg and William Powell Frith, whose famous 'Derby Day' is reproduced and discussed on p.85.

Egg's triptych, 'Past and Present' is extremely unusual in depicting the adultery of a wife and its consequences, and created considerable controversy when shown at the Academy exhibition of 1858. The first scene shows the wife in despair as her husband grimly reads a letter from her lover. A bag stands ready for her departure. Beside her on the floor is an apple whose core can be seen to be rotten. The collapse of the family is symbolised by the house of cards being built by the two children and by the pictures on the wall, a shipwreck on the man's side and the expulsion of Eve from the Garden of Eden on the other. The other two scenes show, months later, the woman with her illegitimate child, destitute under the arches by the Thames at Charing Cross, and the children, now in effect orphaned, since their father has died. The work has been related to the Matrimonial Causes Act of 1857, which made divorce easier, but drew a distinction between adultery of the wife, which was absolute grounds for divorce, and adultery of the husband, which was not.

The original Pre-Raphaelite brothers went their separate ways from about 1853, but a second grouping formed around Rossetti from about 1857, consisting principally of Edward Burne-Jones and William Morris. The importance of Morris was in the field of design, but Burne-Jones became one of the grand old men of late Victorian art. His 'King Cophetua and the Beggar Maid' is reproduced and discussed on p.87. Rossetti himself underwent a shift in style at this time and began to paint beautiful women in a dreamy decorative manner. His 'Beata Beatrix' is reproduced and discussed on p.86.

John William Waterhouse **The Lady of Shalott** 1888

Pre-Raphaelite influence extended right up to the end of the century with painters like J.W. Waterhouse whose 'Lady of Shalott' reflects the Pre-Raphaelite passion for Tennyson. Finally, in paintings such as Herbert Draper's 'Lament for Icarus' we see the innovations of the Pre-Raphaelites fully absorbed into the line of Academy painting that goes straight back to Etty and his 'bum-boat'.

JOHN EVERETT MILLAIS
1829–1896
**Christ in the House of His Parents
(The Carpenter's Shop)** 1849–50
Oil on canvas 864 × 1397 (34 × 55)

This is one of the early religious subjects
of the Pre-Raphaelite Brotherhood and is
a perfect example of the combination of
minute realism and elaborate symbolism
characteristic of their work. Millais based
the setting on a real carpenter's shop,
said to have been in Oxford Street, and
the sheep in the background were
painted from two heads obtained from a
local butcher. Various friends and rela-
tives posed for the figures, including Mil-
lais' father for the head of Joseph. How-
ever, when Millais came to paint Joseph's
arms and legs he employed a real car-
penter to obtain the authentic muscle
structure of the arms, and the varicosed
legs.

Christ has just cut his palm on the nail
left in the door they are making and a
drop of blood has fallen on to his foot,
prefiguring the Crucifixion. In the back-
ground the dove perched on the ladder is
a symbol of the Holy Spirit and the car-

penter's triangle of the Trinity. The
future John the Baptist is shown bringing
water to bathe the wound, but the water
also refers to the baptism. It has been
suggested that the whole scene symbo-
lises the interior of a church, with the
bench representing the altar and Christ
and his mother on the holy, east side of it.
The partition behind it would represent
the rood screen dividing the sacred part
of the church, the chancel, from the
nave. The sheep would represent the con-
gregation, Christ's flock.

The painting was viciously attacked by
the critics, partly for its realism which
defied all current expectations that
religious art should depict the Holy
Family in a highly idealised way. The
elaborate symbolism also seems to have
aroused strong feelings in relation to the
violent controversy going on at precisely
that time over the introduction of Roman
Catholic style ceremony and furniture
(e.g. rood screens) into the Church of
England. The realism of the picture in
particular appears to have upset Charles
Dickens, who delivered an amazing, hea-
vily sarcastic, denunciation of it in his
magazine *Household Words*:

'You behold the interior of a car-
penter's shop. In the foreground of that
carpenter's shop is a hideous, wry-
necked, blubbering, red-headed boy, in a
bed-gown, who appears to have received
a poke in the hand, from the stick of
another boy with whom he has been
playing in an adjacent gutter, and to be
holding it up for the contemplation of a
kneeling woman, so horrible in her ugli-
ness, that (supposing it were possible for
any human creature to exist for a
moment with that dislocated throat) she
would stand out from the rest of the com-
pany as a Monster, in the vilest cabaret in
France, or the lowest ginshop in England
. . . Wherever it is possible to express
ugliness of feature, limb or attitude, you
have it expressed. Such men as the car-
penters might be undressed in any hospi-
tal where dirty drunkards, in a high state
of varicose veins, are received. Their very
toes have walked out of Saint Giles's'.

JOHN EVERETT MILLAIS
1829–1896
Ophelia 1851–2
Oil on canvas 762 × 1118 (30 × 44)

The source for this painting is Shakespeare's account of the death of Ophelia in *Hamlet*, Act IV Scene vii. Ophelia has been driven mad by the murder of her father by her lover Hamlet. Out picking flowers she slips and falls into a stream. In her grief and madness she allows herself to drown.

Millais spent nearly four months from July to October 1851 painting the background, on the bank of the River Hogsmill at Ewell in Surrey. He endured considerable difficulties and discomfort and the whole story of the painting of 'Ophelia' is evidence of the extraordinary dedication of the young Pre-Raphaelites to their goal of 'truth to nature'. In December Millais returned with the canvas to London, where he inserted the figure. The model was Elizabeth Siddal, who posed in a bath full of water kept warm by lamps underneath. The lamps once went out, she caught a severe cold and her father threatened Millais with legal action if he did not pay the doctor's bill.

The brilliant colour and luminosity of 'Ophelia' is the result of the Pre-Raphaelite technique of painting in pure colours onto a pure white ground. The ground was sometimes laid fresh for each day's work – the 'wet white' technique – which gave added brilliance and was used by Millais in 'Ophelia' particularly for the flowers. The picture contains dozens of different plants and flowers painted with the most painstaking botanical fidelity and in some cases charged with symbolic significance. For example, the willow, the nettle growing within its branches and the daisies near Ophelia's right hand, are associated with forsaken love, pain and innocence respectively. The poppy is a symbol of death.

WILLIAM HOLMAN HUNT
1827–1910
The Awakening Conscience 1853
Oil on canvas 762 × 559 (30 × 20)

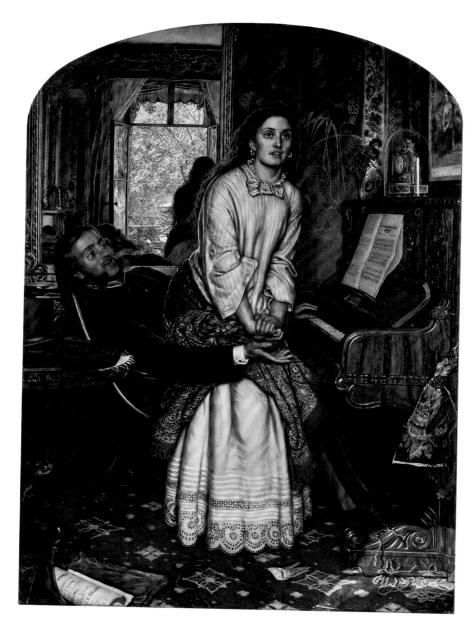

The painting depicts a kept mistress and her lover in a villa in St John's Wood. This district of London was favoured by wealthy Victorians for keeping their mistresses since it was convenient to the family residences of Belgravia but separated from them by Hyde Park. Holman Hunt, with typical Pre-Raphaelite thoroughness, hired a room at Woodbine Villa, 7 Alpha Place, St John's Wood, which, according to the painter's daughter, actually was a 'maison de convenance' where illicit lovers could meet. The young woman's status as a kept woman is indicated by the fact that she has rings on every finger of her left hand except the wedding finger. She is also in what would have been recognised at the time as a state of undress. She has been sitting on her lover's knee singing a song but is in the act of jumping up, staring out of the window at the bright sunlit scene which the spectator sees reflected in the mirror on the wall behind.

The song she has been singing is 'Oft in the Stilly Night' which tells of a young woman thinking back to her innocent childhood. This has reminded the woman of her own lost innocence and as the title of the painting indicates, she has undergone a crisis of conscience, since the light symbolises Christ, amounts to a conversion. Hunt in fact stated that the painting was a secular counterpart to his celebrated picture of Christ as 'The Light of the World'. Hunt clearly sees the woman as a victim of the man, their relationship symbolised by the cat playing with the bird under the table. She may well be discarded by him, like the soiled glove in the foreground, in which case her fate would probably be to fall into common prostitution. The callous disregard of the man for his mistress's feelings, or his obtuse lack of awareness of them, is pointed up by Hunt in the Bible quotation on the frame 'As he that taketh away a garment in cold weather, so is he that singeth songs to an heavy heart.' The frame was designed by Hunt, the marigolds are emblems of sorrow, the bells of warning, while the star at the top represents spiritual revelation.

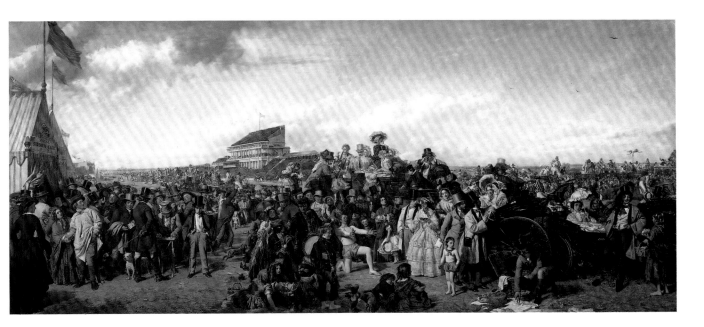

WILLIAM POWELL FRITH
1819–1909
The Derby Day 1856–8
Oil on canvas 1016 × 2235 (40 × 88)

This picture attracted such huge attention at the Royal Academy exhibition of 1858 that it had to be protected by a rail. Frith spent fifteen months painting it and used a variety of live models for the figures, as well as specially commissioned photographs of the Epsom race course. It was sold before the exhibition opened. In recent times 'Derby Day' has often been seen as an amusing but essentially insignificant piece of Victorian genre. This is not, however, the case. It is a cogent piece of social realism providing an extraordinary panorama of Victorian society, its vices and virtues, with particular emphasis on the vices. This was recognised at the time, as Frith's fellow Academician J.E. Hodgson, notes: 'The races on Epsom Downs, the great Saturnalia of British sport, bring to the surface all that is most characteristic of London life. In this picture we can discern its elements, its luxury, its wealth, its beauty and refinement, its hopeless misery . . . All its sad tales are told, from that of the jaded Traviata seated in her carriage to the thimble-riggers' accomplice luring a silly countryman to lose his money; and the hungry young acrobat, who forgets all about his somersault in the cravings of his poor empty little stomach. Though Mr Frith does not intentionally pose as a

moralist in this picture, its truth and its wealth of incident answer the same purpose. We are surrounded by evils . . .' Whether Frith was moralising or not, recent research by Dr Mary Cowling has convincingly suggested that Frith set out to create carefully realised images of nearly one hundred distinct social types, identifiable as such within the enormously elaborate Victorian class structure. These types are recognisable by their dress, and particularly by their physical appearance, which Dr Cowling has suggested is rendered in accordance with the widespread Victorian pseudo-science of physiognomy, which stated that a person's character, criminal or whatever, could be read in their physical features. This would certainly explain the almost obsessive way in which the public responded to the picture, as its anxious owner reported: 'People three or four deep . . . those in front with their faces within three or four inches of the canvas. The nature of the picture requires a close inspection to read, mark, learn and inwardly digest it . . .'.

There are three main incidents. On the right is the young woman in the carriage, referred to by Hodgson as a 'Traviata', the title of Verdi's famous opera about a courtesan, and a characteristic Victorian way of referring euphemistically to a 'fallen woman'. She is the kept mistress of the 'high class roué' leaning against the carriage. Related to her is the woman in brown riding clothes, on the

extreme left of the painting, who is one of the 'pretty horse breakers', high class prostitutes, who at this period daily paraded in Hyde Park on horseback. These women reflect the phenomenal blossoming of prostitution at every level in London in the middle years of Victoria's reign, also the subject of Holman Hunt's 'Awakening Conscience'. In the centre, the child acrobat distracted by the rich party's food, provides a poignant tableau of the social divide, while on the left the focus is on the 'thimble riggers' who have cheated the 'city gent' in his top hat out of his money. On his left, a young countrywoman restrains her man from following the same foolish path.

DANTE GABRIEL ROSSETTI
1828–1882
Beata Beatrix *c.* 1864–70
Oil on canvas 864 × 660 (34 × 26)

The title translates as 'Beatrice blessed' and refers to Dante's *Vita Nuova* (The New Life), the celebrated account of the poet's unrequited love for a young Florentine woman, Beatrice Portinari. Beatrice died prematurely, on 9 June 1290, at the age of twenty four, and the inspiration of Rossetti's picture is the account of her death given by Dante in the *Vita Nuova*: 'She hath gone to Heaven suddenly/And left Love on Earth to mourn with me'. Rossetti was fascinated by the *Vita Nuova*, as one of the world's great accounts of a pure, spiritual passion of a man for a woman and the lines quoted are from his own translation. In the background of the painting can be seen the figures of Dante, on the right, in green, and Love, on the left, in red. Between them, dimly in the distance, is the characteristic shape of the Ponte Vecchio in Florence. The image of Beatrice herself is not, as Rossetti emphasised in a letter of 1873, a literal representation of her death but 'an ideal of the subject, symbolised by a trance or sudden spiritual transfiguration.' Rossetti continues his account: 'Beatrice is rapt visibly into Heaven, seeing as it were through her shut lids (as Dante says at the close of the *Vita Nuova*) "Him who is Blessed throughout all ages"; and in sign of the supreme change, the radiant bird, a messenger of death, drops the white poppy between her open hands. In the background is the City which, as Dante says: "sat solitary" in mourning for her death; and through whose street Dante himself is seen to pass gazing towards the figure of Love opposite in whose hand the waning life of his lady flickers as a flame. On the sundial at her side the shadow falls on the hour of nine, which number Dante connects mystically in many ways with her and with her death.'

There seems little doubt that this painting was intended by Rossetti as a tribute to his dead wife Elizabeth Siddal, of whom the figure of Beatrice is a clear portrait, presumably based on drawings done before her death in February 1862. Rossetti presents an idealised vision of Elizabeth as Beatrice and by implication himself as Dante, and his love as pure as Dante's love. This reading is reinforced by

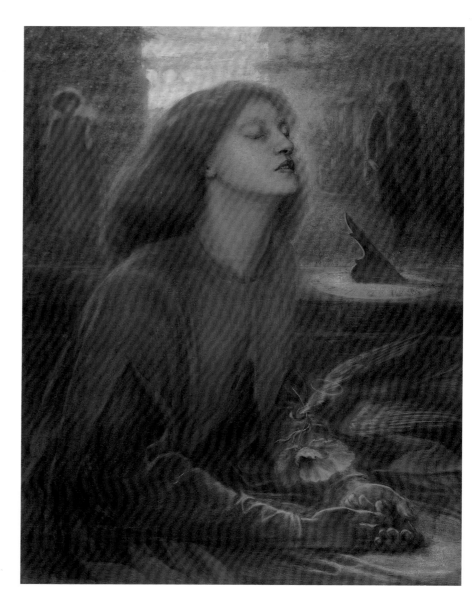

the prominence of the white opium poppy, a fairly common poetic symbol of death, but having a special relevance here, since Elizabeth Siddal died of an overdose of opium, in the form of the popular Victorian medicine, laudanum. The frame was designed by Rossetti and in addition to the date of Beatrice's death at the top, is inscribed with a line from the Book of Lamentations (1.1.) quoted by Dante in the *Vita Nuova* and referred to by Rossetti in his description of the picture: 'Quomodo sedet sola Civitas' – 'how doth the city sit solitary' – suggesting, as Rossetti says, that the whole of Florence was mourning the death of Beatrice. In the roundels are representations of the sun, the stars, the moon and the

earth, referring to the last lines of Dante's *Divine Comedy*: 'Love which moves the sun and all the stars'.

EDWARD BURNE-JONES
1833-1898

King Cophetua and the Beggar Maid
1884

Oil on canvas 2934 × 1359 (115½ × 53½)

The picture is based on an ancient legend which Burne-Jones knew through two poetic versions, one of 1612 by the poet Richard Johnson titled, like Burne-Jones's painting, *King Cophetua and the Beggar Maid* and a poem of two stanzas by Tennyson titled simply *The Beggar Maid*.

The early version tells more of the story: King Cophetua is an African prince who disdains women. One day, however, looking out of his palace window he sees among the beggars at the gate a maid so beautiful that he is instantly struck with love and has her brought into the palace. Tennyson then takes up the tale:

> Her arms across her breast she laid;
> She was more fair than words can say:
> Bare-footed came the beggar maid
> Before the King Cophetua.
> In robe and crown the king stept
> down,
> To meet and greet her on her way;
> 'It is no wonder,' said the lords,
> 'She is more beautiful than day.'

Cophetua swears to make her his Queen and in spite of the horror of his courtiers at the idea of him marrying a commoner, he does so.

The picture was exhibited in London and Paris to great acclaim. Its success was partly due to it being seen as an illustration of the moral idea of the triumph of beauty and spiritual values, represented by the maid, over material wealth and power. In the painting King Cophetua is seated below the beggar maid and has removed his jewelled crown. The egalitarian idea of a king marrying a beggar has also been seen as connected with the socialism that Burne-Jones's close friend William Morris was espousing at this time.

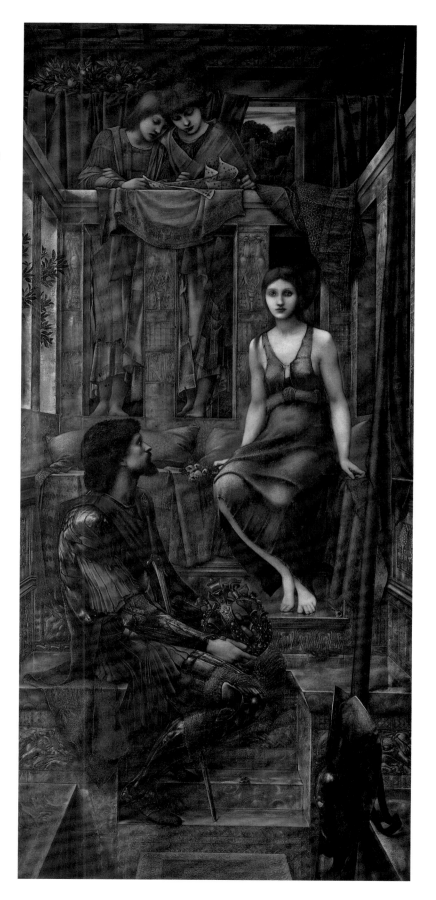

Social Realism and Rural Naturalism 1870–1900

In the mid-nineteenth century the term realism came to mean the depiction in art of specifically ugly or unpleasant aspects of life. Social realism implied the depiction of contemporary social problems, particularly in the urban environment. Rural, or rustic, naturalism implies paintings of rural life with emphasis on the everyday existence of the labouring poor. Both terms also imply a particularly technical approach based on painting directly from life and, in the case of the naturalists, in the open air.

Social realism was not uncommon in British art before the 1870s, particularly in Pre-Raphaelite circles, but a definite revival took place in that decade together with a change in style resulting from continental influences. These influences came originally from the French realist painters Millet and Courbet and were partly transmitted into England by the French painter Alphonse Legros, who settled in London in 1863. His 'Le Repas des Pauvres' (The Poor at Table) is typical of the gloomy style that became characteristic of social realism in Britain in the 1870s.

Alphonse Legros **Le Repas des Pauvres** 1877

This revival was associated with a new, high quality illustrated magazine *The Graphic*, founded in 1869, and with three artists in particular who worked for it, Luke Fildes, Frank Holl and Hubert von Herkomer. The first issue of *The Graphic* included a full page illustration by Luke Fildes of homeless people waiting for admission to a night shelter. Fildes turned this illustration into a large painting, exhibited at the Royal Academy in 1874 with the title 'Applicants for Admission to a Casual Ward' and it now appears as one of the keynote images of this phase of Victorian social realism. The Tate Gallery owns a smaller version. Later, in 1891, Fildes produced another of the most memorable images in Victorian art, 'The Doctor', which is reproduced and discussed on p.90.

Frank Holl's small pair of pictures 'Hush!' and 'Hushed' deal with the all too commonplace event of infant mortality.

Rural naturalism and the practice of open air painting, developed from about 1880 in the work of a group of artists influenced by another French painter, Jules Bastien-Lepage. Some of them, notably Stanhope Forbes and Frank Bramley, moved to Newlyn in Cornwall, attracted by the quality of light and the picturesque fishing community. They were joined by many others and became known as the Newlyn School. Frank Bramley's 'A Hopeless Dawn' is reproduced and discussed on p.91. Other painters such as George Clausen and Herbert La Thangue remained independent.

Stanhope A. Forbes **The Health of the Bride** 1889

◁ Frank Bramley **A Hopeless Dawn** 1888 (detail)

LUKE FILDES 1844–1927
The Doctor exh. 1891
Oil on canvas 1664 × 2419 (65½ × 95¼)

'The Doctor' was the result of a commission from Henry Tate at the time when he was planning to present his collection to the nation, a gesture which led to the foundation of the Tate Gallery. Tate left the precise choice of subject to Fildes, who responded by painting an idea which had been in his mind since 1877, when on Christmas morning his eldest son Paul had died. Fildes had been deeply impressed by the way in which the family doctor had cared for the boy.

To paint it Fildes constructed in his studio a full-scale mock-up of the cottage interior, the window of the cottage corresponding to the window of the studio. The cottage was based on ones he had made studies of in Scotland and Devon the year before the picture was painted.

The image of the quiet heroism of the ordinary doctor was a huge success, not least with the medical profession. When shown at the Royal Academy in 1891 it drew crowds, the print of it issued by Agnews was their most popular ever and it later appeared on two postage stamps.

Fildes himself said that he wanted 'to put on record the status of the doctor in our own time'. In his description of the picture he indicates that unlike the case of his own son, this one has a happy ending: 'At the cottage window the dawn begins to steal in – the dawn that is the critical time of all deadly illnesses – and with it the parents again take hope into their hearts, the mother hiding her face to escape giving vent to her emotion, the father laying his hand on the shoulder of his wife in encouragement of the first glimmerings of the joy which is to follow.'

FRANK BRAMLEY 1857–1915
A Hopeless Dawn 1888
Oil on canvas 1226 × 1676 (48¼ × 66)

Bramley was a leading member of the
Newlyn School of painters, and this
painting made his reputation when it
was shown at the 1888 Royal Academy
exhibition. It was immediately bought for
the nation and has been on almost con-
tinuous view at the Tate Gallery since its
opening in 1897.

The title, and to some extent the sub-
ject, came from a description of a beach
with fishing boats in John Ruskin's *The
Harbours of England*: 'Human effort and
sorrow going on perpetually from age to
age; waves rolling for ever; and still, at
the helm of every lonely boat, through
starless night and hopeless dawn, His
hand, who spreads the fisher's net over
the dust of the Sidonian palaces, and
gave unto the fisher's hand the keys of
the kingdom of heaven.'

The print after Raphael's cartoon of
'Christ giving the Keys to St Peter' repre-
sented on the wall on the right has evi-
dently been placed there deliberately to
bear out the text.

However, the subject can also be
related to Charles Kingsley's famous and
morbid poem of 1851, *The Three
Fishers*, which describes the overnight
vigil of three fishermen's wives whose
husbands are at sea, concluding: 'Three
corpses lay out on the shining sands/In
the morning gleam as the tide went
down/And the women are weeping and
wringing their hands . . ./For men must
work and women must weep . . .'

The wife and mother of the overdue
fisherman have waited a day and a night
and have now given up hope. The dying
flame of the candle on the window ledge
symbolises his death somewhere out in
the stormy sea that is seen beyond it. An
open Bible lies in front of the two women.
As critics noted at the time, the picture is

beautifully painted, particularly in its
effects of light and low key colour, and in
this respect it is one of the finest examples
of Newlyn School painting.

A completely contrasting view of the
life of the sea was provided by Stanhope
Forbes in his equally famous painting
'The Health of the Bride' of 1889 (see
p.89). It depicts the wedding feast of a
young sailor and his bride in a local inn
and like 'A Hopeless Dawn' was also
praised both for its social observation and
for its painterly qualities, particularly
Forbes's ingenious lighting of the scene
from two sources, one out of the picture
on the right.

Aesthetes and Olympians

James Abbot McNeill Whistler **Three Figures: Pink and Grey** 1868–78

George Frederic Watts **Hope,** replica 1886

Lawrence Alma-Tadema **A Favourite Custom** 1909

Frederic Leighton **Lieder ohne Worte ('Songs without Words')** exh. 1861 (detail)

Aestheticism was a phenomenon of English art in the 1870s and 1880s. It involved a cult of beauty for its own sake and embraced both the fine and decorative arts. It was recognised as a distinct movement as early as 1882, when a critic named Walter Hamilton published *The Aesthetic Movement in England*. The rallying cry of the movement was 'l'art pour l'art', or 'art for art's sake', a phrase coined by the French poet Théophile Gautier who also put the word 'aesthetic' into circulation in the sense that it was used by the participants in the Aesthetic Movement.

In painting, the chief aesthetes were James McNeill Whistler and his friend Albert Moore, but the cult of beauty was also central to a group of artists now often called the Olympians, a title which refers not only to their emphasis on subjects from Greek mythology (Mount Olympus was the dwelling place of the Greek Gods) but to their own god-like status in the society of their time. The leading Olympians were Edward Poynter, George Frederic Watts, Lawrence Alma-Tadema and, above all, Frederic Leighton, who by all accounts was actually god-like in person. Exceedingly handsome, an athlete, possessed of brilliant intellectual accomplishments, he was elected President of the Royal Academy in 1879, created a Baronet in 1886, and elevated to the peerage just before his death. Both Poynter and Alma-Tadema were knighted and Watts, a more philosophical and austere figure, whose success tended to be critical rather than financial, received the Order of Merit. Poynter became President of the Royal Academy in 1896 and from 1894 was also Director of the National Gallery.

The Olympians were crucially inspired by the Elgin Marbles – the Greek sculptures from the Parthenon in Athens brought to London in 1807 by the Earl of Elgin and housed in the British Museum from 1816. Aesthetes like Albert Moore also reflect this classical influence, especially in their use of draperies. Whistler, the purest of the aesthetes and the presiding genius of the Aesthetic Movement, developed a completely new kind of painting under the influence of the art of Japan, which was having revolutionary effects on Western art generally at this time. But classical elements can be found combined with Japanese in his 'Three Figures; Pink and Grey' of 1868. In his later, musically titled, 'Nocturnes' and 'Arrangements' his painting became even more purely visual in effect and really belongs to the history of international modernism as much as to the Aesthetic Movement in England.

Works by Leighton and Moore are reproduced and discussed on pp.94, 95.

FREDERIC, LORD LEIGHTON
1830–1896
**Lieder ohne Worte ('Songs with-
out Words')** 1860–61
Oil on canvas 1016 × 629 (40 × 24¾)

'Lieder ohne Worte' is a masterpiece from
the very beginning of Leighton's career in
London, where he finally settled in the
summer of 1859 after his studies abroad.
He had been in Rome, where he met and
became friends with Poynter, and in
Paris, where they both met and became
friends with Whistler.

'Lieder ohne Worte' is extraordinary in a
number of ways. In general it announces
both the classical revival and the Aes-
thetic Movement, and is a perfect mar-
riage of the principles of both. Leighton's
classicism is imaginative, unlike the every-
day literalness of Alma-Tadema for
example, and the picture evokes a deli-
cate poetic mood. It is painted in carefully
controlled harmonies of colour and the
frame is consciously designed, probably
by the artist, to relate to the painting and
so create a unified decorative whole. The
musical title evokes one of the basic prin-
ciples of the Aesthetic Movement, that
painting can function, like music, purely
in an abstract and evocative way
through relationships of colour and form.

Lieder ohne Worte is in fact the title of a
group of forty-eight short piano pieces by
Mendelssohn which were well known
and popular in England. The 'Songs with-
out Words' that the young woman is
hearing are, of course, the musical splash
of the fountain and the song of the bird
above her.

ALBERT MOORE 1841–1893
A Garden 1869
Oil on canvas 1745 × 880 (68¾ × 34⅝)

At the beginning of his career Albert Moore painted Biblical subjects influenced by the Pre-Raphaelites. In about 1865 however, the influence of classical art and particularly the Elgin Marbles became dominant and he began to paint the carefully composed, beautifully coloured, completely subjectless pictures for which he is known.

'A Garden' belongs to the first group of major paintings of full-length, classically draped figures with which Moore established his mature style in the late 1860s. His development of such an extraordinarily purely decorative and mood evoking art was certainly stimulated by his friendship at this time with Whistler. Moore introduced Whistler to classical art, but Whistler in turn introduced Moore to Japanese prints, with their emphasis on surface pattern and distinct areas of clear colour.

The colours of 'A Garden' are astonishingly fresh, and the painting is remarkable even in Moore's own work for the single-mindedness with which, by turning the figure away from the spectator, he has treated it simply as a peg on which to hang his colours and surface effects. This aspect of Moore was well summed up by the critic Sidney Colvin who described Moore's 'habit, right or wrong, of making the decorative aspect of his canvas, regarded as an arrangement of beautiful lines and refreshing colours, the one important matter in his work. The subject, whatever subject is chosen, is merely a mechanism for getting beautiful people into beautiful situations.' The poet Swinburne, who with Walter Pater, Oscar Wilde and Whistler, was a leading promoter in England of the French doctrine of 'l'art pour l'art', art for art's sake, reviewed Moore at the 1868 Academy exhibition, the year before he painted 'A Garden': Moore's paintings, Swinburne wrote, are 'the faultless and secure expression of an exclusive worship of things formally beautiful . . . their reason for being is simply to be.'

Moore was extremely methodical as a painter and the formal perfection of his paintings is the result of an elaborate process of conception and execution.

Impressionism in France and Britain

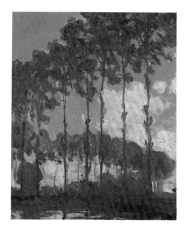

Claude Monet **Poplars on the Epte**
1891

Walter Richard Sickert
**Minnie Cunningham at the Old
Bedford** c.1889

William Nicholson **The Lowestoft
Bowl** 1911

John Singer Sargent **Carnation, Lily,
Lily, Rose** 1885–6 (detail)

French Impressionism developed out of earlier naturalistic landscape painting and the Realist tradition of both rural and urban figure subjects. The vital new twist given to this existing practice by the artists who became known as the Impressionists was to paint their pictures wholly out of doors, a procedure captured for us by John Singer Sargent in his painting of Claude Monet, the leading French Impressionist, out painting near his home at Giverny, on the River Epte, a tributary of the Seine, about forty miles north-west of Paris. Working out of doors, which Monet and his friends began to do consistently from about 1862, led to paintings which display greater luminosity and clearer colour than before and an increasing breakdown of the scene into patches of light and colour, often with an emphasis on surface pattern, as in Monet's 'Poplars on the Epte'. The name Impressionism became current after a critic singled out for particular abuse, on account of its apparently 'unfinished', sketchy quality, Monet's 'Impression, Sunrise' at the first group exhibition held in 1874.

Camille Pissarro was another leading Impressionist. His 'A Corner of the Meadow at Eragny', although painted as late as 1902, is a piece of pure Impressionism, with its surface of flickering greens set off by the red of the apples on the tree. It is inscribed on the back in the artist's hand 'En octobre de 10h. a midi 1/2', which indicates that it is an effect of morning light in October worked on between 10.00 and 12.30 every day. Other works by Pissarro, such as 'The Little Country Maid', reveal the Impressionist inheritance of Realist figure subjects. This strand of Impressionism was most intensely developed by Edgar Degas, not least in the sculptures which he made throughout his mature career. His 'Little Dancer Aged Fourteen' is reproduced and discussed on p.99.

James Abbott McNeill Whistler was born in America, trained in Paris and settled in London about 1863. Taking his point of departure from some of the same sources in art and ideas as the French Impressionists, he pursued a highly personal course, to become the chief representative in England of continental modernism. His 'Nocturne in Blue and Gold: Old Battersea Bridge' is reproduced and discussed on p.100.

After Whistler the practice of Impressionism in Britain was most immediately taken up by Walter Richard Sickert, a pupil of Whistler, and Philip Wilson Steer. In 1886 Steer was a founder member of the New English Art Club, an exhibiting society set up to provide a platform for 'modern' artists to whom the Royal Academy was already showing hostility. Sickert joined in 1888 and the two became leaders of the most avant-garde faction of the club, organising in 1889 an exhibition at the Goupil Gallery in London under the title 'London Impressionists'. Steer's 'Boulogne Sands' and Sickert's 'La Hollandaise' are reproduced and discussed on pp.102 and 130 respectively.

Augustus John **W. B. Yeats** 1907

Henri de Toulouse-Lautrec **The Two Friends** 1894

Aubrey Beardsley **The Fat Woman** 1894

In 1885 the American, John Singer Sargent, settled in London after ten years study and practice as a portrait painter in Paris, where he met Monet. He left Paris after the hostile reception, on account of its perceived eroticism, given to his dramatic and acutely observed portrait of the eccentric society beauty Madame Gautreau, a version of which is in the Tate Gallery collection. In England Sargent went on to become a highly successful society portraitist. The masterpiece of his early Impressionist phase 'Carnation, Lily, Lily, Rose', is reproduced and discussed on p.103.

In the early years of the twentieth century Augustus John became a dominating figure in modern British art. His reputation was made when in 1909 he exhibited 'The Smiling Woman', a portrait of his mistress Dorothy McNeill ('Dorelia'). In his work at this time the traditional elements evident in 'The Smiling Woman' were giving way to various modern French influences which can be seen in later paintings such as 'Washing Day'. In 1907, with his celebrated portrait of W. B. Yeats (Yeats hated it) he made a dramatic start to the series of portraits of famous contemporaries for which he became chiefly known.

John's sister Gwen was overshadowed by him in her lifetime, partly because after training at the Slade School of Art from 1895–8, she moved to Paris in 1904, where she remained for the rest of her life. She is, however, now greatly admired for her consistent, contemplative, low-key yet intense vision of women, and her reputation has outstripped her brother's. Her 'Nude Girl' is reproduced and discussed on p.101.

One of the most important French followers of Degas was Henri de Toulouse-Lautrec, whose dashing graphic style found its fullest expression in the posters which took Paris by storm in the 1890s. 'The Two Friends' is one of the brothel scenes which he recorded, among many others facets of Paris café and bohemian life. In London in the 1890s Aubrey Beardsley appears as something of a equivalent to Lautrec, as an illustrator and graphic artist of great originality. Also at this time, William Nicholson with his partner James Pryde produced bold posters and other graphic work in the new style of 'art nouveau'. Nicholson went on to become one of Britain's greatest painters of still life. Both Beardsley and Nicholson were among the subjects of William Rothenstein, who moved through the modern art and literary world of London in the 1890s, making portrait lithographs of its members and painting in a dark tonal manner inspired by Whistler and Degas.

EDGAR DEGAS 1834–1917
Little Dancer Aged Fourteen 1880–1
Bronze, with muslin skirt and satin hair
ribbon 984 × 419 × 365
(38¾ × 16½ × 14⅜)

Edgar Degas made sculpture from quite
early in his career, although the full, con-
siderable extent of this activity was
revealed only after his death: the 'Little
Dancer Aged Fourteen' was the only
piece of sculpture he ever exhibited in
public. It is also the earliest sculpture by
Degas that can be firmly dated, although
it is generally agreed that he must have
made some sculpture before this extra-
ordinary masterpiece. The model was
Marie van Goethen, a pupil in the ballet
class at the Paris Opera. She was fourteen
on 17 February 1878 so Degas presuma-
bly started work on the piece sometime
after that. He began by making drawings
of her both nude and dressed and then
made a nude version of the final pose.
The medium he used for this and for most
of his other sculptures was a combination
of wax and a kind of plasticene, a mixture
of oil and clay. They were only cast in
bronze after his death. The final clothed
version of the 'Little Dancer Aged Four-
teen' appeared at the 1881 Impressionist
exhibition, although it arrived several
days after the opening, to fill the empty
glass case which had been waiting for it.
The figure had a horsehair wig as well as
clothes and Degas applied colour to the
exposed parts of the flesh to enhance the
naturalistic effect. This does not seem to
have worked everywhere, since one critic
complained that this dancer appeared
never to have heard of the art of washing
her hands and arms. The wig, the bodice
and the real ballet shoes were coated in
wax to incorporate them into the figure.
Apart from the colouring, which has
faded, the present day appearance of the
original wax (in the collection of Mr Paul
Mellon) is superficially very close to the
bronze casts, of which twenty-three are
thought to have been made.

The 'Little Dancer Aged Fourteen' is
one of the most complete manifestations
in art of nineteenth century theories of
Realism which demanded that art should
depict modern life and particularly
aspects generally considered to be ugly or
unaesthetic. Degas has brilliantly, and
with great originality of means, created
the image of an awkward young girl, bar-
ely adolescent, her body already marked

by the pain and stress of ballet training.
Much of the chorus of criticism, not all of
it hostile, which greeted the 'Little
Dancer' focused on this: one of the most
enthusiastic critics, Nina de Villars
wrote: 'Suffering is necessary to arrive at
the airy lightness of the Sylph or the but-
terfly; what we see here is the sad reality
of the profession; the pale, sickly face is
contorted with effort . . . I experienced in
front of this statuette one of the most
violent artistic impressions of my life . . .'
The writer and critic J. K. Huysmans
most authoritatively pronounced on the
originality and significance of the 'Little
Dancer': 'The fact is that at his first

attempt M. Degas has overthrown the
traditions of sculpture just as he long ago
shook the conventions of painting . . .
Both refined and crude with its func-
tional clothes and its coloured flesh
which quivers, furrowed by the working
of the muscles, this statuette is the only
truly modern effort in sculpture that I
know of.'

J. A. M. WHISTLER 1834–1903
Nocturne in Blue and Gold: Old Battersea Bridge *c.*1872–5
Oil on canvas 679 × 508 (26¾ × 20)

This painting is one of the series of 'Nocturnes' done by Whistler in the 1870s which represent the fullest and most extreme development of the aesthetic theory of 'art for art's sake', derived from the French poets and art critics Théophile Gautier and Charles Baudelaire. As Whistler put it in his own formulation, 'Art should be independent of all claptrap – should stand alone and appeal to the artistic sense of eye or ear without confounding this with emotions entirely foreign to it . . .' The mention of the ear is significant, since the Nocturnes mark the beginning of his use of musical titles and his retrospective re-titling of earlier works. The theory of 'Correspondences', of links between the different senses, was pervasive in the mid-nineteenth century and is highly complex, but for painters like Whistler it was mainly a question of a basic analogy: just as music functioned through the effect of a pattern or arrangement of sounds which, though they may be evocative, in no way imitate any other reality, so painting could similarly function through relationships of colour, and patterns of objects whose reality has been transformed into simple, aesthetically pleasing shapes. In the twentieth century this idea was extended, in the work of Kandinsky for example, to encompass forms which were, in effect, completely abstract. Whistler was also strongly affected by Japanese art of which he was a collector and connoisseur. His work reveals particularly his assimilation of the Japanese emphasis on decorative surface pattern and their treatment of objects or figures in terms of bold, flat simplified outlines. The stylised treatment of Battersea Bridge, which was in reality much lower than it appears here, was probably based on a Japanese print of a bridge by Yeisen, a pupil of Hokusai.

Whistler took the term 'Nocturne' from the piano pieces of that title by Frederic Chopin, and used other musical terms, Symphony, Arrangement, Harmony, Variation, for other kinds of picture. The Nocturnes themselves were based on evening, or even night views of the Thames at Chelsea and Battersea where Whistler lived, and the expanse of water and sky, with buildings shrouded in mist or darkness clearly gave him precisely the vehicle he needed for the most extreme manifestation of his art. The paintings were done from memory in his studio, based on observation and some notations in black chalk on brown paper done the evening before. In his famous 'Ten O'Clock' lecture delivered in London, Cambridge and Oxford in 1885 and published in 1888, Whistler reveals something of the poetic attitude behind the Nocturnes: 'And when the evening mist clothes the riverside with poetry, as with a veil, and the poor buildings lose themselves in the dim sky, and the tall chimneys become campanili, then the warehouses are palaces in the night, and the whole city hangs in the heavens, and fairyland is before us . . .'

Whistler's intense concern that his paintings should be objects of pure aesthetic effect extended to the frame and even the signature. He designed and decorated his own frames to harmonise with the painting and adopted a pictorial signature, a highly stylised butterfly, the form and placing of which he varied according to the needs of the picture. In this case, remarkably, he has removed it from the picture altogether and placed it on the frame.

GWEN JOHN 1876–1939
Nude Girl 1909–10
Oil on canvas 445 × 279 ($17\frac{1}{2}$ × 11)

This is one of a pair of pictures of the same model painted in Paris about 1909–10. In the other ('Girl with Bare Shoulders', Museum of Modern Art, New York) the sitter is in an almost identical pose but clothed, in an off-the-shoulder dress. However, she is no longer wearing the pendant present in the nude.

Gwen John here paints a human being with an intimacy, objectivity and grasp of the physical reality of the body, unprecedented in English painting, although such qualities have surfaced since, notably in the figure painting of Stanley Spencer and Lucian Freud.

It may have helped that she appears thoroughly to have disliked the model, a young woman named Fenella Lovell whom Gwen John knew in Paris and employed on a professional basis. Gwen wrote to her friend Ursula Tyrwhitt in September 1909: 'I have not been able to paint much, only lately & I have done quite quickly the portrait of Fenella . . . I think it will be good . . . no one will want to buy her portrait do you think so? It was rather foolish of me to begin it but I meant to do others at the same time. I shall be glad when it is finished, it is a great strain doing Fenella. It is a pretty little face but she is *dreadful*'. The reference here is presumably to the clothed portrait, but Gwen clearly intended doing more than one, and in May 1910 she wrote again to Ursula complaining at length about Fenella, and adding 'Why I want to send two paintings is because I may then sell them & then I shall pay her what I owe her and never see her again'. At least one, and possibly both, paintings were exhibited at the NEAC in 1910 and the following year the nude was presented to the Contemporary Art Society who presented it to the Tate Gallery in 1917.

In 1921 Gwen John's friend Nona Watkins wrote to her after seeing the nude in the Tate: 'The little "Nude Girl" is quite exquisite in its subtle simplicity – a gem of the first water – rare in its conception, wonderfully choice in treatment – felt I must write to you after seeing what depths you can feel.'

Part of the power of this picture and its companion comes from undoubted slight elements of distortion in the painting of

the figure. This was noted by the painter Wyndham Lewis in *The Listener* in 1946: '[they] show the figure of a woman strained up . . . We are astonished by the anguished rigidity of the pose . . .' He also compared them with Francisco Goya's famous pair of portraits of the same woman clothed and naked: 'Indeed, these two pictures, like the "Maja Vestida" and the "Maja Desnuda", are the

Woman clothed and unclothed.' Lewis went further, to suggest a symbolic or allegorical meaning: 'But with the one here it is a revulsion from her nakedness – an Eve after the Fall.' This is a poetic fantasy, of course, but there is no doubt that the painting, in its unblinking realism, possibly fuelled by the artist's dislike of the sitter, is somewhat puritanical in effect.

PHILIP WILSON STEER 1860–1942
Boulogne Sands 1888–91
Oil on canvas 610 × 765 (24 × 30⅛)

Wilson Steer was the first British painter
to develop a fully fledged painting of
sparkling light and colour in the open air
Impressionist manner of Monet and his
circle. He appears to have done this
through his own study of the work of
Monet which he possibly first came
across as early as June 1883, when a
substantial group of French Impressionist
paintings was shown in London. How-
ever, in 1887 he went to Paris where it
seems likely that he was forcibly struck
by the Impressionists, since from the
moment he got back he embarked on a
series of luminous, highly coloured
paintings which he continued until
about 1894, when he adopted a more

subdued style. These pictures are all
beach or seaside scenes or maritime sub-
jects. The Tate Gallery owns an import-
ant group of them, of which 'Boulogne
Sands' is one of the most lightly and bril-
liantly executed. Steer visited Boulogne
regularly between 1888 and 1891; this
painting was exhibited at the New Eng-
lish Art Club in November 1892 and is
signed and dated 1892, but is thought to
have been completed the year before. In
'Boulogne Sands' Steer achieves classic
Impressionist vibrancy of colour and
light by putting down pure colours in
separate, lively touches and using large
amounts of white. The vibrancy of colour
also comes from Steer's use of strong
oppositions of near complementary col-
ours: the girls are arranged alternately
dressed in blue and orange-red and this
colour combination is repeated in the

background with the orange-red striped
bathing tents against the blue sky. Com-
plementary colours are those which con-
trast with each other more strongly than
with any other colour and therefore
'complete' or reinforce each other when
placed together. The three primary col-
ours and their complementaries are red-
green, blue-orange, yellow-mauve, and
each complementary is the secondary
colour made by mixing the other two
primaries. Scientific knowledge of com-
plementary colours was of immense
importance in modern painting from
Impressionism onwards.

JOHN SINGER SARGENT
1856–1925
Carnation, Lily, Lily, Rose 1885–6
Oil on canvas 1740 × 1537 (68½ × 60½)

Shortly after his arrival in England in the summer of 1885 Sargent went on a boating expedition on the Thames with the American artist Edwin Abbey. When Sargent cut his head open diving onto a hidden obstruction, Abbey took him to recuperate to the village of Broadway in the Cotswold hills, which had become a summer colony for a group of young English and American artists and writers. Sargent stayed with the painter F. D. Millet and began this picture in the garden of his house in September 1885. It was partly inspired by a garden with beds of lilies and hung with Chinese lanterns that he had seen on the Thames one evening. He continued work on the painting until early November, then took it up again the following summer and completed it sometime in October. The reason for such slow progress was that the picture was painted out of doors and work could only proceed for a short time each evening when the right kind of mauvish light was present. Sargent would place his easel and paints ready in the garden beforehand and position the models, the daughters Dorothy (on the left) and Polly, of the illustrator Frederick Barnard, who also lived in Broadway. Sargent's biographer Sir Evan Charteris reported that then, as daylight faded, the whole artist colony would accompany Sargent to the scene of his labours: 'Instantly, he took up his place at a distance from the canvas, and at a certain notation of the light ran forward over the lawn with the action of a wag-tail, planting at the same time rapid dabs of paint on the picture, and then retiring again, only with equal suddenness to repeat the wag-tail action. All this occupied but two or three minutes, the light rapidly declining, and then while he left the young ladies to remove his machinery, Sargent would join us again, so long as the twilight permitted, in a last turn at lawn tennis.'

Sargent himself wrote to his sister in 1885: 'Fearful difficult subject. Impossible brilliant colours of flowers, and lamps and brightest green lawn background.

Paints are not bright enough, and then the effect only lasts ten minutes.' In spite of the difficulties 'Carnation, Lily, Lily, Rose' is undoubtedly a triumphant success, glowing with extraordinary effects of colour and was acclaimed at the Royal Academy exhibition of 1887. An outstanding feature of the picture is the richness of its surface and Sargent's later biographer, Richard Ormond, has noted '. . . the dazzling textures of the bushes illumined by the lanterns where the surface has coruscated into fierce whorls of pigment. The sheer expressiveness and intensity of the technique are remarkable in a picture of such size and complexity.' The title comes from a popular song of the time 'The Wreath' by Joseph Mazzinghi.

European Art Around 1900

Henri Rousseau **Bouquet of Flowers**
*c.*1909–10

The French Impressionists held eight group exhibitions in Paris between 1874 and 1886. By the time of the last, certain artists, from within the original Impressionist circle or associated with it, had begun to take their painting in new directions and to create what became known as Post-Impressionism. The four chief Post-Impressionists were Paul Cézanne, Georges Seurat, Paul Gauguin and Vincent van Gogh.

Cézanne is reported to have said of Claude Monet that he was 'only an eye!' Cézanne is also reported, by his friend Emile Bernard, to have said 'I want to make of Impressionism something solid and lasting like the art of the museums'. One implication of this is that Cézanne felt that Impressionism was in some way too superficial, that it lacked the qualities of thoughtfulness, of an intellectual structure given to the artist's response to nature, that was characteristic of the greatest artists of the past. Cézanne illustrated this idea further in another of his most famous statements, again reported by Bernard, in which he referred to the most austerely intellectual of all early landscape painters, Nicholas Poussin: 'I want to re-do Poussin from nature'. Another implication of these remarks is that Cézanne felt that Impressionism had ceased to represent the solid, three-dimensional feel of things in the way that the old masters had. Cézanne's solution to these problems is discussed in relation to his 'The Gardener' which is reproduced on p.108.

Georges Seurat, like Cézanne, wanted to bring order and monumentality to modern painting, and during his student years in Paris in the late 1870s he haunted the Louvre, and also read extensively books on optics and the principles of design. His best known contribution to the development of Impressionism, however, was the application of scientific principles to colour, using the technique which he called Divisionism, often popularly and quite incorrectly referred to as 'pointillism.' His 'Le Bec du Hoc, Grandcamp' is reproduced and discussed on p.109.

Edouard Vuillard **Girl in an Interior**
*c.*1910

For Paul Gauguin Impressionism was too closely bound to the visible world and lacked the poetic and imaginative dimension: in a letter to his friend, the painter Emile Schuffenecker, he wrote, 'Don't paint too much direct from nature. Art is an abstraction. Study nature then brood on it and think more of the creation which will result.' Gauguin also felt that he could only achieve the new imaginative quality that he sought, by getting completely away from European society. He accordingly removed himself to the island of Tahiti in the South Pacific, where he painted the pictures for which he is best remembered. One of these is 'Faa Iheihe' which is reproduced and discussed on p.110.

Gauguin's sometime friend and admirer Vincent van Gogh was, in his basic approach to painting, an orthodox Impressionist; he could only work direct

Paul Gauguin **Faa Iheihe** 1898
(detail)

Odilon Redon **Profile of a Woman with a Vase of Flowers** *c.*1895–1905

from nature and when Gauguin tried to make him conform to his own theory the result was a disaster. However, Van Gogh's response to his subjects was personal and emotional in a manner and to a degree quite different from any of the other Impressionists, and in his paintings what he sees becomes transformed and intensified into something that expresses his own extraordinary feelings for it. His 'Farms near Auvers' is reproduced and discussed on p.111.

Odilon Redon began his career in the 1870s as the creator of bizarre fantasies in black and white lithography and charcoal drawing. In 1886 he met Gauguin who supported his work, as would be expected in view of Gauguin's concern for the imaginative. Contact with the Impressionists and Post-Impressionists led Redon to begin working in oils and pastel and to develop an entirely personal use of colour, vibrant but also rich, mysterious and poetic.

In their interest in imaginative subject matter and decorative effects both Redon and Gauguin belong to the broad movement known as Symbolism. Pierre Bonnard and Edouard Vuillard went through a Symbolist phase in the 1890s as members of the Nabis (Prophets) but went on to an intimate domestic art which extended one of the earlier themes of Impressionism.

By the early years of the twentieth century the next great generation of painters was gathering in Paris. Not all of them were French, for Paris had become a magnet for ambitious young artists with a vision of their own and they came from all over Europe to create what became known as the School of Paris. The undoubted leaders, the 'chefs d'école', were Henri Matisse and Pablo Picasso in painting, and in sculpture Constantin Brancusi, although Rodin, who lived until 1917, remained a dominating figure from an earlier generation. In the years before the 1914–1918 War the leaders of the School of Paris created the avant-garde movements of Fauvism and Cubism, and their work is discussed elsewhere in this book. However, before Cubism, Picasso, in his so-called 'Blue' and 'Pink' periods, created an important group of works in the Symbolist tradition. One of these, 'Girl in a Chemise' is reproduced and discussed on p.107. Among the lesser stars of the School of Paris at this time was the young Italian artist Amedeo Modigliani, who painted intense stylised portraits and sharply erotic nudes. He also made a considerable contribution to early modern sculpture with a group of carvings done before his premature death in 1920. One of these is in the Tate Gallery collection. Its elongated forms, and stylised features, inspired by second century A.D. Iberian art, show how for Modigliani, as for others of the avant-garde at this time, the primitive could be decisively modern.

From outside the traditional art world came Henri Rousseau. Known as Le Douanier, the customs man, from his one-time occupation, he was enormously admired by Picasso and others for the 'primitive', child-like intensity of his vision.

Amedeo Modigliani **Head** *c.*1911–12

PABLO PICASSO 1881–1973
Girl in a Chemise *c.*1905
Oil on canvas 725 × 609 (28⅝ × 23⅝)

Between 1901 and 1904, dividing his time between Barcelona and Paris, Picasso went through the most difficult period of his career, trying to establish himself in Paris, unable to sell his work, sometimes near to starving and, the story goes, forced at one point in the winter of 1901 to burn a pile of his drawings in order to keep warm. The paintings of this period are pervaded by the colour blue and their subjects dwell on poverty and sadness. In 1904 Picasso finally settled for good in Paris, moving into the now celebrated ramshackle tenement building in Montmartre known to the mixture of poverty-stricken clerks, laundresses, actors, writers and artists who lived in it as the 'bateau-lavoir' – the floating laundry. Here he formed a relationship with Fernande Olivier and they remained lovers until 1911. He began to be able to sell some work again and although he remained poor he no longer starved. The all-pervading blue of the previous years began to give way to pink, and his subject matter began to be drawn predominantly from the world of the circus. An element of pathos remained but the extreme gloom of the blue period was gone. 'Girl in a Chemise' seems to belong to the beginning of this pink, or rose, period. The same model appears in several other works of 1905, notably 'The Harlequin's Family', where she appears with a child as the circus performer's wife. In another painting she is seen feeding a baby. Oil paintings by Picasso are relatively rare from this period when he worked mostly in gouache (opaque watercolour), drawing and etching. Typically, it is thinly painted.

Picasso's figure drawing at this time was linear and stylised in a manner partly influenced by El Greco; the body of the young woman appears unnaturally elongated, and this, together with the thin washes of paint and the delicate colour harmony of pink and blue creates an ethereal, spiritualised effect.

PAUL CEZANNE 1839–1906
The Gardener *c.*1906
Oil on canvas 654 × 549 ($25\frac{3}{4} × 21\frac{5}{8}$)

A portrait of Vallier, the gardener and odd-job man at Cézanne's house near Aix-en-Provence. It is one of a group of six paintings for which Vallier was the model and was probably painted in the summer and autumn of 1906, just before Cézanne's death in October that year. It is a very complete expression of Cézanne's mature style, in which, it may be said, he achieved his aim of 'making of Impressionism something solid and lasting like the art of the museums'.

Cézanne's approach to reforming Impressionism was to take to obsessional extremes the basic Impressionist procedure of painting direct from the motif (the view or object being painted), scrutinising every part of it in turn with concentrated attention and rendering it on the canvas in its exact tone, by which he meant both the shade of colour and the degree of its luminosity. 'Penetrate what is before you, and express yourself as logically as possible', he wrote to Emile Bernard. Each tone would be put down in a distinct brushstroke separate from but overlapping its neighbours. This procedure can be seen in the right shoulder of 'The Gardener', for example, which is built up from three overlapping curved brushstrokes of three different tones of blue, the gradations of tone indicating the fall of light over the curved form of the shoulder. Cézanne's way of building the effect of solid form with shaped and graded patches of colour can also be seen very well in the treatment of the knee and thigh, where the knee is modelled in flat chunky patches and then a broad patch, slightly tapering in perspective, runs backwards marking the line of the thigh on its outer curve, its nearest point to the artist. This piece of painting can be related to Cézanne's famous statement, in a letter to Bernard, '. . . treat nature by the cylinder, the sphere, the cone, everything in proper perspective so that each side of an object or plane is directed towards a central point.' The 'cylinder, the sphere, the cone' may refer to objects used for drawing exercises in nineteenth-century art academies.

The right foot of Vallier is interesting in a further way. The foot is, in fact, the nearest to the painter of all the parts of the model and its perspective recession from toe to heel can clearly be seen. But Cézanne has also exaggerated its size to make it appear nearer to us. Of course, he did not see it this way, since where the brain is familiar with the normal size of an object it makes an automatic correction and a familiar object close to is seen as being normal in size, but near. Cézanne is here deliberately seeing in 'uncorrected perspective' as a novel means of creating a sense of space.

At the same time Cézanne was also concerned to create an overall unity and harmony of all the elements in his paintings. He achieved this by the overlapping of brush strokes to link them together, and by the device of *passage* with which he linked the edges of objects to their surroundings and background. In 'The Gardener' *passage* can be seen particularly well in the area of the model's right hip, where Cézanne has repeated the outline of the hip until it blends into the area of bluish grey shadow behind. These repeated outlines suggest that Cézanne was slightly shifting his point of view, and so seeing the model in a different relationship to the background. This characteristic of Cézanne's late paintings, together with their highly structured yet highly unified quality, had a great impact on Picasso when Cézanne's works were exhibited in Paris, in the years just before and after his death in 1906. Paintings such as 'The Gardener' are direct forerunners of Cubism.

GEORGES SEURAT 1859–1891
Le Bec du Hoc, Grandcamp 1885
Oil on canvas 648 × 816 (25½ × 32⅛)

Le Bec du Hoc is a geological feature on the Normandy coast at Grandcamp, where Seurat spent the summer painting in 1885.

In his statement of theory of 1890, Seurat said: 'the means for expression is the optic mixture of tones and colours.' Optical mixture meant placing the components required to mix any given colour separately on the canvas so that at a certain distance they would mix in the spectator's eye. Coloured light mixes up towards white (white light is the mixture of all the colours of the spectrum) whereas the mixture of pigments on the palette goes down to grey. Optical mixture gives Divisionist paintings their

characteristic intense blond luminosity. At the head of his statement of theory Seurat wrote, 'Aesthetic: Art is Harmony' and, further on, 'Harmony is the analogy of contraries'. In colour, Seurat said, these contraries were; 'complementaries, that is a certain red opposed to its complementary, etc. red-green, orange-blue, yellow-violet . . .' This aspect of the theory accounts for one of the most notable features of Seurat's paintings, the way in which colours are accompanied by their complementaries. This can be seen particularly clearly in 'Le Bec du Hoc' in the birds in the sky, which are basically blue but covered in dots of orange. Equally striking is the border painted by Seurat all round the edge of the canvas (the colours on the frame are not by him). In the foreground, where there is green grass, the border is seeded

with a predominance of red but where it edges the blue of the sky it becomes predominantly orange. These complementaries harmonise – they complete each other – but they also react with each other to give the painting vibrancy and life.

Seurat's method was immensely laborious and his paintings are elaborately wrought objects. But he always began by making pure Impressionist studies on the spot, and as is the case with Cézanne, Seurat's paintings powerfully convey the feeling of human intelligence shaping the immediate responses of the artist to nature into the enduring forms of art. This effect is particularly heightened in Seurat by the strongly sculptural quality of his forms.

PAUL GAUGUIN 1848–1903
Faa Iheihe 1898
Oil on canvas 540 × 1695 (21¼ × 66¾)

In a letter to the Swedish playwright
August Strindberg, who had criticised his
work, Gauguin wrote: 'Civilisation is
what you are suffering from; to me bar-
barism is a rejuvenation'. Further on he
spoke of ' . . . the Eve of my choice,
which I have painted in the forms and
colours of another world. This world . . .
will be a paradise of which I alone have
made the rough draft'.

Gauguin was enough of an Impressio-
nist to need the stimulus of some aspect
of the natural world to enable him to
realise in paint his vision of a primitive
paradise, and his search took him
initially to the most unspoilt part of
France, Brittany, which he first visited in
1886. His view of Le Pouldu in Brittany,
showing Breton peasants at work in the
fields, is in the Tate Gallery collection. In
1887 he went to Panama and Martini-
que, then, after returning to Brittany for
a few years, in 1891 he went to the
South Pacific Islands where he spent
most of the rest of his life, largely on the
island of Tahiti. 'Faa Iheihe' is a marvel-
lous example of Gauguin's rich and
decorative mature style, in which he
finally and triumphantly succeeded in
creating a consistent series of images of
his personal paradise, peopled by 'the Eve
of my choice'. 'Faa Iheihe' presents a
vision of beautiful people living in har-
mony with each other and with both the
animal and vegetable kingdoms of the
Earth.

A key element in the paradise is a sim-
ple religion and the figure in the centre
appears to be a goddess or priestess
making a ritual gesture. Gauguin in fact
derived this figure from decorations on a
Javanese temple, photographs of which
were found in his hut at the time of his
death. The whole composition is frieze-
like and decorative, and Gauguin's con-
cern for decorative effect is also evident
in the ornate panel in which he has placed
the title, his signature, and the date.

The title is Tahitian and its meaning
has been the subject of scholarly debate
since there is apparently no word of this
precise spelling in Tahitian. The view of
Bengt Danielsson, now accepted, is that
Gauguin mistranslated the word
fa'ai'ei'e, mistaking the glottal stops for
h-sounds. The meaning is *To beautify,
adorn, embellish* in the sense of someone
beautifying themselves for a special
occasion.

VINCENT VAN GOGH 1853–1890
Farms near Auvers 1890
Oil on canvas 502 × 1003 (19¾ × 39½)

A view at Auvers-sur-Oise, the small town just north of Paris where Van Gogh spent the last few months of his life from mid-May 1890, when he left the asylum at St Remy, to his death on 29 July. At the beginning of June, Van Gogh wrote to his sister: 'there are some roofs of mossy thatch here which are superb and of which I shall certainly make something'. This picture was probably painted soon after.

Painted direct from the motif, it shows how, through the process of painting, Van Gogh transformed what he saw into something intensely personal, expressing in visual form his responses to what he saw about him. The outline of the roofs of the farm buildings and of the hills, the trunks of the trees and the outline of their foliage, are all given a dynamic bounding quality that expresses great vitality. So too does the brushwork, slashes, commas and hooks of paint, that fills the outlines.

This scene appears untroubled, but a few weeks later on, 9 July 1890, Van Gogh wrote to his brother Theo describing some more recent paintings: 'they are vast stretches of corn under troubled skies and I did not need to go out of my way to try to express sadness and the extreme of loneliness'. On 27 July he wrote again: '. . . in my own work I am risking my life and half of my reason has already been lost in it'. This letter was never finished or posted. That day Van Gogh took his equipment and went out into the fields to paint as usual. He also took with him a revolver with which he shot himself. The wound was not immediately fatal; he managed to crawl home and died two days later. He had sold only one painting in his lifetime, to a fellow artist a few months before his death.

The European Avant-Garde 1905–25

André Derain **The Pool of London** 1906

Gino Severini **Suburban Train Arriving in Paris** 1915

In 1905 Henri Matisse, André Derain and a number of their friends exhibited a group of paintings at the Autumn Salon in Paris. Their strongly coloured, freely handled work created a sensation, and in his review of the exhibition the critic Louis Vauxcelles referred to an 'orgy of pure colours' and compared them to wild animals – *fauves*. The name stuck and although the Fauves exhibited together only for a few years they introduced a new concept of colour to painting and Matisse himself went on to become the most profoundly influential modern painter beside Picasso. Derain's 'The Pool of London', painted on the spot on a visit to England in 1906, is a characteristic example of the way in which the Fauve painter exaggerates from what he is seeing to produce heightened and vivid effects based on bold contrasts of complementary colour. Fauve procedures and theory are discussed in more detail in relation to Matisse's 'Portrait of Derain' which is reproduced on p.116.

It was also Louis Vauxcelles who gave Cubism its name. In the summer of 1908 Georges Braque, influenced by innovations in the work of Picasso, produced a group of paintings at L'Estaque, near Marseilles. When they were exhibited that November at Daniel Henri Kahnweiler's gallery in Paris, Vauxcelles wrote that in them Braque had reduced 'everything, sites, figures and houses to geometric outlines, to cubes'. Cubist paintings by Picasso and Braque are reproduced and discussed on pp.118 and 119. Cubism rapidly attracted followers. One of the first of these was Picasso's fellow Spaniard, Juan Gris who developed a cool restrained style of his own.

Beyond its immediate imitators, the Cubism of Picasso and Braque had profound effects on the development of modern art. It offered painters and sculptors completely new possibilities in the representation and treatment of reality, and suggested to some artists the possibility of complete abstraction.

All the members of the European avant-garde in the early twentieth century were concerned with a renewal and revitalisation of existing traditions of art. But in Italy the oppressive weight of the past was felt with particular force and produced an explosive reaction in the form of Futurism, launched by the poet Filippo Tommaso Marinetti in a *Manifesto of Futurism* published on the front page of the Paris newspaper *Le Figaro* on 20 February 1909.

The Futurist message was twofold: first, there must be a new art for the new century, which must express what Marinetti saw as the central characteristic of modern civilisation, the energy or dynamism of the machine and other aspects of the modern environment. This first aim was expressed in the *Manifesto* in the famous and much quoted words 'We declare that the world's splendour has been enriched by a new beauty, the beauty of speed. A racing motor car, its frame adorned by great pipes, like snakes with explosive breath. . . . a roaring

Henri Matisse **André Derain** 1905 (detail)

Giacomo Balla **Abstract Speed – the Car has Passed** 1913

motor car which looks as though running on shrapnel is more beautiful than the "Victory of Samothrace,"' a reference to the celebrated second-century B.C. Greek sculpture in the Louvre. The second main thrust of the *Manifesto of Futurism* was an active attack on the art of the past: 'It is in Italy that we hurl this overflowing and inflammatory declaration with which we today found Futurism, for we will free Italy from her innumerable museums which cover her with countless cemeteries. . . . set fire to the shelves of the libraries! Deviate the course of canals to flood the cellars of the museums. Oh! may the glorious canvases drift helplessly! Seize pickaxes and hammers! Sap the foundations of venerable cities!'

The fragmented treatment of reality developed by the Cubists proved to be a useful device for the Futurists, who adapted it as a means of expressing movement and the dynamism of the modern world, as for example in Gino Severini's 'Suburban Train Arriving in Paris', which can be related to the passage in the *Manifesto* singing the praises of '. . . northern capital cities . . . of the greedy stations swallowing smoking snakes . . . of broad chested loco-motives prancing on the rails, like huge steel horses bridled with long tubes . . .'. Giacomo Balla's 'Abstract Speed – the Car has Passed' of 1913 is one of the outstanding interpretations of the Futurist fascination with racing cars and succeeds in conveying the sensation of speed through purely visual means. The painter and sculptor Umberto Boccioni was perhaps the most gifted of the Futurists and was killed during the First World War. His sculpture 'Unique Forms of Continuity in Space' is reproduced and discussed on p. 115.

Robert Delaunay blended Post-Impressionist colour with elements of Cubism and Futurism to create an art of vibrant colour which because of its degree of abstraction, was named Orphic Cubism by the poet and critic Guillaume Apollinaire, the reference being to the musician Orpheus of Greek myth and the idea of the analogy of painting and music (see also p. 100). His 'Windows Open Simultaneously' is based on a postcard of the Eiffel Tower whose shape can just be made out in the centre of the painting.

After 1900 Pierre Bonnard belonged to no group, but quietly went his own way, evolving a personal language in which to express the sensuous realities of his daily life. His 'The Bath' is reproduced and discussed on p. 117.

Robert Delaunay **Windows Open Simultaneously (First part, Third motif)** 1912

UMBERTO BOCCIONI 1882–1916
Unique Forms of Continuity in Space
1913
Bronze 1140 × 840 × 370
($44\frac{7}{8} \times 33\frac{1}{8} \times 14\frac{1}{2}$) excluding flat part and base

Umberto Boccioni made a distinguished contribution to Futurist painting, then in 1912 he turned to sculpture, impatient with the way it was lagging behind modern developments. He formed a Futurist theory of sculpture, publishing the *Technical Manifesto of Futurist Sculpture* in 1912 and *The Plastic Foundations of Futurist Sculpture and Painting* in 1913. His aim was to make sculpture which would represent the dynamism of modern man, in motion in the modern world. 'Unique Forms of Continuity in Space' is the fourth of a series of striding figures, the other three now lost, in which Boccioni worked out his aim. The titles of the others are highly evocative: 'Synthesis of Human Dynamism', 'Spiral Expansion of Muscles in Movement', and 'Muscles in Speed.' Surviving photographs of them show how Boccioni worked out a series of variations of flowing forms which he developed to express movement. These forms were derived partly from the blurring effect seen in photographs of objects moving at speed, but mostly from the effects of overlapping and extended images seen in the chronophotographs of the pioneer photographer Etienne-Jules Marey, who used a single plate to record successive phases of a movement. Boccioni also wanted to express the way in which objects in motion interrelate with their surroundings as they pass, which he saw as an interpenetration of background elements cutting across the moving figure or vice versa. In his *Technical Manifesto* he wrote 'We proclaim the ABSOLUTE AND COMPLETE ABOLITION OF DEFINITE LINES AND CLOSED SCULPTURES, WE BREAK OPEN THE FIGURE AND ENCLOSE IT IN THE ENVIRONMENT.' 'Unique Forms of Continuity in Space' is the last of the series and, in the words of the art historian John Golding, '. . . . blindingly simple and totally successful'. He also points out that by placing the figure on small blocks Boccioni forces on us 'an awareness of the full span of the figure's giant stride. . . . there is a sense of weightlessness and the sense of speed is now euphoric and heady . . . The bulging

muscles, half metal, half flame, are pulled back to reveal the trajectory of earlier phases of motion.' It has also been suggested, by the art historian Marianne Martin, that the figure can be associated with the vision of Marinetti (the founder of Futurism) of a mechanical superman 'built to withstand omnipresent speed. He will be endowed with unexpected organs adapted to the exigencies of continous shocks. . . .' One of these organs was 'a prow-like development of the projection of the breastbone which will increase in size as the future man becomes a better flyer'. This sounds very like the curved, cruciform projection jutting out from the head of 'Unique Forms of Continuity in Space'.

HENRI MATISSE 1869–1954
André Derain 1905
Oil on canvas 395 × 290 ($15\frac{1}{2} \times 11\frac{3}{8}$)

A portrait of Matisse's friend and fellow Fauve painter André Derain, done at Collioure in the South of France in the summer of 1905. Derain's portrait of Matisse painted at the same time is also in the Tate Gallery and the pair is one of the most notable features of the twentieth-century collection.

The old port at Collioure is still a popular place for painters, who set up their easels in the shade of the dense green foliage of a row of very large, old plane trees and look out at the brilliant view of Mediterranean sun, sea and sky.

Matisse seems to have painted Derain with full sunlight striking his face and casting a heavy shadow down the right cheek. In addition to the sunlight Matisse has brought in two other predominant colours of the scene, blue and green. What has then taken place is a process of adjustment to produce an effect of maximum intensity recreating what Matisse called his 'sensation'. But the effect must also, of course, be balanced and harmonious. In his *A Painter's Notes* published in *La Grande Revue* in 1908 Matisse wrote: 'If upon a white canvas I set down some sensations of blue, of green, of red. . . . it is necessary that the various marks I use be balanced so that they do not destroy each other. . . . From the relationships I have found in all the tones, there must result a living harmony of colours, a harmony analogous to that of a musical composition'.

This is interesting not least for its restatement of the aim of a musical aesthetic for painting. Matisse's 'living harmony' is based on Seurat's discovery of the dynamic but balanced relationship between complementary colours, and in the portrait of Derain all the adjustments that Matisse has made to perceived reality have been in order to create complementary combinations. The sunlit orange-yellow side of the face is against the blue part of the background. Against the green area Matisse has adjusted the colour of Derain's beret up to a strong red and to complement that on the other side has, entirely arbitrarily, rendered the hair as green. For consistency in his colour scheme, he has gone on to give Derain green eyes and a green moustache as

well. The shadow is green where Matisse has assumed reflected colour from the background, but in the twilight zone between the shadow and the full light the true colour of the shadow, blue, appears, and on the cheekbone it is placed against a broad stroke of complementary orange. The discovery that shadows are coloured and that they are the complementary colour of the light that casts them (orange or yellow sunlight = blue or mauve shadow) was of great importance to the Impressionists, Post-Impressionists and Fauves in their development of an art of pure colour.

PIERRE BONNARD 1867–1947
The Bath 1925
Oil on canvas 860 × 1206 ($33\frac{7}{8}$ × $47\frac{1}{2}$)

This is one of the particularly fine group of works by Bonnard in the collection of the Tate Gallery. Bonnard began his career as a member of the Symbolist group, the Nabis (from the Hebrew word for prophet) in Paris in the 1890s. His work then was strongly influenced by Japanese prints, highly decorative, and included some of the greatest *art nouveau* posters from the poster boom of that time. In the early years of the twentieth century he painted in a relatively sombre palette, often erotic subjects, but after the First World War he began a new phase in which his sensuous response to the world, including the female body, was reworked in terms of a highly individual sense of colour combined with an equally personal approach to composition. Mainly between 1925 and 1941 Bonnard painted a series of canvases of a

woman bathing which are among his most memorable works. The model for all of them was almost certainly his wife Marthe. In this one Bonnard has cut off the bath at both ends and exploited the structure of the wall behind to create a strongly geometric, but not too regular, composition whose rigour balances the extreme sensuousness of the extraordinary pearlescent colours in which he has rendered the nude body lying beneath the water. He has also exploited the white enamel of the bath both to reflect light onto the body and to reflect back the play of colour and light from the water. He has adjusted the viewpoint so that the edge of the bath, the body, the side of the bath and the wall, form a sequence of parallel areas which unify the surface of the canvas.

Bonnard did not paint direct from the model, preferring to work alone and from memory, since he held that too much contact with the original object would destroy his initial vision of it and would

prevent him from creating a truly independent work of art. He wrote: 'It is attraction which determines the choice of motif . . . if this attraction, this primary conception fades away the painter becomes dominated solely by the motif, the object before him. From that moment he ceases to create his own painting.' It was perhaps this attitude which enabled Bonnard in works like this to achieve such a perfect balance between the painting as an aesthetic structure of pattern and colour, and as an evocation of the sensuous reality of the object which had originally moved him.

PABLO PICASSO 1881–1973
Seated Nude 1909–10
Oil on canvas 921 × 730 ($36\frac{1}{4}$ × $28\frac{3}{4}$)

Cubism was chiefly created by Pablo
Picasso and Georges Braque between
1908 and 1913 and developed further by
them until at least 1921. Picasso and
Braque were joined in 1912 by Juan Gris.
It was Gris who in 1925 wrote that, at
the start, Cubism was 'simply a new way
of representing the world' and one way of
approaching Cubism is to look at in terms
of a game played with the conventions of
representation in painting. The principal
convention that Cubism overturned was
that which states that everything in a
painting must be seen from a single fixed
viewpoint. This was the basis of Renais-
sance perspective, which enabled the
creation on a flat surface of the illusion of
space and solid form. In 1907 Braque did
a drawing showing the same figure
drawn from the front, the back and the
side, and in 1908 in an interview he said
that it was 'necessary to draw three
figures in order to portray every physical
aspect of a woman just as a house must
be drawn in plan, elevation and section.'
Cubism began to develop its typical
faceted, fragmented structure when these
extra aspects were grafted on to a main
view of the motif. This effect quickly led
Picasso and Braque to extend the game
by freely distributing the component
parts of the motif. 'A face' said Picasso,
'consists of eyes, nose, ears, etc. You can
put them anywhere in the picture, the
face remains a face'. Something of this
extreme fragmentation can be seen in
Braque's 'Clarinet and Bottle of Rum on a
Mantlepiece' (p.119). In 'Seated Nude'
the model is still very recognisable,
indeed she is a powerful if somewhat
mechanical presence. However, her neck
appears to be hollow and Picasso has also
simply left out, or put elsewhere in the
picture, a substantial wedge-shaped piece
of her left shoulder.

An earlier stage of this process of shift-
ing viewpoints and faceting of the image
can be seen in Picasso's 'Bust of a

Woman' of about a year before, where
the process of fragmentation has hardly
begun. The head in this painting also
reveals his interest in the structure of
West African tribal masks. Particularly
since they are, by coincidence, of vir-
tually the same motif, these two paint-
ings in the Tate Gallery collection form
an interesting document of Picasso's evo-
lution at this formative time in the deve-
lopment of Cubism.

GEORGES BRAQUE 1882–1963
**Clarinet and Bottle of Rum on a
Mantlepiece** 1911
Oil on canvas 81 × 60 (31⅞ × 23⅝)

This is a major work from the high point of early Cubism when Picasso and Braque had evolved a new pictorial language in which reality is evoked and alluded to in a playful and poetic way, from within a painterly structure of great subtlety and beauty. It is one of many Cubist pictures which refer to music, including Braque's 'Mandola' (a type of lute) in the Tate Gallery collection. These references certainly relate to the theory of the analogy of painting and music that goes back through the early history of modern painting to Whistler and beyond, but also reflects the Cubist painters' delight in music and in the beauty of musical instruments.

The clarinet can be seen placed horizontally just above the centre of the picture although its centre section is hidden by the lower part of the bottle of rum, identified from the first three letters of the French word for rum where its label would be. The relationship of the barrel of the clarinet to its flared end is a perfect example of a Cubist shift of view point, for much more of it is seen than if both had been painted from the same position. The clarinet appears again, this time seen at a steep angle running diagonally down to the left from the region of the bottom of the bottle. Similarly, the shoulder of the bottle is shown stepped-out in three different positions. Next to it is one of Braque's famous Cubist jokes, a nail, of the kind used for hanging pictures, painted illusionistically, with its shadow, reminding us that this is a game with the art of painting and that reality is the plaything.

An important innovation in this game was the introduction of words to stand for things. Here the word 'Valse' (waltz) appears, introducing the idea of dancing to accompany the music, which is evoked not only by the clarinet but by the suggestions of musical notation, treble and bass clefs, which also appear: there is a bass clef just below the V of 'Valse'. The form in the lower right-hand corner of the canvas is a corbel or bracket, supporting the mantlepiece but it also suggests the scrolling end of instruments of the violin family. It is evidently twisted in space and again the artist's viewpoint

has shifted from one end to the other. The mantlepiece itself may be represented by the two strong parallel lines running diagonally across the canvas but it may be indicated again, this time in receding perspective, by a combination of the left-hand diagonal and a lighter diagonal running up from the lower right part of the picture.

Although the elements of reality in a composition such as this appear only in fragmented form, and often are indicated only in the most allusive way, the thought and attention required for a successful reading of the painting brings a heightened awareness of the realities depicted.

In purely aesthetic terms the fragmented structure of overlapping and interwoven elements, together with the narrow range of delicate, low-key, greys, beiges and sandy-yellows, typical of Cubism at this time, create an intense harmony and unity of effect. The beauty of both colour and paint texture are particularly notable in this work by Braque.

Expressionism

Karl Schmidt-Rottluff **Dr Rosa Schapire** 1919

In 1905 four young German artists living in Dresden, Ernst Ludwig Kirchner, Erich Heckel, Karl Schmidt-Rottluff and Fritz Bleyl, formed a group which they called 'Die Brücke' – The Bridge. The following year they were joined by two others, Emil Nolde and Max Pechstein. The art they developed became known as Expressionism, a term which has come to refer to almost any art showing a marked degree of distortion of naturalistic form and colour for the sake of expressive effect. However, the particular meaning of Expressionism for Northern European artists was well summed up by the Norwegian painter Edvard Munch, one of the great independent figures of Expressionism, and one of its forerunners, who in 1889 wrote 'No longer should you paint interiors with men reading and women sitting. There must be living beings who breathe and feel and love and suffer.' Munch's 'The Sick Child' perfectly illustrates this dictum and is reproduced and discussed on p.122. The undoubted leader of the Brücke group was Kirchner whose large 'Bathers at Moritzburg' is reproduced and discussed on p.123.

Of the other Brücke painters, the Tate Gallery owns a strong group of works by Schmidt-Rottluff thanks to the generosity of one of the Brücke's early supporters, Dr Rosa Schapire, whose portrait by him combines strong non-naturalistic colour with characteristically Expressionist angularity of form, to vivid effect. The Expressionists, like Gauguin, looked to non-European society and art for an untramelled and forceful expression of basic human impulses such as religion and procreation. Schmidt-Rottluff's 'Two Women' echoes Gauguin's vision of archetypal women naked in a natural paradise, and his carved wooden 'Head' is a splendid fertility object. Clearly phallic seen from the front, it was originally painted red.

Emil Nolde was only briefly a member of the Brücke group, leaving in 1907 to work independently. His 'The Sea B', one of a series of six views of the North Sea done on the island of Sylt in 1910, is a marvellous example of his use of rich colour and texture to produce effects of almost visionary intensity. Ernst Barlach was a leading Expressionist sculptor whose 'The Avenger', made at the end of 1914, may be connected with the outbreak of the First World War. Barlach also called it 'the berserk man'. George Grosz and Max Beckmann are two major independent figures in German twentieth-century art. For both of them the First World War was a crucial experience and for Beckmann in particular, it was a turning point. Grosz's 'Suicide' and Beckmann's 'Carnival' are reproduced and discussed on pp.124 and 125. Expressionism developed strongly in Vienna where Oskar Kokoschka emerged as a leading figure about 1910–15 and subsequently pursued a long and fruitful career. His late self-portrait 'Time, Gentlemen, Please' is reproduced and discussed on p.200.

Emil Nolde **The Sea B** 1930

◁ Edvard Munch **The Sick Child** 1907 (detail)

EDVARD MUNCH 1863–1944
The Sick Child 1907
Oil on canvas 1185 × 1210 (46 × 47)

Munch's treatment of colour, form and brushwork in this painting is quintessentially Expressionist. The colour scheme is dominated by the relationship of a range of sea-greens with a hot orange-red, which Munch has even used for his signature. It may be suggested that the greens and reds themselves evoke the queasiness and fever of illness and the effect of the colour scheme is intensified by the fact that these colours are complementaries whose dynamic effect in combination, of simultaneous contrast and affinity, is here being exploited for emotional as well as aesthetic effect. The girl's face glows, almost as if from within, with a pale yellow light of fever. In fact, this almost unearthly light, which is also reflected strongly from the bedhead to form a stark background to the two heads, must come from the window just visible at the right edge of the canvas. The very dark dress of the woman forms an area of strong contrast which acts as a foil, intensifying perception of the rest of the picture. Its funereal blue-black reinforces the feeling of grief which Munch has stated with great economy of means simply through the woman's bowed silhouette. The brushwork is rapid and agitated. This painting is the fourth of six versions in oil that Munch made of this subject, the first dating from 1885–86. Munch later wrote 'In the sick child I opened for myself a new path – it was a breakthrough in my art. Most of what I have done since had its birth in this picture'.

What is understood of the inspiration of 'The Sick Child' is extremely interesting. It appears to have some reference to the death from tuberculosis in 1877, at the age of fifteen, of Munch's elder sister Johanne Sophie. This theory is supported by the identification of the woman by the bed as Munch's aunt, Karen Bjølstad,

who looked after the children after their mother died. However, the immediate inspiration for the painting, in 1885, came when Munch accompanied his father, who was a doctor, on a visit to a boy of five who had broken his leg. The boy's sister Betzy was sitting in the sickroom broken down with grief at the pain the boy was experiencing. Munch appears to have been forcibly struck with this and asked permission to paint Betzy. She then became the sick child and the image of her grief was transferred to the attendant aunt. It seems that Munch used the immediate experience of the episode of the visit to evoke and paint the much more deeply personal trauma of his sister's death eight years previously.

ERNST LUDWIG KIRCHNER
1880–1938
Bathers at Moritzburg 1909–26
Oil on canvas 1510 × 1997 (59½ × 78⅝)

In the first years of the Brücke group's existence its members painted in their studios in Dresden, from imagination or the model. But from 1907 they began to spend time regularly painting in the countryside, both as a group and on their own. This development is of particular significance in the light of the cult of nature which was growing in Germany at this time, manifesting itself through the Wandervögel, a national organisation which encouraged communal hikes and camping, and the nudist movement. This almost mystical new relationship with nature seems to have been epitomised for the Brücke artists by being naked in the landscape, and figure compositions such as this one form an

important part of early Brücke painting. It arose from visits made by Kirchner and other members of the group, together with various female friends and models, to the Moritzburg lakes near Dresden. There, nude bathing and a relaxed communal lifestyle provided the subject matter for several paintings and drawings by Kirchner, of which this is the largest. Overall, 'Bathers at Moritzburg' is clearly related to the type of vision of a primitive paradise developed by Gauguin in the South Seas. However, the Brücke artists were not much interested in the timeless and exotic and Kirchner's picture has a clearly contemporary feel.

Kirchner repainted parts of the picture in 1926, the main effect of which, apart from some alterations and additions to the figures, was to make the colours lighter and more uniform in application. They still, however, have a typical Expressionist vibrancy and even harsh-

ness which, taken with the general atmosphere of sexual frankness and, for example, the uninhibited posture of the woman squatting by the lakeside, make this a painting of considerable force.

The male figure on the left, with one hand on the tree, appears to be a slightly detached observer of the group, and is at the focal point of the two lines of figures running from the water up to the tree and across the foreground. According to the Kirchner authority Dr Lucius Grisebach, 'It's certainly possible to recognise the artist in the figure, not really in the sense of a portrait but as a link between the spectator and the motif itself.' The frame was almost certainly designed by Kirchner and is of a type he consistently used, made of flat wood painted in bronze colours usually with a green tone.

GEORGE GROSZ 1893–1959
Suicide 1916
Oil on canvas 1000 × 776 (39⅜ × 30½)

George Grosz was born in Berlin and
trained there and in Dresden and Paris.
He began painting in 1911 but is best
known for his savagely satirical drawings
of German society. Even before the First
World War his work is infused with what
he later described as his 'profound disgust
for life' and his experience of the war
enormously intensified this feeling. He
was drafted into the German army in
1914 and his loathing for the system led
to his being court-martialled for insulting
the army and blasphemy. He apparently
came close to being shot. When he was
invalided out of the army in 1915 he put
his feelings into his art. Bitterly opposed
to the war, he drew and painted drun-
kards, sadistic murderers, prostitutes,
war cripples and suicides. In his auto-
biography, Grosz recounts that at this
time in his studio in Berlin 'I lived in a
world of my own. My drawings expressed
my despair, hate and disillusionment. I
had utter contempt for mankind in
general.' In the light of this it is not sur-
prising to find him dwelling on the sub-
ject of suicide.

'Suicide' is a powerful and extra-
ordinary compendium of many of Grosz's
themes of this period. In addition to the
principal figure, another body hangs
from a lamppost, a criminal runs out of
the picture to the right, while scavenging
dogs prowl the streets. In the right back-
ground is a tableau of one of Grosz's
favourite targets, the corrupt relationship
of the bloated businessman and the pros-
titute. Finally, highlighted in the extreme
background, the Church presides sere-
nely over this world of death and decay.
Grosz makes telling use of a sinister
Expressionist colour scheme of intense
red and green, and the face of the suicide
is already showing the skull beneath.
Beside him hovers a ghostly face which
might represent his soul or his living self.

MAX BECKMANN 1884–1950
Carnival 1920
Oil on canvas 1862 × 918 ($73\frac{5}{16}$ × $36\frac{1}{16}$)

'Carnival' was painted in 1920 in Frankfurt am Main, where five years previously Beckmann had gone to recover from his harrowing experiences as a hospital orderly on the Belgian front during the First World War. He served first in a typhus hospital and then in an emergency field dressing station. The horrors that he saw, and sketched, eventually caused him to break down and he was discharged in the summer of 1915. After this his painting took on a harsh realism of style in which he created a complex and mysterious symbolism to express his tragic view of human nature.

The German title of 'Carnival' is 'Fastnacht' which refers to the climax of the Carnival season of fancy dress parties, masked balls and street processions with wild music and dancing, which take place in Catholic countries between mid-January and the beginning of Lent on Ash Wednesday. Fastnacht thus traditionally symbolises the vanity and futility and transience of the world. The fact that this carnival scene is taking place indoors may be related to the fact that in 1920 the Frankfurt police banned all public festivities on grounds of extravagance.

The standing figures are portraits of two important people in Beckmann's life. The woman is Fridel Battenburg, wife of his friend the painter Ugi Battenburg, who had taken him in and looked after him for four years after his discharge from the army. The man is I. B. Neumann, an art dealer who was one of the first to realise the significance of Beckmann's new post-war style and the only dealer prepared to exhibit it before 1919. Their relationship was one of close mutual emotional and intellectual support. The image of these two people in the painting reflects Beckmann's affection for them. The figure on the floor has been identified as Beckmann himself disguised as a clown in a monkey mask and wielding a trumpet with his bare feet. Beckmann seems to be using the image of the Clown or Fool to represent the madness of the world and in very general terms this image of carnival may be a metaphor for the world as a madhouse.

Modernism in Britain 1905–1920

Spencer Gore **The Cinder Path** 1912

Charles Ginner **Piccadilly Circus**
1912

David Bomberg **In the Hold**
c.1913–14 (detail)

In 1897 Sickert, who had been a leader of the avant-garde in England, removed himself to France where he lived until 1905. On his return to London he again became active in the propagation of modern art and in 1907 founded the Fitzroy Street Group, an exhibiting society with premises at 19 Fitzroy Street where Sickert had a studio at No. 8. He also rented living accommodation at 6 Mornington Crescent in Camden Town, a seedy area to the north of Fitzroy Street where he had lived before leaving for France, drawing inspiration from its music hall, the Old Bedford. Here he found stimulus for his sombre paintings of realist subjects. One of the most famous of these is his large canvas 'Ennui' (Boredom) of 1914, but in the early period of his return to Camden Town he painted an extraordinary series of nudes which are among the most memorable of all his works. One of these 'La Hollandaise' is reproduced and discussed on p.130. In 1911 Sickert reconstituted the Fitzroy Street Group, which had been a success, as the Camden Town Group, a move which coincided with the sudden emergence in London of a vigorous avant-garde, which by the outbreak of war in 1914 represented all the major modern movements, from Post-Impressionism through Fauvism, Expressionism, Cubism, Futurism and even pure abstract art. A crucial catalyst in bringing about this situation was undoubtedly the two exhibitions of modern French art organised in London by the critic and painter, Roger Fry. The first was *Manet and the Post-Impressionists* at the Grafton Galleries from November 1910 to January 1911, which, beside work by Manet, included twenty-one Cézannes, thirty-seven Gauguins, twenty Van Goghs and works by Matisse and Picasso, although the Picassos were all pre-Cubist. In 1912 Fry organised the *Second Post-Impressionist Exhibition* which included Cubist works and a large group of works by Matisse. Earlier in 1912 there had also been an exhibition of Futurism, at the Sackville Gallery, so London had been exposed to a wide range of continental avant-garde art. Four broad groupings can be distinguished in the English avant-garde in those years of intense activity before the First World War: Sickert and Camden Town, Bloomsbury, the Vorticists and their associates, and Augustus John and his friends and followers, notable among whom was the landscape painter J. D. Innes.

Besides Sickert, the leading members of the Camden Town group were Robert Bevan, Spencer Gore, Harold Gilman and Charles Ginner. These artists developed a variety of personal responses to Post-Impressionism, in general adopting bold colours, strong outline and emphatically textured paint surfaces, as in Spencer Gore's 'The Cinder Path'. Although Gore painted numerous landscapes, the principal concern of the Camden Town artists was with documenting the urban scene in a mood of sober realism although subjects range from the

Duncan Grant **Bathing** 1911

Matthew Smith **Nude, Fitzroy Street, No.1** 1916

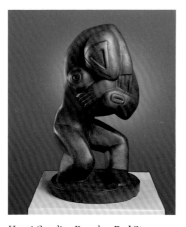

Henri Gaudier-Brzeska **Red Stone Dancer** c.1913

detailed bustle of Ginner's 'Piccadilly Circus' to the interior calm of Gilman's 'Café Royal'.

Bloomsbury is a district near the centre of London, now dominated by London University. Its name is commonly used to identify a circle of intellectuals and artists whose London homes in the period c.1904–40 were often in its quiet and distinguished squares. The circle included the biographer Lytton Strachey, whose brilliantly characterised portrait by Henry Lamb is in the Tate Gallery collection, the economist John Maynard Keynes, the novelist Virginia Woolf, her husband the publisher and political thinker Leonard Woolf, and the art critic Clive Bell. Its principal artists were Vanessa Bell, Roger Fry, also a highly influential art critic and theorist, and Duncan Grant. The art of Bloomsbury was rich and varied, the more so since Vanessa Bell, Fry and Grant were involved in the design firm founded by Fry in 1913, the Omega Workshops, and produced a quantity of decorative art.

Influenced primarily by Cézanne and Matisse (whose studio Duncan Grant visited in about 1909), Bloomsbury art of the period 1910–18 is characterised by an increasingly intense use of colour allied to an emphasis on bold form. Around 1914 all three Bloomsbury painters produced completely abstract works, coinciding with Clive Bell's assertion that 'Significant Form' was a key ingredient in art. Vanessa Bell's 'Abstract Painting' is an example and similar abstract elements can be seen in her portrait of 'Mrs St John Hutchinson', reproduced and discussed on p.131.

Bloomsbury's concern with sensuous and lyrical content combined with formal balance and harmony is perhaps exemplified in Vanessa Bell's 'The Tub'. Duncan Grant's 'Eve' reflects the wide avant-garde interest in tribal art at this time and suggests a fertility image in which the vividly realised female presence also forms part of a totemic phallic design.

Matthew Smith studied painting at the Slade School in London but then went to Paris, where in 1911 he attended the art school run by Matisse from 1908–11. His response to Matisse's approach to colour and form was manifest in a group of boldy constructed and coloured paintings done over the following years, including still lives such as 'Fruit in a Dish' and a pair of nudes, of which 'Nude, Fitzroy Street No. 1.' is in the Tate Gallery collection, its colour scheme of complementary red and green astonishingly extreme even by the standards of continental painting. The title comes from Smith's studio in Fitzroy Street.

The Vorticist group was not officially formed until June 1914 and only one group exhibition was ever held, exactly a year later. However, since at least 1912 Wyndham Lewis, the founder and leader of Vorticism, and a number of artists with related interests, had been forging a distinctive art blending Cubist, Futurist and other ideas. Among these were Jessica Dismorr, Jacob Epstein, Henri Gaudier-Brzeska, William Roberts, Frederick Etchells, and Edward Wadsworth. David Bomberg was never formally a Vorticist although his early

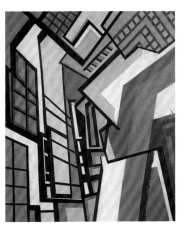

Wyndham Lewis **Workshop** *c.*1914–15

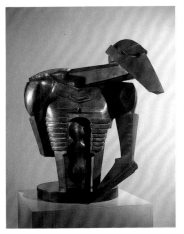

Jacob Epstein **Torso in Metal from 'The Rock Drill'** 1913–14

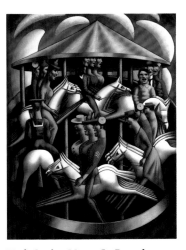

Mark Gertler **Merry-Go-Round** 1916

paintings are now among the most admired works of British Cubo-Futurism. His 'In the Hold' is reproduced and discussed on p.133. C. R. Nevinson claimed direct allegiance to the continent as a pure Futurist and disciple of Marinetti, much to the disgust of Lewis who always maintained that Vorticism was both completely different from and infinitely superior to Futurism. Lewis's 'Workshop' of 1914–15 marks the climax of his Vorticist search at that time for imagery that would evoke, without being imitative, the discordant vitality of the modern city. Lewis achieves his effects with success, using a language of shifting diagonal lines, harsh angles and repeated rectangles suggesting girders, windows, ladders, etc. This imagery is matched by the harsh colour scheme of cold pinks, yellows and white with a focal patch of brilliant blue, perhaps a skylight above the factory floor.

The Vorticists admiration for the industrial led to the creation of one of the most extraordinary of all works of the pre-war avant-garde, Epstein's 'Rock Drill'. Epstein later wrote 'It was in the experimental pre-war days of 1913 that I was fired to do the rock-drill and my ardour for machinery expended itself upon the purchase of an actual drill, second-hand, and upon this I made and mounted a machine-like robot . . .' The work was dismounted later and only the torso of the 'robot' remains, cast into bronze. Epstein's 'Doves' from the same period blends the mechanistic with the cult of nature; it is reproduced and discussed on p.132.

A similar blend of the geometric and the primitive and sensual is found in the sculpture of Gaudier-Brzeska, one of the other great pioneers, beside Epstein and Eric Gill, of modern sculpture in Britain. In 'Red Stone Dancer' the vitality of the dance is expressed through the dense, interlocking cluster of mechanical forms at the head and breast, and the dynamic lines of the composition, spiralling down into the circular base.

Mark Gertler was closely connected with the Bloomsbury circle. His astonishing painting of 1916, 'The Merry-Go-Round', with its endlessly circling, screaming, puppet-like figures in uniform, and sinister orange-yellow colour scheme, is now regarded as an expression of Gertler's horrified response to the growing slaughter of the war. Oddly, it does not appear to have been consciously interpreted in this way at the time, although its power was certainly felt; D. H. Lawrence wrote of it 'Ghastly, utterly mindless human intensity of sensational extremity . . .'

WALTER RICHARD SICKERT
1860–1942
La Hollandaise *c.*1906
Oil on canvas 511 × 408 (20⅛ × 16)

Nudes such as this are among the most complete expressions of Sickert's personal conception of continental Realism, exemplified by his remark, made in 1908, 'Taste is the death of a painter'. That he was referring to the middle-class notion of 'good taste' is made clear by his further comments two years later: 'The more our art is serious the more it will tend to avoid the drawing room and stick to the kitchen. The plastic arts [i.e. painting and sculpture] are gross arts, dealing joyously with gross material facts. . . . and while they flourish in the scullery, or on the dunghill, they fade at a breath from the drawing room'. However, as Sickert also emphasised, the aim of the artist is to make from this unpromising subject matter a painting of beauty, and to this end the physical facts of the subject should only be evoked in a general way, the painter concentrating on creating an aesthetic structure of colour, texture, and surface pattern. His art, wrote Sickert, was not '. . . occupied in a struggle to make intensely real and solid the sordid and superficial details of the subjects it selects. It accepts as the aim of the picture. . . . beauty'. Here, Sickert perfectly realises his aim of creating a painting which functions as a purely pictorial and aesthetic entity but which is charged with vitality from the 'gross material fact' on which it is based. The 'material fact' of this painting is a completely unidealised nude in an awkward, inelegant posture, on rumpled sheets, on an iron bedstead in a darkened interior. Sickert heightens the effect of almost embarrassing intimacy by painting his model from a very close viewpoint and looking slightly down so that, since she is sitting up, her face, breast and prominent thigh are brought close to the surface of the picture. Indeed, only the barrier of the iron bed rail separates the spectator from the naked thigh and the sexual parts hidden in shadow. But it is nevertheless clear that Sickert's concern here has been equally for the pattern of light and

shade, muted colours and textured highlights in which he has rendered this scene, and in 1910 he also wrote: '. the chief source of pleasure in the aspect of a nude is that it is in the nature of a gleam – a gleam of light and warmth and life. And that it should appear thus it should be set in surroundings of drapery and other contrasting surfaces.'

The meaning of the title is not certain but has been linked to Sickert's known admiration for Balzac. In Balzac's novel *Gobseck* of 1830, the prostitute heroine, Sara Gobseck, is nicknamed 'la belle Hollandaise'.

VANESSA BELL 1879–1961
Mrs St John Hutchinson 1915
Oil on board 735 × 580 (29 × 22¾)

An outstanding example of Vanessa
Bell's 'Fauve' manner, and a highly
characteristic Bloomsbury portrait in
that artist and sitter were well known to
each other, Vanessa Bell and her hus-
band Clive being part of the St John Hut-
chinsons' wide circle of friendship and
acquaintance in the world of arts and
letters. For example, also in the collection
of the Tate Gallery is a group portrait by
another painter they knew well, Henry
Tonks, showing them among a gathering
of the friends of the distinguished author
and modern art critic George Moore, at
his home in the Vale, Chelsea. This paint-
ing is one of four portraits of Mary St
John Hutchinson, two by Vanessa Bell
and two by Duncan Grant, all apparently
done at the same time, in three days of
sittings on the 5th, 9th and 11th of
February 1915, at the Hutchinson's Lon-
don home. In a letter to Roger Fry,
Vanessa Bell wrote 'on Friday we painted
Mary. Duncan got very desperate and
began his again which I think I ought to
have done too but I didn't. It is a fright-
fully difficult arrangement for I'm bang in
front of her and everything is very
straight and simple and very delicate col-
our.' It seems likely that it is the Tate
Gallery version of the portrait to which
she is referring since it is certainly
remarkable for its beautiful colour
scheme of delicate pink and near-comple-
mentary acid yellow-green. Characteris-
tic Fauve touches also, are the blue-green
shadows on the cheek-bone and beneath
the lower lip of the full mouth, which is
sensuously realised in a darker, more lus-
cious pink. The sharp blue eyes and alert
posture bring the sitter very much to life,
and while this picture is a striking work
of art in terms of its abstract qualities of
colour and composition, its interest stems
equally from its vivid evocation of a per-
sonality and mood.

JACOB EPSTEIN 1890–1959
Doves *c.*1914–15
Parian marble 648 × 788 × 318
($25\frac{1}{2}$ × $31\frac{1}{2}$ × $13\frac{1}{2}$)

This is one of a group of carved sculptures by Epstein made between about 1908 and 1917, which constitute a major contribution to the history of early modern sculpture. In his work of that period Epstein also laid the foundations of a sculptural tradition in Britain which, taken up by Barbara Hepworth and Henry Moore in the 1920s, has grown in importance ever since.

Epstein developed a fresh approach by adopting the procedure of 'direct carving', and by drawing inspiration, as were many artists of the continental avant-garde, from sources outside Europe: in particular Epstein was an early and distinguished collector and connoisseur of African tribal art. From this he evolved a personal vision of the mystery of procreation and during this early phase of his career produced fourteen sculptures, all but one ('The Rock Drill') stone carvings on themes of copulation, pregnancy and birth. 'Direct carving' means carving without a detailed model or maquette, allowing the final form of the work to emerge through the process of physically working the stone. With direct carving went the idea of 'truth to materials' – preserving the feeling of the original block of stone (or wood) and creating simple uncluttered surfaces, or otherwise working the material so as to present its colour, and texture or markings, as aesthetic elements in themselves. Preserving the block, in particular, gives early modern carved sculpture a quality of elemental force and weight which was central to the aims of its creators.

Epstein received a crucial stimulus when in Paris in 1912 he met Brancusi and Modigliani whose very similar approach was much more fully evolved than his. In particular Brancusi had taken the unprecedented step of making major works of sculpture based on animal rather than human imagery. In his *Autobiography* Epstein recounted 'I finally decided to leave Paris for good, and coming to England I rented a bungalow on the Sussex coast at a solitary place called Pett Level, where I could look out to sea and carve away to my heart's content without troubling a soul. It was here that I carved the "Venus", the three groups of

doves, the two flenite carvings and the marble "Mother and Child . . "' As this indicates Epstein made no less than three versions of this image of mating birds and it seems likely that he regarded it as a universal or archetypal expression of the theme of fertilisation. The Tate Gallery version is believed to be the last of the three and is the most block-like and geometric, reflecting Epstein's interest in Vorticist ideas at this time. Ezra Pound, an important critical supporter of Vorticism, considered it to be the most sculpturally successful of the three, probably because the doves are almost completely unified into a near abstract hard edged ovoid, although the act of copulation remains vividly expressed, not least by the swollen phallic neck and head of the male dove which abruptly breaks the composition at the front. Pound wrote to the American collector John Quinn, an early patron of Epstein and the Vorticists, '. . . if you are still getting Jacob's "Birds", for God's sake get the two that are stuck together . . .'

DAVID BOMBERG 1890–1957
In the Hold *c.*1913–14
Oil on canvas 1962 × 2311 (77¼ × 91)

David Bomberg is always associated with the Vorticists but was in fact an independent figure who, in the years before the First World War, forged his own distinctive brand of Cubo-Futurism, making a substantial and original contribution to the English avant-garde at that time.

This painting shows the outcome of Bomberg's search for a purely visual language in which to express his perceptions of the modern urban environment. In the catalogue of his exhibition he wrote 'I appeal to a *sense of form* . . . I completely abandon *Naturalism* and Tradition. I am searching for an *Interior* expression . . .

where I use Naturalistic form I have *stripped it of all* irrelevant matter . . . My object is the *Construction of Pure Form*.' 'In the Hold' is based on a scene of dockers working in the hold of a steel ship – 'I live in a *steel city*' Bomberg also wrote. A careful exploration of the painting will reveal more of the scene than is at first glance apparent: a ladder runs up across the bottom right quarter of the painting with a hand placed on its lowest rung, in the centre left one of the dockers can be seen, wearing a hat, his outstretched fist appearing near the left edge of the canvas between the fourth and fifth squares down. But to achieve the 'interior expression' he sought and to do so through 'Pure Form' Bomberg has shattered his original image into a glitter-

ing, shifting mosaic of sharp edged, brilliantly but harshly coloured abstract fragments, of undeniably powerful effect. Bomberg's success in achieving his aims in this picture is testified to by the Bloomsbury painter and critic Roger Fry who reviewed it when it was first shown at the London Group exhibition in March 1914: 'He is evidently trying with immense energy and concentration to realise a new kind of plasticity. In his colossal patch-work design, there glimmers through a dazzling veil of black squares and triangles the suggestion of large volumes and movements.'

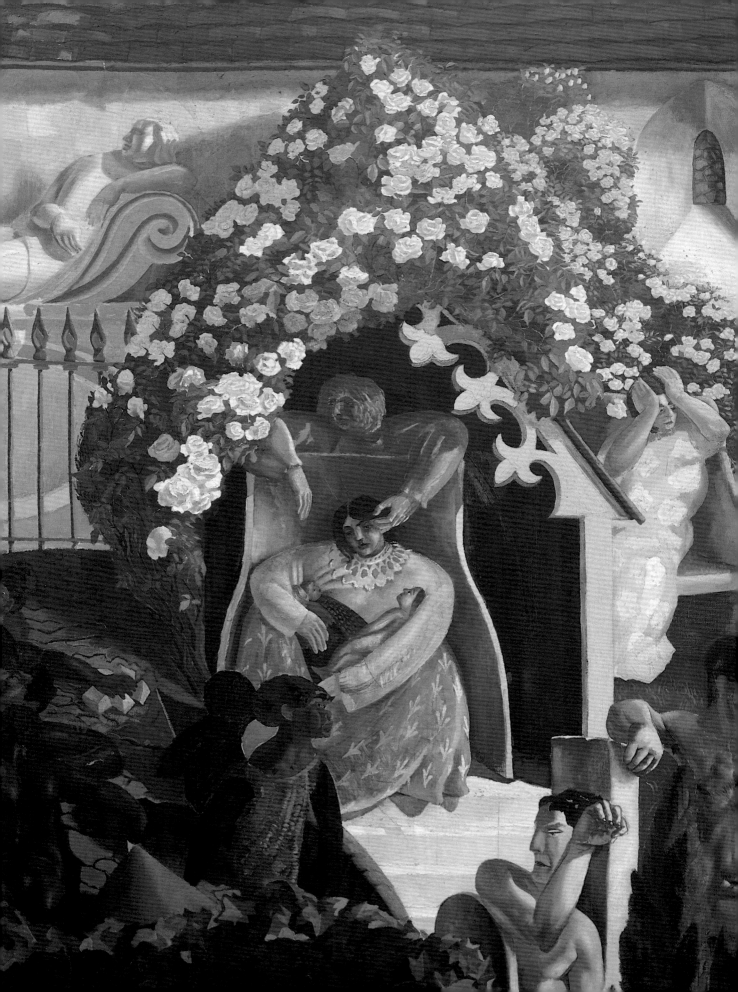

Stanley Spencer and Traditional British Art

Edward Burra **The Snack Bar** 1930

The First World War brought an end to the intense ferment of innovative, avant-garde activity that had developed in Britain in the pre-war years. After the war there was generally a noticeable return to more traditional values in art, exemplified in Britain by the Seven and Five Society which, in the catalogue of its first exhibition, in 1920, proclaimed: 'There has been of late too much pioneering along too many lines, in altogether too much of a hurry . . .'

It was in this atmosphere that Stanley Spencer became a dominant figure in British painting and remained so until his death in 1959, by which time he had been knighted. However, although Stanley Spencer's art is in many ways traditional, it is also unmistakeably of its century, as the critic of *The Times* perceptively pointed out when reviewing 'The Resurrection, Cookham' in 1927: 'What makes it so astonishing is the combination in it of careful detail with modern freedom of form. It is as if a Pre-Raphaelite had shaken hands with a Cubist.' 'The Resurrection, Cookham' and a further work by Spencer are reproduced and discussed on pp.137, and 138.

Edward Burra and Cedric Morris also with great success combined elements of modernism with traditional representational concerns, and were possessed of a quirky and highly personal vision. Burra's most characteristic work, mostly done in watercolour, is based on a sharp, satirical observation of life and belongs in a tradition that ultimately goes back to Hogarth. 'The Snack Bar' is one of his rare oil paintings. It probably represents a scene in the red-light, restaurant and delicatessen district of Soho, one of Burra's favourite parts of London. The high-heel shod legs of a prostitute can be seen outside the door.

Cedric Morris was a notable portraitist, and his other principal subjects were flowers, fruit and birds. 'Belle of Bloomsbury', a painting of his sister Nancy's bull terrier bitch also appears as a vivid portrait, and is a striking example of Morris's ability to reproduce what he saw as a heightened, intensely evoked reality in paint.

Cedric Morris **Belle of Bloomsbury** 1948

Meredith Frampton was a true practitioner in the twentieth century of a style utterly untouched by the developments of modernism. His portraits, indeed, are reminiscent of those of the great nineteenth-century French neo-classicist Ingres, and his work stands out both by its sheer technical beauty and by an almost visionary element which invests pictures such as his 'Portrait of a Young Woman' with a powerful sense of mystery, an almost dreamlike or hallucinatory quality. Frampton wrote that this work 'was painted as a relaxation (rather a strenuous one) after a series of commissioned portraits and it made a welcome change to paint an assembly of objects which appealed to me as being beautiful in their own right and lacking any need for embellishment. The sitter was very musical, though not a performer and a cello seemed an appropriate symbol –

◁ Stanley Spencer **The Resurrection, Cookham** 1923–7 (detail)

Meredith Frampton **Portrait of a Young Woman** 1935

Dod Procter **Morning** 1926

Edward Wadsworth **Regalia** 1928

there was also the challenge presented by having to draw it in correct perspective.'

Dod Procter was a pupil of the Newlyn School painter Stanhope Forbes (p.89). She also trained in Paris from 1910–11 and thereafter spent her entire life at Newlyn. Her early Impressionist influenced manner gave way in the 1920s to a more defined and sculptural treatment of form, exemplified by 'Morning' which created a sensation when exhibited in 1927. It was bought by the *Daily Mail* from the Newlyn Art Gallery and when later shown at the Royal Academy was acclaimed Picture of the Year. Its power as a painting certainly partly stems from its strong evocation of an atmosphere of burgeoning adolescent sexuality, although this does not appear to have been acknowledged at the time. The model was Cissie Barnes, the sixteen-year-old daughter of a Newlyn fish merchant.

Edward Wadsworth after his Vorticist phase painted sharply focused marine subjects such as 'Seaport' of 1923, and later rather strange still-lives like 'Regalia', which have strong affinities with continental Metaphysical and Surrealist painting (p.157). The particular clarity of his work comes from his use of tempera (pigment mixed with egg yolk and water) rather than oil paint. The title of 'Regalia' may express the idea that just as a crown, orb and sceptre (the 'regalia') are essential to a monarch, so these objects are to those who make their living on the sea.

Two very different painters of the rural scene were Alfred Munnings and John Nash. In 'Epsom Downs' and 'Their Majesties Return from Ascot', Munnings gives a fresh interpretation to the eighteenth-century traditions of Sporting Art and Grand Portraiture. John Nash's work is notable for the poetry he extracted from quiet corners of the English landscape.

After his period of carving before the First World War, Jacob Epstein adopted modelling in clay for casting in bronze as his main medium, although he continued to produce occasional major pieces of carved sculpture. He developed a vigorous, highly expressive style, which brought him great success as a portraitist and maker of symbolic subjects such as 'The Visitation'.

After 1920 Sickert's work grew increasingly broad, bold and surprising, not least in subject matter. The relative sobriety of his Camden Town period was succeeded by a freer application of paint, sometimes with dramatic contrasts of light and dark and always with unusual effects of colour. In place of drawing from observation Sickert came to base his paintings on nineteenth century illustrations or on modern snapshots or newspaper photographs. His 'Miss Earhart's Arrival' is reproduced and discussed on p.139. Sickert's career extended from apprenticeship to Whistler to being the Grand Old Man of British painting by his death in 1942. Its final phase was as marked as all the others by exceptional painterly liveliness, a love of tradition and a fascination with human behaviour.

STANLEY SPENCER 1891–1959
The Resurrection, Cookham 1923–7
Oil on canvas 2743 × 5486 (108 × 216)

The vision of Stanley Spencer was formed by his early life in the village of Cookham-on-Thames, not far from London. Here he spent a childhood and youth of such unalloyed happiness that it appeared to him that the village must be a kind of paradise and everything in it possessed of mystical significance. This led him in the early part of his career particularly, to paint a series of pictures in which he imagined biblical events taking place in his native village, interwoven with his own feelings and the events of his own life. This painting is the largest and most complex of these and marks the climax of this phase of his art.

The resurrection is one of the most challenging of all traditional Bible subjects but Spencer, by the power of his personal approach, has created a triumphant masterpiece. The picture created a sensation when shown in his one-man exhibition at the Goupil Gallery in London in 1927 and was bought immediately for the national collections for one thousand pounds. The critic of *The Times* called it '. . . the most important picture painted by any English artist in the present century . . .' and even the Bloomsbury critic Roger Fry, who generally disapproved of narrative painting, wrote 'it

is highly arresting and intriguing . . . a very personal conception carried through with unfailing nerve and conviction.'

The setting is Cookham Churchyard with the River Thames in the background. Christ, with children in his arms, appears enthroned in the church doorway in the centre of the painting, with God the Father leaning over the back of the throne. Along the wall of the church is a row of prophets including Moses, with a dark beard, holding the tablets of the Ten Commandments. The rest of the churchyard is filled with people resurrecting from their tombs. The group of black people emerging from sun-baked soil implies that Spencer's conception embraces the whole of humanity. Spencer made it clear that his Resurrection was a joyous event and that the resurrected are already in Heaven: '. . . in the main they resurrect to such a state of joy that they are content . . . to remain where they are.' Even 'the punishment of the Bad', said Spencer, 'was to be no more than that their coming out of the graves was not so easy as in the case of the Good'.

'The Resurrection, Cookham' was painted at a turning point in Spencer's life, as it was started about a year before his marriage, in February 1925, to the painter Hilda Carline; the painting contains strong autobiographical elements, whose precise significance remains a

mystery. The central nude figure supporting himself on two gravestones is Spencer himself, as is the clothed figure lying on the brick tombs in the lower right corner. The kneeling nude figure is his new brother-in-law the painter Richard Carline. Hilda Carline appears at least three times: most notably, she is the half-hidden figure in a striped dress in the ivy covered tomb in the centre foreground, surrounded by a spiked fence. She is thus contained in a protective bower but is directly linked by the line of her body, and by proximity, to her brother and husband.

Spencer returned to the Resurrection theme in 1947–50 when he painted 'The Resurrection: Port Glasgow', also in the Tate Gallery.

STANLEY SPENCER 1891–1959
**Double Nude Portrait: the Artist and his
Second Wife** 1936
Oil on canvas 838 × 937 (33 × 36⅞)

There is no doubt that Stanley Spencer's
marriage to Hilda Carline in 1925 aroused
in him powerful sexual instincts, and
that he very soon formed a view of sex
that was both highly mystical and very
down-to-earth: 'the first time I delibera-
tely touched a woman, here was a mira-
cle I could perform' he later wrote.

'Double Nude Portrait' belongs to a
group of seven nude or semi-nude por-
traits done between 1933 and 1936 to
which Spencer clearly attached consider-
able importance. They are listed as a
group and discussed by the artist in a
document now in the Tate Gallery
Archive. One of the paintings is a half-
length of the artist's first wife Hilda Car-
line, two are double portraits of the artist
with his second wife Patricia Preece and
the other four are of Patricia Preece
alone. They are interesting not least
because they were, according to the
artist, painted from life rather than from
imagination as was his normally invari-
able practice when painting figure sub-
jects. His account of them begins: 'I wish
my shows could include the nudes (oil)
that I have done. I think to have them
interspersed in a show would convey the
range of my work . . . The nudes are
completely different from the figure
pictures . . .' In a note dated September
1955 he writes 'I have now brought back
home the big double nude . . . a remark-
able thing. There is in it male, female and
animal flesh.

The remarkable thing is that to me it is
absorbing and restful to look at. There is
none of my usual imagination in this
thing: it is direct from nature . . . It was
done with zest and my direct painting
capacity I had.'

The painting was done at Lindhurst,
Spencer's house at Cookham where he
lived from 1932–8. The stove in the
background is a Valor oil heater and
Spencer referred to the joint of meat in
the foreground as 'the uncooked supper'.

The sexual frankness and unblinking
realism of the work is carried by the
intense seriousness of its mood, Spencer
contemplating, almost as if at an alter,
the body of his wife. It is also extremely
beautifully painted, as an internal note
on the picture, prepared for the Tate

Gallery's Trustees at the time of its acqui-
sition conveys: 'among other things it is a
varied anthology of flesh textures show-
ing skill, tenderness and objectivity. The
vividness of Spencer's perception is
accentuated by the contrast between the
human flesh and the raw joint of
mutton.' This note also points out the
originality of the composition '. . . with
the picture edge slicing off the figures in
such a way as to heighten for the specta-
tor the immediacy of their presence.' It is
this device which contributes largely to
the almost uncomfortable sensation of
intimacy which can be experienced in
front of this painting.

Towards the end of his life Spencer
conceived the idea of a half-secular, half-
sacred temple, which he called Church-
House, for the exhibition of his paintings.
In it he wrote '. . . There would be a room
of nudes from life . . . they balance a need
in the whole cosmical conception'. He
also wrote: ''I wanted in the nude section
to show the analogy between the Church
and the prescribed nature of worship,
and human love'. This seems to reinforce

the reading that in this painting he por-
trays himself in an act of worship.

Two other striking self-portraits by
Spencer are in the Tate Gallery. One of
1914 shows him as a young man, the
other was painted shortly before his
death in 1959.

WALTER RICHARD SICKERT
1860–1942
Miss Earhart's Arrival 1932
Oil on canvas 714 × 1832 ($28\frac{1}{8}$ × $72\frac{1}{8}$)

In 1932 the American Amelia Earhart became the first woman to make a solo transatlantic flight. After landing in Ireland she flew to London where, arriving in a thunderstorm, she received a rapturous welcome at the airport. Sickert based his picture of this event on a newspaper photograph published the following day. The painting was exhibited only seven days later.

At seventy-two Sickert occupied a unique position. He viewed with reservation the successive continental influences of Fauvism, Cubism and Surrealism, yet in the interwar years he extended the expressive possibilities of art by openly basing his works on sources in popular and mass-media imagery and by the uninhibited yet masterly ways in which he realised these in paint. Rejecting studio photographs, Sickert particularly valued the amateur snapshot and the news photographer's snatched image, for their qualities of immediacy and pictorial surprise. 'Miss Earhart's Arrival' is a classic example of the kind of improbable but arresting composition which resulted. Almost all the backs of the crowd are turned to the viewer and Miss Earhart can only just be made out, her small, helmeted head to the right of the hat of the man in the blue raincoat. Freely inventing the colours, Sickert also accentuated the image's tonal contrasts and thickened the bold diagonal strokes

which represent the pelting rain. The result of these decisions is a strange concentration and fixing of a moment of drama. The painting was described at the time as 'like a fragment of a magnificent modern fresco'.

From Sickert's periods in London, Dieppe, Venice and Bath the Tate Gallery owns pictures which show his love of architecture. The townscapes of the last two cities in particular remind us that architecture is a stage for the kaleidoscope of human activity. Sickert had originally been an actor. In his painting he saw most locations, from the dingy bedroom to the sweeping crescents of 'The Front at Hove', as the setting for human episode. In the latter painting he himself appears on a bench beside a lady. It is one of many self-portraits in which, always the actor, he presented his own persona in ever-changing guises. Sickert's love of human interest shows, too, in his revival of the work of nineteenth-century illustrators centred on narrative and humour. The Tate's 'The Seducer', an example of Sickert's 'Echoes', presents a scene of domestic passion transcribed into paint from a mid-Victorian illustration. In such small paintings Sickert used lively colours and a confident looseness (yet precision) of handling that were peculiarly his own. Paradoxically, the result enhanced the content of his black-and-white sources.

In his later years Sickert also continued to paint scenes from the theatre and made remarkable portraits of individual stars of stage and screen. Though based on an unposed, off-stage photograph, his

portrait in the Tate of Gwen Ffrangcon-Davies as Isabella of France is eight feet high. The pictorial grandeur, the richness of colour and the broad use of paint in such works recall Sickert's love of the great Venetian masters. As a realist, a painter's painter and a living link with Degas, Sickert was admired by the Euston Road Group (see p.173), yet the frankness and directness with which he translated matter-of-fact source material into fine art proved prophetic of later artists such as Bacon (see p.195) and Warhol (see p.233).

Constructivism and De Stijl: Abstract Art 1910–45

Wassily Kandinsky **Swinging** 1925

The word abstract, strictly speaking, means to separate or withdraw something from something else. In that sense it applies to art in which the artist has started with some object in the visible world and 'abstracted' elements from it, to arrive at a refined and simplified form. The term abstract is also applied where the artist has created the work of art without reference to 'the object'. This type of abstract art usually, but not always, uses a language of purely geometric forms and its practitioners have often preferred terms such as 'concrete' or 'non-objective' to describe their work, as well as inventing their own names for it. In spite of this, the term 'abstract' has remained dominant as a catch-all to describe a wide range of forms of abstract art and of degrees of abstraction.

In the years between 1910 and 1920 there was an explosion of experimentation with the idea of abstract art, and since then abstraction has remained one of the principal currents of modern art.

Increasing degrees of abstraction can be seen in avant-garde art from about 1870 onwards but from 1910–20 a distinctive shift took place, culminating in what was, in effect, a complete rupture of art from the representation of the visible world. Among the prime movers and originators of this development were, in painting, the Russians Wassily Kandinsky and Kasimir Malevich, and the Dutchman Piet Mondrian, and, in sculpture, another Russian, Vladimir Tatlin. In 1917 Mondrian was co-founder, with Theo van Doesburg, of the journal *De Stijl* (Style) and the name became applied to those artists associated with it and whose work reflected its ideas. Mondrian also used the more specific term Neo-Plasticism to describe his own painting and it is generally applied to the work of the De Stijl group. Malevich called his art Suprematism, and that of Tatlin and his followers became known as Constructivism. Kandinsky did not invent a personal name for his art.

Piet Mondrian **Composition with Red, Yellow and Blue** *c.*1937–42

The origins of abstract art are extremely complex and can be traced back into the nineteenth century when artists such as Whistler began increasingly to take the view that painting was essentially a visual language, principally of colour and form, and that the time had come to purify it of all extraneous elements, such as narrative and the function of recording the external appearance of things. Mondrian's term Neo-Plasticism refers to this idea of an art consisting purely of the formal or 'plastic' elements of painting – line, form, colour and space. This rejection of the role of representation for painting was certainly connected to the rapid development of photography through the second half of the nineteenth century, but also stems from the artists' belief that representational detail in painting simply interferes with the spectator's aesthetic responses to form, colour and the compositional arrangement of these. One idea underpinning all this was the notion that painting could appeal

Wassily Kandinsky **Cossacks** 1910–11 (detail)

Naum Gabo **Model for 'Column'**
1920–21

directly to the senses, as it was thought music did. This analogy with music was of particular importance to Kandinsky.

Another major influence on the development of abstract art was the interest of many of its pioneers in spiritualism and other mystical forms of religion. The most important of these was Theosophy, which particularly affected Kandinsky and Mondrian leading them to seek ways of representing the spiritual. This aim is reflected in the title of Kandinsky's book, published in 1912, *Über das Geistige in der Kunst* (Concerning the Spiritual in Art) which is one of the fundamental theoretical texts of modern art. Eventually both Kandinsky and Mondrian concluded that the spiritual could only be represented in forms other than those of the material world. This emphatic turning away from physical reality was shared by Malevich who defined Suprematism as '. . . the supremacy of pure feeling in creative art . . . To the Suprematist the visual phenomena of the objective world are, in themselves, meaningless . . .' However, Malevich's vision, although undoubtedly mystical, was related to a utopian Futurist view of a technological world. His Russian compatriots, the Constructivists, sought to create an abstract art even more directly related to the industrial world. For Tatlin, its founder, Constructivism meant 'real materials in real space'. By 'real' materials he meant anything other than the traditional art materials of bronze or marble, but in practice Constructivist art was made from metal, plastic, glass and similar 'modern' materials, and appears as a kind of abstract architecture or engineering product.

The aesthetics of the Greek philosopher Plato also form an important part of the underpinning of abstract art. In *Philebus* he wrote 'I do not now intend by beauty of shape what most people would expect, such as that of living creatures . . . but . . . straight lines and curves and the surfaces or solid forms produced out of these . . . these things are not beautiful relatively, like other things but always and naturally and absolutely.'

Works by Kandinsky, Mondrian, Malevich and the Russian Constructivist Naum Gabo are reproduced and discussed on pp.143, 144, 145, 146.

The Hungarian-born artist Laszlo Moholy-Nagy was an early follower of Malevich who became an influential teacher, theorist, stage designer and typographer as well as painter and maker of three-dimensional work. The K in the title of his 'K VII' stands for Konstruction and the painting relates to Constructivism as well as Suprematism.

Laszlo Moholy-Nagy **K VII** 1922

In Britain abstract art appeared briefly but with considerable vigour in the work of the avant-garde before the First World War. After the War it largely disappeared not to re-emerge until the early 1930s in the work of Ben Nicholson and Barbara Hepworth. Nicholson's 'Painting 1937' is reproduced and discussed on p.147.

WASSILY KANDINSKY 1866–1944
Cossacks 1910–11
Oil on canvas 946 × 1302 (37½ × 51¼)

This was painted at the moment in Kandinsky's career when he was living in Germany, near Munich, and moving rapidly from a form of Expressionism towards Abstraction. It was acquired by the Tate Gallery in 1938 and in a letter to a friend not long after, Kandinsky wrote 'an American woman living in London has bought a pre-war painting from me and presented it to the Tate Gallery in London! It is the first truly modern painting in the famous museum in London. The painting is called "Cosaques", dates from the year 1911, still bears traces of "the object" but makes nevertheless a wholly "concrete" impression'. (By the time of this letter 'concrete' had become a widely used term for abstract art as had 'non-objective'.) The painting was also, at one time, titled 'Battle'. The 'traces of

"the object"' which Kandinsky mentions are as follows: in the upper left portion of the picture are two horses rearing up against each other, their front legs interlocking. Each has a Cossack (Russian cavalry) rider wearing a tall fur hat which Kandinsky has here painted orange-red. Each is swinging a long curved sabre, painted mauve. Below the horses is a rainbow bridging a valley, and to the left of that, what appear to be two batteries of guns, one of which is firing, producing a cloud of red and orange flame. On the other side of the valley is a building suggesting a fortress and below it are three more Cossacks again distinguishable by their orange hats. Two of them carry long black lances and the third has his arm extended and is leaning on his sabre. A flock of birds flies agitatedly in the sky.

Although the 'objects' in the composition are barely recognisable, the feeling of conflict is vividly expressed by the

structure of powerful diagonal lines which tilt and clash and intersect; all horizontals or verticals are rigorously excluded leaving nowhere for the eye to rest. The focus of this restless linear structure is the group of the horses and the building outlined in thick black lines occupying the upper central part of the picture. Around this focal area Kandinsky has distributed elements of strong colour, the Cossack hats, the rainbow, the gunfire, which further distract the eye and reinforce the disturbing effect.

In 1914 Kandinsky moved back to Russia where he lived until 1922, holding a number of important cultural appointments under the Revolution. His contact with Suprematism and Constructivism seems to have moved him towards a more geometric abstraction as in 'Swinging' of 1925 (see p.141).

PIET MONDRIAN 1872–1944
Composition with Grey, Red, Yellow and Blue 1920–c.1926
Oil on canvas 1005 × 1010 (39¼ × 39½)

This is an early example of the pure geometric form of abstract art developed by Mondrian and named by him Neo-Plasticism. From his early beginnings as a landscape painter Mondrian was led to abstraction largely by his interest in Theosophy, although it was his discovery of the Cubism of Picasso and Braque in about 1911 which gave him a vital stimulus in turning his vision into art. His very abstract Cubist painting 'Tree' is in the Tate Gallery collection. From Theosophy Mondrian took both the idea of the importance of the spiritual element in man and the notion of the existence of a spiritual world, a universal order, beyond the world of natural appearances. In 1917, in the first issue of the journal *De Stijl*, Mondrian wrote 'As a pure representation of the human mind art will express itself in an aesthetically purified, that is to say abstract form . . . The Truly modern artist . . . is conscious of the fact that the emotion of beauty is cosmic, universal. This implies an abstract plasticism for man adheres only to what is universal. The new plastic idea cannot therefore take the form of a natural representation. This new plastic idea will ignore the particulars of appearance, that is to say natural form and colour. On the contrary it should find its expression in the abstraction of form and colour, that is to say, in the straight line and the clearly defined primary colour'.

By the time he painted this picture Mondrian had further developed his ideas and formulated them as a set of principles governing his painting which he wrote down in 1926. These principles may be summarised as: only primary colours and the non-colours, black and white; only straight lines and only in vertical or horizontal configuration; only squares and rectangles. Further, there must be no spatial illusion – the painting must appear absolutely flat, and all the elements must be in a balanced relationship, in equilibrium, although, equally, there must be no symmetry. From this it can be seen that in general Mondrian's painting represented the ultimate development up to that time of the idea of pure painting – the basic ingredients of painting, line, form and colour, used only in their most elementary, irreducible forms. For Mondrian a central meaning of his painting was embodied in the crossing of lines at right angles: paragraph four of *General Principles of Neo-Plasticism* states 'Abiding equilibrium is achieved through opposition and is expressed by the straight line . . . in its principal opposition i.e. the right angle'. This basic crossing of lines represented for Mondrian the union of all opposites, masculine/feminine, positive/negative, into a universal expression of harmony and unity. He wrote 'The positive and the negative break up oneness, they are the cause of all unhappiness. The union of the positive and negative is happiness.' Mondrian also saw Neo-Plasticism as the vehicle for expression of an ideal vision of society. Under the heading *Psychological and Social Consequences of Neo-Plasticism* he wrote 'Neo-Plasticism . . . stands for equity, because the equivalence of the plastic means in the composition demonstrates that it is possible for each, despite differences, to have the same value as others.' By this Mondrian meant that each coloured rectangular element (the 'plastic means'), although different from all the others, plays an equal role in the composition. Thus, his paintings could represent a state of society in which people were different but equal.

Towards the end of the 1930s Mondrian came to feel that his early Neo-Plastic paintings were too static, lacking the feeling of life. In 'Composition with Red, Yellow and Blue' painted from 1937–42, (see p.141), he uses irregularly spaced thick black lines to set up a distinctive optical rhythm, and small areas of pure primary colour (his earlier colours were muted with grey) that also activate the picture. This tendency reached its fullest development in Mondrian's last years, spent in New York City, where 'Composition with Red, Yellow and Blue' was completed and where he began to give his pictures titles such as 'Broadway Boogie-Woogie', relating to the City and to jazz music. In an interview given in New York, Mondrian said that what he now wanted was to express 'dynamic movement in equilibrium.'

KASIMIR MALEVICH 1878–1935
Dynamic Suprematism 1915 or 1916
Oil on canvas 803 × 800 ($31\frac{5}{8}$ × $31\frac{1}{2}$)

The first Suprematist paintings were exhibited in December 1915 in St Petersburg (now Leningrad) at an exhibition titled 'o.10'. The exhibition included thirty-five abstract paintings by Malevich, among them and first on the list of his work in the catalogue, was 'Black Square', the famous painting of a black square on a square white ground, now in the Russian Museum, Leningrad.

Malevich began to develop the idea of Suprematism a year or so before this, and in his book *The Non-Objective World*, published in 1927, he wrote: 'In the year 1913, trying desperately to free art from the dead weight of the real world, I took refuge in the form of the square.' He continued, 'To the Suprematist the visual phenomena of the objective world are, in themselves, meaningless; the significant thing is feeling, as such . . . Art no longer wants to serve the State and Church, it no longer wishes to illuminate the history of manners, it wants to have nothing further to do with the object, as such and believes that it can exist in and for itself without "things" . . . the black square on the white field was the first form in which non-objective feeling came to be expressed; the square = feeling, the white field = the void beyond this feeling'.

The 'Black Square' remained for Malevich a ground breaking statement of his new art of pure feeling, but it appears that its static quality did not satisfy him and in 1915–16 he moved rapidly to what he called 'dynamic' Suprematism. Malevich, like all the pre-World War I Russian avant-garde was strongly influenced by Futurism as well as Cubism. His move to an abstract 'dynamism' appears to be an attempt to express the Futurist utopian vision of the modern city and modern technology in an abstract form. In *The Non-Objective World* he wrote '. . . the art of Cubism and Suprematism is to be looked upon as the art of the industrial, taut environment.' This environment he said '. . . has been produced by the latest achievements of technology, and especially of aviation, so that one could also refer to Suprematism as "aeronautical". The culture of Suprematism can manifest itself in two different ways, namely as dynamic Suprematism . . . or as static Suprematism . . .' In the light of this, 'Dynamic Suprematism' can perhaps be viewed as an attempt by Malevich to evoke the forms and energy of the modern technological world.

NAUM GABO 1890–1977
Head No. 2 1916
(Enlarged Version) 1964
Cor-ten steel 1753 × 1340 × 1226
(69 × 52¾ × 48)

Naum Gabo was born in Russia, trained
as an artist in Munich where he met Kan-
dinsky, and moved to Paris in 1913. He
spent the period of the First World War in
Norway, but in 1917 returned to Russia
to join Tatlin, Malevich and Kandinsky in
the great involvement of avant-garde
artists in the Russian Revolution.

He began to develop his own form of
constructed sculpture in Norway, and
'Head No. 2' is a later enlargement by the
artist of one of his most striking works of
this period. Not completely abstract, it
has a strong human presence, but is con-
structed according to the principle of ster-
eometry which was fundamental to
Gabo's later fully abstract work. The
essence of stereometric construction is
that it enables the artist to define form in
terms of space, rather than mass. In his
essay *Sculpture: Carving and Construction
in Space* published in 1937, Gabo wrote
'Up to now sculptors have preferred the
mass and neglected or paid little atten-
tion to such an important component of
mass as space . . . we consider it as an
absolute sculptural element . . . I do not
hesitate to affirm that the perception of
space is a primary natural sense which
belongs to the basic senses of our psy-
chology.' This last remark is very signifi-
cant since human beings are powerfully
affected by the nature and structure of
the spaces around them, for example the
feelings we have on walking into a great
cathedral or, on the other hand, being
squashed in a crowded tube train.

Gabo's personal theory of abstraction
is continued in his *Realistic Manifesto*,
published to accompany an exhibition of
his work in Moscow, in 1920. The title
was deceptive, as Gabo later explained:
'We all labelled ourselves constructors –
the word realism was used by all of us
because we were convinced that what we
were doing represented a new reality.'
Abstract artists tend to use the term rea-
lism to stress that their work has its own
independent existence, that it is a new
creation, in no way an imitation of some
other thing. In the *Realistic Manifesto*
Gabo wrote: 'the realisation of our per-
ceptions of the world in forms of space
and time is the only aim of our art . . . We

construct our work as the universe con-
structs its own, as the engineer con-
structs his bridges . . . in creating things
we take away all that is accidental and
local leaving only the constant rhythm of
the forces in them'.

Gabo took an important step in his
search for an art of pure space when he
adopted the use of transparent plastics
and glass, and one of his first mature
masterpieces is 'Column', the first model
for which, made in 1920–1, is in the Tate
Gallery collection (see p.142). As Gabo
explained, it is a kind of abstract architec-
ture: 'From the very beginning of the
Constructivist Movement it was clear to
me that a constructed sculpture, by its
very method and technique brings sculp-
ture very near to architecture . . . My
works of this time up to 1924 . . . are all
in the search for an image which would
fuse the sculptural element with the
architectural element in one unit. I
consider this Column the culmination of
that search.'

BEN NICHOLSON 1894–1982
Painting 1937
Oil on canvas 1594 × 2013 (62¾ × 79¼)

Ben Nicholson was the only English
painter to develop a pure abstract art of
international quality between the two
World Wars. In the immediate aftermath
of the First World War, England became
very cut off from the continental avant-
garde: Nicholson recalls visiting Paris as
a young artist in 1921 and seeing his first
Cubist painting: 'I remember suddenly
coming on a Cubist Picasso at the end of
a small upstairs room at Paul Rosen-
berg's gallery . . . it was what seemed to
me then completely abstract'. Over the
next ten years, influenced by Cubism,
Nicholson developed a personal art
notable for its beauty of line, colour and
surface texture. In the early 1930s he

began to make completely abstract work
and his extraordinarily refined aesthetic
sensiblity found its most extreme expres-
sion in a series of pure white reliefs (see
p.184) and, a little later, in a group of
pure abstract paintings of which this is
the most serene and majestic. It is to
some extent based on Mondrian's princi-
ple of using only rectangular form and
primary colour and non-colour (black
and white). But Nicholson does not use a
grid of vertical and horizontal lines to
contain his colours, which therefore float
free, and he furthermore permits himself
several different, delicately modulated,
tones of blue. The result is both monu-
mental and poetic. Nicholson underlined
the poetic nature of his work in his *Notes
on Abstract Art* published in 1941. 'The
problems dealt with in "abstract" art
relate to the interplay of forces . . . the

geometrical forms often used by abstract
artists do not indicate as has been
thought, a conscious and intellectual,
mathematical approach – a square and a
circle in art are nothing in themselves
and are alive only in the instinctive and
inspirational use an artist can make of
them in expressing a poetic idea.'

As has often been pointed out, there is
a particular emphasis on light in this and
other abstract works by Nicholson that
ultimately has its source in a response to
the natural world. It has also been sug-
gested that the structure of 'Painting
1937' has its source in earlier paintings
of still-life subjects of simple objects on a
rectangular table-top.

Masters of Modern Sculpture

Henri Laurens **Autumn** 1948

Pablo Picasso **Still Life** 1914

David Smith **Cubi XIX** 1964

Two of the major founders of modern sculpture were the near contemporaries Edgar Degas and Auguste Rodin, born in 1834 and 1840 respectively, and dying in the same year, 1917. Both revitalised sculpture by bringing it back into direct confrontation with the human body, so much so that their audiences were taken aback: Degas's 'The Little Dancer aged Fourteen' (p.99) exhibited in Paris in 1881, seemed simply too close to life to be art, while Rodin's 'The Age of Bronze' exhibited in 1877, although provided with a suitably symbolic title, appeared so lifelike that Rodin was accused of having cast parts of it direct from the model. In fact both Degas and Rodin were interested in grasping the essence rather than the surface of things. Rodin in particular developed an extremely free approach to making modelled sculpture, with heavily worked surfaces, distortion, and even fragmentation of the body, which helped lay the foundations of one of the main streams of modern sculpture. Rodin also produced some sculpture in marble which in general has an erotic, dreamlike character, very different from the expressive vigour of his bronzes. His great marble, 'The Kiss' is reproduced and discussed on p.150.

In 1904 the young sculptor Constantin Brancusi arrived in Paris, having walked most of the way from his native Romania. Inevitably influenced by Rodin, he nevertheless famously remarked 'Nothing grows in the shade of a tall tree', and proceeded to develop a completely different concept of sculpture. His 'Maiastra' of 1912 is reproduced and discussed on p.151. Brancusi's approach laid the foundations of another of the main streams of modern sculpture.

Modelling in clay for casting in bronze, and carving stone or wood, are very ancient methods of making sculpture, carving the most ancient of all. But in the twentieth century artists did invent one new sculptural method, construction or assemblage. The ultimate originator of constructed sculpture is Picasso, in the Cubist constructions he made from about 1912–14, one of which 'Still Life' is in the collection of the Tate Gallery. These constructions were made from scrap materials, wood, cardboard, string, roughly glued or nailed together, and often painted. From Picasso's Cubist constructions flows a third stream of modern sculpture, characterised by an increasing freedom in the artist's choice of material and wideranging methods of assembly.

◁ Auguste Rodin **The Kiss** 1901–4
(detail)

AUGUSTE RODIN 1840–1917
The Kiss 1901–4
Pentelican marble 1820 × 1020 × 1830
(71¾ × 48 × 60¼)

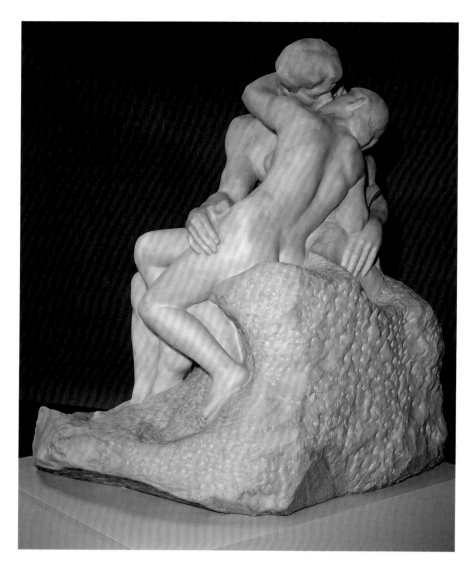

'The Kiss' has its origins in Rodin's first major public commission, given to him in 1880 by the French State. This was for a huge bronze doorway, covered in relief sculpture illustrating Dante's *Divine Comedy*, for a proposed new Museum of Decorative Arts in Paris. Rodin decided to confine his choice of subjects to *Hell*, the first part of the *Divine Comedy*, and the doorway became known as 'The Gates of Hell'. From about 1880–86 Rodin poured energy and inspiration into this project and although the museum was never built and 'The Gates of Hell' never definitively completed, they remained a repository of ideas for the artist and are the source of some of his best known individual works.

The group of 'The Kiss' first appears in the third of Rodin's early small clay models for 'The Gates of Hell', together with only two other recognisable groups. One of these, the figure now known as 'The Thinker', was originally intended to represent Dante himself, the other, a man holding a dead youth (his son) in his arms, represents a character from *Hell* called Ugolino. The three groups are arranged in a triangle, with 'The Thinker' at the top over the doors and the other two opposite each other, on the left and right-hand panels of the doors. The gateway was later to become populated with hundreds of figures, but these three clearly had a fundamental symbolic significance for Rodin, representing sexual love, parenthood and death, and intellectual activity and creation.

There is no doubt that in 'The Kiss' Rodin invented one of the great images in art of human sexual love, whose power derives from its beautifully judged balance between a high degree of idealisation in the depiction of the bodies of the couple and the equally high degree of eroticism with which Rodin has nevertheless succeeded in imbuing the work. The erotic edge of 'The Kiss' is sharpened when its subject from Dante is known. The couple are Paolo Malatesta and Francesca da Rimini. Francesca was married to Paolo's brother but fell in love with Paolo, himself a married man. They were discovered and murdered by Francesca's outraged husband. In Dante,

Francesca recounts how she and Paolo were first moved to physical passion by reading together the Arthurian legend of Lancelot – when they read of Lancelot's first embrace of Queen Guinevere they could resist each other no longer. This is the moment that Rodin has depicted. In the sculpture the book can just be made out still clutched in the surprised Paolo's left hand.

Rodin made the first separate version of 'The Kiss' in 1882, a half-life size bronze, and in 1887 was commissioned by the French state to produce a version in marble on a scale larger than life. This was finally completed and exhibited in Paris in 1898, and is now in the Musée Rodin in Paris. The Tate Gallery version

was made for an American collector of Greek marble sculpture living in England, Edward Perry Warren. Another marble version is in the Carlsberg Glyptotek in Copenhagen and a fourth, produced after Rodin's death, is in the Rodin Museum in Philadelphia, U.S.A.

Rodin used a studio system for the production of his marbles. They were carved by professional marble sculptors under his supervision with finishing touches by the master. The Tate Gallery version of 'The Kiss' was carved by a sculptor named Rigaud and finished by Rodin himself.

CONSTANTIN BRANCUSI
1867–1957
Maiastra 1911
Polished bronze on stone base
905 × 171 × 178 (35⅝ × 6¾ × 7)

In his early years in Paris Brancusi broke
away from the influence of Rodin, then
the leading modern sculptor of the day,
carving, from 1907 onwards, a series of
versions of his own on the theme of 'The
Kiss' which may have been a conscious
reference, or challenge, to the work of the
older artist. (Sculpture such as Rodin's
'The Kiss' is of the kind Brancusi habi-
tually referred to as 'beefsteak'). In his
versions of 'The Kiss' Brancusi dramati-
cally simplified form, suggesting a spiri-
tualisation of the subject, and an empha-
sis on the integrity and innate beauty of
materials – ideas that were to influence
later generations of sculptors. But his
mystic and primitivistic view of life found
its most original and compelling expres-
sion when, in about 1910, he turned
away from the human image and began
to make sculptures of animals, particu-
larly of birds, or rather of one bird, the
Maiastra, a mythical creature in the folk-
lore of Brancusi's native Romania. The
bird is shown singing its marvellous
song, which had miraculous powers. The
'Maiastra' of 1912 in the Tate Gallery
collection is one of seven variations of
this theme, two of which are markedly
taller and more elongated than this one.
The image of the Maiastra was even-
tually refined by Brancusi into the tall,
slender, almost completely abstract 'Bird
in Space', of which he completed twenty-
eight versions. This sequence of bird
sculptures has often been considered to
form the core of Brancusi's achievement.

The first 'Maiastra' was made by Bran-
cusi between 1910 and 1912 and is a
carving in white marble, now in the
Museum of Modern Art, New York. The
Tate Gallery version is a bronze cast
taken from this by Brancusi, to which he
added a carved stone base. It is also the
first work in which Brancusi introduced
the innovation of polishing bronze to its
natural golden colour. Apart from the
sheer beauty of effect, this helps to dema-
terialise or spiritualise the object. The
immateriality of the smooth, gleaming
bronze, and its upward thrust, is given
deliberate emphasis by the extreme con-
trast with the weighty rough stone base,
on which are carved in relief two birds

rather similar to the 'Maiastra', their
heads and necks coiled like springs below
the flat slab on which the bronze bird
rests.

'Maiastra' was bought from Brancusi
in Paris in 1913, by the American photo-
grapher Edward Steichen, who wrote in
his autobiography 'it appealed to me
immediately as the most wonderful con-
cept and execution I had seen by any
sculptor with the exception of Rodin'.
Brancusi installed it in Steichen's garden
at Voulangis, placing it on a square
section wooden pillar about ten feet high,
where it must have looked extraordinary,
shining in the sun, and seen from below
against the sky. It became known then in
the Paris art world as 'L'Oiseau d'Or' –
the golden bird.

HENRI MATISSE 1869–1954
Back I–IV 1909–30
Bronze reliefs 1890 × 1170 × 800
(74½ × 46 × 7) and with small variations

Henri Matisse began to make sculpture
very early in his career, from about
1900, and it is probably in his sculpture,
rather than in his painting, that he rea-
lised most fully the interest in the human
figure which he claimed to be central to
his art: 'What interests me most is
neither still life, nor landscape but the
human figure. It is through it that I best
succeed in expressing the nearly religious
feeling that I have towards life.'

In many of his comments on his art,
both painting and sculpture, Matisse
makes clear that he is concerned not with
detail but with picking out elements of
the model that correspond to his vision
and then finding a purely sculptural or
painterly form that conveys in a heigh-
tened way his feeling for it. Sarah Stein, a
pupil at the academy run by Matisse in
Paris from 1908–11 recorded him saying
that an 'undecided, indefinite' form can-
not express what the artist sees: 'There-
fore, exaggerate according to the definite
character for expression . . . The model
must not be made to agree with a precon-
ceived theory or effect. It must impress
you, awaken in you an emotion, which
you in turn seek to express.'

Matisse's series 'Back I–IV' perfectly
reflects this approach for in it can be
traced, in one of the most extraordinary
sculptural series of the twentieth century,
the evolution of his vision of the formal
structure and the emotional significance
of the female back. This subject, it is
worth noting, had been a major preoccu-
pation of Cézanne, one of Matisse's artis-
tic heroes, in his late paintings of bathers.
The first 'Back' (illustrated above left)
was made by Matisse about 1909–10

and shows a chunky, forceful emphasis
on the main muscles of the model. The
pose with one arm around the head and
the other by the side is compact, the arm
on the right side to some extent balanced
by the prominent breast seen on the left.
The rest of the series shows a progressive
simplification towards the massive,
primitive unity of the final version made
in 1930 (illustrated above right).

JULIO GONZALES 1876–1942
Maternity 1934
Welded iron on stone base
1305 × 410 × 235 (51¾ × 16 × 9¼)
excluding base

Julio González was born in Barcelona. His
father was a jeweller and metal worker
and González learnt this trade in his
father's workshop. In 1900 the whole
family moved to Paris where González
met Picasso and Brancusi, both of whom
became friends. Until about 1927 he sup-
ported himself by making jewellery and
decorative metalwork but also exhibited
paintings and some sculpture. He then
began to make sculpture from welded
iron, the great tensile strength of this
material enabling him to make work of
an unprecedented openness, which he
referred to as 'drawings in space'. In
1928, Picasso began to use González's
technical expertise and equipment to
construct his own very open, linear
sculptures of that time, and González in
turn was stimulated to start to produce
the body of welded iron sculpture for
which he is best known, and which had
considerable influence on later artists.

González's sculpture always retained a
figurative reference although it may
appear to be very abstract, and 'Mater-
nity' is typical in this respect. The open
loop at the top represents the head with
strands of hair sticking out into space
from the open ends of the loop. Below are
two elements presumably representing
breasts and below them a configuration
which suggests the presence of a child.
The conical formation of thin rods is an
indication of drapery. The art historian
Josephine Withers has suggested that it
may be an evocation of the type of Virgin
and Child found in the entrance of Gothic
Cathedrals.

The implications of the sculpture of
González were perhaps most fruitfully
taken up and developed by the American
sculptor David Smith. In the 1940s and
1950s Smith created sculpture from,
first, welded scrap iron, and then from
stainless steel. In his later, stainless steel
works, such as 'Cubi XIX' (see p.149)

Smith evolved a new kind of sculpture,
abstract, monumental in scale, con-
cerned with light and space and the
formal beauty of the material itself,
whose light-reflecting properties Smith
controlled and enhanced by texturing the
surface. With such works Smith, perhaps
the most celebrated American sculptor of
the post-war era, came to influence pro-
foundly the development of sculpture in
the 1960s.

BARBARA HEPWORTH 1903–1975
Bicentric Form 1949
Blue Limestone 1587 × 483 × 311
(62½ × 19 × 12)

'Bicentric Form' is one of a number of
sculptures by Hepworth of upright forms
in which the human figure appears to be
related to ancient standing stones. This is
made explicit in, for example, the later
'Two Figures (Menhirs)' of 1964 in the
Tate Gallery collection. Menhirs is a term
for the standing stones found at Stone-
henge and Avebury, and on many other
sites all over western Europe. 'Bicentric
Form' also belongs in the context of Hep-
worth's particular preoccupation in the
late 1940s and early 1950s with making
sculptures of groups of upright forms
explicitly relating to the human figure
and human relationships. In 1952 she
wrote that this preoccupation dated back
to her 'Three Forms' of 1935 (p.185),
which she said 'initiated the exploration
with which I have been preoccupied con-
tinuously since then and in which I hope
to discover some absolute essence in
sculptural terms giving the quality of
human relationships.' Alan Bowness has
written of this phase of Hepworth's work
'. . . despite the abstract nature of the
forms, their human quality could not be
more evident . . . a social concern for
people in communities is characteristic of
Barbara Hepworth's work in the late
1940s . . .' The artist herself has des-
cribed how her preoccupation '. . . led me
to a renewed study of anatomy and struc-
ture as well as the structure of integrated
groups of two or more figures. I began to
consider a group of separate figures as a
single sculptural entity, and I started
working on the idea of two or more
figures as a unity, blended into one
carved and rhythmic form. Many subse-
quent carvings were on this theme, for
instance 'Bicentric Form' in the Tate Gal-
lery.' 'Bicentric Form' is in fact one of the
most monumental, imposing and pro-
foundly human of all Barbara Hep-
worth's sculptures since 1935 and
although interpretation of its very
abstract forms must be a matter of specu-

lation, it strongly suggests a harking
back to the archetypal theme of the
mother and child which appeared in Hep-
worth's work in the early 1930s: the
bulge pierced with a hole in the upper
part might represent the presence of the
child. However, the top, or 'head' of the
sculpture with its 'eye' is also foetal in
character, evoking an even more funda-
mental image of the theme of procrea-
tion, and the concept of two figures in
one also suggests, of course, the original
procreative embrace.

MARINO MARINI 1901–1980
Horseman 1947
Bronze 1638 × 1549 × 673
(64½ × 61 × 26½)

Marino Marini made his first sculpture on
the theme of the horseman in 1936–7
but his treatment of the subject changed
after the Second World War and took on
a new significance. According to the art
historian J.T. Soby 'His full realisation of
the theme began after he had seen the
Lombard peasants fleeing the bombing
on their frightened horses'. The artist
himself, in a letter to the Tate Gallery in
1953 wrote: 'The sculpture is the result
of a sad period which Italy passed
through during the war. The work is
enclosed in geometrical lines and is very
precise in its tragic and human signifi-
cance'. His mention of geometrical lines
is interesting since it calls to mind the
phrase 'the geometry of fear' coined by
the critic Herbert Read in 1952, and
widely used ever since to describe a dis-
tinctive phenomenon in British and Euro-
pean art in the aftermath of the Second
World War. This was the appearance of a
kind of sculpture which was basically
figurative but which employed a greater
or lesser degree of distortion, and jagged
hard-edged forms, to express anxiety, fear
and other themes related to the post-war
climate. Despite its angular expressive-
ness Marini's 'Horseman' has a timeless,
archaic quality and with its naked, bare-
back figure evokes the same symbolic
relationship of man to the natural world
that is found in the horse and rider in, for
example, Gauguin's 'Faa Iheihe' (p.110).
It also suggests an assertion of the forces
of life in the face of death, since the out-
thrust head and neck of the horse can be
seen as distinctly phallic. This interpre-
tation is supported by another, related,
version of the horseman theme by Mar-
ini, in the Guggenheim collection, in
Venice, in which the rider is given a pro-
minent erect phallus. Marini drew inspi-
ration from Etruscan and archaic Greek
art and his sources for this work also
appear to include Chinese T'ang horses.
An important part of the effect of Marini's
bronze sculptures comes from their
beautifully and expressively textured and
coloured surfaces, all created by the artist
working with chisels and chemical
agents directly on the metal after the
casting of the bronze.

Dada and Surrealism

Alberto Giacometti **Hour of the Traces** 1930

Eileen Agar **Angel of Anarchy** 1936–40

◁ Salvador Dalí **Metamorphosis of Narcissus** 1937 (detail)

Dada and Surrealism were movements of artistic and political revolt in the early decades of this century. The principal form of this revolt consisted in challenging the accepted and established forms of art and in promoting in art the irrational and imaginative, in place of the straightforward representation of the exterior, visible world. As André Breton, the founder of Surrealism and ex-Dadaist, put it, 'the work of art, in order to respond to the undisputed necessity of thoroughly revising all real values will therefore have to refer to a *purely interior model* or it will cease to be.' The key unifying thrust of both movements was found in philosophical and literary ideas; they were not traditional art movements and they had no particular 'style'. Dada and Surrealist art took various forms.

Surrealism grew out of Dada, and Dada itself was a manifestation of the response of writers and artists to the folly and butchery of the First World War. It started in Zurich, in 1916, when a writer named Hugo Ball founded a satirical nightclub which he called the Cabaret Voltaire. His aim he wrote, was 'to draw attention across the barriers of war and nationalism to the few independent spirits who live for other ideals'. As well as stage performances designed to insult and provoke the audience, the Cabaret Voltaire exhibited works of art also intended to provoke. One of the first artists represented there was Picasso and at the beginning Dada simply embraced the existing avant-garde, which its anarchic spirit then began to affect. Dada groups quickly formed in other centres. In Berlin, Dada was ferociously political and George Grosz became a leading figure. (see p.124 for his 'Suicide', painted just before the formation of the Berlin Dada group). The Cologne Dada group nurtured Max Ernst, who became one of the most important Surrealist painters. A separate development took place in New York from 1915, led by Man Ray and the French artists Francis Picabia and Marcel Duchamp, and as the First World War came to an end in 1918 a Dada group formed in Paris around the poets André Breton, Paul Eluard and Louis Aragon.

Dada art regularly included imagery based on industrial or scientific machinery, often provocatively used to imply that human existence is no more than a mechanical process. The greatest Dada work of this type is Marcel Duchamp's 'The Bride Stripped Bare by her Bachelors, Even' which is reproduced and discussed on p.159. Francis Picabia also made extensive use of machine imagery and two of his machine pictures were rejected by the supposedly avant-garde Autumn Salon in Paris in 1922. His response was quickly to paint and submit 'The Fig Leaf', an attack on the post-World War I revival of traditional values which he associated with the censorship of his work. A major source of inspiration for this revival was the great nineteenth-century classicist Ingres,

Salvador Dalí **Lobster Telephone** 1936

Joan Miró **A Star Caresses the Breast of a Negress** 1938

Roland Penrose **Portrait** 1939

noted especially for his emphasis on the discipline of drawing. Picabia's figure is derived from a famous Ingres in the Louvre and the inscription; DESSIN FRANCAIS (French Drawing) is a sardonic reference to Ingres's style then being imitated by others, such as Picasso in his neo-classical phase of the early 1920s. (The fig leaf, in French a vine leaf, is a symbol of censorship.)

By this time Dada in Paris had split into three warring factions led by Picabia, Breton and Tristan Tzara, one of the original Zurich Dadaists. It was Breton who gave a new direction to the movement by creating a fresh and coherent theory of art which he called Surrealism. This theory Breton proclaimed in the *Manifesto of Surrealism*, published in Paris in 1924. In it he continued the Dadaist attack on western society, focusing particularly on its materialism, 'the rule of logic' as he called it, and proposing a new emphasis on the imagination: '*Perhaps the imagination is on the verge of recovering its rights*. If the depths of the mind harbour strange forces capable of either reinforcing or combating those on the surface *then it is in our greatest interest to capture them . . .*'' Breton here locates the imagination in 'the depths of the mind' and his theory was based on his knowledge of psychology, in particular Freud's theory of the unconscious mind and its importance. The aim of Surrealism was to present in art not external reality but the reality of the human mind, especially those aspects of it not normally paraded in public. By confronting people with these kinds of hidden realities in the mirror of art, the Surrealists hoped to change the values of western society and to bring about social change.

The Surrealist approach to making art was broadly based on the psycho-analytic procedure of free association, together with the use of material obtained from dreams. Collage is a form of visual free association and used by Surrealist artists lent itself to the creation of dreamlike imagery: much Surrealist art consists of collage either two or three-dimensional, or paintings such as those by Magritte which are, in effect, painted collage. On the other hand, Miró and others developed ways of painting which were much more directly free-associational, leading to a more abstract and allusive system of signs and symbols.

Surrealism has been widely influential in the arts this century. Its effects on society in general are hard to assess but Surrealism undoubtedly played a part in, for example, the movements of social and political revolt and reform which took place in the West in the 1960s, as well as in the Pop Art of that decade.

The Tate Gallery owns one of the world's best museum collections of Surrealist art. This is in large part due to two British Surrealists who formed large collections, the late Sir Roland Penrose, a great friend of Picasso and Max Ernst, and the late Edward James, friend and patron of Dalí and Magritte.

MARCEL DUCHAMP 1887–1968
and RICHARD HAMILTON b.1922
**The Bride Stripped Bare by her Bachelors,
Even (The Large Glass)** 1915–23,
replica 1965
Mixed media on glass 2775 × 1759
(109 × 69)

The original 'Large Glass' by Marcel
Duchamp is in the Philadelphia Museum
in the U.S.A. and is too fragile to travel.
The Tate Gallery replica was made with
Duchamp's permission for his retrospec-
tive exhibition at the Tate Gallery in
1966. It is an extremely careful and
accurate reconstruction of the original
and was signed by Duchamp when he
came to London for the exhibition.

The 'Large Glass' is one of the most
celebrated avant-garde works in the
history of modern art. To make it
Duchamp used dramatically unconven-
tional materials and techniques includ-
ing chance procedures. Duchamp sought
to establish that a work of art can take
any form that the artist considers appro-
priate to his ideas and can be made of any
materials the artist thinks fit. This was an
important freedom for modern artists and
led to some extremely interesting later
developments.

The 'Large Glass' has always resisted
interpretation; Duchamp himself, in
1934, published 'The Green Box', a flat
case containing replicas of 94 items of
notes, drawings, and photographs relat-
ing to the creation of the 'Large Glass'.
From this it is fairly clear that part of his
intention was to create an ironic image of
human love-making as a mechanistic
and endlessly frustrating process. The top
half of the work represents the Bride, the
lower half the Bachelors, and the whole
seems to represent the ritual climax of the
kind of traditional wedding ceremony at
which the bride was formally disrobed
and put to bed with her new husband in
the presence of witnesses.

The Bride is provided with no less than
nine Bachelors, the upright forms in the
lower glass, which Duchamp also named
the Malic Moulds, a pun on both the
word male and phallic. The Bride is repre-
sented by the mechanical elements on
the left of the upper glass. The pink cloud,
called the Blossoming, represents her ris-
ing desire for the Bachelors and from
within it she signals to the Bachelors
with the three elements which suggest
flag-like waving rectangles of cloth. The

Bachelors respond by producing Illumi-
nating Gas which they pump along
Capillary Tubes to the cone-shaped
Sieves. Duchamp stopped work at this
point and pronounced the Glass 'definiti-
vely unfinished' but we know that the
Illuminating Gas would have emerged
from the end of the chain of sieves,
splashed down in the empty lower right
part of the Glass and was then directed
upwards through the centres of the four
circular elements, the Oculist Witnesses,
to land finally near the tip of the Blossom-
ing. Duchamp did represent its landing,
by the scatter of holes in the Glass known
as the Shots. The whole sequence forms a

disguised account of an incomplete sex-
ual act.

Most of the work was done with oil
paint backed by lead foil. But the contents
of the Sieves were originally created by
allowing dust to settle on the Glass,
which Duchamp placed flat on trestles by
the open window of his New York apart-
ment and left for more than a year. The
position of the 'Shots' was determined by
firing paint-tipped matches at the Glass
from a toy cannon, and the Oculist Wit-
nesses were created by having the Glass
mirror silvered and then scraping away
to form the patterns, which are based on
a type of optician's eye testing chart.

GIORGIO DE CHIRICO 1888–1948
The Uncertainty of the Poet 1913
Oil on canvas 1060 × 940 (41¾ × 34)

More than ten years before the publication of the *Manifesto of Surrealism* the Italian artist Giorgio de Chirico found a way to use the traditional language of painting to describe, not the external world, but a world infused by dream and feelings of melancholy or foreboding. He achieved this, he said, 'by combining in a single composition scenes of contemporary life and visions of antiquity, producing a highly troubling dream reality'. He called this new art 'Metaphysical' and from about 1912 to 1915, while living in Paris, he produced a sequence of stunning pictures which a few years later provided a crucial example to the Surrealists in their more deliberate quest to create art from the unconscious. In 'The Uncertainty of the Poet' the elements of 'antiquity' are provided by the classical bust and the arcade, and the 'contemporary' by the bunch of bananas and the railway train running behind the wall in the background. The dreamlike effect is heightened by De Chirico's deliberate use of incorrect perspective.

De Chirico, like his contemporaries the Futurists, was fascinated by trains, seeing them as an almost magical means of being removed rapidly from everyday reality to strange and exotic places. Trains can often evoke strong feelings of sadness or nostalgia and De Chirico has described how they play a part in the mechanism of his paintings of this type: 'Sometimes the horizon is defined by a wall behind which rises the noise of a disappearing train. The whole nostalgia of the infinite is revealed to us behind the geometrical precision of the square . . .' The bananas, bursting with life and vividly coloured, contrast strongly with the marble bust and the hard geometry of the rest of the picture. In one of his writings of this time De Chirico refers to the 'happiness of the banana tree, luxury of ripe fruit, golden and sweet'. Fruit and flowers in art are generally a symbol of the briefness and insignificance of human life and pleasures, and here De Chirico may be making a contrast between this and the permanence of art represented by the bust. However, the combination of the bust and the bananas has an unmistakeable sexual significance and they also seem to be a symbol of the forces of life and the sensual delights of this world.

De Chirico's practice of creating irrational relationships of objects in equally irrational settings, to achieve a dreamlike visual poetry had a profound influence on the development of Surrealist art.

MAX ERNST 1891–1976
Celebes 1921
Oil on canvas 1255 × 1080 (49⅜ × 42½)

'Celebes' is one of a group of paintings done by Max Ernst between 1921 and 1924 at the time of the transition between Dada and Surrealism. They may be considered as the first Surrealist paintings and three of them are in the collection of the Tate Gallery.

Max Ernst took from Giorgio de Chirico the idea of bringing together unrelated objects in strange settings. This procedure was seized on by the Surrealists because it corresponded to the process of free association which was one of the methods used by Freud to discover the patterns of unconscious thought in his patients. These patterns, Freud believed, were also revealed in dreams.

Following Freud, the Surrealists attached great importance to dreams and the undoubted dreamlike character of de Chirico's pictures gave them a ready model for painting them.

In 'Celebes' the atmosphere of violence and the half mechanical, half elephant-like monster may be related to Ernst's traumatic experiences in the German army during the First World War which he mentions in his autobiography. The monster is somehow reminiscent of a military tank and the mechanical element on top has a single eye looking out as if from a periscope. The monster appears to be standing on an airfield and the trail of smoke in the sky suggests an aircraft being shot down. However, not all is simple, since also in the sky are two fish, swimming. More specifically, the artist has revealed some of the associations which produced the monster. The shape was derived from a photograph, found in an anthropological journal, of a corn storage bin used by a tribe in Sudan. Its elephant-like appearance and non-European origin must then have reminded Ernst of a playground chant about elephants when he was at school: 'the elephant from Celebes,/has sticky yellow bottom grease' is one couplet of it. Celebes is a large island in Indonesia next to Borneo.

RENE MAGRITTE 1898–1967
The Reckless Sleeper 1928
Oil on canvas 1160 × 810 (45½ × 32)

The Belgian painter René Magritte belonged to a group of avant-garde artists and writers in Brussels and in 1925 became aware of Surrealism in Paris. In 1927 he moved there, returning to Brussels in 1930.

'The Reckless Sleeper' is an interesting example of a Surrealist painting that refers explicitly to dreams, which were of great importance to the Surrealists: all were familiar with the ideas of Freud's *The Interpretation of Dreams*, in particular the point that in dreams many desires and thoughts are presented by the mind in censored symbolic form. The candle and the bowler hat in 'The Reckless Sleeper' are typical Freudian symbols for the male and female sexual parts. The painting also appears to be very much about death. The Sleeper is in a distinctly coffin-like box and the grey slab below often reminds people of a tombstone. However, its outline also strongly suggests the outline of a man's head, the nose on the left, the rounded back of the head on the right, in which case the embedded objects might represent thoughts.

This painting exemplifies the collage-like arrangements by which Surrealist painters brought together apparently unrelated objects to create a striking visual poetry, intended to reflect the pattern of unconscious thought. Juxtapositions such as the candle and the bowler hat, inexplicably embedded in a grey substance (which the artist has said is lead) were central to the Surrealist idea. The founder of Surrealism, André Breton, defined the effect of such images as 'convulsive' and in his book *Nadja* of 1928 he proclaimed 'Beauty will be CONVULSIVE or it will not be'. For Breton touchstone examples of convulsive beauty were to be found particularly in the prose poems, *The Songs of Maldoror*, by the mysterious nineteeth century writer, Isidore Ducasse, self-styled Comte de Lautréamont. One passage in the Sixth Song was stated by Breton to be 'the absolute manifestation of convulsive poetry'; it ends with the famous comparison ' . . . as beautiful . . . as the chance encounter of a sewing machine and an umbrella on a dissecting table'.

SALVADOR DALI 1904–1989
Metamorphosis of Narcissus 1937
Oil on canvas 510 × 780 (20⅛ × 30¾)

This is a surrealist reworking of a traditional subject, the Greek myth of Narcissus, which happens to deal with an aspect of human psychology of great interest to Dalí and before him to Freud. Dalí visited Freud in London in 1938 and took the picture with him. Impressed by the young man's seriousness Freud revised his hitherto very low estimate of Surrealist art.

In the ancient myth, as recounted by the Latin poet Ovid, Narcissus is a youth of great beauty; 'Many lads and many girls fell in love with him but his soft young body housed a pride so unyielding that none of those boys and girls dared to touch him.' Eventually a nymph named Echo fell in love with him. When he rejected her she pined away until only her voice was left. Hearing the complaints of his rejected lovers, the goddess of vengeance, Nemesis, punished Narcissus by arranging for him to experience for himself the pain of unrequited love.

Since he could only love himself she caused him to see his reflection in a pool of water. Narcissus fell in love, but was unable to embrace the beautiful stranger in the pool. Frustrated, Narcissus in turn pined away and finally died. At his death the goddess relented slightly and transformed him into the flower we know as the Narcissus.

Dalí shows us first of all Narcissus as he was in life, posing 'narcissistically' on a pedestal in the background, gazing down admiringly at himself. Then we see him kneeling in the fatal pool in the process of transformation into the strange hand holding an egg from which springs the new Narcissus flower. The transformation is brilliantly rendered by Dalí – the knee becomes a thumbnail, the upper arm a finger, the head the egg, the reflection in the water the base of the hand.

Shortly after the picture was completed in 1937, Dalí published a short book about it containing a long poem related to the painting, together with instructions for looking at it. Dalí suggests that the best effect is obtained by staring hard at the figure of Narcissus on the pedestal until your attention involuntarily switches away. 'The metamorphosis of the myth takes place at that precise moment for the image of Narcissus is suddenly transformed into the image of a hand which rises out of its own reflection.'

One of the reasons for the fascinating effect of Dalí's paintings is the brilliant technique with which he makes real for the spectator his fantastic imagery. Dalí memorably described this technique as 'Instantaneous and hand-done colour photography of the superfine, extravagant, extra-plastic, extra-pictorial, unexplored, super-pictorial, super-plastic, deceptive, hyper-normal and sickly images of concrete irrationality.'

PABLO PICASSO 1881–1973
The Three Dancers 1925
Oil on canvas 2150 × 1420 (84¾ × 56)

Picasso was not formally a member of the Surrealist group but he was close to them in Paris and his work was greatly admired by them. 'The Three Dancers' was reproduced in the Surrealist journal *La Révolution Surréaliste* in July 1925 which must have been very soon after it was finished.

With this painting Picasso began a completely new phase of his art. The importance he himself attached to it is indicated by the fact that he kept it by him for the next forty years, before finally selling it directly to the Tate Gallery through the intermediary of his friend the English artist and collector Sir Roland Penrose.

The painting shows three figures dancing in a room in front of French windows opening onto a balcony with railings. But behind the dancer on the right can be seen a fourth figure, a mysterious presence whose face, much more naturalistic than the others, is silhouetted against the blue sky. Picasso told Penrose: 'While I was painting this picture an old friend of mine, Ramon Pichot, died and I have always felt that it should be called "The Death of Pichot" rather than "The Three Dancers". The tall black figure on the right is the presence of Pichot. X-rays show that the picture began as a more conventional representation of three dancers rehearsing.

At this time Picasso was closely involved with the Russian ballet of Diaghilev. Since 1918 he had been married to one of Diaghilev's dancers, Olga Koklova, and in 1925 he spent the early spring with the company in Monte Carlo where they were performing.

The death of Ramon Pichot seems to have aroused a chain of memories and associations in Picasso which led him to transform the painting into its present form, in which the distorted angular figures, harsh colours and thickly worked paint surfaces seem to express violent and unpleasant emotions. Ramon Pichot was a Spanish painter and friend of Picasso's student days in Barcelona. In 1900 Pichot went with Picasso on his first long visit to Paris together with another young painter, Carlos Casagemas. In Paris Casagemas fell in love with a young woman friend of Picasso named Ger-

maine. She rejected him and Casagemas committed suicide, after first taking a shot at Germaine, who soon after married Pichot. This drama greatly affected Picasso and 'The Three Dancers' can be read as a reference to the affair. The female dancer on the left has sharp teeth, a grotesque exposed breast and wears a crude image of her genitals on the outside of her skirt. She is a type of *femme fatale* – a woman who destroys men through her sexuality – and could represent Germaine. Between her and the figure of

Pichot on the right is the central figure, which as well as being in a dance position is also unmistakeably in the pose of a crucifixion. This may represent Casagemas, martyred between Germaine and Pichot.

JOAN MIRO 1893–1983
Painting 1927
Water soluble background and motifs in
oil, on canvas 970 × 1300 (38 × 51)

The Catalan painter Joan Miró visited
Paris regularly from 1919 onwards and
was received with enthusiasm into the
Surrealist group when it formed in 1924:
'The tumultuous entry of Miró', later
wrote André Breton, the Surrealist
leader, 'marked an important stage in the
development of Surrealist art'. He also
once remarked that 'Miró may pass for
the most Surrealist of us all'. Breton's
enthusiasm may be explained by Miró's
way of painting, very different from that
of Ernst, Magritte or Dalí in that it was
much more spontaneous in its use of free
association and seemed to Breton to cor-
respond more closely to the Surrealist
ideal of an art coming straight from the
unconscious mind. Breton had defined

this ideal in the *Manifesto of Surrealism* as
'pure, psychic automatism . . . the dic-
tation of thought in the absence of all
control exercised by reason and outside
all aesthetic or moral concerns'. Miró
himself has described his procedure thus:
'Rather than setting out to paint some-
thing, I begin painting. As I paint the
picture begins to assert itself under my
brush. The form becomes a sign for a
woman or a bird as I work . . . the first
stage is free, unconscious'. In fact for
paintings such as this, Miró generally
made a series of drawings in which the
signs are developed from representational
sources. The process is more conscious
and planned than his own account sug-
gests. Miró's paintings then, are systems
of signs representing ideas and associa-
tions, and they mostly seem to celebrate
the basic experiences and processes of
life, particularly procreation, using ani-
mal and human imagery especially, as

Miró indicates, women and birds.

The forms in 'Painting 1927' should
be looked at in the light of this. For exam-
ple, the solid black form looks very like
the uterus, or womb, seen frontally,
while the red-tipped form surrounding it
suggests a breast with nipple at which is
feeding the brown creature. However, it
could also be a phallus penetrating the
brown form. On the left is a large white
form surrounded by black leech-like
swimming creatures. Miró said that it is a
circus horse – the white cloth kind, with
one person inside and the empty body
trailing behind. Miró, like all the Surrea-
lists, loved popular entertainments. He
was fascinated by the circus and similar
white circus horses appear in other
pictures of this time. The black line pro-
bably represents the ring master's whip.

Figurative Art between the Wars: The School of Paris

Pablo Picasso **Seated Woman in a Chemise** 1923

Georges Braque **Guitar and Jug** 1927

Fernand Léger **Leaves and Shell** 1927

Pablo Picasso **Woman in a Red Armchair** 1932 (detail)

In the aftermath of the First World War there took place a change of direction in French avant-garde art which has come to be known as 'le rappel à l'ordre' – the recall to order. This shift is a highly complex phenomenon, but in general it may be said that after the horrors of the war there simply seems to have been a desire for a return to calm and order in art as in life. In particular, there was a widespread revival of interest in classical art and culture.

The move amongst avant-garde artists towards a modern reinterpretation of the classical tradition found perhaps its most extreme manifestation in the art of André Derain: a leading Fauve in 1905, by about 1920 he was painting large, calm, still lives directly in the manner of the Dutch and French seventeenth-century masters, and equally imposing portraits, such as his life-size, full length of his wife, 'Mme. Derain in a White Shawl'. Derain is reported as having said at this time, 'Everything done by the Egyptians, the Greeks and the Italians of the Renaissance *is*. A great many modern works *are not*.' Also in the Tate Gallery collection is Derain's large 'Still Life' of 1942 and his remarkable self-portrait 'The Painter and his Family' which is reproduced and discussed on p.169.

In the early 1920s Picasso went through a classical period, in which he painted figures inspired by antique sculpture and the great French nineteenth-century neo-classical painter Ingres. References to both are evident in his 'Seated Woman in a Chemise', a work typical of this period. From 1925, however, Picasso reverted to a visual language in which the freedoms of Cubism were used to express diverse aspects of human experience, both personal and universal. This development began very abruptly with 'The Three Dancers' of 1925 (see p.164) and reached a climax with the celebrated 'Guernica' of 1937 (now in the Prado, Madrid). Closely connected with 'Guernica' is 'Weeping Woman', which is reproduced and discussed on p.171. In the early 1930s Picasso made a series of paintings inspired by his young mistress Marie-Thérèse Walter. One of these, 'Nude in a Red Armchair' is reproduced and discussed on p.170.

Georges Braque's 'Bather' of 1925, and particularly his still life, 'Guitar and Jug' of 1927, show how he, like Picasso, adapted the language of Cubism to a new end. In the case of Braque this was the creation of intensely harmonious paintings of a familiar world of the studio nude or still life.

In the early 1920s distinct figurative imagery also reappeared in the art of Fernand Léger. His 'Still Life with a Beer Mug' is reproduced and discussed on p.168.

FERNAND LEGER 1881–1955
Still Life with a Beer Mug 1921–2
Oil on canvas 921 × 600 ($36\frac{1}{4} \times 23\frac{5}{8}$)

In his formative period as an artist in
Paris from about 1908–14, Léger was
affected by Cubism, and found in Futur-
ism a confirmation of his own fascination
with the throb of modern life, its bustle,
its people, its architecture, its machines,
its methods of transport. To express this
vision Léger developed a personal form of
Cubism. Around 1912 his work became
almost completely abstract in the series of
'Contrasts of Forms' paintings, in which
numbers of tubular or blocklike forms are
set in dynamic opposition to each other.
By the end of the First World War how-
ever, he became convinced that his art
should be based on objects in the world
and he began to paint pictures of the city
in which recognisable but fragmented
elements of architecture, streets,
machines and people, appear in dynamic,
kaleidoscopic arrangements. But from
1920, influenced by the ordered abstrac-
tion of the De Stijl artists and the Purist
group in Paris, Léger increasingly sought
to reconcile his vision of modern life with
a high degree of order and clarity. His
'Still Life with a Beer Mug' is a marvel-
lous early example of this attempt.

The painting is constructed around
three contrasting elements – the geo-
metric grid-like background, mostly stark
black and white, which represents the
patterned floor, the wall and the window
frame of the kitchen; the relatively natur-
alistically treated table with its plates of
fruit and some other food, and pots of
butter, painted in warm soft tones; and
the beer mug itself floating in front of the
table, painted in an apparently random
pattern of brilliant orange-red, blue and
white, within a simply drawn, instantly
recognisable outline. These elements set
up a dynamic relationship among them-
selves, and the vibrant interaction of the
near-complementary orange-red and
blue of the mug is reinforced by the con-
siderable optical busyness of the back-
ground, particularly in the diamond pat-
tern of the floor. All this activity is
beautifully concentrated and controlled
by the rigorous geometry of the main
lines of the composition.

ANDRE DERAIN 1880–1954
The Painter and his Family *c.*1939
Oil on canvas 1765 × 1230 (69½ × 48⁷⁄₁₆)

Derain's attachment from about 1920 onwards to a form of painting rooted in the art of the past, particularly that of the seventeenth century, was based on a deeply thought out philosophy. Essentially he believed that art was timeless and that its function was to reveal meaning through elements of the real world that had, or could be given by the painter, a symbolic significance. Derain was not alone in his view, but the particular rigour and thoughtfulnes of his position made him a central and influential figure in the current of theory and practice of painting in France between the wars which is sometimes referred to as *traditionisme*.

'The Painter and his Family' is an allegory, a symbolic statement about art and the life of the artist. It is a completely invented scene, bearing no resemblance to the artist's actual working conditions, always alone in his studio. Derain is seated, in front of him on the table a still life of fruit in a bowl. He has paused in his painting to stare hard at the parrot perched on the easel. The art historian Jane Lee has suggested that the parrot as 'a symbol of worldliness and lust' refers to Derain's belief in the fundamentally dionysiac or joyful nature of art. The peacock also represents earthly glory, while the cat reflects Derain's interest in 'arcane sciences and esoteric practices'. The artist is supported by his family: out of the mysterious shadows behind him enters his sister-in-law bearing refreshment in vessels, in a manner strongly reminiscent of seventeenth century religious painting. Behind him his niece stands, her statuesque appearance suggesting a muse, the dog a symbol of her fidelity to the artist, and of his to art. The artist's wife, another muse, is reading a book, a reference to the realm of literature, and the artist's literary interests, as an integral part of his art. All these elements, including the artist himself, form a circle, the centre of which is the gap between artist, easel and his subject, the still life. It is across this gap that the act of creation takes place.

PABLO PICASSO 1881–1973
Nude Woman in a Red Armchair 1932
Oil on canvas 1300 × 970 (51⅛ × 38¼)

In January 1927 Picasso met a young woman named Marie-Thérèse Walter. He was forty-five years old and she seventeen. It is not known exactly when they became lovers, but her image starts to appear in Picasso's work in 1931, and from the early spring to the autumn of 1932, at his Château de Boisgeloup, he produced a series of canvases inspired by her which, as a group, constitute one of the high points of his achievement. These paintings are of a complex lyrical eroticism, celebratory of the serene physicality of Marie-Thérèse, who had appeared in Picasso's life just at the moment of the acrimonious break-up of his first marriage, to the Russian ballerina, Olga Koklova. In some paintings of the series, although not markedly in this one, the imagery is emblematic of fecundity and procreation as well as pure sexuality, and in September 1935 Marie-Thérèse gave birth to their daughter Maya. Surviving photographs of Marie-Thérèse, one of them showing her on a beach in a bathing costume holding a large round beach ball, another of her in a sleeveless dress holding a white dove in each hand, reveal the extent, surprising perhaps, to which Picasso presents us in this picture with her essential physical characteristics. She was plump and compact with a quite small, high bosom; above all she had a striking 'classical' straight-nosed profile and straight short-cropped blond hair.

In this, as in almost all his paintings of Marie-Thérèse, Picasso sees every part of her in terms of a basic system of sensuous curves. Even the scrolling arms of the chair have been heightened and exaggerated to echo the rounded forms of the body. The abrupt right-angle of the chair's back provides an essential element of contrast. The forms given to the woman's arms are not random inventions, but echo her erotic anatomy of hip and thigh. In the right arm Picasso presents a view of this anatomy on a reduced scale, seen from the other side: a view of rounded buttocks and the back of the thighs. This kind of double, or metamorphic, image is often found in Picasso's work of this time. The other arm presents an even more intimate view, as if of the model lying on her back with legs apart

exposing the v-shaped genital area, just above which Picasso has placed an extraordinary passage of thick, creamy, sensually applied, white paint. The hand of the white, right arm resembles the wing of a dove, a reading given credence by the photograph mentioned above, and it is clear that Picasso sometimes associated Marie-Thérèse with doves with all their traditional romantic connotations (not least, of course, their status as attributes of the Greek goddess of love, Aphrodite). The association with doves is possibly also echoed in the beautiful, soft, mauvish dove-grey in which Picasso has painted the thighs and torso. The face is

also a double, or metamorphic image. The white side, with Marie-Thérèse's yellow-blond hair, is a full face view, the eye half-closed. The blue side is a profile view, as of a personage leaning over the back of the chair staring intently, and kissing her on the lips. In this reading the blue arm would also belong to this personage. Here Picasso has created, in a way only possible through the freedom of Cubism, an ideal image of human love as a perfect merging of two bodies into one. As such it has a significance as universal as Rodin's 'The Kiss', but this universal image is given additional force by the deeply personal nature of its inspiration.

PABLO PICASSO 1881–1973
Weeping Woman 1937
Oil on canvas 608 × 500 ($23\frac{15}{16} \times 19\frac{11}{16}$)

In July 1936 the Spanish Civil War
began, with the revolt of General Franco
against the Republican government
which had replaced the Spanish
monarchy in 1931. In January 1937
Picasso, a supporter of the Republic, was
asked to paint a mural for the Spanish
Government pavilion at the Paris World's
Fair that year. The artist agreed, but did
nothing. On 26 April 1937 German
bombers, sent by Hitler on behalf of
Franco, attacked and devastated the Bas-
que town of Guernica. Two days later
Picasso began his mural, a canvas
twenty feet wide picturing, in the expres-
sive and symbolic language that he had
been exploring since 'The Three Dancers'
of 1925, a scene of massacre and suffer-
ing in which women and children were
the principal victims. For one of the main
groups in 'Guernica', a weeping, scream-
ing woman holding her dead child,
Picasso made numerous studies of the
woman's head during the painting of the
picture but, after its completion on 4 June
1937 he continued, almost obsessively it
would seem, to return to the theme. In
June and July he made ten 'weeping
women' and in October three more, in
various graphic media. And he made four
oil paintings, one in June, one in Sep-
tember, and two in October within a
week of each other. The Tate Gallery
'Weeping Woman', dated by Picasso 26
October 1937, is the second of these, and
the last and the most complex and ela-
borate of the series. It puts the final full-
stop to one of the most celebrated epi-
sodes of Picasso's artistic life. In it the
emotion of grief is expressed with great
concentration and intensity through
both form and colour. The focus of the
composition is the jagged area of hard
blue and white forms around the mouth
and teeth, clenched savagely on a
handkerchief. Above, the eyes and fore-
head are also fragmented and dislocated,
and the woman appears almost literally
'broken up' with grief. The harshness of
the forms is echoed by the harshness of
the colours, the face, neck and hand
painted in acid, incongruous, yellow and
mauve and green, colours perhaps of
putrefaction and decay. The yellow and

mauve however, are complementary col-
ours, as are the blue and orange-red of
the woman's hat. The background, furth-
ermore, is painted in strong yellows, con-
trasting with the blues of the hat and the
blues and mauves of the hair, and Picasso
enormously heightens the impact of the
painting by the almost paradoxical bril-
liance and vibrancy of its colour scheme.
The power and immediacy of this paint-
ing also undoubtedly stems from the fact
that the face is that of a living person,
Picasso's mistress at the time, the photo-
grapher Dora Maar, who had been clo-
sely involved with the making of 'Guer-
nica', taking a remarkable series of
photographs of it through the stages of its
creation.

Euston Road, Neo-Romanticism and Henry Moore – British Art 1935–55

Graham Sutherland **Somerset Maugham** 1949

Henry Moore **King and Queen** 1952–3

Graham Sutherland **Black Landscape** 1939–40 (detail)

By the time the *International Surrealist Exhibition* was held in London in 1936 both the continental avant-garde extremes, of Surrealism and abstraction, had followers in Britain. Towards the end of the decade, however, extreme positions were modified, and there were some reactions. A distinctly humanist and representational current emerged in British art and flowed strongly through the forties and fifties. Within this current separate streams appear. John Piper and Paul Nash reasserted the importance of landscape, although their approach to it was romantic and imaginative, as was Graham Sutherland's and it was to the art of these three in particular that the term Neo-Romantic came to be applied. During the war they were joined by younger artists such as John Craxton and John Minton. Works by Sutherland, Nash and Craxton are reproduced and discussed on pp.174, 175 and 178. In 1948, Sutherland began also to paint portraits, making a distinctive modern contribution to the British portrait tradition, beginning with his celebrated 'Somerset Maugham'. An entirely individual figure was Cecil Collins, who evoked in visionary images humanity's search for a lost Paradise. In Collins's art this vision is expressed principally through the archetypal figure of the Fool, a symbol of the imaginative, spiritual man set in opposition to modern utilitarian civilisation. 'The Saint, the artist and the poet are all one in the Fool', he wrote.

Even at his most abstract in the early 1930s, Henry Moore never lost an essential concern with the human figure and his work always revealed powerful psychological forces. During and after the Second World War, in much of his work the human image became more specific than before, expressing a response to the war and its aftermath. His 'King and Queen' can perhaps be read as a reassertion of ancient values of social stability through monarchy and the family.

The most extreme reaction to the avant-garde came from the artists of the Euston Road School, a school of art at 316 Euston Road founded in 1937 and centred around the teaching of William Coldstream, Graham Bell, Claude Rogers and Victor Pasmore. Influenced by social considerations in the economic climate of the Depression, they adopted a straightforwardly realist style in the hope of taking their art beyond the narrow audience for the avant-garde. Works by Coldstream and Pasmore are reproduced and discussed on p.176 and 177. A highly personal realism, existential and erotic, matured in the work of Lucian Freud around 1950. His 'Girl with Dog' is reproduced and discussed on p.179.

GRAHAM SUTHERLAND
1903–1980
Black Landscape 1939–40
Oil on canvas 819 × 1321 (32¼ × 52)

Graham Sutherland began his career in
the 1920s as an etcher and engraver of
English landscape scenes in the imagina-
tive, Romantic tradition of Samuel
Palmer (p.70). When he began to paint,
about 1930, he retained this fundamen-
tally imaginative approach, combined
with a considerable degree of abstraction.
A crucial influence on his development as
a painter was his discovery in 1934 of
the landscape of Dyfed (Pembrokeshire)
in West Wales, whose particular topogra-
phy and atmosphere struck a strong
chord in him: 'I felt as much a part of the
earth as my features were part of me. I
did not feel that my imagination was in
conflict with the real, but that reality was
a . . . form of imagination . . . It was in
this country that I began to learn paint-
ing'. He explains that he discovered he
could not express his feelings for it simply
by painting what he saw, but had to let
his impressions work in his mind and
imagination until he could produce what

he referred to as a 'paraphrase' – a con-
densed essence of a particular aspect of
the landscape: 'It seemed impossible here
for me to sit down and make finished
paintings "from nature" . . . The spaces
and concentrations of this clearly con-
structed land were stuff for storing in the
mind. . .' Sutherland has also described
how, as he soaked himself in it, this coun-
tryside took on a metamorphic quality in
which different elements became part of a
unified vision: 'I would lie on the warm
shore until my eye, becoming riveted to
some sea-eroded rocks, would notice that
they were precisely reproducing, in
miniature, the forms of the inland hills.'
In Sutherland's paintings forms not only
metamorphose into each other but take
on powerfully expressive shapes and col-
ours. 'Black Landscape' was probably
inspired by the twin mountains of Clegyr-
Boia which Sutherland has described in
lyrical detail and which were clearly a
key element for him in the landscape
around St Davids: 'One approaches
across a wide plain from the north, its
emptiness relieved by the interlocking of
tightly-packed strips of field and their
bounding walls of turf-covered rocks.

One soon notices . . . what appear to be
two mountains. As one approaches
closer one sees that these masses of rock
scarcely attain a height of more than
seven hundred feet. But so classically
perfect is their form, and so majestic is
their command of the smoothly-rising
ground below, that the mind . . . holds
their essential mountainous significance.
A rocky path leads round the slopes of the
nearer mountain, where, to the west, the
escarpment precipitates itself to a rock-
strewn strip of marsh . . .' Much of this
can be recognised even in the abstracted
forms of 'Black Landscape'. Later he
speaks of 'the solemn moment of sunset'
when he feels 'the enveloping quality of
the earth which can create, as it does
here, a mysterious space limit, – a womb-
like enclosure . . .' This seems to give a
strong clue to the mood of 'Black Land-
scape' with its marvellous pink light of
the setting sun coming from the west to
cast deep, mysterious black shadows over
the hillsides. The rounded form of the
furthest mountain is echoed in the simply
defined perimeter of the plain to create 'a
womb-like enclosure.'

PAUL NASH 1889–1946
Totes Meer (Dead Sea) 1940–1
Oil on canvas 1016 × 1524 (40 × 60)

The British government appointed official
war artists in both the First and Second
World Wars. Paul Nash served as a war
artist in both and out of his experiences of
each produced, among much else, one or
two exceptionally large, powerful, and
disturbing paintings in which he gave a
personal expression to his recording of
the war.

'Totes Meer' is his most compelling
statement as an official war artist in the
Second World War. He spent the first part
of his service attached to the Air Minis-
try, from 1940–41 and most of his
Second World War pictures are of sub-
jects related to the war in the air.

Nash, like Graham Sutherland, effected
an imaginative, at times visionary,
transformation of what he saw. 'Totes
Meer' has its origins in a set of photo-
graphs taken by Nash at a dump for
wrecked German aircraft at Cowley near
Oxford. On 11th March 1941 Nash

wrote to the Chairman of the War
Artists' Advisory Committee, Kenneth
Clark (later Lord Clark) describing the
dream-like, or rather, nightmare, vision
of this place that had come upon him:
'The thing looked to me suddenly, like a
great inundating sea. You might feel –
under certain influences – a moonlight
night for instance – this is a vast tide
moving across the fields, the breakers
rearing up and crashing on the plain.
And then, no: nothing moves, it is not
water or even ice, it is something static
and dead. It is metal piled up, wreckage.
It is hundreds and hundreds of flying
creatures which invaded these shores . . .
By moonlight, this waning moon, one
could swear they began to move and
twist and turn as they did in the air. A
sort of rigor mortis? No, they are quite
dead and still. The only moving creature
is the white owl flying low over the
bodies of the other predatory creatures,
raking the shadows for rats and voles.'
The owl can be seen low on the horizon
on the right.

WILLIAM COLDSTREAM
1908–1987
Seated Nude 1951–2
Oil on canvas 1067 × 708 (42 × 27⅞)

As a student at the Slade School of Art in
1926 William Coldstream discovered
Cézanne, and was profoundly affected by
the Frenchman's obsessional system of
painting from nature: 'I became inter-
ested in real appearances . . . every
attempt at realistic painting, however
crude was for me a discovery' However,
by the early 1930s, influenced by current
avant-garde theory, Coldstream found an
increasing conflict between his need to
paint what he saw and the pressure to
abstract. He found too that in the prevail-
ing conditions of economic slump it was
hard to sell any art, and the market for
anything that looked at all abstract was
virtually non-existent. He gave up paint-
ing and worked for the G.P.O. Film Unit,
at that time producing highly realistic
documentaries directed by John Grierson.
When he returned to painting in 1937, it
was with a fully thought out idea of
'straight' painting, done directly from the
model, a transcription of what is seen.
This concept satisfied his personal artistic
needs and he hoped that it would more
generally benefit art and artists by
appealing to a wider public than the
avant-garde: 'It seemed to me important
that the broken communication between
the artist and the public should be built
up again and this most probably implied
a movement towards realism.' He then
joined Claude Rogers and Victor Pas-
more, who had started a teaching studio
in Fitzroy Street, and together they
founded the Euston Road School of Art.
The school itself was short-lived but its
style and philosophy remained influential
for the next two decades. The work of its
adherents is known as 'Euston Road
School'. Coldstream was appointed Slade
Professor at the Slade School of Art in
1949 and remained an influential
teacher until his death.

Coldstream's method was based on a
system of measuring using sightings
taken with the brush handle in order to
obtain a precisely correct relationship of
the parts of the model. The small col-
oured dots, lines and occasional crosses
visible on the figure in the painting are
measuring points. 'Once I start painting'
Coldstream has said, 'I am occupied
mainly with putting things in the right

place.' The sitter was a Slade School of
Art model and the painting required,
Coldstream recalled, at least thirty sit-
tings, each of about two hours. The easel
was set up about eight to nine feet from
the model who was seated against a
screen and repositioned accurately for
each sitting by reference to small col-
oured markers on it. The artist permitted

himself the use of only one brush for the
painting, a size nine Winsor and Newton
sable.

VICTOR PASMORE b.1908
The Quiet River: The Thames at Chiswick 1943–4
Oil on canvas 760 × 1015 (30 × 40)

Victor Pasmore was a founder member of the Euston Road School. In 1937 he and the painter Claude Rogers opened a teaching studio in Fitzroy Street, Soho. Later in the year, they were joined by William Coldstream and the studio blossomed into 'A New School . . . of Drawing and Painting' under the direction of the three of them. On moving to premises at 316 Euston Road it became known as the Euston Road School. Its prospectus stated: 'In teaching, particular emphasis will be laid on training the observation . . . No attempt, however, will be made to impose a style and students will be left with maximum freedom of expression.'

Euston Road painters favoured scenes of everyday London life, in much the same way as had Sickert and the painters of Camden Town, earlier in the century. Pasmore's paintings of the Thames at Chiswick, where he was living in the early 1940s, may be compared with Whistler's of the Thames at Chelsea. Like Whistler, Pasmore has extracted a delicate and highly aesthetic poetry from the River that already sets him apart from the generally rather sombre realism of Euston Road. In its delicate atmospherics this painting also looks back to Turner, and another in the series of Thames views of which it is part is titled 'Sun Shining Through Mist', an echo perhaps of Turner's famous 'Sun Rising Through Vapour' in the National Gallery in London. This series also displays distinct abstract tendencies and Pasmore moved steadily from this time onwards to an increasingly pure abstraction.

JOHN CRAXTON b.1922
Pastoral for P.W. 1948
Oil on canvas 2045 × 2626 (78½ × 103⅜)

The 'P.W.' of the title is Peter Watson, a wealthy collector and important supporter of the arts in Britain in the 1940s and 50s. As a young artist Craxton became friendly with Watson during the Second World War. He recalls seeing for the first time works by Picasso and Sutherland in Watson's London flat, and that Watson also at this time showed him reproductions of work by Samuel Palmer. 'They were all I needed' Craxton later said, adding, 'Palmer took the essence of something and paraphrased it so that one had a poetic image of it. It was a distillation of nature –' From this time Craxton developed a consistent pastoral vision of '. . . landscapes with shepherds or poets

as single figures. The landscapes were entirely imaginary; the shepherds were also invented – I had never seen a shepherd – but in addition to being projections of myself they derived from Blake and Palmer . . . A shepherd is a lone figure and so is a poet. I wanted to safeguard a world of private mystery and I was drawn to the idea of bucolic calm as a kind of refuge.' Craxton's early works were of a sombre mysteriousness, but in 1946 he went to Greece for the first time, discovering a landscape of light and warmth and the Dionysiac heritage of music, dance and lust of the goat-god, Pan. Greece was a revelation to Craxton and since that first visit he has spent much of his life there.

'Pastoral for P.W.' uses a sharp, Cubist derived language of form, and above all brilliant Mediterranean inspired colour,

to evoke a mood of pagan vitality. The painting, Craxton has said, 'was a celebration of the power of music' in which the goats '. . . daemonic, wilful and undisciplined, are held in thrall by the sound of a flute . . .' He added that 'I suppose the flautist was in origin myself but a very emblematic me'. The picture strongly suggests a reference to the Greek myth of Orpheus, the great musician, whose song was so entrancing that even the wildest animals sat at his feet to listen.

LUCIAN FREUD b.1922
Girl with a White Dog 1950–1
Oil on canvas 762 × 1016 (30 × 40)

Since the end of the Second World War,
Lucian Freud has been the practitioner of
a consistent realism based on working
directly from the model. Yet his paintings
also have an intensely personal char-
acter, an atmosphere of psychological
revelation and force that goes far beyond
the simple rendering of the presence of
the model. (With Sigmund Freud as his
grandfather, this aspect of his talent may
not be surprising). His paintings make
statements about human existence, and
also, perhaps incidentally, about the
nature of painting and the business of
being a painter; it is that, as much as any
other ingredient, that makes them such
extraordinary and compelling art.

Freud's career has so far fallen into two
quite distinct parts. Up to about 1958 he
worked in the smooth tightly focused
manner exemplified in this picture. After
that his handling of paint became much
freer and the slight stylisations that can
be detected in, for example, the treatment
of the eyes and mouth of the model in
'Girl with a White Dog' disappear. A
major work of his later phase, 'Standing
by the Rags' is reproduced and discussed
on p.221. Freud's early style has roots in
the smooth and linear portraiture of the
great nineteenth-century French neo-
classicist, Ingres. This, together with the
particular psychological atmosphere of
Freud's early work led the critic Herbert
Read to make his celebrated remark that
Freud was 'the Ingres of Existentialism'.
This sense that Freud gives of human
existence as essentially lonely, and spiri-
tually if not physically painful, is some-
thing shared by his great contemporar-
ies, Francis Bacon and the sculptor
Alberto Giacometti. These artists repre-
sented a view of life that was seen as
highly relevant in the atmosphere of
post-war Europe and which found a
theoretical philosophical expression in
the Existentialism of Jean-Paul Sartre.

The model for this and a number of
other major early works by Freud was his
first wife Kitty Garman, daughter of the
sculptor Jacob Epstein and his second
wife Kathleen Garman. A bronze portrait
bust of Kathleen Garman, begun by
Epstein the day after he met her in 1921,
is in the Tate Gallery collection.

Towards Abstraction: Art in Britain 1925–40

John Piper **Abstract I** 1935

From the mid-1920s a gradual resurgence of avant-garde art took place in Britain, reaching a peak about ten years later in the mid-1930s. Leading figures were Barbara Hepworth, Henry Moore, Paul Nash, Ben Nicholson, and John Piper and his wife, the writer Myfanwy Evans. The theorist, art critic and philosopher Herbert Read also played an important role.

One of the focal points of the new avant-garde was the Seven and Five Society. At its foundation in 1919, the Seven and Five was highly conservative. However, it was joined by Ben Nicholson in 1924 and became increasingly fresh and lively from then. In 1932 Hepworth and Moore also joined the Society and in 1934 Nicholson, who had been President since 1926, engineered a change of the rules: the Society was renamed Seven and Five Abstract Group and an all abstract exhibition, including work by Hepworth, Moore, Nicholson and Piper was held at the Zwemmer Gallery in London, in 1935. Also at the Zwemmer Gallery, the previous year, was the exhibition of *Objective Abstraction*, a non-geometric form based on freely applied brushstrokes, whose chief practitioners were Rodrigo Moynihan and Geoffrey Tibble. Meanwhile, in 1933 Paul Nash had founded Unit One, a group which also included Nicholson, Hepworth and Moore. Nash announced its formation in a letter to the *Times* in which he stated that the group was 'to stand for the expression of a truly contemporary spirit, for that thing which is recognised as peculiarly of *today* in painting, sculpture and architecture'. The only exhibition of Unit One was held in 1934, accompanied by a publication edited by Herbert Read, *Unit One, The Modern Movement in English Architecture, Painting & Sculpture*.

Members of Seven and Five and Unit One were in close contact with the international Abstraction-Création group in Paris and, encouraged by one of its leaders, Jean Hélion, Myfanwy Evans, assisted by John Piper, founded *Axis* 'A quarterly review of contemporary abstract painting and sculpture'. The first issue of *Axis* appeared in January 1935 and in 1936 work began on *Circle, International Survey of Constructive Art*, edited by the Russian Constructivist sculptor Naum Gabo, Ben Nicholson, and the architect J. L. Martin. Gabo lived in England from 1935–46 and was one of a number of distinguished continental refugees who made a vital contribution to the development of modern art in Britain during that period. Among the others was Mondrian, in London from 1938–40.

Ivon Hitchens **Coronation** 1937

The other major avant-garde movement of the inter-war period, Surrealism, staged a major manifestation in London in 1936 with the sensational *International Surrealist Exhibition*. This was organised by Roland Penrose, the painter, poet, collector and friend of Picasso, together with the poet David Gascoyne, assisted by a committee which included Henry Moore, Paul Nash and Herbert

Ben Nicholson **Guitar** 1933 (detail)

Read, who wrote the introduction to the catalogue. These three, therefore, had a foot in both the abstract and Surrealist camps. However, from its foundation in Paris in 1924, Surrealism always had a very abstract side, in the painting of Miró and the sculpture of Jean Arp, in particular, and their approach was reflected in the work of Hepworth, Moore and even Nicholson in the early 1930s. The clearest thinking on this issue was done by Henry Moore, who in an interview, published in *The Listener* in 1937, said that the 'quarrel between the abstractionists and the surrealists . . . seems to me quite unnecessary. All good art has contained both abstract and Surrrealist elements. . . .' Moore's 'Four-Piece Composition: Reclining Figure', reproduced and discussed on p.187, is typical of the powerfully imaginative abstraction of his work in the 1930s. Another major example is 'Composition' 1932 also in the Tate Gallery Collection.

Winifred Nicholson **Quarante Huit Quai d'Auteuil** 1935

Barbara Hepworth and Ben Nicholson moved towards a purer abstraction whose imaginative dimension is poetic and allusive. Hepworth's 'Three Forms' of 1935, is reproduced and discussed on p.185. Nicholson reached his most extreme point of abstraction in the group of white reliefs he made from 1934, arriving there via a refined and beautiful personal form of Cubism. Examples of both are reproduced and discussed on pp.183 and 184. His wife, Winifred Nicholson also painted pure, lyrical abstractions at this time as did Jessica Dismorr. In the 1930s the painter Ivon Hitchens, living in London, developed a freely painted, colourful and expressive form of abstraction, then in 1940 moved to the country where his painting, while remaining very abstract began to express a romantic, often brooding vision of nature. Christopher Wood, before his premature death in 1930, made a distinctive contribution to the fresh forms of painting which were emerging in Britain in the 1920s. On a visit to St Ives in 1928, he and Ben Nicholson 'discovered' the Cornish primitive painter Alfred Wallis, a retired fisherman whose childlike vision and practice of painting on irregularly shaped boards had a considerable impact on them both.

Paul Nash **Harbour and Room** 1932–6

The art of Paul Nash is rooted in a powerful imaginative response to landscape, but almost from the beginning of his career, reveals an equally powerful interest in pure form. 'Equivalents for the Megaliths', reproduced and discussed on p.186, is an example of the balance between these forces that he achieved in some works, while 'Harbour and Room', included in the 1936 *International Surrealist Exhibition*, and 'Landscape from a Dream', show him at his most Surrealist. 'Harbour and Room' was inspired by a visit to Toulon in 1930, where a mirror in his hotel room reflected scenes from the harbour outside.

BEN NICHOLSON 1894–1982
Guitar 1933
Oil on wood 832 × 197 (32¾ × 7¾)

Ben Nicholson's enthusiasm for the Cornish primitive, Alfred Wallis, led him to publish an article on his work (in *Horizon*, January 1943) in which, among other things, he noted the way in which Wallis deliberately cut irregular cardboard shapes from old boxes and composed his pictures to fit these shapes, often also exploiting the colour of the board itself as part of the painting. This gave Wallis's works a strong 'object quality', a vitality and life of their own, especially when simply hung on a nail, or propped on a shelf. Contemporary photographs of Nicholson's studio show 'Guitar' displayed on a mantlepiece in this way. Treating the work as an object in its own right like this strongly reinforces the independence from simply imitative or illusionistic representation which is so important to modern art. Perhaps it should be added that this particular effect is somewhat reduced in the case of both Wallis and Nicholson when their works of this type are seen framed and glazed in museum conditions.

In 'Guitar' the sense of life comes also from the texture of the surface, prepared with a layer of special plaster painted on while wet, from the physical bite of the incised lines, and perhaps above all from the nervous, bounding, calligraphic quality of the line itself which makes such a vivid presence of the guitar. Nicholson plays a Cubist game with the relationship between the material, wood, of which guitars are made, the fact that the picture is evidently on a wooden panel, and the fact that the wood colour and surface that we see is not natural but beautifully created by the artist. The fluently incised wavy line at the top of the panel serves a decorative compositional function but also describes a distant hilly horizon suggesting that Nicholson has imagined the guitar placed in front of a window. The red-striped white form might be a pottery jug, although its stripes also echo the frets of the guitar. Evidence of the influence of Surrealism on Nicholson at this time, is his description of this work as 'the scratched Surrealist guitar'.

BEN NICHOLSON 1894–1982
White Relief 1935
Oil on relief wood panel 1016 × 1664
(40 × 65½)

Nicholson's work on panel paintings
with incised lines, such as 'Guitar', led
him to the idea of working in full relief.
According to the artist his move into
relief came about as the result of a happy
accident when a chip fell out at the inter-
section of two lines on one of his panels.
The use of relief seems to have provided
him with an additional element in the
pictorial structure, which enabled him to
abandon one of the existing ones, recog-
nisable imagery, and develop a pure
abstraction. The white reliefs which
followed are remarkable not least for
their extremism, which is such that they
become emblematic of the ideas of purity
and order, expressing an ideal universal
beauty. The colour white in particular,
with all its associations of health and
hygiene, is of central significance in the
Modernist tradition stemming from Mon-
drian and De Stijl which Nicholson's
reliefs are part of. In them Nicholson's
already extraordinarily refined aestheti-

cism reaches almost spiritual heights. In
this work the principal elements are the
two circles which are played off against
each other, and against the structure of
rectangles. Both forms are in turn mani-
pulated within the spatial dimension
provided by the relief. This is the 'inter-
play of forces' which Nicholson has said
is central to his abstract art: '. . . you can
create a most exciting tension between
these forces'. The 'tension' here comes
from the relationship of the circles, par-
ticularly their differences, some of which
the spectator may only half consciously
perceive: for example one is drawn with a
compass and one freehand, and one
penetrates the layers of relief to a greater
depth than the other. The particular
effect of cutting circles through layers of a
relief is central to these works by Nichol-
son, as he has made clear: 'You can take
a rectangular surface and cut a section of
it one plane lower, and then in the higher
plane cut a circle deeper than but with-
out touching, the lower plane. One is
immediately conscious that the circle has
pierced the lower plane without having
touched it. . . . and this creates space. The
awareness of this is felt subconsciously

and it is useless to approach it intellec-
tually, as this, so far from helping, only
acts as a barrier.'

BARBARA HEPWORTH 1903–1975
Three Forms 1935
200 × 533 × 343 (7 × 21 × 13½)

In 1934 in the publication *Unit One* Barbara Hepworth wrote that her aim was 'to project into a plastic medium some universal or abstract vision of beauty'. In 1935 she completed 'Three Forms' her first sculpture to represent this ideal. This work has close affinities with Ben Nicholson's 'White Relief', also of 1935, in its devotion to pure white, its use of rounded forms set off against a rectangle, and by the way the sculptor sets up tensions and relationships between a number of similar but distinct, forms. In particular there is an interplay between the pure geometry of the sphere and the softer, more organic, slightly flattened pebble-like forms, which are set closer to each other

than to the sphere. A tension is in turn set up between these two by placing one flat and one on its edge.

'Three Forms' was made after an enforced break from carving caused by the birth of Barbara Hepworth's triplets by Ben Nicholson, two girls and a boy, on 3 October 1934. The artist later wrote: 'When I started carving again in November 1934, my work seemed to have changed direction, although the only fresh influences had been the arrival of the children. The work was more formal and all traces of naturalism had disappeared, and for some years I was absorbed in the relationships in space, in size and texture and weight, as well as in the tensions between the forms.' However, she also went on to make clear that these pure forms and their interrelationships have an ultimate human signifi-

cance: 'This formality initiated the exploration with which I have been preoccupied continuously since then, and in which I hope to discover some absolute essence in sculptural terms giving the quality of human relationships'. In the light of this it may not be too fanciful to see a connection between Barbara Hepworth's 'Three Forms' and her triplets, especially since they share the pattern of two similar elements and one different.

PAUL NASH 1889–1946
Equivalents for the Megaliths 1935
Oil on canvas 460 × 660 (18 × 26)

This work brings together four preoccupations of Nash, all of them central to his art yet rarely brought together in a way in which they are so fully integrated yet remain so individually explicit. They are: the mystical or symbolic qualities of inanimate objects; the English landscape and its history; the abstract qualities of structure and design; and an overall dream-like super-reality having links with Surrealism.

Megaliths are the great stones, remains of ancient temples, which can be seen in Britain particularly at Stonehenge and Avebury. It was Nash's first encounter with them that triggered his awareness of the mystery he could find in other objects such as driftwood, bones or shells, and in 1937 he published an article on the subject, *The Life of the Inanimate Object*. After his first visit to Avebury, Nash wrote:

'The great stones were then in their wild state, so to speak. Some were half covered by the grass, others stood up in the cornfields, were entangled and overgrown in the copses, some were buried under the turf. But they were always wonderful and disquieting and as I saw them I shall always remember them. . . . their colouring and pattern, their patina of golden lichen, all enhanced their strange forms and mystical significance.' The megaliths in particular seem to have been able to produce in Nash a state almost of waking dream or hallucination. In 1934, in his statement in *Unit One*, he wrote 'Last summer I walked in a field near Avebury where two rough monoliths stand up, sixteen feet high. . . . A mile away, a green pyramid casts a gigantic shadow. In the hedge at hand, the white trumpet of a convolvulus turns from its spiral stem, following the sun. In my art I would solve such an equation.' The solution to the equation, in 'Equivalents for the Megaliths' and others of Nash's paint-

ings, is to recreate the dream in which such disparate elements can co-exist in an irrational order that nevertheless possesses an imaginative truth. Nash achieves this not by literal representation of the megaliths, but by recasting them, inventing 'equivalents' for them whose formal geometry remains mysterious while creating a powerful element of abstract design. The megalith equivalents are set in a rolling, fertile landscape whose utter emptiness of human life contributes strongly to the dream atmosphere of the painting. In the distance the stacked disc form, equivalent for an ancient hill fort or earthwork, echoes the megaliths in the foreground and echoes too the green pyramid, the third element, with nature and the megaliths, of Nash's waking dream at Avebury.

HENRY MOORE 1898–1986
**Four-Piece Composition: Reclining
Figure** 1934
Cumberland alabaster 175 × 457 × 203
(6⅞ × 18 × 8)

This sculpture is an expression of the sin-
gle most important theme of Henry
Moore's art, the reclining figure, in
which the female form is related to land-
scape to create images resonant with
allusions to procreation, motherhood,
mother-child relationships and the rela-
tionship of all human life to the earth.

'Four-Piece Composition' is an extreme
manifestation of Moore's interest, at this
time and later, in the idea of splitting the
human figure into parts. He did this
partly in pursuit of one of the fundamen-
tal principles of his art which, in his state-
ment in *Unit One* in 1934, he defined
under the heading '*Full three dimensional
realisation.*' For Moore, since sculpture is
by its very nature three-dimensional,
then it became a matter of philosophical
principle to be as truthful to that nature
as possible. Beyond that, fully utilising
every aspect of the sculpture increases

the artist's scope for expression, and
actually breaking the forms apart creates
a further and dramatic enrichment of the
work through the changing relationships
of the parts as the spectator moves
around it. Later, Moore also commented
'I realised what an advantage a separated
two-piece composition could have in
relating figures to landscape. Knees and
breasts are mountains. Once these two
parts become separated you don't expect
it to be a naturalistic figure: therefore you
can justifiably make it like a landscape or
a rock.'

Here the arched form, which is in fact
the left leg of the figure, with bent knee, is
strongly suggestive of an arched cliff for-
mation. The boomerang shape, the artist
has said, represents a mixture of body
and leg, the leg being conceived as rest-
ing flat on the ground bent at the knee.
The large upright form is the head and
top part of the body, indeed Moore said, it
is 'nearly a body in itself'. The curved
shape carved out of the top of this ele-
ment was introduced to counteract the
excessive simplicity and abstractness of
the form but also has the implication of a

mouth. The small pebble-shaped element
is the umbilicus, or belly button, an
important symbol to Moore, representing
the connection of one life to another and
by extension the whole process of pro-
creation. The circle penetrated by a line
incised on the boomerang form could be
another umbilicus, the artist has said,
and to the outside observer it may also
suggest an image of fertilisation, just as
the mouth may appear to be open in an
orgasmic cry. These incised lines, and
those on the head form, are not intended
to have hard and fast readings as body
elements, although the circle on the head
could be an eye. The lines are there to
activate and emphasise the surface of the
sculpture, which for Moore was particu-
larly important in this case because of the
smoothness and translucency of the
stone, Cumberland alabaster, from which
it is made. However, people's enthusiasm
for the natural beauty of Moore's Cum-
berland alabaster carvings was such that
he later gave up using it, feeling that the
response to the material was interfering
with the significance of the sculpture.

Painting and Sculpture in post-war Europe 1945–60

Francis Bacon **Three Studies for Figures at the Base of a Crucifixion** *c*.1944 (detail, centre tryptch)

Jean Hélion **Nude with Loaves** 1952

Alberto Giacometti **Jean Genet** 1955 (detail)

The European art scene in the post-war era was complex and multifarious, but among the most notable of the European artists who emerged into full maturity in these years were Alberto Giacometti and Jean Dubuffet, both in Paris. To them must be added, in London, the British painter, Francis Bacon. All three of these artists developed what have been characterised as 'new images of man' (the title of a survey exhibition of this period held in New York in 1959) and their work has been widely interpreted as illuminating, in its different ways, the spiritual or social condition of humanity in their time. Giacometti, in particular, has been associated with the Existentialism of Jean-Paul Sartre. None of these artists was especially young, and all three had struggled through the decade before the war to find their true artistic path. All three, again, found this path during the war, Bacon in London, Dubuffet in Paris, and Giacometti first in Paris and then, from 1942–5, in Geneva in his native Switzerland. Giacometti did not exhibit in public for some time after the war, but the work of both Dubuffet and Bacon caused considerable shock and controversy when first shown, in 1944 and 1945 respectively.

Giacometti, who was born in 1901, has described his attempts, from his student days onwards, to realise his personal vision of reality ('ma vision de la réalité') by working directly from the model. He found in practice that he could not reconcile the nature of his vision with the presence of the model and turned to working from imagination and memory, making an important contribution to Surrealism from about 1930–35. His Surrealist work the 'The Hour of the Traces' is in the Tate Gallery collection, as is his 'Walking Woman', with its references to both archaic Greek, and African art. Eventually, after a period of five years from 1935–40 spent working daily from the model without satisfactory result, he again temporarily turned away from it and, still not without great difficulties, through the war years and just after, forged the style for which he is now chiefly known. His 'Man Pointing' is reproduced and discussed on p.192. Giacometti was always a painter as well as sculptor, and his portrait of his friend, the French writer Jean Genet, is reproduced and discussed on p.193.

Intimations of Francis Bacon's mature vision appear in three paintings of the Crucifixion which he made in 1933. However, he then found himself unable to paint consistently until sometime during the war, and it was in 1944 that he completed the painting with which, he once said, 'I began'. This was 'Three Studies for Figures at the Base of a Crucifixion' which is in the collection of the Tate Gallery. A later work, 'Study for Portrait of Van Gogh IV' of 1957 is reproduced and discussed on p.195. Bacon's art has some parallel with that of Giacometti in that it takes its point of departure from a naturalistic human image which then appears considerably transformed in the final work. What is

Karel Appel **People, Birds and Sun**
1954

César **The Man of Saint Denis** 1958

Lucio Fontana **Spatial Concept
'Waiting'** 1960

extraordinary about both of them is that from within the expressive, non-naturalistic structures of their painting and sculpture, there always emerges a vivid human presence.

Dubuffet's image of humanity is taken not directly from life but from art – of a kind. This was what Dubuffet named 'Art Brut' – raw art. Art Brut embraces graffiti, the art of the insane, of children and of 'primitive' or naïve artists, and folk art. The first two of these were of particular importance, graffiti most of all. In a general way, Dubuffet's interest in Art Brut represents a continuation of the old quest of the modern Western artist for sources of inspiration outside the sophisticated traditions of European culture. For Dubuffet it seems that these traditions were so discredited by recent historical events that only forms so far outside them, and so subversive of them, as graffiti, or the art of the insane, remained valid.

Dubuffet's concerns and attitudes were to a large extent shared by the Cobra group formed in 1948 by artists from Copenhagen, Brussels and Amsterdam and taking its name from the first letters of the name of each city. Leading members of the group were Karel Appel, Asger Jorn and Constant Nieuwenhuys (known simply as Constant).

Influenced by Giacometti, and in Britain by Henry Moore as well, there was a widespread development of sculpture in which the human figure, and sometimes animal forms, were subjected to a wide variety of expressive distortions or reconstructions, with varying degrees of abstraction also. Among the leading practitioners of this sculpture were Germaine Richier and César Baldaccini (known simply as César) in France, and in Britain, Henry Moore and a circle of younger artists, as well as Eduardo Paolozzi who lived, worked and exhibited in Paris from 1947–50.

Among more traditionally figurative artists prominent in Paris after the war were Balthus, one of the greatest figurative painters of the century, the previously abstract painter Jean Hélion, and the sculptor Raymond Mason. Abstract art continued to flourish, one of the most significant contributions to it in Paris being made by the widely influential painter Nicholas de Stael. Elsewhere, the Italian-based Lucio Fontana sought new ways of expressing space in painting, notably by puncturing or slashing his canvases so that the holes, or the slash, became themselves a metaphor for the whole of space.

JEAN DUBUFFET 1901–1985
Monsieur Plume with Creases in his Trousers (Portrait of Henri Michaux)
1947
Oil and grit on canvas 1302 × 965
(51¼ × 38)

In his lecture *Anticultural Positions*, given in 1951, Dubuffet said 'our culture is a garment which no longer fits. It is more and more estranged from our true life. I aspire to an art plugged directly into everyday living.' Dubuffet found his inspiration for such an art in what he called Art Brut, the art of outsiders, particularly the insane, and the anonymous art of graffiti. These things had a force and vitality stemming from the direct expression of their creators' feelings, untramelled by any consideration of 'art'. As well as reflecting the crude vision and energy of graffiti in the style of his images, Dubuffet developed a way of painting in which the colours and textures, and the materials themselves, evoked in an unprecedentedly direct way the urban environment in which graffiti, and the people and scenes that Dubuffet painted, are found. His paintings were made up of a thick messy impasto, in which oil paint was mixed with grit and other substances, including in some cases tar, as used for city roads. His use of tar was signalled in the title of his second exhibition in Paris in 1946, *Mirobolus Macadam et Cie – Hautes Pâtes*. (Hautes Pâtes, 'high pastes' is the term Dubuffet coined to describe these paintings). Furthermore, the images in the paintings were scratched or incised into the surface as graffiti are scratched onto a city wall. In 'Monsieur Plume' this characteristic is particularly vivid, not least because, typically, Dubuffet has cut through a surface layer to a lighter ground beneath. This painting was included in Dubuffet's third Paris exhibition, in 1947, titled *Portraits à Ressemblance extraits, à Ressemblance cuite et confite dans la Mémoire, à Ressemblance éclatée dans la Mémoire de M. Jean Dubuffet Peintre* (Portraits with extracted Likeness, with Likeness cooked and confected in the Memory, with Likeness exploded in the Memory of Mr Jean Dubuffet Painter). In similar playful and ironic vein the catalogue was headed 'Les gens sont bien plus beaux qu'ils croient' (People are much more beautiful than they think). These portraits, done from memory, were of his friends, writers, artists, art critics and art dealers. This is one of the six portraits Dubuffet made between December 1946 and January 1947, of the poet, painter and draughtsman Henri Michaux. The nickname 'Monsieur Plume' translates as 'Mr Pen' and probably refers to Michaux's prominence as a writer, combined with the fact that, even as a visual artist he was very much a draughtsman, strongly influenced by oriental calligraphy. The French writer André Pieyre de Mandiargues commented on these works: 'Inscribed as if with the point of a nail in the stained plaster these are the best portraits of modern times.'

ALBERTO GIACOMETTI
1901–1966
Man Pointing 1947
Bronze 1765 × 902 × 622
($69\frac{1}{2}$ × $35\frac{1}{2}$ × $24\frac{1}{2}$)

Between 1925 and 1928 Giacometti
made a group of sculptures which, later,
in a letter of 1948 to his gallery in New
York, he said were the 'closest I could get
to my vision of reality' but, he added, '. . .
they lacked something that I felt about
the whole, a structure, a sharpness that I
saw as well, a kind of skeleton in space'.
The search for these qualities led him
most immediately to the open-structured
very abstracted sculptures of his Surrea-
list phase, such as 'Hour of the Traces'
(p.157) in the Tate Gallery collection, but
the phrase 'a kind of skeleton in space'
seems an apt description too of his later
works such as this. 'Man Pointing' is in
fact one of the first sculptures in which
Giacometti finally realised to his own
satisfaction his vision of the human
figure. It is roughly life-size in terms of its
height but is inordinately thin. Giaco-
metti has described how, in the years
from 1942–7, during which he forged
this final style, first 'to my terror the
sculptures became smaller and smaller.
Only when small were they like A
big figure seemed to me to be false and a
small one just as intolerable and thus
with a final stroke of the knife they disap-
peared into dust.' Then, when he made
further efforts to make large figures after
his return to Paris in 1945, he found 'to
my surprise, that only when long and
slender were they like'. The extreme slen-
derness and blurred outlines of a figure
such as 'Man Pointing', combined with
its nevertheless vivid human presence,
tends to create a feeling of distance. This
is even more apparent in other sculp-
tures, such as the 'Four Figurines on a
Base', which gives the impression of a
group of figures seen on the horizon.
This, of course, is because things appear
smaller to us and less defined the further
away they are. So Giacometti is making
sculptures of the human figure as if he is
seeing it from a distance, and it seems
that this is the basic nature of his vision.
This would explain why his figures only
looked real to him when very small or
very thin. Beyond this Giacometti's sculp-
tures suggest a range of associations and
interpretations which may be left to the
viewer to explore. However, it is worth

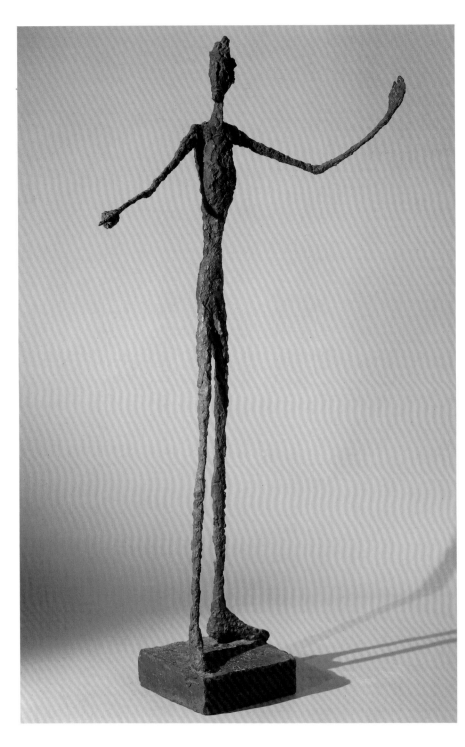

noting that they were greatly admired by
the Existentialist philosopher Jean-Paul
Sartre, as well as by Giacometti's friend,
Sartre's protégé, the Existentialist writer
Jean Genet, whose portrait by Giacometti
is discussed on p.193. Giacometti's
sculptures do undeniably suggest a vision
of human beings as isolated, lonely crea-
tures suffering the anguish of existence in
a universe without any given meaning.
Genet wrote of them: 'The resemblance of
his figures to each other seems to me to
represent that precious point at which
human beings are confronted with the
most irreducible fact: the loneliness of
being exactly equivalent to all others.'

ALBERTO GIACOMETTI
1901–1966
Jean Genet 1955
Oil on canvas 653×543 $(25\frac{7}{8} \times 21\frac{3}{8})$

In the context of Giacometti's association with Existentialism this portrait has a particular interest. Jean Genet was one of the leading Existentialist writers; he was also the author of a short book on Giacometti which the artist stated meant more to him than any other text, and which Picasso said was the best book about an artist that he had ever read.

About 1954 Giacometti saw Genet, whom he did not then know, sitting in a café and was fascinated by his appearance, especially his baldness which revealed the structure of the skull, in which Giacometti was particularly interested. He invited Genet to pose and a strong bond developed between the two men, their understanding of each other becoming so great that they were able to play the game of choosing from the passers-by those whom the other would find most desirable. The sittings resulted in two oil portraits and several drawings, and it was while they were taking place that Genet composed his essay on Giacometti.

The focus of the portrait is on the head, which is built up of successive layers of flickering linear brushstrokes to render, in a highly concentrated and compressed way, the presence of the sitter. Something of the significance of the head to Giacometti is indicated by a remark recorded by Genet 'I shall never manage to put into a portrait all of the power that there is in a head. Merely being alive already demands such will and such energy'. Within the head, the eyes have a peculiarly arresting quality, one of them being noticably blurred in focus. The critic David Sylvester has recorded Giacometti telling him that when the artist was a student in the 1920s he spent some months painting and drawing a skull: 'One day, when I wanted to draw a girl, something struck me, which was that suddenly I saw that the only thing that stayed alive was her gaze. Everything else . . . came to the same thing more or less as the dead man's skull'. Giacometti went on to stress that what he was interested

in was 'not the imitation of an eye [but] purely and simply a gaze. All the rest is a prop for the gaze'. Here, in the portrait of Genet, the quality of the gaze, combined with the slight upward tilt of the head and downturned mouth, create an impression of aloof remoteness. This remoteness also comes from Giacometti's characteristic distancing effects, created by the compression of the head and its smallness in relation to the body, and the shrinking of the figure into the lower right corner of the canvas. Genet himself was struck by this and wrote '. . . I have the impression . . . that the painter is pulling back (behind the canvas) the meaning of the face'.

CONSTANT (CONSTANT NIEUWENHUYS) b.1920
After Us, Liberty 1949
Oil on canvas 1395 × 1066 (55 × 42)

The Dutch painter Constant was one of the co-founders in 1948 of the international Cobra group, named from the opening letters of the words Copenhagen, Brussels and Amsterdam. This painting was included in the first major exhibition of Cobra art, *International Experimental Art*, held at the Stedelijk Museum in Amsterdam in 1949. In a letter to the Tate Gallery, Constant has explained that the title, originally 'A nous la Liberté' (We want Freedom), referred to the restriction of creative freedom by the official art system in Holland at that time, which he saw as symptomatic of a lack of liberty in society at large. He became even more disillusioned after Cobra fell apart in the early 1950s, and changed the title to its present one: 'I changed the title to express my doubts about the possibility of 'free art' in an unfree society, and at the same time, my hopes for the freedom all men are longing for.'

In a statement in the magazine *Cobra* (Issue 4) Constant set out a vision of cultural regeneration through spontaneity and free expression. In the same issue were reproductions of paintings by chilsen, some of which came from the exhibition of children's art held at the Stedelijk Museum in 1948–9. This had found an appreciative audience among Cobra artists in Holland who greatly admired the unrestrained imagination of the children's work. Constant was particularly interested since he had a five-year old son at the time, and something of the quality of children's art is certainly reflected in this painting. Against a dark background swarm strange and fantastic creatures with prominent teeth and wild eyes. Animal imagery abounds throughout Cobra art, and the name of the group seems to have been chosen, from a number of possible alternatives, partly for its animal associations. In 1978 one of the founders of Cobra, Christian Dotremont, commented: 'There is certainly much to be thought about in the choice of a name which is not to be an *ism*, but that of an animal. In fact, we were against all *isms*, which implied systematisation. And Cobra is, after all, that snake

which you often find in Cobra painting.' In the bottom left-hand corner, isolated and threatened in this nightmarish environment, is a tower-like structure topped by what may be a window, with a triangular roof with pennants on top and streamers of red and white floating below. The colour blue is also in evidence and Constant seems to be evoking the red white and blue French tricolor flag of liberty. From the bottom of the painting a ladder of escape leads up to this place of freedom at the top of the tower. The ladder's fragility and sharply receding perspective imply both the difficulty and the distance of the climb.

FRANCIS BACON b.1909
Study for a Portrait of Van Gogh IV
1957
Oil on canvas 1524 × 1168 (60 × 46)

This is one of eight paintings made by Bacon in 1956 and 1957 inspired by a self-portrait by Vincent van Gogh, 'The Painter on the Road to Tarascon' of 1888. The Van Gogh was destroyed during the Second World War and Bacon knew it only from a colour reproduction. His use of such a source is typical of his practice in general of taking his point of departure for a painting from a photographic image of some kind. Usually these are photographs taken directly from life, but in addition to the Van Gogh series he has also made a famous series of paintings based on a reproduction of the 'Portrait of Pope Innocent X' of 1650 by Velásquez. The distancing effect of working from a reproduction enabled Bacon in both cases to recreate the original image in terms of his own painting, and to produce works which were simultaneously a homage to the master of the past and an expression of his own ideas and feelings.

It should perhaps be stressed that Bacon does not copy directly from his sources. Rather, the images which strike him forcibly enough for him to use them in his art take their place in his memory, and it is from there that they surface into his painting, often radically transformed, but always retaining some vivid quality of the original. In this case, the original Van Gogh shows the painter, carrying his painting equipment, walking in bright sunlight along a country road on the way to the site of his day's work. The figure of the artist appears in marked isolation in the centre of the composition, framed between two trees and seen against a brightly lit background of fields and sky. The road runs directly across the painting parallel with its bottom edge, adding to the geometric grid within which the figure of Van Gogh is held. Although he is walking across the painting from right to left, Van Gogh has paused in mid-stride to turn slightly and stare straight out at the spectator. In Bacon's painting the figure is much more stooped, appearing to look down at the ground as it trudges along, suggesting a sense almost of despair. The paint, however, is brilliant in colour and applied thickly and with great freedom, in a way not quite matched either before

or after in Bacon's oeuvre, except in some others of the Van Gogh series. In this respect this work is an extreme example of a central and important characteristic of Bacon's painting, which is the remarkable balance he achieves between the purely abstract qualities of paint texture and colour and their representational function.

It is not known exactly why Bacon became so fascinated with this image of Van Gogh during 1956–7. He told the critic John Russell, 'Actually, I've always liked early Van Gogh best, but that haunted figure on the road seemed just right at the time . . . like a phantom of the road, you could say.' From this it may be speculated that at this point in his career

Bacon felt some particular kinship with that great lonely genius who, a complete failure in his own lifetime, and a suicide, perhaps represents more than any other figure the isolation and anguish of the artist struggling to create in a hostile and uncomprehending world.

Much of Bacon's art has been seen as expressing isolation, the 'space frames' that appear around the figure in many of his early works having been interpreted in this way particularly. The grid-like composition of the original Van Gogh painting, isolating the figure, may have struck Bacon for this reason, and the 'space frame' in fact appears in another of the Van Gogh series.

Picasso, Matisse, Léger, Kokoschka: Later Works

Among the earliest artistic events to take place in Paris after the liberation from German occupation in August 1944 was a retrospective exhibition of Picasso. The following year a similar homage was paid to Matisse, and beside these two founding fathers of modern art many other artists of the older generation were still alive and still had much to offer.

Pablo Picasso **Goat's Skull, Bottle and Candle** 1952

Picasso's 'Goat's Skull, Bottle and Candle' of 1952 is a striking meditation on death, painted in uncompromising monochrome and with jagged fragmented forms reminiscent of his 'Weeping Woman'. However, the year after he painted this picture a period of crisis in his personal life began when Françoise Gilot, his companion since 1946 and mother of his two youngest children, left him. This event seems to have stimulated Picasso to begin a complex reassessment of the direction of his art, culminating in about 1964 in the emergence of a late style of great vigour, which, misunderstood in the immediate aftermath of Picasso's death in 1973, has more recently been highly acclaimed. Picasso's 'Nude Woman with Necklace' of 1968 is reproduced and discussed on p.201.

Matisse's colourful, decorative, but intensely thoughtful and meditative art reached new heights in his paintings of interiors of the 1940s, but the most remarkable development of the last years of his life was his use of the medium of collage to create a group of works in which he made the final and most extreme statements of his vision of intense colour and harmony. One of these, 'The Snail' is in the Tate Gallery collection and is reproduced and discussed on p.198.

In the 1930s the human figure became increasingly important in Léger's art, and he also became increasingly concerned with the democratisation of art. He spent the war in the U.S.A. which he saw as a socialist dream of egalitarianism and opportunity. On his return to France he joined the French Communist Party and continued to develop an ideal vision of the life and leisure of working people. 'The Acrobat and his Partner' of 1948, a characteristic painting of this time, is reproduced and discussed on p.199.

Joan Miró **Woman and Bird in the Moonlight** 1949

After the war, Joan Miró had nearly four immensely productive decades before his death in 1983. 'Woman and Bird in the Moonlight' of 1949 is one of a group of works done at that time in which his characteristic fantasies are rendered more elaborately than previously, with a new intensity of colour which he was to develop further.

The Viennese Expressionist, Oskar Kokoschka lived in England from 1938–46 and in 1947 became a British citizen. A British pub is the implied setting for his remarkable self-portrait 'Time, Gentlemen Please' which is reproduced and discussed on p.200.

Pablo Picasso **Reclining Nude with Necklace** 1968 (detail)

HENRI MATISSE 1869–1954
The Snail 1953
Gouache on cut and pasted paper
2870 × 2880 (113 × 113⅜)

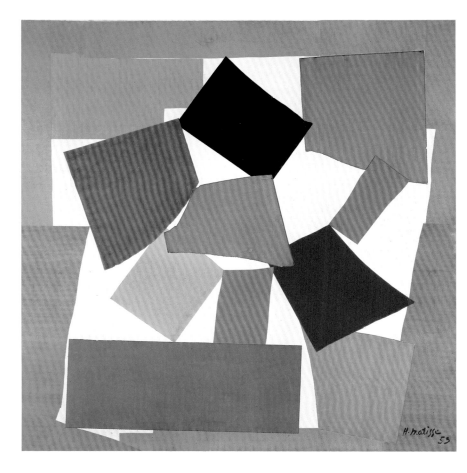

Matisse's collage works of this kind are usually referred to as 'gouaches décou-pees', 'cut-out gouaches', and they were made by preparing large sheets of paper with gouache – opaque water colour – which Matisse would cut, or sometimes, as can be seen here, tear, into shape. Matisse began to make regular use of this technique from 1948 when ill-health prevented him from working at his easel. He was able, however, to manipulate paper and scissors and to direct assistants in the placing of the coloured pieces on the background sheet. In the last years of his life Matisse produced a group of collage works, some of them, like 'The Snail', very large, which are regarded as the final great flowering of his art.

'The Snail' appears very abstract but like all Matisse's work it is rooted in his responses to the world about him. It is characteristic of Matisse that for 'The Snail' he should take his point of departure from an everyday creature associated with relaxed calm, and possessing in its shell a naturally occurring geometric form of considerable beauty. In 1952 Matisse made a much smaller gouache découpée of a snail, in which the spiral of the shell is unrolled into an open curved form. He told the critic André Verdet 'I first of all drew the snail from nature, holding it. I became aware of an unrolling, I found an image in my mind purified of the shell. Then I took the scissors'. In 'The Snail' this process of purification has resulted in an open structure of coloured fragments arranged in such a way as to suggest that they are floating in space in slowly spiralling movement within the enclosing frame of orange. It is clear that the coloured shapes themselves must be simply vehicles for the colour, which Matisse has selected and organised in such a way as to create a decorative effect of great intensity. The scheme consists of the three primaries, red, yellow and blue, and their three secondaries green, mauve and orange, with some variations of green and mauve. The non-colours black and white provide, respectively, contrast – a place for the eye to rest – and the dimension of space. Matisse deliberately places together complementary colours, red and green, blue and orange, yellow and mauve; complementary colours 'complete' each other and so look stronger and more vibrant when placed together. The colour scheme of 'The Snail' makes an interesting comparison with that of Matisse's 'André Derain', painted almost half a century earlier, also in the Tate Gallery collection, (p.116) and it may be suggested that, like the earlier work, 'The Snail' is an expression of Matisse's response to the colour and light of the Mediterranean scene – its sun, sky, sea and vegetation. What might be a cut-out silhouette of a snail with its horns out appears in the top left corner.

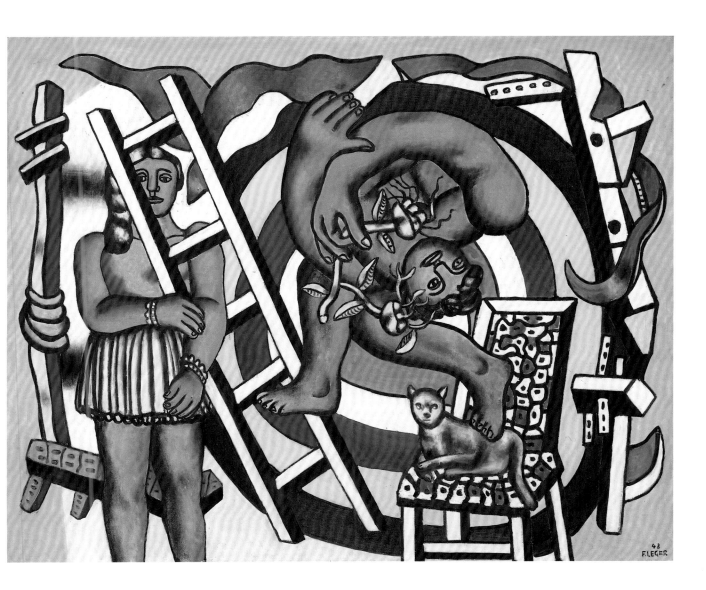

FERNAND LEGER 1881–1955
The Acrobat and his partner 1948
Oil on canvas 1302 × 1626 (51¼ × 64 1/16)

Early in his career Léger developed a
vision based on his love of the modern
urban and industrial scene, and his fasci-
nation with what he saw as the beauty of
machines. In the 1930s however, he
became increasingly interested in the
working people who animated this
environment and in the last ten years of
his career in particular, painted many
pictures celebrating the leisure activities
of the working population. These activi-
ties, cycling, swimming, picnicking,
music and the circus, Léger saw as tan-
gible symbols of human freedom. The
circus was the most important of these
themes, leading to his huge painting 'La
Grande Parade' of 1954, filled with an

entire cast of circus characters. Of these
the acrobat seems to have been of special
interest; in his 1926 essay on popular
entertainments, *Le Spectacle*, Léger wrote
'The most marvellous world is the "Big
Top",' and spoke of '. . . the little acrobat
high up there, risking his life each even-
ing, lost in that extraordinary metal pla-
net, bathed in spotlights . . .' For Léger
the acrobat and his partner were heroes,
and here he has made the acrobat the
expression of the dynamism that he saw
all his life as representing the essence of
modern life. In a catalogue note on this
painting when it was first exhibited in
Paris in 1949 Léger wrote: '. . . the acro-
bat and the disc around him represent
movement. The flower which he holds in
his hand and which is entirely composed
of curves reinforces the impression of
movement as does the form of the cat on

the chair.' Léger also pointed out the
importance of the contrast of the static
upright forms in the painting, which
further emphasise the energy of the acro-
bat: 'the straight lines of the chair and
those on the same side, near the edge of
the canvas, together with the ladder and
the acrobat's partner, constitute the sta-
tic part of the painting which is in violent
contrast with the dynamic part. The
more contrasts there are in a painting the
stronger the work is . . .' The vivid, rather
strange pattern of the chair upholstery
adds to the 'dynamic part' of the picture
and Léger also seems to have jokingly
made the back of the chair look like a
framed painting.

OSKAR KOKOSCHKA 1886–1980
Time, Gentlemen Please 1971–2
Oil on canvas 1300 × 1000 (51¼ × 39⅜)

Kokoschka was an important painter of Biblical and mythological subjects, landscape and still-life. But he first made his reputation, in Vienna before the First World War, as a painter of portraits that were exceptionally strongly characterised, and often appeared to reveal the mind or spirit of the sitter, as much as their physical appearance. Throughout his life Kokoschka was frequently his own sitter, producing many self-portraits, a number of them of a strange and disturbing character. This, the last of his self-portraits, painted when he was eighty-five years old, is one of the most striking of them all.

The subject is clearly the approach of death, and the setting would appear from the inscription to be an English pub. Kokoschka lived in England from 1938–46, becoming a British citizen, and visited the country regularly thereafter. The ritual calling of time in British public houses at the legal closing hour, must have struck him as an apt metaphor for the final summons of death, all the more striking for its association with preceding wordly pleasure. He may even have known Samuel Johnson's celebrated remark that 'There is nothing which has yet been contrived by man, by which so much happiness is produced as by a good tavern or inn.' The pub, then, becomes the metaphor for this world. A figure, possibly Death or Time, is holding open the door, but the artist seems to be refusing to go, staring intently upwards, perhaps in appeal towards the source of the words, among them 'time' heavily emphasised, which are painted in such a way as to appear floating in space, suggesting that they have only just been uttered. His hand gestures backwards as if to say 'just one more?' The vigorous paint handling, bright colours and intensity of facial expression make this painting a particularly moving example of Kokoschka's late work, akin in its mixture of animation and desperation to the late work of Picasso.

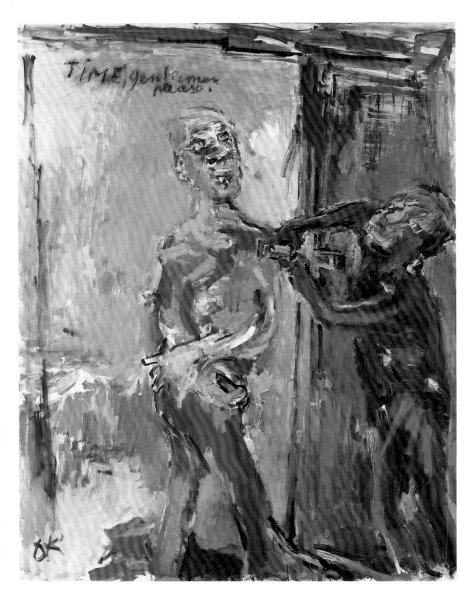

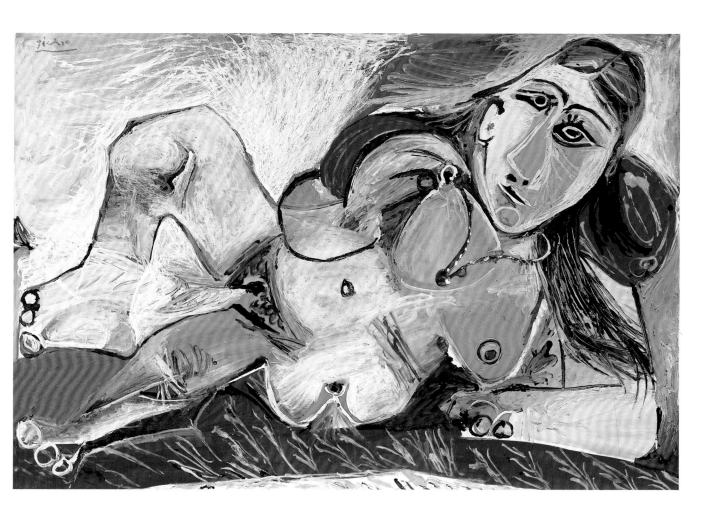

PABLO PICASSO 1881–1973
Nude Woman with Necklace 1968
Oil and oil/alkyd on canvas
1135 × 1617 (44$\frac{11}{16}$ × 63$\frac{5}{8}$)

The last phase of Picasso's career seems to have begun with a personal crisis: his companion of seven years, Françoise Gilot, left him, taking with her their two children. Simultaneously, a new love, Jacqueline Roque, came into his life and in 1961 became Picasso's second wife. It is her image, much transformed, which appears repeatedly in his late work, including probably this painting. Seemingly in response to this change of emotional circumstances Picasso embarked on a virtual frenzy of work, re-examining the basis of his art through a long series of drawings of the artist and his model and then a series of paraphrases, or reworkings, of celebrated paintings from the past, Manet's 'Déjeuner Sur L'Herbe' and 'Las Meniñas' by Velásquez among them.

By about 1964 Picasso had forged what is generally now seen as a distinctive late style, of which this painting is an outstanding example. Picasso's late work is characterised by an extraordinary energy and freedom in the handling of both paint and form, and by his devotion to the central theme of the female figure. As has been widely pointed out, these paintings convey very powerfully the feelings of a great artist, acutely aware of approaching death but refusing to accept it, and defiantly affirming life by a virtually continuous act of creation of works which in every way are themselves emblematic of the will to live and create. These paintings seem to have flowed from Picasso's brush like some natural outpouring, as he himself remarked to the writer Pierre Cabanne: 'There is a time in life after one has worked a great deal, when forms come of their own accord. Everything comes of its own accord, death too.'

Not the least remarkable aspect of paintings such as this is the way in which Picasso, after a lifetime of re-inventing the human body, does so with renewed vitality, continuing to surprise. The vitality of this painting is further expressed in the cloud of white paint cascading upwards behind the figure like fireworks or sea spray. Overall the paint is applied in a wide variety of types of brushwork and always with a visible urgency and energy. The forms of the body are arranged in a dynamic interplay, paralleled by the interplay of the complementary red and green which are the principal elements of the colour composition. In the midst of this activity the face is calm and unmoved, looking out at the spectator with a challenging stare which, taken with the pose, strongly suggests that when he made this painting Picasso had somewhere in his mind Manet's 'Olympia', one of the foundation works of modern art, which so profoundly shocked the Paris public at the Salon of 1865 with its image of a sexually attractive young woman, completely confident in her nudity, coolly returning the prurient gaze of the visitor.

Abstract Expressionism

Barnett Newman **Moment** 1946

Mark Rothko **Untitled** *c.*1946–7

Jackson Pollock **Number 14** 1951
(detail)

The term Abstract Expressionism refers to the new American painting evolved from about 1942–52, and developed further thereafter, by a loosely-knit group of artists living and working in and around New York City. Of these artists four in particular are now seen as leading figures, Willem de Kooning, Barnett Newman, Jackson Pollock and Mark Rothko. These four also represent something of the wide range of appearance of Abstract Expressionist painting, from the highly 'gestural' marks of De Kooning, and the work of Pollock, in which the paint is dripped, poured or even squirted from syringes onto the canvas, to the calm, softly brushed paintings of Rothko and the tighter, flatter, geometrically divided canvases of Newman.

Abstract Expressionism arose from the response of some of the most talented and idealistic artists of a generation to the artistic, social and political circumstances of America in the 1930s and 40s, and to the advent of the Second World War. During the war, and in the years immediately following, the future Abstract Expressionists sought to create an exemplary and moral art expressive of the universal psychological truths of human existence. Like earlier idealists such as Mondrian, Malevich and Kandinsky they also came to believe that such an art must be abstract, purified of references to the corrupt and compromised material world: in 1947 Rothko wrote 'The familiar identity of things has to be pulverised in order to destroy the finite associations with which our society increasingly enshrouds every aspect of our environment.' At first Rothko and the others turned to mythology, and archaic and primitive art, as repositories of the universal truths, or myths, for which they sought a new expression. In so doing they were certainly influenced by the ideas of C. G. Jung, who postulated a deep layer of the unconscious mind, the collective unconscious, in which humans shared a common pool of inherited experience, going right back, in theory, to the creation. The collective unconscious generated myths which were the expression of these common experiences and were made manifest in religion and the arts, and most clearly in art untouched by modern society. 'The Alchemist' of 1945 and 'Labyrinth No.2' of 1950, by Rothko's friend Adolph Gottlieb, are from a group of early works in which Gottlieb evokes ancient hieroglyphs and American Indian totem signs and petroglyphs (rock carvings). The Abstract Expressionists were also crucially influenced by the theory and practice of Surrealism, which since 1924 had been pursuing the idea of an art coming from the unconscious. In particular they were indebted to the Surrealist painting of Miró, in which fundamental themes of life are expressed in abstracted signs and symbols. There are echoes of Miró in Rothko's 'Untitled' of *c.*1946–7, an example of his painting at that time in which what he called 'organisms' float in an undefined space, evoking perhaps the origins of life on

Arshile Gorky **Waterfall** 1943

Willem de Kooning **The Visit**
1966–7

earth. More distinct figurative imagery can be seen in Pollock's 'Birth' of *c*.1941 which is reproduced and discussed on p.205. 'Birth' reveals the particular influence on Pollock of Picasso's very freely composed and painted, psychologically powerful paintings of the period *c*.1925–35, when he was closely associated with Surrealism. The Surrealist painters Max Ernst, André Masson, Roberto Matta, and the Armenian born American Arshile Gorky, also influenced the development of Abstract Expressionism, as did the Mexican muralists Orozco and Siqueiros. During the Second World War a number of the Europeans, notably Ernst, Masson and Matta, found refuge in New York, as did the abstract artist Piet Mondrian. Their presence seems to have acted as a catalyst and Abstract Expressionism was finally forged out of a synthesis of the new ideas of the Americans with Surrealism and the tradition of ideal abstract art.

Through the mid-1940s the Americans progressively stripped away all remaining figurative references from their work. Barnett Newman's 'Moment' of 1946 is a key painting from this time, when he was also turning from Classical myth to the Old Testament for his basic subject matter. 'Moment' probably refers to the moment of creation in *Genesis* – 'let there be light' – and marks an early appearance of the characteristic vertical band, running from edge to edge of the canvas, that Newman called a 'zip'.

Mature Abstract Expressionism was characterised by the development of a large, often mural scale, to create the imposing effects these artists sought, and by the use of flat, frontal, iconic compositional structures. Their effects also came in some cases from the deployment of unprecedentedly large fields of colour and, in the case of Pollock and the 'gestural' painters particularly, the elevation of the act of painting into a spontaneous outflowing so that the marks on the canvas became abstract signs for the artist's psychic world. Mature works by Pollock, Newman and Rothko, are reproduced and discussed on pp.206–208. Among other Abstract Expressionists represented in the Tate Gallery are Willem de Kooning and Clyfford Still. De Kooning, after a highly gestural, very abstract phase from about 1945–50 reintroduced the human figure, painting a celebrated series of 'Women' and placing increasing emphasis on the immediate sensuousness of colour and paint handling. 'The Visit' of 1966–7 is a characteristically voluptuous example of his later work. Clyfford Still was one of the most deeply introspective of all the Abstract Expressionists who, after ten years living in New York, moved in 1961 to Maryland to work in tranquillity. His painting simply titled '1953' is reproduced and discussed on p.209.

JACKSON POLLOCK 1912–1956
Birth *c.*1938–41
Oil on canvas 1164 × 551 (45⅞ × 21⅝)

'Birth' is one of a group of three paintings
by Pollock purchased by the Tate Gallery
from the estate of the artist's widow.
They represent three distinct and import-
ant phases of the artist's work and, it has
been suggested by the artist's old and
close friend Ruben Kadish, are from
among those works that Pollock retained
in his own possession because '. . . they
represented a peak point . . .'

'Birth' is a painting from the moment,
about 1940, when Pollock, in his late
twenties, was still assimilating various
influences. These, notably of Picasso,
Miró and American Indian art, are still
evident, but as his brother Sanford wrote
in a letter referring to this early phase of
Pollock's development '. . . his painting is
abstract, intense, evocative in quality.'
'Birth' would probably have been seen by
many people at that time as abstract, and
in it Pollock is already clearly moving
towards an increasingly free way of
applying paint in which the references to
the human figure, and the other signs
and symbols visible in this painting,
would finally be absorbed into an overall
web of marks. The Tate Gallery's 'Sum-
mertime' is a superb example of that later
development, whose shape and atmos-
phere, together with its title, suggest a
universalised, internal vision of the
natural world, possibly ultimately
inspired by the expansive landscapes of
the American West, whose importance to
him Pollock acknowledged.

'Birth' depicts a figure, presumed
female, possibly in the process of giving
birth. Only two features of the body can
be identified with certainty: a leg bent at
the knee in the lower left corner and a
large hand pointing upwards, towards
the middle of the right side of the canvas.
Above the hand are two circular mask-
like elements in which eyes and grimac-
ing mouths full of teeth can be discerned.
These masks, said to be inspired by
Eskimo and North-West American
Indian examples, contribute to the whole
effect of savage energy and anguished
writhing movement which make this
painting a convincing expression of the
theme indicated by its title.

JACKSON POLLOCK 1912–1956
Number 14 1951
Enamel paint on canvas 1465 × 2695
(57⅝ × 106⅛)

From about 1946 Pollock developed his
now famous technique of pouring and
dripping paint onto the canvas as a
means of achieving his stated goal of
creating art from the unconscious. Using
this method he was able to work in a free
and highly intuitive way, his ideas and
feelings finding direct expression in the
rhythmic patterns he created. In a well-
known statement of 1947–8 Pollock des-
cribed his way of working: 'My painting
does not come from the easel. I hardly
ever stretch my canvas before painting. I
prefer to tack the unstretched canvas to
the hard wall or floor. I need the resis-
tance of a hard surface. On the floor I am
more at ease. I feel nearer, more a part of
the painting, since this way I can walk
around it, work from the four sides and
literally be *in* the painting'. This gives
some idea of the unprecedented extent to
which for Pollock the process of painting
was a physical action, driven by inner
impulses, in the arena of the canvas.
According to Pollock, he would begin a
painting with an almost trance-like,
unconscious phase: 'When I am in my
painting, I'm not aware of what I am

doing.' However he also makes clear that
this is followed by a much more con-
sidered phase: 'It is only after a sort of
"get acquainted" period that I see what I
have been about. I have no fears about
making changes . . . because the painting
has a life of its own . . .' He goes on to
speak of 'an easy give and take' between
him and the painting and these state-
ments also bring out vividly the way in
which, after the initial phase, Pollock's
paintings continued to develop through a
deeply intuitive process.

From about 1946–50 Pollock's work
was effectively abstract, as in the Tate
Gallery's 'Summertime' of 1948. In
1951, however, his art changed and he
began to paint predominantly black
pictures in which symbolic figurative
imagery reappears, akin to that of his
early works such as 'Birth'. In 'Number
14' a horizontal form which might be an
animal or a human figure dominates the
upper centre right of the canvas. At the
right-hand end appears what might be a
grotesque head on a stalk-like body and
at the other end there appears to be a
large face looming through the bars of
black paint in the upper left-hand corner.
There is also a suggestion of another hor-
izontal figure lying beneath the principal
one. 'Number 14' is one of a group of
Pollock's black paintings all with similar

imagery which have been given a Jun-
gian interpretation by the art historian
Francis V. O'Connor, a leading authority
on Pollock. (It is well known that Pollock
underwent psychotherapy with two Jun-
gian practitioners in 1939–40 and
1941). O'Connor identifies the main
figure with the artist himself and sees the
paintings as being about the artist's rela-
tionships; '. . . they are best understood
not in terms of explicit sexual congress . . .
but in terms of the figure/protagonist/
artist's struggle in these works of 1951 to
re-establish his sense of, and capacity for,
relationship. The overriding drama of all
these dark paintings is the eternal strug-
gle to break away from the stranglehold
of the mother complex . . .' All such inter-
pretations remain highly speculative, but
there is no doubt that this painting pow-
erfully evokes a psychological drama all
the more disturbing for being ill-defined.
A full and extensive discussion of
'Number 14', together with Pollock's
'Birth' and 'Summertime', is in the *Tate
Gallery Catalogue of Acquisitions 1984–
86*, pp. 231–251.

BARNETT NEWMAN 1905–1970
Adam 1951–2
Oil on canvas 2429 × 2029 ($95\frac{5}{8} \times 79\frac{7}{8}$)

Barnett Newman was one of the most intellectual of the Abstract Expressionists, and in his art he is certainly the most arcane and numinous of them all. In a long unpublished essay, or 'monologue', written about 1943–5 and titled *The Plasmic Image* Newman set out his ideas, making it clear that the subject matter of his art was, in the broadest sense, the mystery of creation and the meaning of human existence. Among much else, he wrote '. . . in his desire, in his will to set down the ordered truth, that is the expression of his attitude towards the mystery of life and death, it can be said that the artist like a true creator is delving into chaos. It is precisely this that makes him an artist for the Creator in creating the world began with the same materials, for the artist tries to wrest truth from the void.' On the question of how this was to be done, Newman further wrote '. . . abstract art is a language to be used to project important visual ideas . . . The effect of these new pictures is that the shapes and colours act as symbols to [elicit] sympathetic participation on the part of the beholder with the artist's thought.' The critic Thomas B. Hess has described how in the mid-1940s Newman became particularly preoccupied with the Jewish myths of Creation, not only in the book of Genesis, but in the Kabbalah, the whole tradition of Jewish mystical thought. About 1946 Newman began to evolve a pictorial image, a band of light running vertically from edge to edge of the canvas, which echoed the consistent literary metaphor in Genesis, and in the Kabbalah, of light as the symbol of creation. More specifically, Newman may have drawn on certain traditions which evoke both God and man as a single beam of light – creator and created in one. The vertical band first appears in a group of paintings of which 'Moment' in the Tate Gallery collection is one (p.203). But Newman was dissatisfied with the effect of the band against a soft background, and in 1948 finally found the solution he sought in a painting which he called 'Onement I', consisting of a narrow band of light cadmium red running straight down the centre of a canvas painted in a uniform dark cadmium red. Of 'Onement I' Hess

has written: 'Newman's first move is an act of division, straight down, creating an image. The image not only re-enacts God's primal gesture, it also presents the gesture itself, the zip [Newman's term for the band of light], as an independent shape – man – the only animal who walks upright, Adam, virile, erect'.

'Adam' is one of a number of developments and variations of this concept made by Newman over the next few years and in its colour scheme and title in particular, seems to hark back quite directly to 'Onement I'. As Hess pointed out, as well as the 'zip' representing the idea of man, 'The red-orange stripe on its red-brown field could have suggested another metaphor from the Kabbalists' interpretation of Genesis'. This concerns the relationship between the Hebrew word *adamah* meaning Earth, the name

Adam, which directly derives from it, since God made man from the earth, and the Hebrew word *adom* which means red. The suggestion is that Newman may have been associating the colours he used with both earth and Adam in this image of creation. 'Adam' has a companion, 'Eve', painted at the same time. In a letter to the Tate Gallery of 1983 Analee Newman, his widow, wrote 'I think he thought of them as a pair because he worked on the first painting and then on the second continuously until they were finished and then named them 'Adam' and 'Eve'.'

MARK ROTHKO 1903–1970
Black on Maroon 1958–9
Oil on canvas 2665 × 3660 (105 × 144)

This painting comes from one of three series of canvases painted by Rothko in 1958–9 in response to a commission for murals for the small dining room of the Four Seasons Restaurant in New York. The Four Seasons, one of the smartest restaurants in the city, is in the Seagram Building, a celebrated classic modern skyscraper on Park Avenue designed by Mies van der Rohe and Philip Johnson. As he worked on the commission Rothko's conception of the scheme became more and more sombre and he abandoned the first series as being too light in mood. He then adopted a palette of black on maroon and dark red on maroon, and compositional structures of open, rectangular, window-like forms, rather than his usual arrangement of uniform rectangular patches, used for the first series. He later said 'After I had been at work for

some time I realised that I was much influenced subconsciously by Michelangelo's walls in the staircase room of the Medicean Library in Florence. He achieved just the kind of feeling I'm after . . .' The reference is to the motif of heavily pedimented blank stone windows set in the white walls of the ante-room of the Laurentian Library, which together with other architectural effects created there by Michelangelo, create an atmosphere noted for its oppressive, almost frightening, grandeur. In the end Rothko decided to withhold his murals from installation in the Four Seasons, his reported reason being that he did not wish his pictures to be a background to the eating of the privileged. Clearly, in any case, he had created a series of paintings whose particularly solemn and meditative character ill-suited a fashionable restaurant. It was these paintings, seen in Rothko's studio in 1960 by John and Dominique de Menil, that prompted these art lovers to commission Rothko to decorate a cha-

pel that they would build in Houston, Texas. The project, described by Rothko as the most important of his life, was completed just before his death in 1970.

In 1965, influenced by the idea that his pictures would be in the same building as Turner, Rothko suggested making a gift to the Tate Gallery. The works would be from the Four Seasons series and would be chosen by the artist to form a coherent group, to be shown in a space on their own. The gift was finalised in 1969 and the paintings arrived in 1970. On the day of their arrival, as the huge crates were being unpacked to reveal their contents, a cable was received from New York announcing that Rothko had been found dead in his studio.

CLYFFORD STILL 1904–1980
1953 1953
Oil on canvas 2359 × 1740 (92½ × 68½)

The paintings of Clyfford Still with their heavily worked surfaces, jagged craggy forms and sudden fissures, have often been seen as metaphors for the awesome landscapes of the American West. Still's own writings make it clear that the landscape metaphor is not wholly inapplicable, but that he in turn sees landscape as a metaphor for the unlimited expanses of the mind and imagination, and it is that purely metaphysical landscape that is to be seen in his paintings. In a letter of 1959, describing his own development as a painter he wrote: 'It was a journey that one must make, walking straight and alone . . . Until one had crossed the darkened and wasted valleys and come at last into the clear air and could stand on a high and limitless plain. Imagination, no longer fettered by the laws of fear, became as one with Vision. And the Act, intrinsic and absolute, was its meaning, and the bearer of its passion'. The 'Act' is the act of painting and Still's phrasing here gives an indication of the not less than sacred regard in which this act was held by the Abstract Expressionists (Newman, for example, explicity equated painting with the original Creation).

The sense of openness, of limitlessness, so important to Still and to much Abstract Expressionist painting, is often created, as here, by running the painting off the edge of the canvas: what is seen appears, simply, to be part of some potentially unlimited whole. Such a way of composing was unprecedented in the history of art and is one of the distinguishing innovations of Abstract Expressionism. In a letter to the Tate Gallery, Still wrote of this painting '. . . there was a conscious intention to emphasise the quiescent depths of the blue by the broken red at its lower edge while expanding its inherent dynamic beyond the geometries of the constricting frame.' The orange-red is a near complementary to the blue and does indeed have the effect of activating it.

Commenting on the title Still wrote '. . . My paintings have no titles because I do not wish them to be considered illustrations or pictorial puzzles. If made properly visible they speak for themselves.'

In the years immediately following the Second World War, Barbara Hepworth and Ben Nicholson continued to be the most outstanding British abstract artists. In August 1939, just before the outbreak of war, they had moved to the Cornish fishing town of St Ives, which since the end of the nineteenth century had attracted large numbers of artists. Hepworth and Nicholson were joined in St Ives by the refugee Russian Constructivist sculptor Naum Gabo, and the trio played an important part in keeping alight the flame of ideal abstract art through the war and into the post-war period. Then, Gabo pursued his career successfully in the U.S.A. while Hepworth and Nicholson achieved increasing fame and recognition in Britain and Europe.

Barbara Hepworth continued to develop her uniquely sensitive approach to making carved sculpture, although from about 1956 she also began to work in bronze. Her sculpture, while remaining substantially abstract, nevertheless embodied her strong response to the light and atmosphere and appearance of what she described as the 'remarkable pagan landscape which lies between St Ives, Penzance and Land's End', as well as including allusions to the human presence in that landscape. Hepworth's 'Figure (Nanjizal)' of 1958 is reproduced and discussed on p.216.

Ben Nicholson similarly continued to explore and develop the implications of his pre-war achievements, in particular moving freely between complete abstraction and an austere linear figuration, and often mixing, in a completely undoctrinaire way, readable references to landscape or still-life motifs with purely abstract elements. All his work of this later period is characterised by its allusive and evocative use of form, colour, texture and atmosphere.

Meanwhile, in London, Victor Pasmore's development had been decisively influenced by his reading in the history and theory of modern European art, and by the 1945 Picasso and Matisse exhibition at the Victoria and Albert Museum. In 1948 he moved away from Chiswick where he had been painting increasingly abstracted views of the Thames and began to make fully abstract art. At a time when there was animated debate about the relative merits of abstract versus figurative art this was seen in art circles as a dramatic conversion and caused some considerable stir. Pasmore went on to become the most distinguished British abstractionist of his generation, developing in particular a form of pure constructed relief, often using transparent elements, extending the tradition of De Stijl and Gabo. Other British Constructivists, as they were named, emerged in the late 1940s and 1950s, notably Kenneth and Mary Martin and Anthony Hill. Pasmore's 'Spiral Motif in Green, Violet, Blue and Gold: the Coast of the Inland Sea' of 1950, is reproduced and discussed on p.213.

In St Ives a younger generation of artists was gathering around the twin stars

William Turnbull **Head** 1954

Victor Pasmore **Spiral Motif in Green, Violet, Blue and Gold: The Coast of the Inland Sea** 1950 (detail)

Peter Lanyon **Thermal** 1960

John Hoyland **28.5.66** 1966

Bernard Cohen **Matter of Identity I** 1963

of Hepworth and Nicholson, forming what became known as the St Ives School, among whose leading figures were Peter Lanyon, Terry Frost, Patrick Heron and Roger Hilton. Paintings by Frost and Heron are reproduced and discussed on pp.214 and 215. Peter Lanyon was a native Cornishman who met both Nicholson and Gabo on their arrival in St Ives at the outbreak of war in 1939. From about 1950 he broke from these influences, developing a personal style of abstraction reflecting a close relationship with the Cornish landscape, which was enriched when he took up gliding in 1956. 'Thermal' refers to the rising air currents exploited by gliders and may be looked at in terms of the pilot's experience of the landscape from the air. Roger Hilton, like Lanyon, developed a form of loose abstraction based on landscape forms, although Hilton was always equally concerned with the figure, as in 'February 1954'. Patrick Heron moved to Zennor, close to St Ives, in 1956. He had experimented with abstract painting in the early fifties and by 1955 was making important large abstract works. His 'Horizontal Stripe Painting: November 1957–January 1958' is reproduced and discussed on p.215.

Away from St Ives a younger generation of artists was developing a large-scale abstract art, partly in response to Abstract Expressionism, first seen at the Tate Gallery in 1956 and again in 1959 in much larger quantity, in the exhibition *New American Painting*. The first major manifestation of this new British abstraction came in the exhibition *Situation* in London in 1960. Among the principal exhibitors were Gillian Ayres, Bernard Cohen, Harold Cohen, Robyn Denny, John Hoyland, Richard Smith and William Turnbull. These artists developed a bold, abstract art, emphasising colour and space and particularly stressing large scale. Their painting ranged from the sensuous simplicity of works such as Hoyland's '28.5.66' in which a large field of one colour is activated by elements of its complementary, to the complex imagery of Cohen in a painting such as 'Matter of Identity I' of 1963. The strange but compelling appearance of this, as of all Cohen's paintings, is the result of his practice of making art by following to its conclusion a predetermined procedure, of which the precise outcome could not be known.

The painter-sculptor William Turnbull had been evolving an increasingly pure abstraction in both media from the late 1940s, when he lived in Paris. His 'Head' 1955, is one of a long series of sculptures in which this motif is used as the basis for an exploration of abstract concerns.

Although a high degree of abstraction was present in a wide range of British sculpture from 1945, a substantial and revolutionary change took place in 1960, when Anthony Caro began to make abstract sculpture from iron and steel sheets and girders, welded and bolted together and painted, often in bright, clear commercial colours. Caro's 'Yellow Swing' 1965, is reproduced and discussed on p.217.

VICTOR PASMORE b.1908
**Spiral Motif in Green, Violet, Blue and
Gold: The Coast of the Inland Sea** 1950
Oil on canvas 813 × 1003 (32 × 39½)

In the late 1940s Victor Pasmore evolved
rapidly from the relative naturalism of his
paintings of the Thames at Chiswick
(p.177) to the austere abstraction of his
constructed reliefs such as 'Abstract in
White, Black, Indian and Lilac' in the
Tate Gallery collection. This painting
belongs to an intermediate phase, in
which he evoked landscape sensations
through a limited vocabulary of basic
forms, notably the spiral and the square.
'Square Motif, Blue and Gold: The
Eclipse', in the Tate Gallery collection, is
one of a series of paintings based on the
square which preceded those based on
the spiral. In both series Pasmore deploys

rich and evocative colour. Pasmore
wrote of this work: 'The coast of the
inland sea is, in this picture, a sea coast of
subconscious experience. It does not refer
to any coast known or seen by the artist.
The word ''inland'' here denotes this
extreme subjectivity. The picture was one
of a limited series of landscape themes
developed by means of a free construc-
tion of pure form elements, either the
spiral line as in this case, or the square as
in ''Eclipse''. By developing and arrang-
ing these forms in certain ways and by
emphasising their emotive qualities an
image finally formed suggestive of certain
landscape forms.' On the subject of the
spiral, he wrote that he had been particu-
larly influenced in developing it as a motif
by a woodcut print of a great curling
wave by the Japanese artist, Hiroshige.
In the end these paintings did not seem

to Pasmore sufficiently abstract. In parti-
cular he felt that they still created spatial
illusion, which abstract artists have in
general tried to eliminate, on the grounds
that it compromised the truth of the two-
dimensional nature of painting. For this
reason Pasmore began to make reliefs, in
which the space is real, and in these he
achieved his goal of pure abstraction.

TERRY FROST b.1915
Green, Black and White Movement
1951
Oil on canvas 1092 × 851 (43 × 33½)

Terry Frost's career as an artist began
during the Second World War in a Ger-
man prison camp, where he met the
painter Adrian Heath. After his release he
moved in 1946 to St Ives, where he
attended a local art school before getting
a grant to Camberwell School of Art in
London. He returned to St Ives in 1950
and worked for a while as an assistant to
Barbara Hepworth which, he said later
'. . . affected my other work deeply. . . . I
stopped painting for about nine months
and then I began to experiment with col-
lage, which to a certain extent has been
present in my work ever since.' In this
painting a collage-like compositional
approach has enabled him to interrelate
a rythmic sequence of clearly defined
forms with each other and with their set-
ting. At first glance completely abstract,
it is in fact, characteristically of St Ives art
at this time, rooted in the artist's percep-
tion of his surroundings. It is one of a
series of paintings by Frost inspired by the
rocking movement of boats at anchor in
the harbour of St Ives. Frost has given an
account of another work in the series
which equally illuminates this one: 'I had
spent a number of evenings looking out
over the harbour at St Ives in Cornwall.
Although I had been observing a multip-
licity of movement during those even-
ings, they all evoked a common emotion
or mood – a state of delight in front of
nature. On one particular blue twilit
evening, I was watching what I can only
describe as a synthesis of movement and
counter-movement. That is to say the rise
and fall of the boats, the space drawing of
the mastheads and the opposing move-
ments of the incoming sea and outblow-
ing off-shore wind. . . . I was not portray-
ing subject matter but concentrating on
the emotion engendered by what I saw.
The subject matter is in fact the sensation
evoked by the movement and the colour
in the harbour. What I have painted is an
arrangement of form and colour which
evokes for me, a particular feeling.'

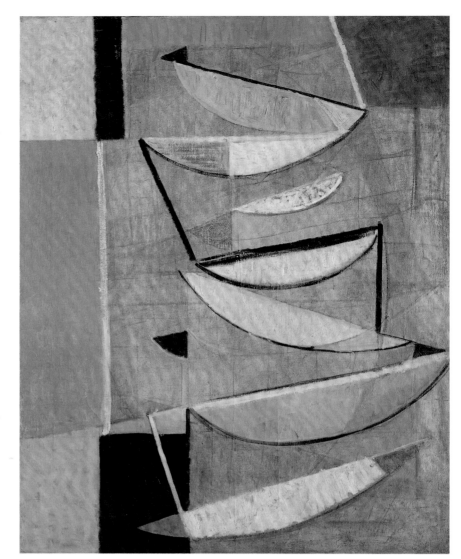

PATRICK HERON b.1920

**Horizontal Stripe Painting: November
1957–January 1958** 1957–8
Oil on canvas 2743 × 1548 (108 × 61)

Patrick Heron settled in Cornwall in
1956 when he was already established as
a writer on art as well as a painter. His
1955 book *Changing Forms of Art* was
highly influential. This is one of a group
of horizontal stripe paintings made by
Heron in 1957–8. Although in effect
rigorously abstract it nevertheless,
according to Heron, with its 'swept
together blending of the bands of parallel
colour, gave rise to a suspicion of a poss-
ible figurative, land and sea and sky read-
ing.' This possible landscape connotation
led him soon to abandon stripes in favour
of rectangular forms.

Heron is above all concerned with col-
our which, he says, is 'both the subject
and the means; the form, and the con-
tent, the image and the meaning in my
painting . . .' He has made it clear that the
stripes are simply vehicles for the colour:
'Early in 1957, when painting my first
horizontal and vertical colour-stripe
paintings, the reason why the stripes suf-
ficed as the formal vehicle of the colour
was precisely that they were very
uncomplicated as shapes. I realised that
the emptier the general format was, the
more exclusive the concentration upon
the experiences of colour itself'. Interest-
ingly, Heron has described the colour
composition of this painting in musical
terms, writing of '. . . the stratified spatial
bars which ascend in chords of different
reds, lemon-yellow, violet and white up
the length of my vertical canvas.'

This particular horizontal stripe paint-
ing was made to be part of a new interior
scheme for the London offices of the pub-
lishers Lund Humphries, which were
being refurbished by the architect Trevor
Dannatt. The scheme featured a sus-
pended ceiling of wooden slats whose
alignment was parallel to the bars of Her-
on's painting when installed in its given
position, a relationship which Heron
found extremely intriguing. The commis-
sion was given on the basis of Heron's
previous horizontal stripe paintings and
the painting remains wholly independent
when removed from its original setting,
as occurred in 1970.

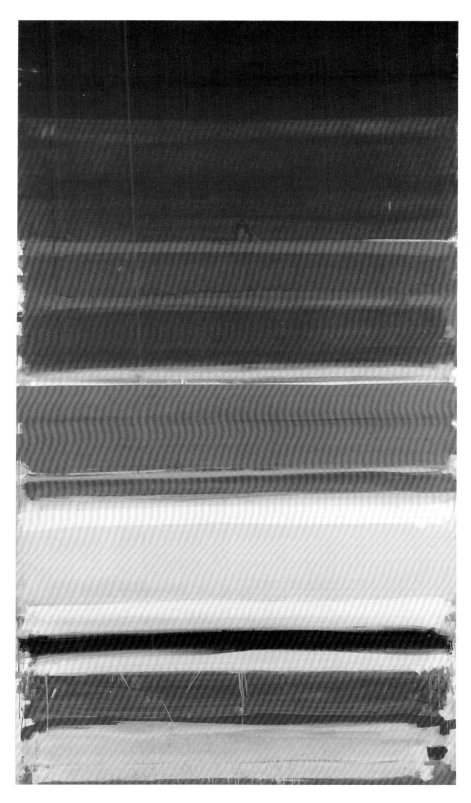

BARBARA HEPWORTH 1903–1975
Figure (Nanjizal) 1958
Carved Yew Wood 2496 × 457 × 13
(98¼ × 18 × 5)

The 1950s was a period of great expansion for Barbara Hepworth both in her work and reputation. She began to receive commissions for large public sculptures which called for her to work on a larger scale than ever before, and she now had the financial resources to make large scale sculpture of her own whenever she wanted. 'Figure (Nanjizal)' is one of a sequence of majestic wood carvings that Hepworth made from about 1954 onwards. Nanjizal is a Cornish place name and this work is characteristic in its embodiment in abstract form of the artist's complex response to the Cornish landscape. In 1952 she wrote that this was '. . . a landscape which still has a very deep effect on me, developing all my ideas about the relationship of human figure in landscape – sculpture in landscape. . . .' She also wrote 'From the sculptor's point of view one can either be the spectator of the object or the object itself. For a few years I became the object. I was the figure in the landscape and every sculpture contained to a greater or lesser degree the ever-changing forms and contours embodying my own response to a given position in that landscape. . . .' The title of this work, as well as its appearance, suggests that this statement may be relevant. Indeed, in a letter to the Tate Gallery of 1961 on the subject of this and another sculpture with a Cornish place-name title, the artist wrote 'Nanjizal is a superb cove with archways through the cliffs. Both sculptures are really my sensations *within* myself when resting in these two places.'

An opening up of the sculpture with pierced holes became an increasingly notable feature of Hepworth's work at this time, although she had begun to do this as early as 1931. She has said that this procedure '. . . seems to open up an infinite variety of continuous curves in the third dimension. . . .' She also began to add colour to the inside surfaces of the holes, writing that 'The colour in the concavities plunged me into the depth of water, caves, or shadows deeper than the

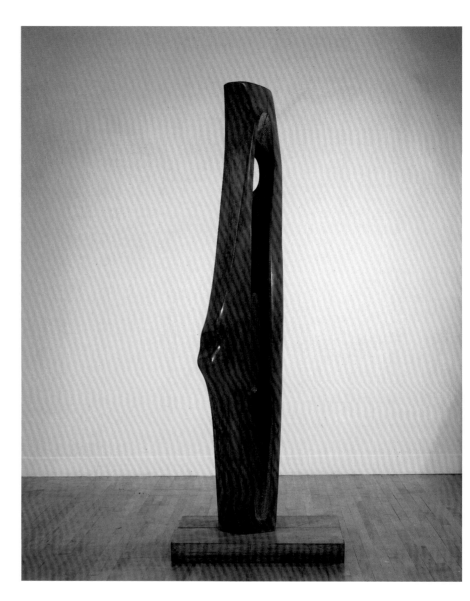

concavities themselves . . .' In this sculpture the holes are lightly coated with chalky white, perhaps evoking the quality of light in the arches of the cliffs at Nanjizal.

This piece is a notable example of the doctrine of 'truth to materials', so important to modern carved sculpture, giving the feeling that the forms have been found naturally within the single trunk of yew from which it is made. The sculptor has also brought out with great success the intrinsic beauty of the wood, its colour and grain.

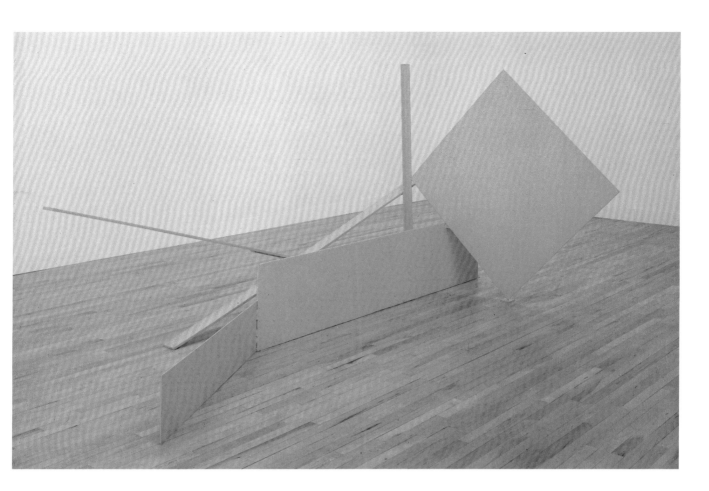

ANTHONY CARO b.1924
Yellow Swing 1965
Painted Steel 1791 × 1981 × 3975
(70½ × 78 × 156½)

This is a major early example of the
painted steel sculpture that Anthony
Caro began to make in 1960. When it
first appeared such sculpture was in
strong contrast to all other European
sculpture of the time, whether abstract or
figurative, although the contrast was
starkest with the work of Moore and the
younger British sculptors whose work, as
it happened, was prominent at the inter-
national *Documenta* exhibition of 1960.
This exhibition was visited by Philip
King, who became a leading figure
among the many younger artists who
quickly took up the new abstract sculp-
ture. He later wrote 'The sculpture there
was terribly dominated by a post-war
feeling which seemed very distorted and
contorted. Moore stood out with the Eng-
lish School . . . And it was somehow
terribly like scratching your own wounds
– an international style with everyone

showing the same neuroses.'
Caro has himself said that the change
in his work in 1960 was prompted by his
desire ' to get away from all the old sort of
work associated with plaster and clay . . .'
He has also said that he began to paint
steel sculpture in order to make it 'look
straightforward: no art props, no nostal-
gia, no feelings of the preciousness asso-
ciated with something because it's old
bronze, or it's rusty encrusted or pati-
nated.' There is no doubt that the colour-
ful, open, spacious and often playful
character of the work of Caro and King
created a completely new type of feeling
in European sculpture, what King char-
acterised as 'a message of hope and
optimism'.
This message, as Caro has acknow-
ledged, came from the U.S.A., both from
the large-scale abstract painted steel
sculpture of David Smith, whom Caro
visited in 1959, and from the similarly
large-scale abstract painting of artists
such as Kenneth Noland, who had
rejected the emotiveness and transcen-
dentalism of the Abstract Expressionists

in favour of a much cooler exploration of
colour and space. 'Yellow Swing' is a par-
ticularly exhilarating work with its
bright buttercup-yellow paint, and see-
saw rhythms creating the suggestion of
an upward springing movement. Caro
stressed the completely abstract char-
acter of his work at this time and his titles
must be read primarily as purely descrip-
tive, in this case referring to the colour,
and to the swing of one element against
another which is the formal nub of the
composition. However, his titles also
often appear allusive, and this work in
particular has irresistible connotations of
a children's playground on a summer's
afternoon.
An important component of the novel
experience offered the spectator by Caro's
sculpture is the way in which it rests
directly on the floor. Taken with its open-
ness and extent, this means that the spec-
tator experiences Caro's sculpture, not as
a traditional art object, but in the same
way as things in the everyday world.

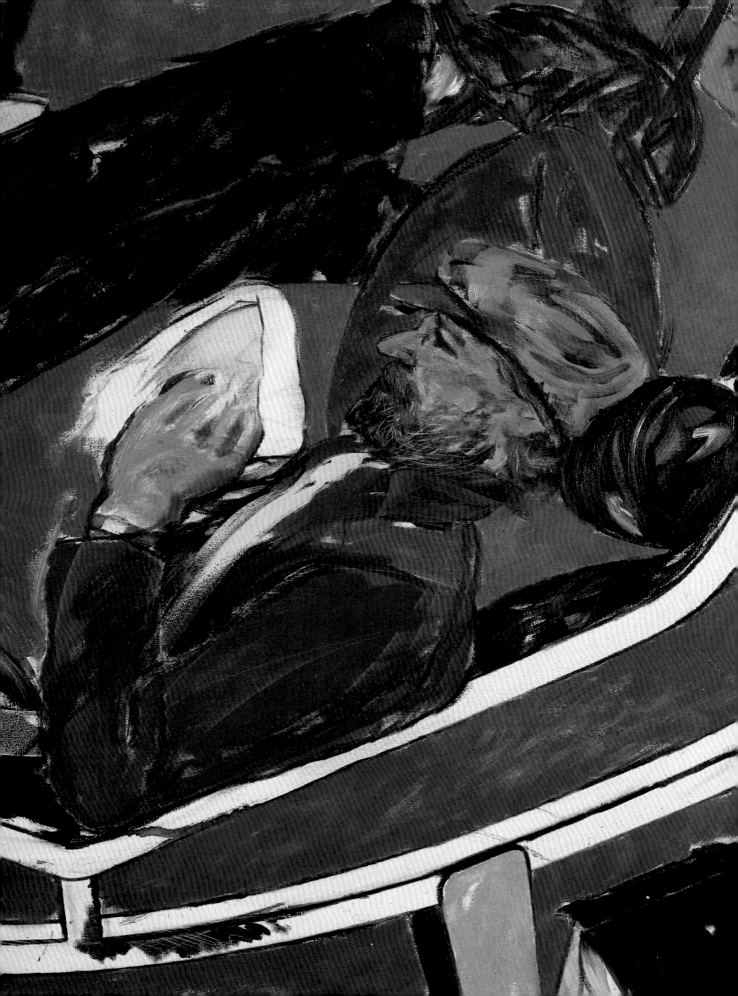

British Figure Painting

Lucian Freud **Naked Portrait**
1972–3

Frank Auerbach **J.Y.M. Seated No. 1**
1981

Michael Andrews **The Deer Park**
1962

R. B. Kitaj **Cecil Court, London** wc2
(**'The Refugees'**) 1983–4 (detail)

British art since the Second World War has often appeared preoccupied with the issue of abstraction or with creating new forms of art. But throughout that period there have always been many artists who chose to confront traditional concerns with painting the human figure and the physical and social world. Outstanding among them are Michael Andrews, Frank Auerbach, Lucian Freud, David Hockney, Howard Hodgkin, R. B. Kitaj and Leon Kossoff.

The longest established of these artists is Lucian Freud, whose early work is discussed on p.179. The nude was relatively rare in his art before about 1965–6 but since then it has become his principal subject, resulting in some of the most remarkable nudes in the history of western painting. His 'Standing by the Rags' of 1988–9 is reproduced and discussed on p.221.

Although their work is distinctively different, Frank Auerbach and Leon Kossoff have in common an approach to painting in which the paint, while performing a representational function, nevertheless retains a powerful independent reality of its own. Auerbach's 'The Sitting Room' of 1964 and Kossoff's 'Booking Hall, Kilburn Underground' of 1987 are reproduced and discussed on pp.220 and 225.

The art of David Hockney and R. B. Kitaj is often explicitly autobiographical, that of Kitaj in extremely complex ways, touching on major issues of politics and society. Hockney's 'Mr & Mrs Clark and Percy' and Kitaj's 'Cecil Court, London wc2 (The Refugees)' are reproduced and discussed on pp.222 and 224. Michael Andrews is famous for his paintings of the 1960s of groups of people in psychologically charged situations. 'The Deer Park' was inspired by Norman Mailer's novel of the same title of 1957. The central theme of the book is the struggle of a film maker to create a masterpiece and achieve personal happiness in the frantic atmosphere, laced with drink and sex, of the Hollywood film industry in the fifties. At the time he read *The Deer Park*, Andrews was painting a picture of the now celebrated Soho drinking club, The Colony Room, frequented by himself and artists such as Francis Bacon and Lucian Freud. He felt that Mailer had presented, on a much larger stage, the world of Soho and immediately painted this new picture.

Howard Hodgkin's pictures may appear very abstract but are recreations from memory of people and scenes that have been important to him. His 'Dinner at West Hill' is reproduced and discussed on p.223.

FRANK AUERBACH b.1931
The Sitting Room 1964
Oil on hardboard 1282 × 1277
(50½ × 50⅛)

The paintings of Frank Auerbach are remarkable not least for the way the image of some observed reality is incorporated into structures of paint which have an exceptionally powerful and independent reality of their own. This way of working is certainly connected with the general desire of modern painters to make work which, in Auerbach's own words, is '. . . a new thing for the world, that remains in the mind like a new species of living thing.' But in Auerbach's case the exceptional thickness of the paint and its heavily worked character also vividly express the struggle of the artist to realise in paint the image that has moved him.

This painting has its origins in drawings made during 1963–4, and took the best part of 1964 to execute, Auerbach arriving at the final image by a constant process of reworking. The room is the sitting room of his friend E.O.W. whom Auerbach visited several times a week to paint during 1963–5. E.O.W. appears in profile leaning forward in her chair on the left of the picture. Across the room in the other chair is her daughter Julia. Beside this chair is a tall standard lamp providing the major light source for the room and forming the lightest area of the painting. Between the two chairs is a low collapsible table and in the background on the right is a window revealing evening light outside. Above the head of E.O.W. are three objects of particular interest in the context of modern painting since they evoke some of the different ways in which people can be represented: on the wall is a framed painting of E.O.W. by Auerbach; to the lower right of it, on the bookcase, is a framed photograph of E.O.W.'s late husband, while on the mantelpiece immediately above E.O.W.'s head the small reddish object is a sculptured head. The tension in Auerbach's painting between the reality depicted and the reality of the paint is enhanced here by his use of a palette of close-toned earth colours and by his treatment of the images as flat shapes interlocking on the surface. Taken with the emphatic geometry of the main lines of the composition the result is a painting which appears simultaneously as an abstract work of austere beauty, and a vivid evocation of a reality filled with human and artistic significance.

LUCIAN FREUD b.1922
Standing by the Rags 1988–9
Oil on canvas 1683×1384 ($66\frac{1}{4} \times 54\frac{1}{2}$)

Lucian Freud began consistently to paint the nude in about 1965–66 after a change in his method of painting had given him the means to render flesh in a way more satisfactory to him than in his earlier work. Since then he has created a sequence of paintings which strikingly extend the history of the nude in western art into the late twentieth century. Freud's nudes are the outcome of prolonged observation under very bright light. But the results are very far from simply being the totality of what the artist sees, as Freud himself has indicated: 'When I look at a body I know it gives me choices of what to put in a painting . . . there is a distinction between fact and truth. Truth has an element of revelation about it.' His use of the word 'revelation' seems to confirm what is evident from the paintings, that Freud's nudes are the expression of a distinctive vision, embracing both the physical and the psychological, of what it is to be human. The most immediately striking aspect of this vision, of course, is the complete lack of idealisation, the unblinking objectivity of his treatment of the body, so that the images of it do indeed represent a truth, that of the everyday reality of the flesh.

The effect of Freud's nudes, and their presence for the spectator, is heightened in a number of ways. One is through the slight awkwardness and tension, even distortion, that can appear in the pose, particularly felt in this painting, where there seems to be some ambiguity as to whether the model is standing or leaning. Freud also often, as here, places the figure so that it appears very close to the surface of the picture, rather than in a notional space beyond, and is thus presented to the spectator with almost embarrassing intimacy. Another significant characteristic of Freud's nudes is the way in which they are painted, the flesh being vividly realised in a wide variety of brushstrokes which have an intense presence. It is this ability to embody his vision in the physical substance of paint that, not least, gives Freud's paintings their impact.

The 'rags' of the title are the painters rags, used to wipe brushes, which accumulate in the artist's studio, and which Freud has here used as the background to the model. This choice, and the reference to it in the title, suggests that a sub-theme of this painting is that of the life of the artist, as exemplified in the triangular relationship between artist, model and painting equipment, in the studio. This has been an important theme of some of the twentieth century's greatest artists, Picasso, Matisse and Braque notable among them.

DAVID HOCKNEY b.1937
Mr and Mrs Clark and Percy 1970–1
Acrylic on canvas 2134 × 3048
(84 × 120)

This is one of a group of large double
portraits of his friends which constitute
one of the high points in David Hockney's
career. In a remarkable way it combines
informality and immediacy in the presen-
tation of the sitters and their surround-
ings, with the formality and grandeur of
traditional portraiture. The composition
is constructed on a grid of strong verti-
cals, broken and activated only by the
diagonal of the male sitter and the corres-
ponding inward thrust of the coffee table.
Its stability is further enhanced by the
almost symmetrical placing of the figures
on either side of the window, which is the
source of light.

The picture is also painted in a way
which, while appearing highly tra-
ditional, is nevertheless distinctively
modern. This is evident in, for example,
the treatment of the two figures and the

cat as rather flat silhouettes, although
the faces by contrast are more fully
modelled. Similarly, the naturalistically
painted lilies are set against the table and
book, which are treated as featureless
abstract rectangular forms. This tension
between representation and abstraction
is a central underlying theme of Hock-
ney's art, which he has explored in a
variety of ways throughout his career.

The sitters are Ossie Clark and Celia
Birtwell, celebrated fashion and fabric
designers, respectively, in the 'Swinging'
London of the late sixties. They were
married in 1969 with Hockney as best
man. The setting is the living room of
their home in the Notting Hill Gate area
of London. Hockney deliberately chose to
paint them against the light (*contre-jour*),
presumably to heighten their presence as
strong silhouettes. The picture was
painted from drawings made from photo-
graphs and from drawings made from
life. In his biography of Hockney, Peter
Webb reports 'Ossie remembers the day
Hockney came to take some photographs

for the basic composition. He had only
just got up and so had no shoes on. He
slumped into a chair with a cigarette and
Blanche, one of their two white cats,
jumped onto his lap. Celia was standing
on the other side of the window with her
hand on her hip and Hockney said
"That's perfect"'. He later changed the
name of the cat to Percy (the name of the
Clarke's other cat) because it sounded
better. Webb also quotes Hockney as say-
ing 'I think it works because you feel
their presence, you feel the presence of
two people in a weird relationship. Ossie
is sitting down and Celia is standing up.
Yet you know it should be the other way
round'. Webb comments: 'The Clark's
marriage had been unconventional from
the start, and their portrait seems to
show an awareness of the tensions that
were to lead to divorce.'

The picture on the wall is one of Hock-
ney's own etchings. Its title 'Meeting the
Good People', might be seen as a sub-title
to this portrait of Hockney's two friends,
which he spent most of a year painting.

HOWARD HODGKIN b.1932
Dinner at West Hill 1964–6
Oil on canvas 1065 × 1270 (42 × 50)

Howard Hodgkin has extended, in a highly personal and original way, a long tradition of modern painting, going back to Matisse and Bonnard, in which the artist's responses to the world around him are recreated, in heightened and often abstracted form, in the structures and colours of the painting. As in this case, a typical Hodgkin is inspired by a particular occasion when he experienced a person or group of people of significance to him, in an interior which also had memorable characteristics. The process of painting the picture is then an act of recollection, in the course of which Hodgkin seeks equivalents in colour and form for his memories and impressions of the scene. The result is a complex, highly wrought, sensuously coloured and textured work in which only through hints and allusions does the spectator sense the original physical circumstances. These were described by Hodgkin in 1970: '"Dinner at West Hill" is perhaps the most complicated and delicately balanced picture I have so far allowed myself. It commemorates a dinner party given by Bernard and Jeanie Cohen [the painter Bernard Cohen and his wife] on March 15 1964 . . . Most of the forms in the painting which are not part of my normal language derive of course from Bernard's pictures. In some cases these even overlap (his and my forms). This painting was very difficult to conclude and I had to contend with a nervous and glittering evening in a green and white room full of small B. Cohens on the wall and Tony and Jasia R[eichardt] (to the L in the picture, Tony at Far L) and also Bernard's pictures which were particularly undisciplined and Dionysiac at that moment and of course finally and most difficult to contain all these things inside an object as formally and physically solid as a table or chair . . .' The two figures of the Reichardts (collectors, and writers on art) can be discerned on the left and other figures are perhaps represented by the round head-like forms on the right. The arch-like form may be a chair back, but also refers to similar forms typical of Bernard Cohen's painting in the early sixties. The white line represents the edge of the table.

R. B. KITAJ b.1932
Cecil Court, London WC2 (The Refugees) 1983–4
Oil on canvas 1830 × 1830 (72 × 72)

R. B. Kitaj was born in Ohio, U.S.A. and settled in London in 1959. He attended the Royal College of Art from 1959–62 where he had some influence on a generation of slightly younger artists which included David Hockney (who became a close friend) and others later associated with Pop Art in Britain.

A central aspect of Kitaj's subject matter from very early on has been the social and political crises of the twentieth century, the lives of the intellectuals and revolutionaries involved in them, and their consequences for other people. Interwoven with these are themes connected with the world of literature and thought, as contained in books and other forms of publication. Kitaj's art also reflects his involvement with other art, both of the past and the present. These themes are typically manifested in collage-like compositions in which disparate images, drawn from a wide range of visual and artistic, as well as social, historical and intellectual sources, are brought together to form richly poetic and allusive works. In their allusions to their sources Kitaj's paintings, as in this case, are often extremely complex and, to the uninitiated, obscure. But they are also invariably extremely sensuous in their visual effects, being notably beautiful in drawing, paint handling and, not least, colour.

This is one of a number of paintings made by Kitaj since about 1970, arising out of his increasing awareness of his own Jewishness, and of the history of the Jews. In particular, it is one of a group of three paintings from the early 1980s, each of which, according to the art historian Marco Livingstone, 'contains a narrative about the fate of the Jews, their exile and dispersal . . . Only "Cecil Court" which treats those whose lives were set off-course, but not destroyed, by anti-semitic persecution, gives much cause for hope.' Kitaj himself wrote 'Among some other things I think I have a lot of experience of refugees from the Germans and that's how this painting came about. My dad and grandmother Kitaj and quite a few people dear to me just barely escaped'. Livingstone describes the picture as 'A reverie on the way in which

[Kitaj's] own life has been touched by that of refugees from the holocaust . . . a compendium of images rich in personal significance . . .' The bearded figure in the foreground is the artist himself reclining on one of the classics of modern furniture design, Le Corbusier's chaise-longue of 1928. He is wearing the clothes in which he married the painter Sandra Fisher on 15 December 1983 at a London synagogue, an event which took place while this picture was being painted. The setting is Cecil Court, an alley noted for its many antiquarian and specialist bookshops, running between Charing Cross Road and St Martin's Lane, in the heart of the theatre district of London. These bookshops have been a constant haunt of the artist since his arrival in London. On the left, holding a bunch of flowers is Ernest Seligmann, a refugee who for many years ran a specialist art bookshop in Cecil Court, and who, Kitaj has said, 'sold me many art books and prints.' The figure opposite with a green book under his arm is Kitaj's recently deceased step-father, Dr Walter Kitaj. The atmosphere of the

painting, appropriate to its setting, is highly theatrical, its structure suggesting a stage set in which scenes from the artist's life are being played out behind him. Kitaj has explained that this atmosphere, and the character of the people, was inspired by the peripatetic troupes of the Yiddisher Theatre in Central Europe, which he had heard about from his grandparents, but had also found extensively described in the diaries of the Austrian novelist Franz Kafka.

The head of Seligmann is partly derived from a painting by Tintoretto in the Cathedral at Newcastle upon Tyne, and the whole concept of the painting is closely related to the two versions of the painting 'The Street' by the great French figure painter Balthus.

LEON KOSSOFF b.1926
Booking Hall, Kilburn Underground
1987
Oil on board 1980 × 1830 (78 × 72)

Leon Kossoff draws his subjects from his immediate family and friends and from the parts of London which he knows best. His painting is grounded in a continuous process of drawing these subjects from life, but he combines this with study of the great painters of the past from whom he has made a number of personal transcriptions. In 1985 for example, he painted what he titled 'A Memory' of Titian's 'The Flaying of Marsyas'. Kossoff's assimilation of the Renaissance tradition is apparent in paintings such as 'Booking Hall, Kilburn Underground' in the way in which subject matter – on the face of it, is very ordinary and everyday – is given the monumentality and grandeur of old master art. In fact, of course, Underground stations are very rich in associations and Kossoff has painted this subject many times in recent years, this being the final realisation of the theme. He concentrates on the hurrying movement of Londoners in transit through the station, vividly evoking their passage both across the picture and through it in depth, as the spectator's eye is drawn through the foreground to the 'picture within a picture' of the distant staircase which people ascend and descend. The figures in the foreground are clearly contemporary but are treated with great gravity and have, one critic has suggested, a medieval quality. This, taken with the overall grandeur of Kossoff's conception, gives this vivid image of a place of transit a strong suggestion of a metaphor for the transitory nature of human life, as well as evoking notions of different planes of existence.

Kossoff typically works on his paintings for a very long time, constantly adjusting the image, until the final satisfactory result may be achieved in a single day's work on the foundation of what has gone before. He has movingly described the interconnected processes of drawing and painting by which this result is arrived at: 'My dialogue is with these discarded images left on the floor. The subject, person or landscape, reverberate, in my head unleashing a compelling need to destroy and restate. Drawing is a springing to life in the presence of the friend in the studio or in the sunlight summer streets of London from this excavated state and painting is a deepening of this process until, moved by unpremeditated visual excitement, the painting, like a flame, flares up in spite of oneself, and, when the sparks begin to fly, you let it be.'

Pop Art and New Realism

Eduardo Paolozzi **I was a Rich Man's Plaything** 1947

The terms Pop Art and New Realism came into being to describe an art based on imagery drawn both from the world of popular culture (pop music, Hollywood movies, fairgrounds, slot machines, advertising, packaging, comics, the mass media of communication) and more generally from the whole urban and technological environment.

'Pop Art' refers to developments in the U.S.A. and Britain from about 1955–65, while 'New Realism', from the manifesto *Le Nouveau Réalisme* published in Milan in 1960 by the French critic Pierre Restany, refers to related developments in continental Europe.

Pop Art and New Realism were movements created by a generation of artists who grew up during and just after the Second World War, in reaction to what they perceived as stultifying prevailing standards in art and life. In the U.S.A. there was a particular rejection of the subjectivity and remoteness from reality of Abstract Expressionism, while in the austerity of 1940s and early 1950s Britain there was a strong attraction to the glamour of U.S. consumerism. Pop Art and New Realism owed much to the heritage of Dada and Surrealism not only in spirit but in their approach to the making of art, which depended heavily on the procedures of collage and assemblage.

British Pop Art had important origins in a group of artists, architects and intellectuals who in the mid-1950s were members of the Independent Group of the Institute of Contemporary Arts, in London. Two leading artists of the group were Eduardo Paolozzi and Richard Hamilton. Paolozzi played an important part in preparing the ground for British Pop Art, his collages of the late 1940s such as 'I was a Rich Man's Plaything' showing his pioneering appreciation of the possibilities of such source material. It even contains the word Pop, although it was not until later that the term began to be used to describe art inspired by popular culture. Richard Hamilton's '$he' of 1958, a combination of painting and collage, with imagery drawn from advertising, is now seen as one of the establishing works of British Pop Art. It reveals Hamilton's characteristically cool, intellectual and art-historically knowing approach to making art, and his particular interests in advertising and design. It is reproduced and discussed on p.230. At the same time the painter Peter Blake, working in a different spirit and with different kinds of source material, also emerged as a major figure. His 'The Toy Shop' of 1962, is reproduced and discussed on p.229.

A second phase of British Pop Art began in 1961 when a group of younger artists, mostly still students, and mostly at the Royal College of Art in London, made a great impact at the *Young Contemporaries* exhibition that year. They included David Hockney, Allen Jones, Derek Boshier, Peter Phillips and Patrick Caulfield.

Jasper Johns **Zero Through Nine**
1961

Peter Blake **The Toy Shop** 1962
(detail)

Claes Oldenburg **Counter and Plates with Potato and Ham** 1961

Niki de Saint Phalle **Shooting Picture** 1961

Yves Klein **IKB 79** 1959

In the U.S.A. leading figures were Roy Lichtenstein, Claes Oldenburg and Andy Warhol, all of whom emerged into prominence in the early sixties. However, from the mid-fifties the painter Jasper Johns had made influential paintings of popular or commonplace images, notably the American flag, targets and numbers. In these works Johns found ways of vividly evoking the presence of the original source while simultaneously creating highly abstract pictorial effects, as for example in 'Zero Through Nine' of 1961. Johns thus explored new ways of presenting reality in art, as well as new aspects of reality as the subject matter for art. This kind of enquiry has been central to the history of modern art and was continued in Pop Art and New Realism. The assemblage and collage works of Robert Rauschenberg were also highly influential. Both Roy Lichtenstein and Andy Warhol adopted approaches in which they presented their subject matter so that it appeared so close to the original as to be disqualified as art. This gave their paintings great impact although, combined with the nature of their subjects, and other aspects of their treatment of them, it also made their work appear at first to be puzzling, pointless or absurd. Lichtenstein's 'Whaam!' of 1963 and Warhol's 'Marilyn Diptych' of 1962 are reproduced and discussed on pp.232 and 233.

The sculptor Claes Oldenburg, by contrast, seeks to create work in which his source images, while not lost sight of, take on strange and fantastic forms which may also evoke or refer to many other things. 'Counter and Plates with Potato and Ham' of 1961 is an early work in which he achieved these effects using plaster on wire netting, and painting the result with enamel paint. However, soon after this he began to use soft materials, so that the sculpture took on an even more extraordinary life of its own. An outstanding example is his 'Soft Drainpipe – Blue (Cool) Version' of 1967, in the Tate Gallery Collection. Oldenburg's engagement with the urban environment as well as with popular or commercial culture links him to the European New Realists, whose 1960 manifesto called for 'the real seen as itself and not through the prism of an imaginative and intellectual transcription'. In practice their art was often both imaginative and intellectual but many of them shared a common approach of incorporating elements of reality directly into art in some form of collage or assemblage. Their work ranges from the mysterious wrapped objects of Christo, the crushed car bodies of César, the 'trapped' meals of Spoerri, the assemblages of plastic objects of Raysse and the elaborate, purposeless machines made of scrap of Tinguely, to the 'accumulations' of Arman, one of which 'The Condition of Woman I' is reproduced and discussed on p.231. Niki de St Phalle exploited chance in her 'shooting' pictures while for Yves Klein the prime reality was that of art itself. More specifically, he took the view that the essence of art lay in colour and in one primary colour in particular, blue. He expressed this view in a truly extraordinary series of blue monochrome paintings of which 'IKB 79' is one. (I.K.B. = International Klein Blue).

PETER BLAKE b.1932
The Toy Shop 1962
1568 × 1940 × 340 (61¼ × 76⅜ × 13⅜)

Peter Blake's art reflects his affection and nostalgia for the popular culture of his own childhood and youth, his favourite sources including toys, comics, badges, pop music and jazz, Hollywood films and film stars, fairgrounds, and other popular entertainments such as all-in wrestling and striptease.

The toys in this work are from Blake's own collection of such things and it was partly conceived as a solution to the problem of how to store safely some of the smallest items. The choice of these is so personal, the artist has said, that the work amounts to a kind of self-portrait, reflecting his interests and activities. Examination reveals, among much else,

obvious references to painting in the toy palettes, card of brushes and child's paint box, and to pop music in the picture post cards of Elvis Presley, Chubby Checker and others. There are also references to other art notably in the *Whirlpool* and *Slipperyslabs* puzzles in the upper left window. These were certainly chosen for their evocation of, respectively, the target paintings of the American abstract painter Kenneth Noland and the grid-like abstract paintings of Mondrian, representing a kind of art to which Pop was theoretically opposed, although in fact strong abstract elements are often present in it – the grid of the windows here, for example. The fairground targets, which are also prominent, refer to Blake's love of the fair and probably to the target paintings, seen as precursors of Pop art, of the American Jasper Johns.

Blake's overall aim in this work is to evoke an old fashioned corner shop with a window full of cheap toys, which he does so effectively that at first glance it might be the real thing, perhaps taken from a demolition site and reconstructed in the museum. However, the colours of the window and its surround are the three primaries red, yellow and blue. These are an unlikely choice for a real shop front but here they seem natural and appropriate because they echo the heraldic colours of the union flags and targets in the window, as well as the flag Blake attached to the outside. The door is a convincing green and appears highly realistic in construction until the spectator becomes aware of its less than human scale, giving the work a slightly mysterious, Alice-in-Wonderland quality.

RICHARD HAMILTON b.1922
She 1958–61
Oil and collage on board 1219 × 813
(48 × 32)

This is one of a group of early Pop paintings by Hamilton which reflect his interest in consumer goods and their advertising, and in the role of these in society. These works also reveal Hamilton's equal interest in presenting subject matter in ways which are abstract and allusive rather than directly representational, creating elaborate and subtle compositions which reflect the complexity of his responses to his sources. The theme of '$he' is the presentation of women in advertising; Hamilton's possible alternative title for this work was 'Women in the Home'. The form of the title which he finally chose, with the 'S' as a dollar sign is a characteristically witty and economical reference to the glamour of American consumerism. Hamilton himself described the painting as 'a sieved reflection of the ad man's paraphrase of the consumer's dream'. This was in a lengthy account of the work published in *Architectural Design* in October 1962. From this we know that the overall source of the work was an advertisement for an R.C.A. Whirlpool fridge/freezer. Hamilton was particularly attracted by its 'cadillac pink' colour and by the composition of the photograph, 'a brilliant high shot of the cornucopic refrigerator'. This comment reveals, incidentally, the serious critical interest taken by Pop artists in the creative qualities of commercial art. In the painting the fridge is evoked through a glimpse of its door viewed in steep perspective and part of the freezer compartment inside. The woman standing proudly beside it is represented by one eye (near the top edge of the painting) and her bare right shoulder and upper left breast. Below is a curved form representing her hips. Below that is a combined toaster and vacuum cleaner. These things are represented in a wide range of ways chosen by Hamilton for their appropriateness to the source, and sometimes because they offer opportunities for wit or allusion. The woman's flesh is painted with an airbrush to give the effect of a glossy magazine photograph and the silver toaster is also airbrushed to a smooth metallic finish echoing the original. The hips of the woman are in low relief to suggest the idea of tactile three-

dimensionality. Her eye is a joke one in plastic; it winks. The bottle of Pepsi-Cola in the door of the fridge is hand painted in a traditional still-life manner. Pepsi and Coca-Cola had iconic significance for Pop artists as symbols of youth and American culture but in this case the way in which Hamilton has painted the bottle is also strongly reminiscent of the bottle of Bass beer in Manet's famous 'Bar at the Folies Bergère'. The row of dots emerging from the toaster is a diagrammatic represen-

tation of movement, wittily indicating the path of the toast when ejected from the machine. They are also a homage to the 'Shots' in Marcel Duchamp's 'Large Glass', another work concerned with sex, costume and machines, long admired by Hamilton, who later made the reconstruction of it in the Tate Gallery collection (p.159).

ARMAN b.1928
Condition of Woman I 1960
Assemblage, 1918 × 464 × 321
($75\frac{1}{2} \times 18\frac{1}{4} \times 12\frac{5}{8}$)

Arman was one of the foremost expo-
nents of the New Realist aim to present
reality as directly and rawly as possible in
art. From about 1959 he developed a
number of types of work, dealing with
different categories of objects and
expressing different themes. Among
these were the 'colères' (tantrums) in
which the objects were destroyed and re-
presented in fragments, the 'accumu-
lations' in which similar or identical
objects were presented in a glass case or
embedded in transparent resin, and a
development of the 'accumulations', the
'poubelles' or dustbins, consisting of rub-
bish. These represented an extreme
manifestation of New Realist ideas, and
the nature of the rubbish in this example
make it of particular interest. 'Condition
of Woman I' is related to a group of rub-
bish works by Arman in which the rub-
bish, rather than being randomly chosen,
consisted of items obtained from friends
which were then presented as a form of
portrait. The items presented here came
from Arman's first wife's bathroom but,
as the title indicates, they present a
general rather than a particular image of
woman. The ornate Second Empire
pedestal came from Arman's father's
antique shop. The contrast between it
and the container of rubbish was import-
ant to the artist as presenting for con-
sideration a range of contradictions: old
and valuable versus new and valueless,
art and non-art. The pedestal also implies
in an ironic way that the container of
rubbish is a museum object. The feet and
shouldered form of the pedestal with the
transparent box on top also has an
anthropomorphic quality, evoking a
human figure. As so often in Pop Art or
New Realism the artist here presents
striking images or materials with little or
no indication of a personal view. What
we can be sure of is the artist's serious-
ness, and it is in that light that we should
consider what these objects, in them-
selves and in their relation to the pedes-
tal, have to say about the condition of
woman in our society.

ROY LICHTENSTEIN b.1923
Whaam! 1963
Acrylic on canvas 1727 × 4064
(68 × 160)

Pop Art in America was in part a reaction to the dominance of Abstract Expressionism there in the 1950s. As Roy Lichtenstein commented '. . . art has become extremely romantic and unrealistic, feeding on art, it is utopian, it has less and less to do with the world, it looks inward'. When asked why he chose to paint material such as comic strips and advertisements Lichtenstein replied, 'I accept it as being there, in the world . . . Signs and comic strips are interesting as subject matter. There are certain things that are usable, forceful and vital about commercial art.' In particular Lichtenstein was attracted by the way in which in comic strips highly emotionally charged subject matter was conveyed in 'standard, obvious and removed techniques'. This characteristic of comics gave him the clue as to how he might make paintings in which striking and emotive subject matter could be presented in a very cool, formal way, giving equal emphasis to the abstract and decorative qualities of the painting without immediately apparent expression of the personality of the artist. One important result of this approach is that spectators are left in the position of having to consider the subject for themselves rather than being offered a comment by the artist.

'Whaam!' is one of a large group of paintings based on comic strip images made by Lichtenstein in the early 1960s and which brought him international acclaim. Their subjects are almost all either of love or war and they constitute a fascinating, thought provoking and often witty compendium of images dealing with these topics of perennial human significance.

Like other leading American Pop artists, Lichtenstein was concerned to preserve as far as possible the essential character of his source material, which he did so successfully that many critics complained that he was simply enlarging the comic images. In fact, Lichtenstein's comic sources were painted by him in a fundamentally traditional way. He began by making a sketch of the scene, in much the same way as, for example, John Constable would sketch a piece of Suffolk landscape for later elaboration into a full-size painting. In the sketch Lichtenstein adjusts and strengthens the original composition, making both omissions and additions, and devises a colour scheme using the simple primaries of comic art but bearing no necessary relation to the original. The drawing is traced onto the canvas using a projector. The finished paintings, as in the case of 'Whaam!' are notable for their bold colours and often extraordinary forms, which while retaining a strong representational function, take on a life of their own as abstract and expressive shapes. Examples here include the black elements, like snake's tongues,

in the flames of the explosion, or the extraordinary amoeba-like form of its yellow core. The highly stylised nature of this painting is also emphasised by its large scale.

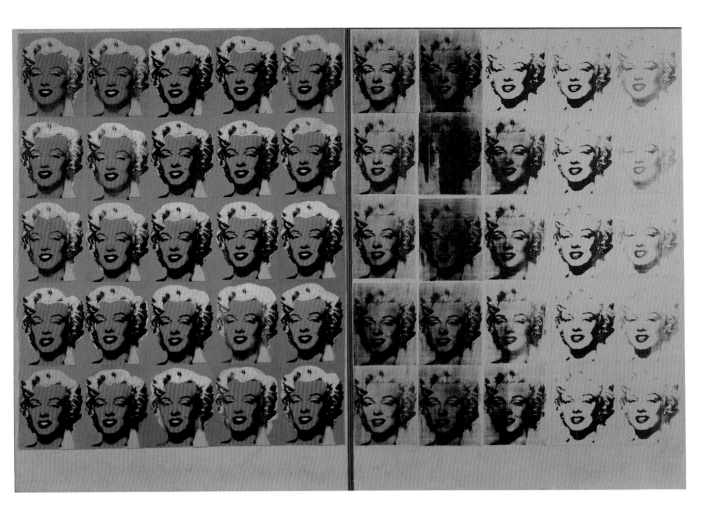

ANDY WARHOL 1928–1987
Marilyn Diptych 1962
Acrylic on canvas 4108 × 2896
$(161\frac{1}{4} \times 114)$

More than any other Pop artist Andy Warhol presented his subject matter so as to appear so close to the original, in paintings so remote from existing ideas of composition and execution, that the work seemed to many people to be disqualified as art.

He raised, in unprecedently acute form, questions of how reality may be represented in art which have been of central concern to modern artists from Courbet on, and which were central to Pop Art. His extreme position on such issues is one important element in his art, but there is more, since Warhol was possessed of an acute vision of the major themes of human life – food, sex, death, money, power, success and failure – as these were manifest in the surface appearances of his own times. Above all

perhaps, he was unerring in his choice of images which encapsulated these themes. His choice of Marilyn Monroe and of a particular photograph of her, is a case in point. Campbell's Soup, as exemplary of convenience food, is another. As in other Pop Art, but again to a much more intense degree, these images are presented in Warhol's paintings in a detached and dispassionate manner, as a series of silent questions for the spectator to make of as much or as little as they will. Warhol's painting took on its mature edge when, following the logic of his printed source material, he began to adapt the silkscreen printing process to painting. Silkscreen is a form of stencil, much used by artists for print-making, and normally prepared and printed by hand. However, the image can be put on the screen photographically, which is what Warhol did, thus mechanically reproducing his source. In 'Marilyn Diptych' this was a still photograph of Monroe in the 1953 film *Niagara*. Marilyn

Monroe died, from an overdose of sleeping pills, on 5 August 1962. Between then and the end of that year Warhol made at least twenty-three silkscreen paintings of her. In them he retained the handprinting of the silkscreen onto the canvas and, as can be seen, constantly varied the image by changes in the registration of the different colours or the amount of paint put through the screen. In the right panel of 'Marilyn Diptych' he has produced effects of blurring and fading strongly suggestive of the star's demise. The contrast of this panel, printed in black, with the brilliant colours of the other, also implies a contrast between life and death. The repetition of the image has the effect both of reinforcing its impact and of negating it, creating the effect of an all-over abstract pattern.

Minimal Art

The term minimal art is applied to certain exceptionally austere forms of abstraction which flourished particularly in the 1960s, principally in the U.S.A. Minimalism is best understood in the context of the previous history of abstract art since it represents an extreme development of ideas first stated by Malevich, Mondrian, De Stijl and the Constructivists. Minimalism can be seen as an attempt to go further, to present art more than ever before as a blunt reality stripped down to the very minimum possible consistent with the result still being definable as art.

As well as having roots in the European abstract tradition, Minimal art was certainly affected by the very reductive Abstract Expressionism of Newman and Rothko, and by its scale and environmental character. Minimal sculpture in particular affects the space in which it is placed and the viewer's perception of that space. An important related characteristic of Minimal sculpture is that it is situated not on a pedestal or base but directly on the floor, or sometimes leaning against a wall, and has therefore the same relationship to the viewer as any ordinary object. An extreme example of this is Carl Andre's '144 Magnesium Square' which can be walked on, like a carpet (reproduced and discussed on p.239).

Robert Ryman **Ledger** 1983

In their pursuit of a factual, 'real' art, stripped of traditional aesthetic trappings, Minimalists turned to non-art, often industrial materials, assembling or presenting them without alteration, in ways logically related, or natural to the materials, as in Andre's '144 Magnesium Square' where the squares are placed edge-to-edge in a solid block. Minimal art also tends to be made according to simple systems, either logical or random, so that the final work is the outcome of a predetermined process.

Robert Ryman has devoted himself to a long investigation of one particular element of art, paint, using only white, much favoured generally by Minimal artists for its purity and status as a non-colour. 'Ledger' is painted in a commercial 'pigmented shellac' on fibreglass, both materials being chosen in relation to an effect of translucency. The paint surface, though impersonal, is varied, and the carefully selected wooden frame and brushed aluminium mounts are integral to the work.

Ellsworth Kelly **White Curve** 1974

Ellsworth Kelly's relief, 'White Curve', is a segment of a circle presented as a reality in itself. It is geometrically accurate in form and was manufactured by a craftsman from Kelly's precise drawings. The surface is sprayed car body enamel. Kelly's works ultimately refer to landscape or objects around him. This one relates to the hill and valley forms near his home in Chatham, New York.

◁ Frank Stella **Six Mile Bottom** 1960 (detail)

Works by other Minimal artists are reproduced and discussed on pp.236–238.

AD REINHARDT 1913–1967
Abstract Painting No. 5 1962
Oil on canvas 1524 × 1524 (60 × 60)

Ad Reinhardt was the great polemicist of Minimal Art, calling with visionary passion for an art that would express nothing but the idea, or essence, of art. In an article published in 1962 he wrote 'The one object of fifty years of abstract art is to present art-as-art and as nothing else, to make it into the one thing it is only, separating it and defining it more and more, making it purer and emptier, more absolute and more exclusive – non-objective, non-representational, non-figurative, non-imagist, non-expressionist, non-subjective.' About two years before this statement appeared, Reinhardt had found the concept of painting which for him fulfilled this ideal: a canvas exactly five feet square, divided into a grid of nine squares painted in very closely related shades of matt black. Some of the early paintings in this format were titled by Reinhardt 'Ultimate Painting', and he continued to paint in this way until his death, his aim being, he wrote, '. . . to paint and repaint the same one thing over and over again, to repeat and refine the uniform again and again. Intensity, consciousness, perfection in art come only after long routine, preparation and attention.' Reinhardt's late paintings are not in fact absolutely identical, he seems to have started each one completely afresh and when seen together they exhibit considerable tonal differences. The initial appearance of these paintings is of a uniform matt black but after a time the spectator begins to distinguish the different tonal areas of the grid. What emerges is a cruciform shape created by Reinhardt's painting of the central horizontal line of squares in one tone, the four corner squares in a different tone, and the centre top and centre bottom squares in a third tone. The different tones are arrived at by mixing the black

with a small amount of colour, in this case red for the corners, green for the central horizontal band, and blue for the other two squares. As has often been pointed out, Reinhardt's 'black' paintings, in spite of their rationality of structure, have a compelling mystery of presence stemming not least from the symmetrical cruciform structure hovering within them. In the end even Reinhardt admitted that his art was a visionary one: in 1961 he wrote 'Everything is square, cruciform, unified, absolutely clear . . . All is one vast symbolism . . . All images share the "state of identical form."'

AGNES MARTIN b.1912
Morning 1965
Acrylic and pencil on canvas
1826×1819 ($71\frac{7}{8} \times 71\frac{5}{8}$)

Agnes Martin was initially influenced by
Abstract Expressionism, but after settling
in New York in 1957 she came into con-
tact with Ad Reinhardt and began to
develop symmetrical compositions in her
paintings. At first these were of rectan-
gles or circles within a square, but from
about 1960 she adopted a standard six
foot square canvas and began to use
grids, expanding these to create a com-
plete all-over structure, as in this case.
The lines are delicately and sensitively
drawn in lead pencil and red crayon, and
the effect of this faint grid, with its hint of
colour, on the white ground is curiously
atmospheric. As Agnes Martin's titles
imply, within the limits of her chosen
format and procedures she finds equiva-
lents for certain sensations and states of
mind. Of this painting she wrote: 'When I
painted "Morning" I was painting about
happiness and bliss. I had to leave out a
lot of things that one expects to see in a
painting. Happiness and bliss are very
simple states of mind I guess. To myself
and some others there is a lot of differ-
ence between one work and another –
difference of meaning. There are many
different happinesses and blisses. "Morn-
ing" a wonderful dawn, soft and fresh –
before daily care takes hold. It is about
how we feel. Some titles are more
obscure. "Tree" for instance means an
exceptionally innocent (innocent knowl-
edge and action) state of mind. And
"Desert" is a very arid, that is unsenti-
mental state of mind.'

FRANK STELLA b.1936
Six Mile Bottom 1960
Metallic paint on canvas 3000 × 1822
(118⅛ × 71¾)

There is no doubt that in his early work, from 1958–60, Frank Stella created a kind of painting that was effectively more abstract than any before. He did this by using a format which eliminated to an extent greater than ever before both the illusion of space and the element of composition. At the same time he also eliminated colour, confining himself to non-colours, at first black, and then the silver-coloured aluminium paint used here. The surface pattern of this painting was arrived at basically by making a narrow stripe following the edge of the canvas, and repeating it until the whole surface is covered. The width of the stripe was determined by the width of the house-painter's brushes used. In his first works of this type, the 'black paintings', Stella used a traditional rectangular canvas, but for the aluminium series began to shape the canvas in various ways, which introduced variation and also drew attention to the nature of his procedure. This system of composition, in Stella's own words, '... forces illusionistic space out of the painting at a constant rate by using a regulated pattern.' The spectator's eye always moves smoothly across the surface, either to and off the edge, or, in this case, to and into the real space in the centre. The artist has also said that the aluminium paint was chosen partly for the role it could play in reducing illusion: 'The aluminium surface had a quality of repelling the eye in the sense that you could not penetrate it very well. It was a kind of surface that wouldn't give in and would have less soft, land-scape-like or naturalistic space in it. I felt that it had the character of being slightly more abstract.' Not the least striking aspect of these works is that because their structures directly echo the shape of the canvas they are in fact pictures of them-selves – a near perfect expression of Ad Reinhardt's idea of 'art-as-art'.

The title refers to Six Mile Bottom, a village in England near Newmarket, where the poet Byron's half-sister Augusta Leigh lived.

CARL ANDRE b.1935
144 Magnesium Square 1969
Magnesium sculpture, each unit
$10 \times 305 \times 305$ ($\frac{3}{8} \times 12 \times 12$)

The work of Carl Andre, one of the lead-ing Minimal sculptors, is notable for the extreme reductiveness of its format, which consists basically of the repetition of identical units, or even, at its most extreme, the presentation of a single unit, such as a single metal square. Within this format Andre's dominating, although not exclusive, preference is for square or rectangular forms, the overriding factor in his choice of elements being that they should pre-exist. Sometimes the elements are found as scrap, sometimes, as here, obtained from a manufacturer. Andre does not alter them in any way, and his works are made by simply placing the elements together, edge to edge, in the desired pattern, without any kind of fix-ing, on the principle that nothing at all

should be added to the original, so that the sculpture is a completely truthful expression of the nature of the materials. In this respect, as well as in its use of repetition, Andre's work, for all its often baffling minimalism, takes its place in a tradition of modern sculpture that has its roots in Brancusi, whose influence on him Andre has acknowledged. It was Brancusi who helped to establish the idea that sculpture should, as part of its con-tent, reveal and reflect its materials, and who introduced unitary repetition in his 'Endless Column'. Andre has said 'The one thing I learned in my work is that to make the work I wanted you couldn't impose properties on the material. You have to reveal the properties of the material.' Clearly the best way to reveal the properties of manufactured square sheet metal plates is to lay them flat in a solid square to emphasise, and echo on a large scale, their basic characteristic of flatness, squareness and unity of surface.

In fact, since each plate is 12 inches square, the whole work represents any one of its parts multiplied by itself. '144 Magnesium Square' is one of six similar pieces by Andre, identical except that they are made from different metals, the others being aluminium, steel, zinc, copper and lead.

This piece is unusual in the history of modern sculpture in that it can be walked upon, emphasising a general characteris-tic of minimal sculpture which is that it functions 'environmentally', that is, it directly affects the way we experience and use the space in which it is placed.

New Painting

Avant-garde art in the 1970s was dominated by the continuing of Minimalism, and by Conceptual Art, in which painting and sculpture were largely abandoned in favour of stating the idea or content of the work of art in media not normally associated with fine art, such as words or photographs. Towards the end of the 1970s it became increasingly apparent that a reaction was taking place in favour of art which was both more traditional in its physical form and in which there was a fresh emphasis on painterly gesture, bright or powerfully sombre colour, figurative imagery and symbolic or mythological content. This reaction was an extremely complex phenomenon in both painting and sculpture, but in painting there was a strong tendency to draw on, and extend in new ways, the existing avant-garde traditions of Expressionism.

Philip Guston **Black Sea** 1977

Certain artists of an older generation appear as forerunners of this 'new painting'. Among them are the American, Philip Guston and the German, Georg Baselitz. From 1950 Guston was an Abstract Expressionist in New York, but in 1966 he decided that he needed to bring his painting back into contact with, he said, 'common objects, things rooted in the tangible world . . .' Among these were old shoes which particularly fascinated him. In his paintings, shoes and other objects are transformed into strange and powerfully enigmatic shapes, taking on new identities. They are often placed in incongruous settings, echoing Surrealism, as in 'Black Sea' of 1977 where a giant boot heel rises from the sea. This image also relates to one of the artist's wife sitting up in bed with the blankets pulled up to her chin.

Georg Baselitz **Adieu** 1982

From about 1965 Georg Baselitz developed a distinctively personal figurative painting in which heroic, mythical figures appeared, towering over ruined landscapes, as in his 'Rebel' of 1965, in the Tate Gallery collection. In 1969 Baselitz began to invert the figures in his paintings, and has continued to do so ever since. By doing this Baselitz hopes that the spectator will consider first the purely pictorial or abstract qualities of the painting rather than its imagery and content. The pictures are actually painted as they are to be seen. The theme of 'Adieu' 1982, is parting, and in a letter to the Tate Gallery the artist stressed the separation and isolation of the figures: 'one of them is only half there, while the other is going away . . . I think the arch between the two figures is big enough, in order that they can each be viewed isolated in their situation.'

Other works by 'new painters' are reproduced and discussed on pp.242–245.

Sandro Chia **Water Bearer** 1981
(detail)

ANSELM KIEFER b.1945
Parsifal III 1973
Oil and blood on paper laid on canvas
3007 × 4345 (118⅜ × 171 1/16)

In the early 1970s, against the grain of
then current avant-garde trends, Anselm
Kiefer began to produce paintings in
which great myths of the German tra-
dition were reworked in ways that were
both deeply personal and gave them a
fresh relevance in the light both of Ger-
many's recent past and of its present con-
dition. 'Parsifal III' is one of four paint-
ings of this title which can be exhibited as
a group or individually. Three of them
are in the Tate Gallery, and when shown
together form a triptych of which this is
the centre panel. The title refers both to
Wagner's opera *Parsifal* and the original
medieval legends that were Wagner's
sources. Parsifal's father dies a heroic
death in battle while still young; his
mother determines that he shall not
suffer the same fate, and brings him up in

innocence of the chivalric world of arms
and combat. He nevertheless discovers it,
and, aspiring to knighthood, leaves his
mother and arrives in the kingdom of the
Holy Grail, where he fulfils a prophecy
that a 'guileless fool' will save the Grail
(the cup used by Christ at the Last
Supper) from destruction or domination
by the forces of evil. He does so by retriev-
ing the Holy Spear (that wounded
Christ's side) and using it to heal the mor-
tally wounded Guardian of the Grail,
Klingsor.

In the left-hand panel appears a cot
and, just to the right of it, the name of
Parsifal's mother, Herzelayde, ('Suffering
Heart'), evoking Pasifal's birth and early
life. It seems likely that Kiefer saw a par-
allel between Parsifal's upbringing in
rejection of his father's warrior past, and
the circumstances of the post-war gene-
ration in Germany, bent on assuaging
the guilt of recent German history.

The right-hand panel refers to Parsi-
fal's defeat of the evil knight Ither, whose

name appears beside his broken sword
spattered with real blood (not human)
while Parsifal's sword quivers trium-
phantly erect in the boards beside it.

In the centre panel appears the Holy
Spear, the goal of Parsifal. The names of
all the principal characters in the drama
are inscribed around the painting and the
quotation across the bottom translates as
'O woundful wonderful holy spear'. Also
inscribed, in the upper left of the picture,
but hard to see because the artist orig-
inally covered them up and they have
emerged with time, are the names of the
principal members of the Baader-Mein-
hoff terrorist group, who were at the fore-
front of national attention in Germany at
the time Kiefer made this painting. Their
activities marked the most extreme mani-
festation of the discontent of the gene-
ration that reached adulthood in the
1960s, with the Germany of their par-
ents. The setting is derived from the
wooden beamed interior of the artist's
studio.

SANDRO CHIA b.1946
Water Bearer 1981
Oil and pastel on canvas 2065 × 1700
($81\frac{5}{8}$ × 67)

Sandro Chia is one of a number of young
Italians who in the late 1970s turned
away from Minimal and Conceptual art
to create a new kind of figurative paint-
ing. Like many of his colleagues Chia
draws freely on the art of the past to
create a style that is entirely personal, yet
is enriched by the echoes of its sources,
which here include a classical sculpture
of the same subject, as well as Italian
Futurist painting. In execution Chia's
paintings are notable for the energy of
their drawing and paint application, and
particularly for the extraordinary inven-
tiveness and richness of their colours and
textures, exemplified here in the treat-
ment of the background.

Chia's subjects are often men or boys
travelling, and in an essay based on con-
versations with the artist, the art histor-
ian Anne Seymour suggests that 'the
male figures in Chia's pictures are search-
ing for something, or perhaps they are
pilgrims of a sort, for they often seem
bound on some unidentified mission.'
There is also a suggestion that they repre-
sent Chia's view of the role of the artist:
'they are, the artist points out, figures
born of painting and thus possessed of a
strong code of morals and justice, for the
rules of painting are strict and the res-
ponsibilities heavy. He sees them as hav-
ing something in common with heroes
and with monks, and their moment of
action in his painting as being their
moment of ecstasy.' Chia's water bearer
here is certainly a heroic and virile figure,
and the fish can probably be read as an
additional symbol of this virility.
Although carrying a fish, the figure
becomes a water bearer by a process of
poetic association (metonymy) in which
an attribute of water, a fish, comes to
represent water itself. This poetic substi-
tution has enabled Chia to create a strik-
ing symbolic image, which may have a
further dimension in its relation to the
Bible story of Tobias and the angel. Chia
has said that there is no specific connec-
tion between this and his painting, but
that the subject was relevant to it, as part
of the same family of images. In the Bible,

Tobias is the son of Tobit, author and
narrator of the Book of Tobit. He is sent
by his father, who has become blind, on a
dangerous journey to retrieve some
money left with a kinsman. To accom-
pany him he finds a companion, who is
in fact the angel Raphael in disguise. At
the end of a day, washing in the river
Tigris, Tobias is attacked by a huge fish
'which would have swallowed him.' He
succeeds in killing it and is advised by the
angel to retain its gall bladder, heart and
liver. These later enable him to marry a
virgin whose previous seven husbands
have mysteriously died on the wedding
night before consummation, and, on his
return home, to cure his father's
blindness.

CHRISTOPHER LE BRUN b.1951
Dream, Think, Speak 1981–2
Oil on canvas 2440 × 2285 (96 × 90)

The relationship between abstraction
and figuration is of particular concern to
Christopher Le Brun. He has said 'By
temperament I'm an aspirational or
visionary painter after Turner or Blake,
but that avenue is closed theoretically
and practically. It's a cultural dilemma,
not a personal one . . .' Le Brun is here
referring to the problem central for any
modern painter who wishes to deal with
figurative and symbolic imagery, of doing
this while remaining within the main-
stream of the modern tradition.

To solve this dilemma Le Brun has
drawn inspiration from some of the great
Romantic painters, such as Turner and
Delacroix, whose work combines power-
ful imagery with an equally strong
emphasis on the purely visual qualities of
the painting. With this he has developed
a highly intuitive approach to painting,
in which images from his imagination
form on the canvas as he works and may
then be destroyed to be replaced by
others. The accumulation of images may
at some point suggest one which the
artist 'recognises' as significant and he
then allows the painting process to be
directed by the needs of this particular
image. The results are highly ambiguous
and mysterious, imagery appearing fit-
fully and elusively amid the rich and
dense textures and looming forms of the
painting. This is one of a number of Le
Brun's paintings in which the image of a
horse appears. It has no specific meaning
but is rich in mythical and literary asso-
ciations. The title refers to a passage in
the *Journals* of Delacroix which the artist
recollected as 'colour dreams, thinks,
speaks'. It struck him particularly as
expressing the idea, closely correspond-
ing to his own approach, that the
ingredients of the painting are them-
selves in some way active participants in
its creation. The words also evoke the
imaginative and revelatory character of
Le Brun's work.

SEAN SCULLY b.1945
Paul 1984
Oil on three canvases
2590 × 3200 × 240 (102 × 126 × 9½)

Sean Scully's relief paintings, which he has made since 1981, have a superficial resemblance to Minimal Art but in fact their structures are arrived at intuitively, their colours are rich, varied and expressive, and their surfaces bear the evidence of the painter's gesture with the brush. Scully's aim may be said to be to extend and develop the Abstract Expressionist project of creating abstract art that nevertheless carries symbolic connotations, as the artist explained '[I am] interested in art that addresses itself to our highest aspirations. That's why I can't do figurative paintings – I think

figurative painting is ultimately trivial now. It's all humanism and no form . . . Abstraction's the art of our age . . . it allows you to think without making oppressively specific references so that the viewer is free to identify with the work. Abstract art has the possibility of being incredibly generous, really out there for everybody. Its a nondenominational religious art. I think it's the spiritual art of our time.'

Scully has said that this painting, as well as relating to the work of Rothko and Newman, has links with the tall vertical sculptures of Giacometti, which he also admires greatly. The painting is named after, and dedicated to, the artist's son Paul who died in 1983. The artist associates the tall central panel with the figure of his son. The triptych

format places the work within the tradition of religious painting, and Scully has made other triptychs with religious titles.

The paint surfaces of Scully's works are built up in layers, the colour of one layer often being different from that of the previous one. The artist considers the build up of paint in depth to be a metaphor for depth of feeling and inner life.

The panels were not all painted together and the right hand one was taken from another work because Scully felt it was needed for this one. 'Paul' like other triptychs by Scully has a sense of stability and solidity although Scully has said that he is also interested in the tension set up by the 'violence' of the joins of the panels within the overall stability of structure.

New European Sculpture

The period from about 1965 has seen an intense questioning of the nature and language of sculpture, with artists exploring an unprecedentedly wide range of materials and processes to produce an astonishing and exciting variety of work.

The artists represented in this section fall broadly into two generations: one, whose contribution was made from the mid-1960s onwards, includes Eva Hesse, Luciano Fabro, Mario Merz, Giuseppe Penone, Ulrich Rückriem, Barry Flanagan and Richard Long; the other, generally younger, includes Stephen Cox, Tony Cragg, Richard Deacon, Shirazeh Houshiary, Anish Kapoor and Alison Wilding all of whom rose to prominence in the 1980s.

In Italy the use of materials that were ordinary, inexpensive or not previously considered as suitable for the making of art gave rise to the term *Arte Povera*, 'poor' or 'shabby' art. This also carried an implication of the rejection of the status of art as a precious, marketable commodity, an attitude common to many artists in the 1960s and 1970s, in the U.S.A as well as in Europe. Mario Merz's wickerwork 'Cone', 1967, combines a basic abstract geometry with a strongly natural or organic quality stemming from its material and the ancient craft process by which it is made. Its shape also suggests a shelter or hiding place and in this respect it relates to Merz's central concern with human society and its survival. Luciano Fabro's 'Ovaie', 1988, explores the symbolism of the egg and contrasts natural and artificial means of production in its striking contrast of steel cable and marble eggs. Giuseppe Penone also investigates basic processes of life and growth; 'Tree of 12 Metres' is one of a series of works he has made by stripping down huge rough sawn timbers to reveal the form of the tree within. His 'Breath', 1978, is reproduced and discussed on p.249. Ulrich Rückriem works with stone, emphasising its innate qualities of mass, weight and colour. His 'Untitled', 1989 is reproduced and discussed on p.253.

The work of Barry Flanagan in the 1960s was concerned with the properties of materials such as sand, cloth and rope. In 'Four Casb 2 '67' striking organic shapes are created by loose sand poured into tubes of cloth, the shapes directly expressing the interaction between the cloth, simply sewn together beforehand by the artist, the sand, and the force of gravity. The artist discovered that this work, when exhibited with two others of 1967, 'Ringl 1 '67', and 'Rope (Gr2Sp60)6 '67', formed a significant relationship, and they are now normally shown as a group. From 1975 Flanagan turned his attention to stone sculpture, producing in 1981–2 a series of marble carvings based on small clay models, formed by the artist squeezing or rolling a lump of clay in his hand. The result is an organic shape, abstract yet highly mysterious and allusive, the connotations in 'Carving 13', in particular, being distinctly sexual.

'Addendum' 1967, by Eva Hesse is reproduced and discussed on p.250.

Giuseppe Penone **Tree of 12 Metres**
1980–82

Giuseppe Penone **Breath** 1978
(detail)

Mario Merz **Cone** *c.*1967

Richard Long **Slate Circle** 1979

Richard Deacon **Struck Dumb** 1988

From the mid-1960s Richard Long developed a landscape art which, while strikingly original in the forms it took, was the expression of a contemplative and poetic response to nature that can be related back to Constable and Wordsworth. Long's work, however, is based on a much more intensive and continuous presence of the artist in the landscape than has ever previously been the case. Long undertakes solitary walks, all over the world, and in some of its most remote places. The work that results takes various forms from poster-like verbal statements – a kind of concrete poetry – evoking routes, places, things seen, thoughts evoked and things done, to sculptures assembled from natural elements – twigs, driftwood, stones – either left in the landscape or brought into the gallery space. Many of these, like 'Slate Circle', 1979, are based in some way on the form of the circle, and Long uses a range of other geometric forms, straight lines, spirals, squares, crosses, parallels. The significance of these is that they are simple and distinctively human: they are the simplest possible means by which the artist can structure his response to the landscape. In particular, the contrast of the geometric marks of man with the irregularities of the natural world produces a heightened awareness of their interrelationship.

Richard Deacon works with metal, wood and sometimes cloth. The processes of fabrication that he uses – riveting, welding, or laminating and glueing – are exposed as part of the work, setting up an interesting tension with the organic, often sexually allusive forms. A further theme of Deacon's work is the relationship between interior space and surface skin, a concern evident in his huge, hollow metal piece 'Struck Dumb', 1988, whose title may refer to the highly mysterious, enigmatic character of the work, and its refusal to communicate the mystery of its interior. Shirazeh Houshiary also works with metal to create hollow organic forms although her sources of inspiration are very different from those of Deacon. Her 'The Earth is an Angel', 1987, is reproduced and discussed on p.251.

Anish Kapoor uses a range of geometric and organic, sometimes erotic shapes brought together in groups and given brilliant life by raw pigment pressed into their surfaces. 'As if to celebrate, I discovered a mountain blooming with red flowers' (1981) is a characteristically allusive title, the first four words of which come from a Haiku (short Japanese poem). The rest Kapoor invented, but it relates to a Hindu myth of a goddess born out of a fiery mountain which was composed of the bodies of male gods.

The work of Tony Cragg is rooted in a philosophical concern with man's relationship to the man-made environment, which Cragg has called 'the new nature'. He makes direct assemblages of manufactured objects as well as sculptures of them in other media. His large bronze 'On the Savannah', 1988, is reproduced and discussed on p.252.

GIUSEPPE PENONE b.1947
Breath 5 1978
Terracotta 1540 × 830 × 840
(61 × 32 × 33)

The art of Giuseppe Penone is often concerned with the revelation and realisation in the form of sculpture of natural processes which may normally be hidden or invisible. His 'Tree of 12 Metres', for example, was made by scraping away the wood from a complete felled tree which had already been roughly sawn into a beam, to reveal within it the original form of the tree at an earlier stage of its growth. 'Breath 5' represents the imagined shape of the artist's breath spreading out into the air around as he blows down towards the ground. The lumpy effect along the edges of the cleft in the sculpture represents the breath billowing around the artist's body and the cleft itself is the impression in negative of his jean-clad leg, made by him pressing himself against the wet clay with one leg forward. The object at the top of the sculpture is an impression taken in the clay of the interior of the artist's mouth.

For Penone the main significance of this work may be as an image of the act of creation, related to various myths and to the common phrase 'to breathe life into' something. Commenting on the 'Breath' series of sculptures in 1978 Penone wrote '. . . according to a myth the creator of man was the God Khnum, who is represented as a potter shaping man on his wheel. In another myth, Athena breathes life into men whom Prometheus had made from clay and water.' With its impression of both the artist's mouth and at least part of his body, the work represents both the act of creation and the man created. The idea for the 'Breath' sculptures came from a series of drawings made by Leonardo da Vinci of how he imagined the currents of air in a single breath. He based his design on patterns he had observed in running water. Penone's association of this work with the act of creation suggests that with its great thick-lipped cleft and bulbous form it may be seen as a gigantic image of female fertility, which the spectator almost seems invited to enter.

EVA HESSE 1936–1970
Addendum 1967
Painted papier mâché, wood and cord
124 × 3029 × 206 ($4\frac{7}{8}$ × 119$\frac{1}{4}$ × 8$\frac{1}{8}$)
without cords, length of cords approx
3000 (118$\frac{1}{8}$)

Eva Hesse was born in Germany. From
1939 she lived in New York, where she
died at the age of thirty-four, just as the
sculpture she had been making since the
early 1960s began to be acclaimed.

Eva Hesse's work has much in
common with Minimalism, which was
such a dominant feature of avant-garde
art in America in the mid-1960s. This is
particularly apparent in her use of
repeated identical or similar elements,
and simple serial progressions of these
elements, as in this work. Her art also
explores unusual materials, its appear-
ance reflecting their nature. However, as
her writings make clear, she was primar-
ily interested in expressing a highly

personal and poetic vision which she
often characterised as 'absurd', a term
associated with the traditions of Dada
and Surrealism and with the theatre of
Samuel Beckett and Eugene Ioneso. In
this respect Eva Hesse appears as one of a
number of artists who, in the late 1960s,
reacted against the extreme abstractness
and factuality of Minimal art in favour of
forms which, while remaining abstract,
were organic and evocative. In particular
Hesse and others exploited soft and flex-
ible materials such as rope, cloth and
latex rubber. In this work Hesse sets up a
deliberate tension between the rational
geometric structure of the rectangle, the
strongly contrasting geometry of the
hemispheres and their mathematical ser-
ial progression, and the irregular and
irrational forms of the cords. A further
irrational element is introduced by hang-
ing the piece seven feet high on the wall.
In her notes on 'Addendum' the artist
wrote 'The chosen nine foot eleven inch

structure, the five inch diameter semi-
spheres and the long thin rope are as
different in shape as possible. The choice
of extremely different forms must recon-
cile themselves. To further jolt the equili-
brium the top of the piece is hung seven
feet high. The cord is flexible. It is ten feet
long hanging loosely but in parallel lines.
The cord opposes the regularity. When it
reaches the floor it curls and sits irregu-
larly. The juxtaposition and actual con-
necting [of the] cord realises the contra-
diction of the rational series of semi-
spheres and irrational flow of lines on the
floor. Series, serial, serial art, is another
way of repeating absurdity.' Of the title
she said 'the title of this work is "Adden-
dum"; a thing added or to be added. A
title is after the fact. It is titled only
because that is preferred to untitled.'

SHIRAZEH HOUSHIARY b.1955
The Earth is an Angel 1987
Brass and zinc over plywood
1900 × 2000 × 2000 (74¾ × 78¾ × 78¾)

Shirazeh Houshiary was born in Iran and trained in the sculpture department of Chelsea School of Art, London, graduating in 1979. In the early 1980s she developed a sculptural language of a kind often described as biomorphic, that is, abstract, yet relating to the forms and processes of life with particular reference to growth and procreation. These sculptures were made of clay and straw, and their particular forms often alluded to sources in Houshiary's own cultural heritage. In 1984, feeling that she needed to explore fresh materials she began to make her sculpture from hammered and soldered zinc or copper, and later, as in this work, brass. The use of metal enabled Houshiary to give sharpness and energy to her forms and to deploy a range of beautiful surface effects of colour and texture, produced by treatment with acids.

'The Earth is an Angel' is one of a group of sculptures by Houshiary in which the forces of life are symbolised in curved and pointed forms derived from the wings of Byzantine angels. These angels, found in churches in Istanbul, have four wings, one pair directed towards earth and one pair towards heaven, representing a conflict and union of opposing forces. Power, according to the artist, lies at the meeting point. In the sculpture this relationship is expressed in the dynamic intertwining of the sharply edged and pointed wing forms, in simultaneous union and opposition. The wing forms are contained within a sphere which, as the measurements of the sculpture reveal, is even slightly flattened at top and bottom like the earth. Thus, if the wings are taken as standing for the whole of the angel, the title has an almost literal meaning. The poetic idea of the earth as a benevolent being, an angel, has a universal appeal, but further light on it may be shed by Fulvio Salvadori in an essay written in close collaboration with the artist, in the catalogue of a 1988 exhibition of this and related works by Houshi-

ary. Salvadori writes of 'the Soul of the World [which] appears also as the Angel of the Earth, heading the Guardian Angels, reddened in its clash with darkness, the fire of strife.' He further cites in this connection the mystic writer Sohravardi: 'Let it be known that Gabriel has two wings. The first, to his right side, is pure light . . . And there is the left wing. On this one there is a kind of reddish glow resembling the reddish colour of the rising Moon or that of a peacock's claws.' This passage in particular may be related to the forms and colours of 'The Earth is an Angel'.

TONY CRAGG b.1949
On the Savannah 1988
Bronze 2250 × 4000 × 3000
(88½ × 157½ × 118)

Tony Cragg's interests, he has said, are
'Man's relationship to his environment
and the objects, materials and images in
that environment. The relationships
between the objects, materials and
images'. These interests are expressed in
Cragg's sculpture through modern,
manufactured objects, often of an extre-
mely ordinary kind such as plastic liquid
detergent bottles. The use of such objects
highlights Cragg's belief that they are as
full of aesthetic potential as traditional
subjects, and his art is an exploration of
what he has called 'the new nature' of
the urban and industrial environment.
His early works were assemblages of
manufactured objects themselves, often
retrieved as rubbish or scrap. More
recently he has also made cast steel or
bronze sculpture based on these things,
creating works, such as this one, in
which highly functional manufactured
objects are given the grandeur of tra-
ditional sculpture and take on new poetic

and symbolic meanings. Very impor-
tantly, Cragg also reveals the often very
considerable innate beauty of these ano-
nymously designed things. The three ele-
ments of 'On the Savannah' are derived
from laboratory vessels whose forms,
greatly enlarged, but otherwise closely
corresponding to the original, reveal
themselves as the spectator moves
around the work. The tall upright form
suggests a connecting pipe of some kind,
or may refer to a Bunsen burner used for
heating to produce chemical reactions in
the laboratory. In the two lower elements
can be seen the shapes of a laboratory
flask and a mortar, and a laboratory jar
and carboy. These forms have been
drawn out and fused into each other so
that they metamorphose, or mutate, into
new, flowing and organic forms which
seen from above particularly, strongly
suggest references to female sexual parts.
Cragg has thus created two extra-
ordinary images in which hard, utilitar-
ian, technological objects simultaneously
refer to procreation and the forms of life.
But he may also be drawing an analogy
between biological processes of change
and creation and those in the laboratory.

In both cases the upright form, as a
source of heat or a male symbol, would
be the activating agent. Such a view of
this sculpture is suggested by the title of
the work which, Cragg has said, 'refers to
a time in evolution when it [the Savan-
nah] was a huge genetic reservoir . . . It is
the idea of mutation.' The reference is to
the Savannah lands of Africa and else-
where on which advanced animal and
human life first appeared and developed.
It seems clear from this that Cragg sees
this work as a metaphor for the whole
process of life and evolution. As such it is
an invention of truly remarkable power
and imagination.

ULRICH RÜCKRIEM b.1938
Untitled 1939
Dolomite stone, four parts, each
1800 × 1100 × 35 (70 × 45 × 13)

Ulrich Rückriem trained as a stonemason in order to equip himself with the technical skills to become a sculptor. He worked for two years on the restoration of Cologne Cathedral and also made gravestones to earn a living. About 1964 he began to work as a sculptor, carving massive stone portrait heads. One day a lorry load of stone arrived at his studio with the five pieces he had ordered stacked together so as to appear once again to form the single block from which they had been cut. Rückriem was deeply struck by this sight and decided to visit a stone quarry, something he had never done before. Astonished by the power and presence of the stone he saw at the quarry, he arranged to live there. His work since then has been devoted to making sculpture whose overriding aim is to reveal the natural power and beauty of stone, emphasising its block-like character and articulating, or composing, the work only by splitting or sawing the block into simple harmoniously proportioned parts. It is fundamental to Rückriem's art that these parts are reconstituted to form the original block. In this work the structure is based on making three splits in each block in a sequence of variations. The splitting is done by drilling and the use of a wedge. The splits also have the effect of lightening the appearance of the block and of making the spectator aware of its interior. The face of the stone itself is oxidised and bears the marks of iron deposits, giving a beautiful natural tone. Each of the four stacks is self-supporting, standing an inch away from the wall, rising and tapering towards the top. In their stress on verticality and their tripartite divisions they have human overtones, as well as evoking the monolithic building blocks of prehistoric structures such as Stonehenge.

Modern Works on Paper

In addition to paintings and sculpture, the Modern Collection of the Tate Gallery also comprises prints and unique works on paper. Although some of the drawings in the collection are studies for paintings and sculpture, most are independent works of art. Owing to the vulnerability to light of works on paper the Gallery generally presents a changing selection of prints and drawings.

Edgar Degas **Woman at her Toilet** *c.*1894

Drawings have been collected by the Tate Gallery since its inception. Among the earliest works in the Modern Collection is Degas' richly wrought pastel, 'Woman at her Toilet' *c.*1894 with its shimmering light, its rich tapestry of fabrics and wall coverings, its dissolving forms and marked sense of physicality. It is typical of Degas' many images of women performing actions in the privacy of the dressing room – bathing, dressing or combing their hair – all seen as a kind of ritual. The close viewing point, together with the strong emphasis on diagonals, plunges the viewer into intimate proximity. The collection also includes masterpieces by Picasso such as the exemplary *papier collé* of 1913 (reproduced and discussed on p.257) and a portrait of Dora Maar of 1938 who was the model for the 'Weeping Woman' (p.171) painted in the previous year. There are also fine works by Cézanne, van Gogh, Klee and Rouault among others.

Henry Moore **Pink and Green Sleepers** 1941

The greatest concentration within the collection lies in works by British artists. Among the outstanding British drawings are those by Henry Moore executed during the Second World War, when he was an official war artist. From notes he made in Underground stations during the Blitz, Moore executed larger drawings in his studio which capture memorably the hardship and unguarded moments of those sheltering from bombs. Many of these drawings, collectively known as the 'Shelter Drawings', anticipate the themes of sculptures of draped reclining nudes he would execute later. Among other important British artists in the collection are Ben Nicholson, John Piper, Graham Sutherland, Paul Nash and David Jones.

Abstract Expressionism is represented by significant works by Jackson Pollock, Mark Rothko and Willem de Kooning. Pollock's 'Number 23' 1948 was executed in the same year as the Tate's large painting 'Summertime' and shows the extent to which Pollock's drip technique was adaptable to a smaller scale. Such works on paper were executed over a short period of time and demonstrate the beauty of the rhythm of Pollock's gesture. More recently greater emphasis has been placed on the acquisition of contemporary drawings, in particular by British sculptors including Gilbert and George, Richard Deacon, Anish Kapoor, Antony Gormley, Shirazeh Houshiary and Stephen Cox.

Unlike the collection of unique works on paper, the Gallery began to acquire prints consistently only as recently as 1975, hence very few works date from

◁ Georg Baselitz **Female Nude on a Kitchen Chair** 1977–9 (detail)

Jasper Johns **Decoy** 1971

Jackson Pollock **Number 23** 1948

Georg Baselitz **Female Nude on Kitchen Chair** 1977–9

before the end of the Second World War, although outstanding among those which do is the portfolio entitled 'Victory over the Sun' 1923 by the Russian artist, El Lissitzky. The strength of the Print Collection resides in the post-war period and particular emphasis is given to the acquisition of contemporary prints.

Printmaking techniques have advanced enormously since the early sixties, particularly in the U.S.A where some of the print workshops, such as Gemini GEL, Los Angeles have been highly experimental. They, together with other print studios such as Crown Point Press, San Francisco and Universal Limited Art Editions, New York have been among the leaders in the field in terms of quality and interest. Among those who have worked at both Gemini and ULAE is Jasper Johns. Johns's 'Decoy' 1971 was radical in the use of a hand-fed offset lithography press. Offset was previously only used in commercial printing and the press had been purchased by ULAE solely for proofing, but Johns employed it to advantage in this important print. It not only enabled a faster pace of proofing and trials but also a larger number of subtle overprintings on one print. Offset also has the advantage of allowing the artist to work the right way round whereas normally the printed image is a mirror image of the plate. 'Decoy' contains reworkings of a number of images found in Johns's oeuvre and is unique in that he made a painting of the same title after the print. Among other major American printmakers represented by important groups of prints are Barnett Newman, Andy Warhol and Roy Lichtenstein.

Screenprinting was developed in Britain particularly at Kelpra Press and many of the fine prints by Richard Hamilton, Eduardo Paolozzi and others published by Kelpra are in the collection. The representation of the immediate post-war period is also growing apace and the collection now has important prints by many of the leading European artists of this period such as Miró, Braque, Fautrier, Wols, Hartung and Bissière, as well as British artists associated with Cornwall such as Ben Nicholson, Barbara Hepworth, Patrick Heron, Peter Lanyon, Roger Hilton and Terry Frost.

Among more recent works to be found at the Tate are those by Barry Flanagan, whose representation is extensive, David Hockney, the abstract artists Sean Scully, John Walker and Brice Marden, and an artist whose work resists such categorisation, Howard Hodgkin (see p.257). Recent European prints are also collected in depth including fine works by Arnulf Rainer. Günter Brus and Georg Baselitz whose linocut, 'Female Nude on a Kitchen Chair' 1977–9, is monumental in size and gestural in execution, a work of such scale requiring the involvement of the whole of the artist's body. The contrast between gashes and fine lines emphasises Baselitz's forceful approach to his materials. The inversion of the image is intended to encourage the viewer to examine the formal properties of the work rather than focussing on its narrative content.

PABLO PICASSO 1881–1973
Guitar, Newspaper, Wine Glass and Bottle 1913
Papier collé and pen and ink on blue paper 465 × 625 (18⅜ × 24⅝)

This *papier collé* is one of a series of such works which Picasso made in 1913 and which heralded the change in direction of Cubism from the analytical to the synthetic. Whereas earlier paintings had approached the object as three dimensional, displaying it from many different angles, synthetic Cubist works emphasised the flatness of the picture surface and reconstructed the object on this basis. The newspaper may have been chosen for its faded colour, since it was already thirty five years old before Picasso used it. However, the front page of the issue of the *Figaro*, from which this has been cut, carried an account of the coronation in Moscow of Czar Alexander III and may have appealed to Picasso because the 300th anniversary of the foundation of the Romanov dynasty was being celebrated in Spring 1913 and was a topic of great international interest.

HOWARD HODGKIN
For Bernard Jacobson 1979
Lithograph with hand colouring
1057 × 1499 (41⅝ × 59)

Howard Hodgkin has executed a large number of prints in a variety of media. A characteristic associated with his more recent editioned works is hand colouring, where colour is applied to the printed surface, generally by an assistant, in a prescribed way and area. The hand colouring in this print is found in the curved leaf shapes and the broad wash brushstrokes. 'For Bernard Jacobson' is named after the London art dealer who was the publisher of this print. The image objectifies a memory of a scene on a balcony in India at night, with banana trees below, and is typical of Hodgkin's images in which the senses of sight, sound and smell are evoked by a subtle juxtaposition of colours and shapes. It was the first of Hodgkin's prints to approach the scale of his paintings and was printed on two sheets.

Further Reading

Tate Gallery Reports and Catalogues of Acquisitions. H.M.S.O. (1954–1967), Tate Gallery (from 1968).

David Bindman (ed.). The Thames and Hudson Encyclopedia of British Art. Thames & Hudson 1985.

Nikolaus Pevsner. The Englishness of English Art. Penguin 1964 (repr. 1984).

Ellis Waterhouse. Painting in Britain 1530–1790. Penguin 1953 (4th ed. 1978).

Simon Wilson. British Art from Holbein to the Present Day. Tate Gallery, Bodley Head 1979 (repr. 1982 as Holbein to Hockney: a History of British Art).

Bernard Denvir. The Eighteenth Century: Art, Design and Society 1689–1789. Longmans 1983.

Ellis Waterhouse. The Dictionary of British 18th Century Painters in Oils and Crayons. Antique Collectors' Club (Woodbridge, Suffolk) 1981.

Elizabeth Einberg. Manners and Morals: Hogarth and British Painting 1700–1760. Tate Gallery 1987.

Elizabeth Einberg, Judy Egerton. The Age of Hogarth: British Painters born 1675–1709. Tate Gallery 1988.

Martin Butlin. William Blake 1757–1827 (catalogue of the Tate Gallery's collection). Tate Gallery 1989.

David Bindman. Blake as an Artist. Phaidon 1977.

Bernard Denvir. The Early Nineteenth Century: Art, Design and Society 1789–1852. Longmans 1984.

Martin Butlin, Evelyn Joll. The Paintings of J. M. W. Turner. Yale University Press 1977 (rev. 1984).

Andrew Wilton. Turner in his Time. Thames & Hudson 1987.

Leslie Parris. The Tate Gallery Constable Collection. Tate Gallery 1981.

Jeremy Maas. Victorian Painters. Barrie & Jenkins 1969 (repr. 1974).

Christopher Wood. The Dictionary of Victorian Painters. Antique Collectors' Club (Woodbridge, Suffolk) 1971 (2nd ed. 1978).

The Pre-Raphaelites (exhibition catalogue). Tate Gallery 1984.

Christopher Wood. The Pre-Raphaelites. Weidenfeld & Nicolson 1981.

Christopher Wood. Olympian Dreamers: Victorian Classical Painters 1860–1914. Constable 1983.

Ronald Alley. Catalogue of the Tate Gallery's Collection of Modern Art, other than works by British Artists. Tate Gallery, Sotheby Parke Bernet 1981.

Robert L. Herbert. Impressionism: Art, Leisure, & Parisian Society. Yale U.P. 1988.

John Rewald. The History of Impressionism. Secker & Warburg 1946 (4th ed. 1973).

Kenneth McConkey. British Impressionism. Phaidon 1989.

Camilla Gray. The Russian Experiment in Art 1863–1922. Thames & Hudson 1962 (rev. 1986).

Caroline Fox, Francis Greenacre. Painting in Newlyn 1880–1930. Barbican Art Gallery 1985.

John Rewald. Post-Impressionism from Van Gogh to Gauguin. Secker & Warburg 1956 (rev. 1978).

Belinda Thomson. The Post-Impressionists. Phaidon 1983.

Simon Watney. English Post-Impressionism. Studio Vista 1979.

Wendy Baron. The Camden Town Group. Scolar Press 1979.

David Britt (ed.). Modern Art: Impressionism to Post-Modernism. Thames & Hudson 1989.

Francis Frascina, Charles Harrison (eds.). Modern Art and Modernism: a Critical Anthology. Harper & Row, for The Open University, 1982.

Norbert Lynton. The Story of Modern Art. Phaidon 1980 (rev. 1989).

Riva Castleman. Prints of the 20th Century: a History. Thames & Hudson 1976 (rev. 1988).

Susan Compton (ed.). British Art in the 20th Century: the Modern Movement. Prestel-Verlag (Munich), for Royal Academy of Arts, 1987.

Charles Harrison. English Art and Modernism 1900–1939. Allen Lane, Indiana U.P. 1981.

Richard Shone. The Century of Change: British Painting since 1900. Phaidon 1977.

Frances Spalding. British Art since 1900. Thames & Hudson 1986.

Sandy Nairne, Nicholas Serota (eds.). British Sculpture in the Twentieth Century. Whitechapel Art Gallery 1981.

Christos M. Joachimides, Norman Rosenthal, Wieland Schmied (eds.). German Art in the 20th Century: Painting and Sculpture 1905–1985. Prestel-Verlag (Munich), for Royal Academy of Arts, 1985.

Emily Braun (ed.). Italian Art in the 20th Century: Painting and Sculpture 1900–1988. Prestel-Verlag (Munich), for Royal Academy of Arts, 1989.

Sarah Whitfield. Fauvism. Thames & Hudson 1990.

John Golding. Cubism: a History and an Analysis 1907–1914. Faber & Faber 1959 (3rd ed. 1988).

Christopher Green. Cubism and its Enemies: Modern Movements and Reaction in French Art 1916–1928. Yale U.P. 1987.

Caroline Tisdall, Angelo Bozzolla. Futurism. Thames & Hudson 1977.

RoseLee Goldberg. Performance Art, from Futurism to the Present. Thames & Hudson 1988.

Richard Cork. Vorticism and Abstract Art in the First Machine Age. Gordon Fraser 1976 (2 vols.).

Anna Moszynska. Abstract Art. Thames & Hudson 1989.

Meirion & Susie Harries. The War Artists: British Official War Art of the Twentieth Century. Michael Joseph 1983.

Hans Richter. Dada: Art and Anti-Art. Thames & Hudson 1965.

William S. Rubin. *Dada and Surrealist Art*. Thames & Hudson 1969.

Patrick Waldberg. *Surrealism*. Thames & Hudson 1965.

Frank Whitford. *Bauhaus*. Thames & Hudson 1984.

Thirties: British Art and Design before the War. Arts Council 1979.

Richard Shone. *Bloomsbury Portraits: Vanessa Bell, Duncan Grant, and their Circle*. Phaidon 1976.

Alexander Robertson et al. *Angels of Anarchy and Machines for making Clouds: Surrealism in Britain in the Thirties*. Leeds City Art Galleries 1986.

Jeremy Lewison (ed.). *Circle: Constructive Art in Britain 1934–40*. Kettle's Yard Gallery (Cambridge) 1982.

David Mellor. *A Paradise Lost: the Neo-Romantic Imagination in Britain 1935–55*. Lund Humphries 1987.

Malcolm Yorke. *The Spirit of the Place: Nine Neo-Romantic Artists and their Times*. Constable 1988.

Edward Lucie-Smith. *Movements in Art since 1945*. Thames & Hudson 1969 (3rd ed. 1984).

Edward Lucie-Smith. *Sculpture since 1945*. Phaidon 1987.

Julian Spalding (ed.). *The Forgotten Fifties*. Graves Art Gallery (Sheffield) 1984.

David Anfam. *Abstract Expressionism*. Thames & Hudson 1990.

Irving Sandler. *Abstract Expressionism: the Triumph of American Painting*. Harper & Row 1970.

Irving Sandler. *The New York School: the Painters & Sculptors of the Fifties*. Harper & Row 1978.

Lucy R. Lippard. *Pop Art*. Thames & Hudson 1966 (3rd ed. 1970, repr. 1988).

Robert Hewison. *Too Much: Art and Society in the Sixties 1960–1975*. Methuen 1986.

Irving Sandler. *American Art of the 1960s*. Harper & Row 1988.

Kenneth Baker. *Minimalism, Art of Circumstance*. Abbeville Press 1988.

Edward Lucie-Smith. *Art in the Seventies*. Phaidon 1980.

Starlit Waters: British Sculpture an International Art 1968–1988 (exhibition catalogue). Tate Gallery Liverpool 1988.

Edward Lucie-Smith. *American Art Now*. Phaidon 1985.

Richard Morphet. *The Hard-Won Image: Traditional Method and Subject in recent English Art*. Tate Gallery 1984.

Tony Godfrey. *The New Image: Painting in the 1980s*. Phaidon 1986.

The Tate Gallery Archive

Archive of 20th century British Art
Thursday–Friday 10–1; 2–5.30
by appointment only

The Tate Gallery *Archive of 20th Century British Art* collects documents that record and illustrate the history of British Art in this century. It is essentially devoted to British 20th century painting, sculpture and printmaking, although there is some earlier material and some foreign documentation. It contains and collects a wide variety of material based on personal papers and gallery records, most of which is unpublished. Many artists, writers and their relatives have generously given or bequeathed their papers which include sketchbooks, drawings, notebooks, diaries, letters, photographs, films, presscuttings, printed ephemera, and audio visual records to be preserved in perpetuity.

The Archive was formed in 1969, based on papers already donated to the Library and the increasingly rich records of the Gallery's own activities. It now contains over a million documents. From time to time, it provides special documentary exhibitions and frequently lends items to exhibitions at home and abroad.

Archive staff are pleased to answer telephone and written enquiries. Access to the Search Room is limited to bona fide researchers and priority is given to those undertaking research for publications, films and postgraduate degrees. Applicants should write to the Archive outlining their topic of research and requesting information. Each applicant will be asked to fill in a form and to provide a letter of reference. Prior appointments must be made for each visit.

The Tate Gallery Library

The Tate Gallery Library
Monday–Friday 10–5.45
by appointment only

The *Tate Gallery Library* was established, in its present form, in the 1950s to meet the research and information needs of the staff of the Gallery. It therefore collects published material in all forms in subject areas which correspond to the Gallery's collections of British painting since the Renaissance and international 20th century art. The emphasis is on fine art in the Western tradition: painting, sculpture, print-making and the myriad media which contemporary fine artists employ. Particular attention is given to collecting the documentation of contemporary British art. The Library does not cover architecture, photography, design or the decorative arts.

The particular strengths of the collection are its international coverage of post-war art and the collection of exhibition catalogues, now numbering over 100,000. There is also a special collection of artists' bookworks from the 1960s onwards.

The Library may be used, for reference only, by members of the public unable to find the material they require in other libraries. As accommodation is very limited, an appointment must be made for each visit.

In addition, the Library staff will answer telephone and written enquiries and lend material library-to-library through the national inter-library lending system.

The Clore Gallery Study Room

The Clore Gallery Study Room
Tuesday–Friday 12–5.00
Hours may change from time to time
and visitors are advised to refer
to the Gallery Information Desk

The Study Room provides conditions for
viewing the works on paper in the
Turner Bequest and the British
Collection. The drawings, watercolours
and sketchbooks in the Bequest
constitute the core of the collections,
supported by large holdings of prints by
and after Turner, a library of Turner
literature, and an extensive
photographic archive. Among other
artists, Blake and the Pre-Raphaelites
are particularly strongly represented.

As in all print rooms, visitors will be
asked to follow simple rules of conduct
for the safety of the collections, and as
space is limited, there may occasionally
be a short delay before admission on
busy days. Whenever possible the staff
will provide immediate access to works
requested during opening hours,
although Turner sketchbooks and other
fragile items may only be shown upon
prior application. Copying is permitted
upon request. The staff will be pleased to
answer telephone and written enquiries
about the collections and welcome
requests for small-group teaching and
seminars although applicants are urged
to give plenty of notice.

The Friends of the Tate Gallery

The Friends of the Tate Gallery exist to help buy works of art that will enrich the collections of the Tate Gallery. It also aims to stimulate interest in all aspects of art.

Although the Tate has an annual purchase grant from the Treasury, this is far short of what is required, so subscriptions and donations from Friends of the Tate are urgently needed to enable the Gallery to improve the National Collection of British painting to 1900 and keep the Twentieth Century Collection of painting and sculpture up to date. Since 1958 the Society has raised close to £2 million towards the purchase of an impressive list of works of art, and has also received a number of important works from individual donors for presentation to the Gallery.

In 1982 the Patrons of New Art were set up within the Friends organisation. This group, limited to 200 members, assists the acquisition of works by younger artists for the Tate's Twentieth Century Collection.

A similar group, Patrons of British Art, was established in late 1986 to support purchases for the British Collection.

The Friends are governed by a council – and independent body – although the Director of the Gallery is automatically a member. The Society is incorporated as a company limited by guarantee and recognised as a charity.

Advantages of Membership include:
Special entry to the Gallery at times the public are not admitted. Free entry and invitations to private views of exhibitions at the Gallery. Opportunities to attend lectures, private views at other galleries, films, parties, and of making visits in the United Kingdom and abroad organised by the Society. Many Tate Gallery publications are available at reduced prices. The Reading Room in the Clore Gallery is always open.

MEMBERSHIP RATES (1989–90)

Any membership can include husband and wife
Benefactor Life Member £5,000 (single donation).
Patron of New Art £475 annually or £350 if a Deed of Covenant is signed.
Patron of British Art £475 annually or £350 if a Deed of Covenant is signed.
Corporate £250 annually or £200 if a Deed of Covenant is signed.
Associate £65 annually or £50 if a Deed of Covenant is signed.
Life Member £1,500 (single donation).
Member £18 annually or £15 if a Deed of Convenant is signed.
Educational & Museum £15 annually or £12 if a Deed of Covenant is signed.
Young Friends £12 annually.

For further information apply to:
The Friends of the Tate Gallery.
Tate Gallery, Millbank, London
SW1P 4RG
Telephone: 01-821 1313 or
01-834 2742

Copyright Credits

The following works are copyright of ADAGP, Paris and DACS, London 1990: Bonnard p.118; Braque pp.119, 167; Delaunay p.114; Derain pp.113, 169; Dubuffet p.191; Giacometti pp.157, 188, 192, 193; Gorky p.204; Helion p.189; Kandinsky pp.140, 141, 143; Klein p.228; Margritte p.162; Miró pp.197, 158, 165; Severini p.113

The following works are copyright of COSMOPRESS, Geneva and DACS, London 1990: Schmidt-Rottluff p.121; Sutherland pp.172, 173, 174

The following works are copyright of DACS 1990: Johns pp.227, 256; Appel p.190; Beckmann p.125; Chia p.243; De Chirico p.160; Ernst p.161; Grosz p.124; Léger pp.199, 167, 168; Mondrian pp.141, 144; Picasso pp.107, 117, 149, 164, 165, 167, 170, 171, 196, 197, 201; Vuillard p.105

The following work is copyright of DEMART PRO ARTE/DACS 1990: Dalí pp.156, 158, 163

The following work is copyright of The Estate of Edward Wadsworth/DACS 1990: p.136

The following work is copyright of The Munch Museum, Oslo 1990: Munch pp.120, 122

The following work is copyright of The Nolde Foundation, Seebull 1990: Nolde p.121

The following work is copyright of Succession Henri Matisse/DACS 1990: Matisse pp.116, 198

The following work is copyright of The Estate of Andy Warhol/ARS N.Y: Warhol p.233

The following works are copyright of Pollock-Krasner Foundation/ARS N.Y: Pollock pp.205, 208, 256

The following work is copyright of Kate Rothko Prizel & Christopher Rothko/ARS N.Y: Rothko p.208

The following work is copyright of Frank Stella/ARS N.Y: Stella p.238

This book is to be returned on or before
the last date stamped below.

15 APR 1994

22 SEP 1995 A

13 NOV 1996 A

- 6 DEC 2000

- 1 DEC 1997 A

15 MAR 1999 A

23 MAR 1999 A

23 APR 1999

14 DEC 1999

708·2 TAT

SIMON WILSON

TATE GALLERY

An Illustrated Companion

TATE GALLERY

front cover
The Duveen Sculpture Galleries, restored 1989–90
 Photo: Dennis Gilbert

frontispiece
The Tate Gallery 1989

ISBN 1 85437 030 8 paper
ISBN 1 85437 031 6 cloth

Published by order of the Trustees 1990
Design: Caroline Johnston Production: Joanne Ennos
Published by Tate Gallery Publications, Millbank, London SW1P 4RG
Copyright © 1989 The Tate Gallery All rights reserved

Printed on Parilux matt 150gsm by Balding + Mansell Ltd,
Wisbech, Cambridgeshire Typeset in Photina by Servis
Filmsetting Ltd, Manchester

Sponsored by The British Petroleum Company p.l.c.

with additional assistance from Westminster City Council